PENGUIN

KT-493-815

PAX BRITANNICA

This is the second volume of James Morris's brilliant and superb-
ly written triptych depicting the rise and decline of the British
Empire, in which the author describes the Empire at its moment
of climax at the Diamond Jubilee of 1897, and elaborates on
that tangled, sprawling and magnificent edifice.

The three volumes – 'a vast panorama of history, glorious,
savage, sad and painful' – are intended as an impressionistic
evocation of a great historical movement. Graced by the hand of
a chronicler and interpreter whose eye for detail and ear for
anecdote are combined with a formidable knowledge, they en-
capsulate for the reader all the poetry and panache of that glit-
tering adventure.

'In scholarship and humour this ... might, without undue
optimism, be placed upon the same shelf as Edward Gibbon's
history' – James Pope-Hennessy

'Mr Morris has admirably captured the confusion of brilliance
and squalor, dynamic energy and bizarre comedy that made up
the imperial picture of 1897 ... as entertaining as ever, he pep-
pers with wit each slice neatly carved from the huge imperial
carcase ... ebulliently readable' – *Economist*

During the writing of the *Pax Britannica* trilogy James Morris completed a change of sexual role, and now lives and writes as Jan Morris. Of Anglo-Welsh parentage, she divides her time between her library-house in North Wales, her family home in the south, and travelling abroad. Her best-known books, in one *persona* or the other, have included *Venice*, *Oxford*, *Spain* and *Conundrum*: she has also published three volumes of travel essays and edited *The Oxford Book of Oxford*.

JAMES MORRIS

PAX BRITANNICA

The Climax of an Empire

PENGUIN BOOKS

Penguin Books Ltd, Harmondsworth, Middlesex, England
Penguin Books, 40 West 23rd Street, New York, New York 10010, U.S.A.
Penguin Books Australia Ltd, Ringwood, Victoria, Australia
Penguin Books Canada Ltd, 2801 John Street, Markham, Ontario, Canada L3R 1B4
Penguin Books (N.Z.) Ltd, 182–190 Wairau Road, Auckland 10, New Zealand

First published by Faber and Faber Ltd, 1968
Published in Penguin Books 1979
Reprinted 1980, 1981, 1982, 1984

—

—

Made and printed in Great Britain by
Richard Clay (The Chaucer Press) Ltd,
Bungay, Suffolk

For

TOM MORRIS

tea-time imperialist

Set in this stormy Northern sea,
 Queen of these restless fields of tide,
England! what shall men say of thee,
 Before whose feet the worlds divide?

OSCAR WILDE

INTRODUCTION

THE theme of this book is one of muddled grandeur. It sets out to describe the largest of Empires, the British, at its moment of climax—which I have taken to be the Diamond Jubilee of Queen Victoria in 1897, before the Boer War cracked the imperial spirit, and still more terrible events destroyed it. The scale of this spectacle was tremendous, but there was nothing simple or clear-cut to it. All was sprawling, tangled, contradictory, elaborate. For every idealist there was a rascal, for every elegance a crudity, and the British presence across the world displayed no ordered Roman logic.

This ornate variety I have tried to catch in my text, so that the book itself becomes a microcosm of its subject. It is a kind of historical travel book or reportage, limited in period, for I have confined myself fairly closely to the late 1890s, but not in place. It does not pretend to completeness. I have tried only to recall what the Empire was, how it worked, what it looked like, and how the British themselves then saw it—for what it meant to their alien subjects, it would be presumptuous of me to conjecture.

It is one of the happier imperial moments to describe, for all its brag, opportunism and occasional brutality. The morality of imperialism as a principle was not generally in question, and only a handful of radicals passionately opposed the right of any one people to impose its rule upon any other. The subject races had not yet developed that awareness of nationality which was later to make the colonial idea degrading both to rulers and to ruled: to most people, on both sides of the fence, British dominion seemed far more a blessing than a curse. In subsequent volumes I intend to recall the warlike rise of the Victorian Empire, and its later disillusionment: in this one I have not tried to hide a sensual sympathy for the period, haunted as it is in retrospect by our knowledge of tragedies to come.

Introduction

I have fondly imagined my book orchestrated by the young Elgar, and illustrated by Frith; its pages are perfumed for me with saddle-oil, joss-stick and railway steam; I hope my readers will feel, as they close its pages, that they have spent a few hours looking through a big sash window at a scene of immense variety and some splendour, across whose landscapes there swarms a remarkable people at the height of its vigour, in an outburst of creativity, pride, greed and command that has affected all our lives ever since.

TREFAN, 1968

CONTENTS

Contents

14

Contents

THE BRITISH EMPIRE, 1897

IN EUROPE: Great Britain and Ireland: Channel Islands: Gibraltar: Isle of Man: Malta

IN AFRICA: Ashanti: Basutoland: Bechuanaland: British East Africa: Cape Province: Gambia: Gold Coast: Natal: Nigeria: Nyasaland: Rhodesia: Sierra Leone: Somaliland: Uganda: Zanzibar

IN AMERICA: Bahamas: Barbados: British Guiana: British Honduras: British Virgin Islands: Canada: Falkland Islands: Jamaica: Leeward Islands: Newfoundland: Tobago: Trinidad: Turks and Caicos Islands: Windward Islands

IN ASIA: Aden: Brunei: Ceylon: Hong Kong: India: Labuan: Malay Federated States: North Borneo: Papua: Sarawak: Singapore

IN AUSTRALASIA: New South Wales: New Zealand: Queensland: South Australia: Tasmania: Victoria: Western Australia

IN THE ATLANTIC OCEAN: Ascension: Bermuda: St Helena: Tristan da Cunha

IN THE INDIAN OCEAN: Mauritius: Seychelles: seven other groups and islands

IN THE PACIFIC OCEAN: Ellice, Gilbert, Southern Solomon, Union groups: Fiji: Pitcairn: twenty-four other groups, islands and reefs

Transvaal was debatably subject to British suzerainty: Egypt was under British military occupation: Cyprus was British-administered, but nominally under Turkish sovereignty

Area: about 11m square miles

Population: about 372m

CHAPTER ONE

The Heirs of Rome

But hush—the Nations come from overseas,
Attend, with trumpets blown and flags unfurled,
To swell thy Jubilee of Jubilees,
* Heart of the World!*

Cosmo Monkhouse
Punch, June 26, 1897

I

BEFORE she set out on her Diamond Jubilee procession, on the morning of June 22, 1897, Queen Victoria of England went to the telegraph room at Buckingham Palace, wearing a dress of black moiré with panels of pigeon grey, embroidered all over with silver roses, shamrocks and thistles. It was a few minutes after eleven o'clock. She pressed an electric button; an impulse was transmitted to the Central Telegraph Office in St Martin's le Grand; in a matter of seconds her Jubilee message was on its way to every corner of her Empire.

It was the largest Empire in the history of the world, comprising nearly a quarter of the land mass of the earth, and a quarter of its population. Victoria herself was a Queen-Empress of such aged majesty that some of her simpler subjects considered her divine, and slaughtered propitiatory goats before her image. The sixtieth anniversary of her accession to the throne was being celebrated as a festival of imperial strength, splendour and unity—a mammoth exhibition of power, in a capital that loved things to be colossal. Yet the Queen's message was simple—'*Thank my beloved people. May God bless them*'—and the technicians at St Martin's le Grand later reported that the royal dot on the Morse paper at their end was followed by a couple of unexpected clicks: indicating, they thought, 'a certain amount of nervousness on the part of the aged Sovereign at that supreme moment in her illustrious career'.

2

The crowds outside waited in proud excitement. They were citizens of a kingdom which, particularly in its own estimation, was of unique consequence in the world. The nineteenth century had been pre-eminently Britain's century, and the British saw themselves still

as top dogs. Ever since the triumphant conclusion of the Napoleonic Wars they had seemed to be arbiters of the world's affairs, righting a balance here, dismissing a potentate there, ringing the earth with railways and submarine cables, lending money everywhere, peopling the empty places with men of the British stock, grandly revenging wrongs, converting pagans, discovering unknown lakes, setting up dynasties, emancipating slaves, winning wars, putting down mutinies, keeping Turks in their place and building bigger and faster battleships.

By June 1897 all this vigour and self-esteem, all this famous history, had been fused into an explosive emotional force. The nation had been carried away by the enthusiasm known as the New Imperialism, an expansionist, sensational concept of Empire which exactly fitted the spirit of the nineties. It was an era of dazzle and innovation—a time of heightened responses, a quickened time, with a taste for things bizarre and overstimulating, and a sense of history on the turn. This was *fin de siècle* at last, and the very French phrase carried undertones of excitement, suggestions of racing pulse and melodrama. Out of this inflamed setting the New Imperialism started. The Empire had been growing steadily throughout the century, generally without much public excitement, but since the 1870s it had expanded so violently that the statistics and reference books could scarcely keep up, and were full of addenda and hasty footnotes. Recalled now from the grand junction of the Jubilee, the separate lines of the Victorian story seemed to have been leading the British inexorably towards the suzerainty of the world—the methodical distribution of their systems, their values, their power and their stock across the continents. Their Empire, hitherto seen as a fairly haphazard accretion of possessions, now appeared to be settling into some gigantic pattern: and like gamblers on a lucky streak, they felt that their power was self-engendering, that they were riding a wave of destiny, sweeping them on to fulfilment. The New Imperialism was the one certain political winner of the day. With its help the Conservatives and their Liberal Unionist allies had won the 1895 General Election so completely that they seemed destined to stay in office for decades to come. Supremacy, dominion, authority, size, were the watchwords of the time. Social progress

rarely cropped up in the literature of the Jubilee, and even the arts had mostly succumbed to the national taste for elaborate grandeur, expressing themselves in mass choirs and enormous set-pieces. All was summed up in that splurge of red across the map, and was now deliberately commemorated in the pageantries of the Diamond Jubilee—the first pan-Britannic festival, *The Times* called it.

3

Many and varied energies had swept the British to this meridian. Impulses shoddy and honourable, pagan and pious, had turned them into imperialists—a word which had itself shifted its value from the dubiously pejorative to the almost unarguably proper.

First there was simply the wealth, vigour and inventiveness of Victorian Britain, a dynamic State in an age of excitement: capital looking for markets, vitality looking for opportunity, success looking for new fields. Then a succession of disparate prophets, from Jeremy Bentham and Tennyson to Disraeli and Cardinal Newman, had excited the instincts of the people for space, power and sacramental dazzle. Darwin, a half-understood household sage, seemed to have demonstrated that some races, like some animals, were more efficiently evolved than others, and had a right to leadership and possession. The Evangelical movement had drawn attention to the plight of the ignorant heathen of the tropics, only awaiting redemption—'educating the natives of Borrioboola-Gha', as Mrs Jellyby expressed it, 'on the left bank of the Niger'. Among the gentry Dr Arnold and his reformers of the public schools had implanted concepts of privileged service that led logically to the idea of a new Rome; among the masses popular education had opened a generation's eyes to the thrill of the world outside, contrasting so compellingly with the drabness of the new industrial cities at home. The new penny Press, led by the brilliantly boastful *Daily Mail*—'the embodiment and mouthpiece of the imperial idea' —assiduously fanned the aggressive patriotism of the people. The more blustering sort of Briton reacted violently to the Yellow Book decadence of the intellectuals, whose notions seemed the very

antithesis of Nelson, the Pound Sterling and the Charge of the Light Brigade.

Politically the Liberals were in eclipse, and Gladstone's voice, the voice of the English conscience, was silent.[1] The perennial discontent of the Irish, a squalid constant of English politics, had hardened rather than weakened the British will to rule, and that summer Kitchener was gloriously revenging the death of Gordon, twelve years before, with his imperial armies in the Sudan.[2] To the innocent public everything seemed to be going right. The monarchy was more popular than ever. The prestige of the Royal Navy had reached an almost mystical plane. The spectacle of other peoples coalescing in powerful federations—in Germany, in Italy, in America —made the British wonder if they might not also combine their scattered communities, all over the world, into an unapproachable super-state. Jingo imperialism was intoxicating fodder for the newly enfranchised working classes, and the Conservative-Unionist Government was dominated by imperialists of complementary styles: Lord Salisbury the Prime Minister, stroking the surface of affairs with his patrician and scholarly hand; Joseph Chamberlain the Colonial Secretary, an expansionist of the new kind, impulsive and insatiable, who had even gone so far as to install electric light in the Colonial Office. It all went with an almost frantic gusto, like universal craze.

Among the better-informed, doubts also played their part. Complete though British supremacy might appear to be, the era of

[1] Gladstone, whose family fortunes were founded on the Indian and Caribbean trades, remained vehemently anti-Imperialist, and at 87 took no part in the Jubilee events—he thought the Queen ought to celebrate the occasion by abdicating. He died in the following year.

[2] The British, who theoretically ruled the Sudan in the name of Egypt, had decided in 1883 to withdraw the Egyptian garrisons from the country in the face of a rebellion led by a Muslim prophet known as the Mahdi. For this task they chose Charles Gordon, then 50 years old and already a national hero, who had made his name in China and had served in the Sudan before. Having successfully organized the withdrawal of the garrisons, Gordon himself held on in Khartoum, against orders, until in 1885 the city fell and he was killed. A British relief expedition reached the city too late, and Gordon was virtually canonized in England as the archetypical Christian soldier. Kitchener's expedition to reconquer the Sudan had started south from Egypt in 1896.

splendid isolation was ending. New rivalries abroad seemed to compel the British towards an imperial, rather than an insular, sufficiency. The rise of Germany was apparently forcing Britain out of Europe, while Bismarck's bid for German colonies in Africa and the Pacific had transformed the leisurely old habits of Empire-building into urgent power politics. There were technical challenges from Germany, too, commercial challenges from America, and standing political challenges from the Russians and the French. Britain's essential vulnerability, with her extended colonial frontiers, her dependence upon imported food, her excess of population and her *smallness*—the basic fragility of the British position in the world goaded her into imperialism. European reactions to the fiasco of the Jameson Raid had brought home to the British how bitterly they were envied and disliked on the Continent.[1] Britain's industrial lead was still absolute, but it was lessening each year. Both the Germans and the French were building powerful new navies. There was a subconscious feeling, perhaps, that British ascendancy could not last much longer, and must therefore be propped up with pomp and ceremony. The ghosts of imperial heroes seemed to be calling out of the past, urging the nation to be mightier yet—Livingstone and 'Chinese' Gordon, dead in the Christian cause; Nicholson and Havelock from the shambles of the Indian Mutiny;[2] philanthropists like Wilberforce; explorers like Burton and Baker;

[1] The Boer Republic of the Transvaal in South Africa was only theoretically subject to British suzerainty, but its gold reefs on the Rand were being exploited by a predominantly British community—whose members, known as Uitlanders, were allowed no political rights. In 1896 Cecil Rhodes, Prime Minister of the Cape Colony and a diamond millionaire, had given his sanction to a plot designed to seize the Transvaal for the Empire. His lieutenant, Leander Starr Jameson, led a raid into the Republic intended to coincide with a rising of Uitlanders in Johannesburg, but the rising did not take place and Jameson's posse was ignominiously captured by the Boers, the Kaiser sending a congratulatory telegram to President Kruger of the Transvaal. In the summer of 1897 a Select Committee of the House of Commons was inquiring into the circumstances of the raid.

[2] The Mutiny (1857–8) was a rising by Indian sepoys of the Bengal Army which became a popular insurrection in some provinces of central India. It was caused by Indian resentment at certain British reforms, fear of compulsory Christianization, and the issue of cartridges greased with animal fats that were offensive to Hindu and Muslim soldiers.

generals like Lord Napier of Magdala; Disraeli, the glittering impresario of Empire; Raffles, the saintly merchant-venturer.

All these circumstances, these memories, these currents of thought, these men, had so worked upon the British that the grand flourish of the New Imperialism properly represented, as G. M. Young once wrote, 'the concentrated emotion of a generation'. 'Imperialism in the air', Beatrice Webb recorded in her diary that June, 'all classes drunk with sightseeing and hysterical loyalty.' The Diamond Jubilee celebrated not only sixty years of the Victorian era, but the final assembly of the forces and satisfactions of imperialism. The idea of Empire had reached a climax, too. It had meant different things to different generations in Britain—military power, commercial opportunity, prestige. It had been discredited in the middle years of the century, when the colonies generally seemed more nuisance than they were worth, and to some Britons it still meant pre-eminently the establishment of British settlements abroad, rather than the subjugation of alien peoples. But in these last years of the Victorian century, these last decades, perhaps, of the Christian epoch, it was achieving the status of a creed. It was not merely the right of the British to rule a quarter of the world, so the imperialists thought, it was actually their duty. They were called. They would so distribute across the earth their own methods, principles and liberal traditions that the future of mankind would be reshaped. Justice would be established, miseries relieved, ignorant savages enlightened, all by the agency of British power and money.

Among the professionals of Empire, and among the governing classes in general, whatever their politics, this imperial duty became as self-evident as patriotism itself. The young Bertrand Russell was a self-confessed imperialist. H. G. Wells and Sidney Webb both declared imperialist sympathies.[1] Arnold Wilson, recalling his ap-

[1] Russell did not keep it up for long: by 1901, when he was 27, he was a pro-Boer and a pacifist, and abandoned the Empire for ever—much regretting, he says in his autobiography, the imperialist letters of his youth. Wells (1866–1946) was already a Socialist, and his imperialist ideas presumably blossomed into the World State conception of his later years. Webb (1859–1947) had long been a Socialist, too, but had previously been a clerk in the Colonial Office, and was to become, as Lord Passfield, Colonial Secretary in the Labour Government of 1929.

prenticeship in the imperial service, described himself and his colleagues as 'acolytes of a cult—Pax Britannica—for which we worked happily and, if need be, died gladly. We read our Bibles, many of us, lived full lives, and loved and laughed much, but we knew, as we did so, that though for us all, the wise and the foolish, the slaves and the great, for emperor and for anarchist, there is one end, yet would our work live after us, and by our fruits we should be judged in the days to come.'[1]

Not so long before, when men spoke of Empire they were thinking of Napoleon III, the Tsar, or lesser foreign despots. Now they thought only of Victoria, Regina et Imperatrix. The British Empire was reaching its full flush—it had, thought the Indian administrator Sir George Campbell, 'pretty well reached the limits set by nature'.[2] Within the past ten years it had acquired new territories fifty times as large as Britain itself. Light had burst upon the British people, said Sir West Ridgeway, the Governor of Ceylon, in his Jubilee speech that day. 'It dispelled the darkness of ignorance, the scales fell from their eyes, the sordid mists which obscured their view were driven away, and they saw for the first time before them, the bright realm of a glorious Empire.'

4

Within two minutes, we are told, the Queen's message had passed through Teheran on its way to the eastern dominions of the Crown. By the time her carriage was clattering down the Mall, bobbed about by cavalry, her thanks and blessings had reached Ottawa, the Cape, the colonies of West Africa, the strongholds of the Mediterranean and the sugar islands of the Caribbean. London was a self-consciously imperial city, symbolically central, with channels of authority reaching out east and west across the oceans. *Punch*

[1] The cult predeceased the acolyte. Pilot Officer Sir Arnold Wilson, having been British High Commissioner in Iraq, a Member of Parliament, an admirer of Adolf Hitler and a visionary prophet of social security in Britain, was killed when his Blenheim bomber was shot down near Dunkirk in 1940. He was 55.

[2] In fact, ignoring nature, it continued to grow until 1933, when its area was 13.9 million square miles and its population 493 million.

celebrated the occasion with a cartoon of The Queen's Messenger—
a winged, long-haired and androgynous figure of love, holding a
dove close to the chest, flying very low over the sea and flourishing
a piece of paper inscribed *Message V.R.* There was not much else in
sight—only a very subservient sea and a few hangdog islands—
and the effect of the picture was one of effortless mastery, universal
right of way. As never before, London seemed the heart of the
world.

Even the better-disposed foreigners generously recognized the
fact. Animosities were suspended, and the London newspapers
gratefully recorded the comments of their more flattering contem-
poraries abroad. *Le Figaro* roundly declared that Rome itself had
been 'equalled, if not surpassed, by the Power which in Canada,
Australia, India, in the China Seas, in Egypt, Central and Southern
Africa, in the Atlantic and in the Mediterranean rules the peoples
and governs their interests'. The *New York Times* claimed: 'We are a
part, and a great part, of the Greater Britain which seems so plainly
destined to dominate this planet.' Even the *Kreuz Zeitung* in Berlin,
the mouthpiece of the hostile Junkers, described the Empire as
'practically unassailable'. Everywhere, in paying their respects to
the Queen, the nations appeared to be paying homage to Britain.
In Vienna the Emperor Franz Josef called at the British Embassy
wearing the Garter and the uniform of his British regiment. In
Gibraltar the Governor of Algeciras, swallowing two centuries of
Spanish resentment, drove to the Rock for a parade of British troops.
In Brooklyn the Women's Health Protective Association sang *God
Save the Queen* at a jubilee meeting, and in Philadelphia the poet
Alfred Raleigh Goldsmith eulogized England in epic verse:

> *Our father's land! Our mother's home!*
> *By freedom glorified!*
> *Her conquering sons the wide world roam*
> *And plant her flag in pride!*
> *For England's fame, for thy lov'd name,*
> *Have bled, have won, have died.*
> *Victoria! Victoria! Long live our nation's Queen.*
> *Victoria! Victoria! God bless Old England's Queen.*

5

More gratifying still was the tribute of the Empire itself. It is true that somebody had stolen the £300,000 diamond intended by the Nizam of Hyderabad as a present for the Queen, and the suggestion that every one of her 372 million subjects should send her a congratulatory telegram was fortunately not pursued: but everywhere in the Empire that day statues were being unveiled, garrisons were being inspected, thanksgiving services were being held in thatch-roofed outposts of the Anglican communion, ships were dressed overall and commemorative horses' drinking troughs were unveiled. Even President Kruger of the Transvaal, the Queen's most difficult tributary, obligingly released two obdurate Englishmen held in Pretoria gaol since the Jameson Raid, and in Hyderabad every tenth convict was set free (asked why, one of them said he understood Her Majesty had at last given birth to a son and heir). At Alligator Pond in Jamaica a week's free food was distributed to poor families. In Baroda there was free travel on the State Railways for twenty-four hours. In Aden the 'poorer natives' were feasted at the expense of the British community. There was a grand ball at Rangoon, a dinner at the Sultan's palace in Zanzibar, a salute of gunboats in Table Bay, a 'monster Sunday-school treat' at Freetown, a performance of the Hallelujah Chorus in Happy Valley at Hong Kong.

And into London there poured, to the amazement and delight of all, the gilded emissaries of Empire. As the poet Laureate, Alfred Austin, wrote:

> *From Afric's Cape, where loyal watchdogs bark,*
> *And Britain's Sceptre ne'er shall be withdrawn,*
> *And that young Continent that greets the dark*
> *When we the dawn;*
>
> *From steel-capped promontories stern and strong,*
> *And lone isles mounting guard upon the main,*
> *Hither her subjects wend to hail her long*
> *Resplendent Reign.*

The Colonial contingents for the Jubilee procession were mostly encamped at Chelsea, where curious crowds had been wandering among their tents for days. The Premiers of the eleven self-governing colonies, with their ladies, were put up at the Cecil, the largest hotel in Europe: they were often to be seen driving here and there to official functions, choosing gloves at Dents' or silk hats in St James's Street, or alighting at great town houses to take tea with duchesses. Wilfrid Laurier, the Prime Minister of Canada, was knighted on Jubilee morning, and the newspapers recorded approvingly that the Premier of Tasmania, Sir Edward Braddon, was the author of a book about big-game hunting in India—just the speciality the British public expected of a proper Empire-builder.

At the Grosvenor Hotel, the gossip columns reported, was staying 'Sir Jamsetjee Jeejeeboy, an eminent Parsee'—in whose employment, as principal of a private art school in Bombay, Rudyard Kipling's father Lockwood had first gone to India. Another eminent guest was James Tyson, who had made a fortune supplying food to the gold-diggers in Australia, and was now reputed to be worth more than £5 million. There was an Imperial Fête in Regent's Park, and an Imperial Ballet at Her Majesty's Theatre, the Australian prima donna Nellie Melba was singing at the Opera, and all the visiting colonial and Indian officers had been taken by special train to a demonstration in Kent of the new Maxim-Nordenfeldt gun. In the parks, cafés and music-halls of the capital were to be seen princes and sultans, Sikhs and Chinese, exquisite Malay ladies, and West African policemen clumping uncomfortably about in boots, the first they had ever worn.

The British were still astonishingly ignorant about their possessions, and they viewed all this with genial if rather patronizing innocence. Contemporary accounts of the event are full of wonder, precariously avoiding prejudice: were it not for the British uniforms and the Union Jacks, one feels, the responses to these colourful visitors might have been different. As it was, all those strange figures of Jubilee were brothers-in-Empire, and a writer in the women's page of the *Illustrated London News* even suggested that the British male might learn a thing or two from their uninhibited fineries. The British saw the whole celebration as a kind of family reunion, how-

ever vague they were as to the exact origins of the Hausa constables, the jurisdiction of the Privy Council over the protected persons of Basutoland, or even the constitutional status of Western Australia. It was not a sophisticated occasion, the Diamond Jubilee. It was full of sentiment and extravagance, indulgent tears and thumping brass bands, strung about with flags and lavishly illuminated. 'It may safely be said,' one commentator wildly claimed, 'that the Jubilee will be the costliest event in the world's history.'

6

The procession itself was a superb display of braggadocio. With its 50,000 troops, it was thought to constitute the largest military force ever assembled in London, and as it marched in two separate columns through the streets of the capital, to converge upon St Paul's for the thanksgiving service, even the exuberant reporters of the nineties sometimes found themselves beggared of hyperbole. 'How many millions of years has the sun stood in heaven?' inquired the *Daily Mail*. 'But the sun never looked down until yesterday upon the embodiment of so much energy and power.' It was, wrote G. W. Steevens, 'a pageant which for splendour of appearance and especially for splendour of suggestion has never been paralleled in the history of the world'.[1] 'History may be searched,' thought *The Times*, 'and searched in vain, to discover so wonderful an exhibition of allegiance and brotherhood amongst so many myriads of men. . . . The mightiest and most beneficial Empire ever known in the annals of mankind.'

One half of the procession was led by Captain Ames of the Horse Guards, at six foot eight inches the tallest man in the British Army, and looking more stupendous still wearing his high plumed helmet, swelled out with breastplate and cuirass, and astride his tall charger. The other half was led by Field-Marshal Lord Roberts of Kandahar, the most beloved of imperial generals, riding the grey Arab,

[1] Steevens, who was born in 1869, was the *Mail*'s most brilliant recruit. A distinguished classicist at Oxford, he became the paper's star descriptive reporter, and expressed more vividly than anyone the heightened emotions of the New Imperialism. He died as a war correspondent in the siege of Ladysmith during the Boer War, aged 31, and is buried in the cemetery there.

Vonolel, which had conveyed him from Kabul to Kandahar in his victorious march of 1880.[1] Not far behind Lieutenant Festing rode the Sudanese horse which had taken him to the capture of Bida in West Africa, and cheers of sympathy greeted the empty sleeve of the Honourable Maurice Gifford, wounded during a recent skirmish with the Matabele.

Before, behind and among these champions marched a weirdly imperial force of arms. There were cavalrymen from New South Wales—gigantic soldiers, the papers reported, with an average height of five feet ten and a half inches and an average chest of thirty-eight inches. There were Hussars from Canada and Carabiniers from Natal, camel troops from Bikaner and Dyak head-hunters from North Borneo, wearing bright red pillbox hats and commanded by Captain W. Raffles Flint. The seventeen officers of the Indian Imperial Service troops were all princes, and the Hong Kong Chinese Police wore conical coolie hats. There were Malays, and Sinhalese, and Hausas from the Niger and the Gold Coast, Jamaicans in white gaiters and ornately embroidered jackets, British Guiana police in caps like French gendarmes, Cypriot Zaptiehs whose fezzes struck so jarring a chord that some of the crowd hissed them, supposing them to be Turks, and a jangling squadron of Indian lancers led by a British officer in a white spiked helmet. London had never seen such a spectacle. One of the Maoris weighed twenty-eight stone. One of the Dyaks had taken thirteen human heads. It was a properly Roman sight, a pageant of citizens and barbarians too, summoned from the frontiers to that grey eternal city. The British-bred colonials, said the Golden Issue of the *Daily Mail*, printed throughout in gold ink and sometimes breaking into exultant cross-heads, were 'all so smart and straight and strong, every man such a splendid specimen and testimony to the

GREATNESS OF THE BRITISH RACE

that there was not an Imperialist in the crowd who did not from the sight of them gain a new view of the glory of the British Empire'.

[1] Vonolel, who had been awarded the Afghan war medals by special order of the Queen, died in 1899, aged 27, and was buried in a corner of the Royal Hospital grounds in Chelsea: but the whereabouts of his grave seems to have been forgotten.

Through welcoming banners and fluttering handkerchiefs this allegorical pageant passed, with *Soldiers of the Queen* up the Strand and 'Three Cheers for India' at the end of Fleet Street, with applause for the dazzlingly ostentatious uniform of Sir Partab Singh, and a rippling of black and white from the massed clergy outside St Paul's—through the massed hierarchy of Civil Servants on Constitution Hill, past the survivors of Balaclava assembled at a window on Ludgate Hill—with cheers rolling across London, with the thump of drums and the singing of patriotic songs along the route, with an empress, a crown prince, twenty-three princesses, a grand duke, three grand duchesses, four duchesses, forty Indian potentates riding three abreast and gorgeously decorated, with guns booming and bells chiming, beneath a banner in St James's proclaiming in English and Hindustani that Victoria was alone the Queen of Earthly Queens, with the Papal Nuncio sharing a carriage with the representative of the Emperor of China, and the Princess of Wales in mauve spangle-trimmed satin, with rajahs glittering in diamonds and their ladies all in gold, and tens of thousands of Union Jacks, flying from towers, draped from windows, merry in the hands of school-children or haughty above the bearskins of colour sergeants. The Queen wore a bonnet with ostrich feathers in it, beneath a white silk parasol, and she was greeted at St Paul's by her son the Prince of Wales, who was on horseback in a plumed hat, and received her with knightly courtesy.[1]

7

Everybody agreed it was a great success. As an affirmation of national pride it justly expressed the mood of the people, and gave an explicit warning to foreigners that Britain had not lost the taste for greatness. As a tribute to Victoria it was a moving reminder of all that had happened to the British since she had come to the

[1] The Queen could not walk easily, and it had been proposed that a ramp should be built up the steps of St Paul's, enabling her carriage to be driven inside. She would attend the Jubilee service sitting in her carriage directly beneath the dome, her six white horses held steady by grooms. This truly imperial scene was never enacted, for they lost their nerve and held the service outside the cathedral instead.

throne, so long ago that most of the spectators could hardly imagine a Britain without her. As Mark Twain wrote, the Queen herself was the real procession—'all the rest was embroidery'. Victoria returned to her palace in the evening, exhausted but marvellously pleased, through the blackened buildings of her ancient capital, whose smoke swirled and hovered over the grey river, and whose gas-lamps flickered into tribute with the dusk. At home she found that most of the colonies had already replied to her Jubilee message: their answers were being prepared for presentation to Her Majesty, and for later publication as a Blue Book.

CHAPTER TWO

Palm and Pine

What if the best of our wages be
An empty sleeve, a stiff-set knee,
A crutch for the rest of life—who cares,
So long as the One Flag floats and dares?
So long as the One Race dares and grows?
Death—what is death but God's own rose?
Let but the bugles of England play
Over the hills and far away!

W. E. Henley

2

THE Diamond Jubilee crystallized the new conception of Empire, and made people feel they were part of some properly organized working unit. The notion of a Greater Britain had been devised by the young Charles Dilke[1] thirty years before: but though the phrase had caught on among educated people, until the eighties and nineties the great British public had never really seen their Empire as anything but a vague and ill-explained appendage to sea-power, scattered somewhere beyond the horizon, and sporadically growing. It was Sir John Seeley who remarked, in his seminal book *The Expansion of England*,[2] that the Empire had been acquired 'in a fit of absence of mind'. He did not mean that it had been won by wool-gathering, but that the public at home was cheerfully indifferent to the whole 'mighty phenomenon of the diffusion of our race and the expansion of our State'.

Not long before the statesmen themselves had often doubted whether the Empire was worth its trouble, and not only radicals but High Tories and even colonial officials had assumed it would eventually disintegrate. Gladstone the Little Englander had expressed a popular view, when he called the triumphs of Empire 'false phantoms of glory'. The Bill which, in 1876, created Victoria

[1] Charles Dilke (1843–1911) was a rare kind of politician, a radical imperialist. His book *Greater Britain*, written at 23 after a world tour, was an immense popular success, offering educated Britons a new vision of themselves as a benevolent master race. Dilke's distinguished career as a Liberal republican was ruined by a famous divorce case in 1886, in which he was accused of adultery with the wife of another M.P.

[2] *The Expansion of England* was a series of lectures delivered by Seeley (1834–95) as Professor of Modern History at Cambridge. It dealt with the period 1688–1815, but served to give the British a wider view of their imperial mission, and was one of the source books of the New Imperialism, remaining in print until 1956—the year the British realized that their expansion had ended.

Empress of India, had aroused furious opposition. Disraeli, its progenitor,[1] loved addressing her as 'Your Imperial Majesty', but Gladstone called it 'theatrical bombast and folly', and *The Times* thought it 'tawdry'. In those days the word 'Empire' still referred, in liberal British minds, to the dominions of foreign tyrants, and the idea of a *British* Empress seemed a monstrous negation of principles.

Twenty years had passed, Gladstone was dying, and Greater Britain had grown so explosively that the Colonial Office List, 153 pages long in 1862, occupied 506 pages in 1897. The Empire had become an official enthusiasm. Victoria approved of it. Tennyson had hymned it. The public now surveyed Greater Britain with a proprietorial concern, as though they were inspecting a hitherto neglected piece of family property. What they saw was this: an immense conglomeration of territories, of every kind, climate and state of development, linked only by Britain's mastery of the sea, and strewn untidily across all the continents. The British Empire was a gigantic hotchpotch. Represented in pillbox hats and embroidered jackets, with British officers swankily in the van, the constituent colonies may have seemed to possess a certain uniformity, if only of foot-drill. In fact they were a wild jumble of territories, and ranged from proper nations like Canada, negotiating its own commercial treaties and announcing its own tariffs, to backwaters like British Guiana, into whose murky hinterland no Englishman had ever penetrated.

2

Outside this heterogeneous mass there shone a reflected glow of Empire. There were many foreign countries in which an Englishman did not feel himself altogether abroad, in which he enjoyed the advantages of an economic influence, a cultural understanding or an historical link: countries like the Argentine, where British enterprise had lately provided not only the first shorthorn, sheep-dip

[1] Progenitor, too, of the New Imperialism. Disraeli (1804–81) had first given glamour to the imperial idea, with gestures like the acquisition of Suez Canal shares, strokes of policy like the movement of Indian troops to Malta to confront Russia, and phrases like: 'The key of India is not Herat or Kandahar, the key of India is London.'

and game of polo, but also the first electric light, steamship, tram-
way, bank, telephone service and insurance company, and all the
original railways; or Nepal, where a British Resident lived in semi-
regal style, surrounded by his own protective cavalry; or Siam,
whose foreign trade was almost all in British hands; or even the
United States, where England was still commonly regarded as the
Mother Country. All sorts of special privileges, accorded to British
subjects in many parts of the world, acknowledged the fact of
imperial power. Colonies of Britons thrived, their conceits hu-
moured and their extravagances welcomed, in places like Florence,
St Petersburg and Bordeaux. Consular courts stood outside the
local law in countries like Persia and Turkey—the British court at
Constantinople had its own gaoler. Some of the China treaty towns
were virtually self-governing British colonies. The military adviser
to the Sultan of Morocco was a Scotsman, the Inspector-General of
the Chinese Customs an Irishman, Thomas Cook's the travel
agents owned the funicular up Mount Vesuvius.[1] The Imperial
Bank of Persia was a British registered company and the British
colony in Venice kept, against all the rules, seventeen cows in a
garden. All this was the nimbus of Empire, or the earthshine.

One degree nearer the Crown were those many territories which,
though unquestionably British, were only coloured red on the map
by courtesy of the adventurers. The world was still unfolding itself
before the Victorians, largely at British instigation, and the great
age of African exploration, only just ending, was inextricably linked
with the imperial saga. The public was addicted to tales of far ad-
venture, and tall stories of Empire (the crows of northern Austra-
lia, it was said, flew backwards to keep the dust out of their eyes,
while in New Guinea there was alleged to be a mountain 32,000 feet
high). The British Empire was half-empty and half-explored. Its

[1] The Scotsman was Harry Aubrey de Vere Maclean (1848–1920), who
played the bagpipes and the guitar and was an indefatigable amateur inventor.
The Irishman was Robert Hart (1835–1911), resident in China for fifty-four
years and virtually the creator of the Chinese maritime customs service.
 The Vesuvius funicular, the subject of the song *Funiculì Funiculà*, was
destroyed in the eruption of 1944, and Cook's sold its remains after the
Second World War, retaining a share in the ownership of the chairlift that
has replaced it.

average density of population was 36.8 to the square mile, compared with 373.3 at home in Britain, and there was room for every sort of wildness: the aboriginal mothers of Australia habitually ate their new-born children, the Gonds of Nagpur worshipped serpents and the smallpox. In every continent men of British stock and nationality were still extending the limits of the Pax Britannica, into territories that grew wilder and less hospitable as they grew scarcer. In Africa they were pressing up the Nile, across the Zambesi, inland from the Gold Coast and the mouth of the Niger. In Asia they had recently moved into Upper Burma, North Borneo, and many islands of the South Pacific. In the south they were penetrating the miserable heartland of Australia, and ih the west the Klondike gold rush was luring thousands of prospectors into the Yukon. This was the moving frontier of the British, the uncompleted adventure.

Then there were the islands, fortresses and coaling stations, strung out along the shipping lanes. Gibraltar, Malta, Aden, Singapore and Hong Kong stood along the orient route. St Lucia guarded the West Indies, Bermuda lay in mid-Atlantic, Halifax in Nova Scotia was the home of one British squadron, Esquimalt in British Columbia the base of another. Everywhere British ships could berth in British harbours, stock up with British coal, replenish their supplies of British beer or biscuits, paint their hulls with British paint, pick up their instructions from British cable stations beneath the protection of British guns. In every sea a ragbag of islands announced the imperial presence: islands close at home, like the Channel Islands and the Isle of Man, which were technically not parcel of the realm, but overseas possessions; petty islands of the south Atlantic, like St Helena where Napoleon died, or Ascension where the Lord Mayor of London's turtles came from; desert islands like Perim or Socotra; high-sounding islands like the Solomons, the Spice Islands or the Leewards; islands everyone hankered after, like the Bahamas or the Seychelles, and islands that nobody had ever heard of, like the Chagos Islands, or Dudosa; islands as big as Newfoundland or as infinitesimal as Diamond Rock, a granite lump in the Caribbean which had been garrisoned by the Navy in the Napoleonic Wars, and given the prefix 'H.M.S.'. There were valuable islands, useless islands, heavenly islands, ghastly islands. Barbados was claimed to be the most

densely populated island on the globe. Bermuda lived chiefly by supplying early vegetables to the city of New York. For the possession of the island of Cyprus the British paid £92,800 a year in tribute to the Sublime Porte, together with 4,166,220 okes of salt—fortunately more than covered anyway by repayments on a British loan to Turkey made forty years before.

Many of these strongpoints and outposts stood on the road to India, the grandest of the imperial possessions. India was different in kind from the rest of the Empire—British for so long that it had become part of the national consciousness, so immense that it really formed, with Britain itself, the second focus of a dual power. If much of the Empire was a blank in British minds, India meant something to everybody, from the Queen herself with her Hindu menservants to the humblest family whose ne'er-do-well brother, long before, had sailed away to lose himself in the barracks of Cawnpore. India was the brightest gem, the Raj, part of the order of things: to a people of the drizzly north, the possession of such a country was like some marvel in the house, a caged phoenix perhaps, or the portrait of some fabulously endowed if distant relative. India appealed to the British love of pageantry and fairy-tale, and to most people the destinies of the two countries seemed not merely intertwined, but indissoluble.

And finally there were the white colonial settlements, for many Britons the core and real point of their Empire. Into almost every temperate territory of the unoccupied globe the British had moved—only in Latin America had they been irrevocably forestalled. Full-scale British nations flourished in Australia, New Zealand, Canada and South Africa. Lesser settlements were implanted in the Falkland Islands, the sugar islands of the Caribbean, Bermuda, Fiji, Ceylon and India. Hundreds of thousands of Englishmen had settled in Ireland. The first emigrants were prospecting the farming country of the East African highlands, and out-spanning their ox-wagons in the Rhodesian veldt. Wherever there was White Man's country vacant, the British had seized and occupied it, filling in the empty spaces of the world, and setting up their own kind of society wherever they went. Such was, so the romantic idealists thought, the manifest destiny of the Empire.

3

All this the British people surveyed, as they thumbed through the Jubilee souvenirs, or wondered at the sweep of red on the schoolroom map. It was an extraordinary estate. Disraeli had called its character 'peculiar—I know no example of it, either in ancient or modern history'. An inventor had to take out thirty-five separate patents if he wished to protect his device throughout the Queen's possessions. The Roman Empire in its prime comprised perhaps 120 million people in an area of 2½ million square miles: the British Empire, now that it had reached 'the limits set by nature', comprised some 372 million people in 11 million square miles—ninety-one times the area of Great Britain. Throughout this immense dominion, this quarter of the globe, the British enjoyed rights of suzerainty, shading away from automatic citizenship in Canada or Australia to a very probable invitation to the New Year Durbar at the British Residence in Bahrein,[1] or a distinctly better chance than most of getting a room with a bath at Shepheard's.

The acquisition of it all had been a jerky process. Absence of mind it never was, but it had happened so obscurely that to the ordinary Briton the rise of the Empire must have seemed more like some organic movement than the conscious result of national policies. There seemed no deliberation to it. One thing simply led to another. There had been a British Empire for nearly three hundred years, and though colonies had come and gone since then, there were distant parts of the world which had been British for twice as long as the United States of America had been in existence. Greater Britain was born in 1583, when Sir Humphrey Gilbert took nominal possession of Newfoundland, and by 1609 the first imperial settlers, a company of castaways, had been washed up on Bermuda— to inspire the first imperial work of art, *The Tempest*. Later in the seventeenth century the British implanted their authority in several

[1] This traditional function is still going strong. Its guests, proceeding to the Residency from their air-conditioned villas, generally think they are merely celebrating the passage of another year of exile, but in fact they are honouring the proclamation of Victoria as Queen-Empress on January 1, 1877.

Caribbean islands, in North America, in Honduras, West Africa and India. In the eighteenth century they extended themselves in Canada and India, took over Ceylon and the Cape of Good Hope and sent their first convict settlers to Australia. In the nineteenth century they had acquired a vast new empire in Africa, besides New Zealand, Fiji, North Borneo and much of Malaya. And through all these centuries they had been picking up islands, forts and spheres of influence along the way, St Helena (1651) to Cyprus (1878), and what the Colonial Office List described as 'countless smaller possessions and nearly all the isolated rocks and islands of the ocean'. The Empire had never been static, and would never be complete. The Romans honoured a God of frontiers, Terminus, who used to be represented as a very large stone. A comparable British deity would be symbolized by something far more portable, for their Empire grew in jumps, sometimes leapfrogging a continent to possess a further island, sometimes by-passing a river basin, sometimes swapping one territory for another, sometimes even refusing one— the Dualla chiefs of the Cameroons repeatedly asked to be annexed, but the British either declined or took no notice at all.

Most Englishmen, asked what it was all about, would probably have described it as a trading system, but this was only partly true. The trading instinct had led to the early settlements in India, and to the slave colonies of West Africa with their protective forts, but most of the British possessions were acquired either for *Lebensraum* or for strategy. In India the British were gradually forced into conquest to protect their original interests, rather than to extend them: first across the subcontinent itself, then beyond the perimeters of India—into Baluchistan in the west, Burma in the east, Sikkim and Bhutan in the north, and across the Indian Ocean into Aden, East Africa and Egypt.

French Canada and many of the Caribbean Islands were acquired as a result of European wars. Ascension Island and Tristan da Cunha were occupied as garrison islands, to prevent a rescue of Napoleon when he was imprisoned upon St Helena (when Napoleon died and the troops were withdrawn three men, with a woman and two children, decided to stay on Tristan—their descendants formed its population still, and their settlement, officially Georgetown, was

always known as Garrison). Cyprus was taken over from the Turks under a convention engaging Britain to help the Sultan defend his Asiatic possessions against Russia. Australia was glumly colonized when the loss of the American colonies deprived the British of a convict dumping-ground. The partition of Africa in the past two decades, which had given Britain a lion's share of the continent, was largely a diplomatic or strategic exercise—less a matter of getting oneself in than of keeping others out.

Often the causes of Empire were petty. Honduras became British because ships' companies used to cut logs upon its beaches, and Bombay was part of Catherine of Braganza's dowry when she married Charles II. Hong Kong fell into British hands in 1841 as a result of the Opium War, fought to protect the interests of British opium-growers in India. Perak became British ostensibly because of feuds there between rival groups of Chinese miners. Some territories were imperially acquired to rescue them from local empire-builders —New Zealand, for instance, which was plagued by lawless British adventurers, or Basutoland, whose King asked to be taken under imperial protection to forestall annexation by the British settlers of the Cape, and who later wrote to Queen Victoria that 'my country is your blanket, and my people the lice upon it'.

4

So they were motley origins: but the British were generally able to rationalize the expansion of Greater Britain—if not the movement as a whole, at least each spasm of growth. This is how Sir F. W. R. Fryer, of the Indian Civil Service, explained the three invasions by which the British eventually acquired dominion over Burma. The first Burmese war, 1824, was 'due to the encroachment of the King [of Burma] upon our borders'. The second war, 1852, was 'due to a succession of outrages committed on British subjects by the Government of Burma'. The third war, 1885, was 'due to the oppressive action of the King towards a British company, and to his advances towards a foreign Power'. Such an expansion of British boundaries, Fryer thought, was inevitable: oriental Powers were 'sooner or later unable to appreciate the fact that it is for their own interest to

maintain peace and to abstain from provoking their European neighbours'.

'Adjusting the relations between the two countries' was a favourite euphemism for the process, and a whole vocabulary of evasive justification was devised to illustrate the strategies of Greater Britain, and define the blurred edges of the Empire. Frontiers were habitually rectified. Spheres of influence were established. Mutually friendly relations were arranged. River systems were opened to trade. Christian civilization was introduced to backward regions. One spoke vaguely of the confines of Egypt, the basin of the Zambesi, the watershed of the Niger, and one naturally could not afford to allow the Sultanate of Witu to fall into the hands of a potentially hostile Power. The imperial records were full of paramountcies, suzerainties, protectorates, leases, concessions, partitions, areas of interest, no-man's-lands and related hinterlands—this last, an especially convenient conception, picked up from the German within the past ten years.

Accounted for in these diverse ways, one acquisition seemed to lead logically to the next. Trade led to the defence of trade, exploration led to settlement, missionaries needed protection, where once the Liverpool merchants loaded their transports with slaves for America, now the Royal Navy needed bases to keep foreign slavery in check. It was like a monumental snowball, and though in the past the lesser campaigns of Empire had scarcely fired the passions of the public, now the British had suddenly become aware of the staggering momentum of it all. During Queen Victoria's reign they had acquired eighteen major territories, and now scarcely a month passed without another satisfactory adjustment of relations.

5

Never since the world began, Seeley had written, did any nation assume anything like so much responsibility. 'Never did so many vast questions in all parts of the globe, questions calling for all sorts of special knowledge and special training, depend upon the decision of a single public.' Literally thousands of languages and dialects were spoken in the British Empire, from Hindustani, Chinese and Arabic

to the shadowy remnants of Manx, still occasionally to be heard in hill farms on the Isle of Man. Every world problem was Britain's problem. She was the greatest Hindu and the greatest Muslim Power, and there was no kind of climate or terrain with which Englishmen of the day were not familiar. The official lists of imperial appointments wonderfully demonstrated this range and versatility. What a state it must have seemed, when one could thumb through a red-bound register to see which of one's fellow countrymen was Governor of Madras or Agent in Egypt, which was the officer in charge of the ex-Amir of Kabul, who commanded H.M.S. *Alert* on the North American Station, who was presently Inspector of Steam Boilers and Prime Movers in Bombay, and who it was in charge of the police post on the Yukon trail between Skagway and Dawson City!

Never so much responsibility: but then at that moment of her history Britain was settled in the habit of authority—authority in the family, in the church, in social affairs, even in politics. It was the last heyday of the patricians. British Governments, for all the liberalizing influences of reform, were still paternally authoritarian, and the English posture abroad was habitually one of command. To the educated Englishman responsibility came naturally. No other Power had been so strong for so long, so stable in its institutions and so victorious in its wars: and Britain's naval supremacy really did give the country a measure of universal sovereignty, that immemorial dream of conquerors. In theory no other state could ship an army across the seas without British consent, and in practice the merchant shipping of the rest of the world was largely dependent upon British cables and coaling stations. The presence of the sea, at once insulating the Mother Country and linking it with the Empire, gave the British an imperial confidence. 'I do not say the French cannot come,' as Admiral St Vincent had once remarked; 'I only say they cannot come by sea.'

6

So it looked to the British. By means complex and often shadowy, they had acquired a quarter of the world, and could behave with privileged immunity in much of the rest. There was a good deal of

brag to the Britain of the nineties, but then there really was a good deal to brag about. It was expressive of the size and variety of the British Empire that papers marked S.L. often went astray in the Colonial Office: nobody could be sure whether they were intended for Sierra Leone, a colony for liberated slaves on the west coast of Africa, or for St Lucia, an island in the West Indies ceded by France under the Treaty of Paris, where the laws were mostly French, the food was mostly Creole, and the mongoose had recently been introduced from India in an attempt to keep down the rats.

CHAPTER THREE

Life-lines

Sons, be welded, each and all
Into one imperial whole,
One with Britain, heart and soul!
One life, one flag, one fleet, one Throne!
 Britons, hold your own!

Alfred, Lord Tennyson

3

THE Roman Empire was self-contained. The Spanish Empire was concentrated. The Russian Empire was continental. The British Empire was broadcast across the earth, and communications were the first concern of its late Victorian rulers. The electric telegraph and the steamship had transformed the Pax Britannica. Fifty years before the imperial offices in London had been geared to time-lags of months or even years. Now the mail took four weeks to Australia, and there were only a few remote or recent colonies to which the Queen's Jubilee message finally made its way in the pouch of a native runner. The whole Empire was suddenly accessible, and every new link seemed to be welding it into something more muscular and permanent. The communications of the world were overwhelmingly in British hands. It was a preoccupation of the British to keep them so, and to ensure that every territory of the Empire was linked to London by British routes—All-Red Routes, in the jargon of the day. Cecil Rhodes's idea of a Cape-to-Cairo railway line was more than just a speculator's dream: it vividly expressed the national vision of British-controlled highways criss-crossing all the continents.

Of course the control would be asserted, the British emphasized, for the benefit of everybody: but as the Russian Foreign Secretary remarked, when told in 1889 that the British were opening up the Karun River in Persia for the advantage of all nations, '*c'était là une manière de parler*'. To other nations the imperial methods often seemed preposterously high-handed. The British roamed the seas as though they owned them, and treated waters particularly important to their strategy, like the Red Sea and the Persian Gulf, more or less as territorial preserves. The Navigation Acts, which reserved British imperial traffic for British ships, had been repealed half a century before: but the Empire still depended upon British command of its

arteries, and phrases about the life-lines and the imperial links occur with such monotony throughout the literature of imperialism that one would expect them to lose their impact by sheer repetition, like soldiers' swear-words.

2

A favourite map of the time was the kind that showed a small red blob for each British ship at sea—like thousands of corpuscles sprinkled through the veins of the world. It was on the shipping lanes, more than anywhere, that British supremacy showed. At sea at any one moment, we are told, were British ships carrying 200,000 passengers and as many merchant seamen. More than half the merchant shipping of the world flew the Red Ensign—13½ million tons of it, or half as much again as in 1877. A thousand new ships were launched in the years 1896 and 1897, and of every thousand tons of shipping passing through the Suez Canal in the 1890s, 700 tons were British (95 were German, 63 were French, 43 were Dutch, 19 were Italian: 2 were American). The British had originally enjoyed a monopoly of the steamship trade, and they were still vastly more experienced than any of their competitors.

The three biggest shipping lines, Peninsular and Oriental, Elder Dempster and British India, had all based their fortunes on the Empire trade, and scores of lesser companies lived by it, from ex-slavers of Liverpool to raffish schooner partnerships of the South Seas, their captains cheerfully drinking and whoring their way from one cargo to another. The Royal Mail Steam Packet Company had direct imperial origins—it was chartered in 1839 because the Government thought a steam service to the West Indies an imperial necessity, and still sent its ships to Barbados once a fortnight. The New Zealand Shipping Company prospered by feeding Britain with frozen mutton from the Antipodes. The 'Blue Funnel' Line—the Ocean Steamship Company—based many of its ships on Singapore, never bringing them home at all. The Shaw Savile ships on the New Zealand run went out by the Cape of Good Hope and came back by the Horn, circumnavigating the globe every three months.

Four big shipping lines ran from England to Canada; two went from Liverpool to West Africa, following the slavers' route; there was a weekly service to South Africa. Britain had a greater share of ocean traffic than ever before in her history, and much of it was on the imperial routes. In every imperial port the London shipping agents were the mainstays of commerce, and in smaller places the arrival of the boat from England was a great event. High on Signal Hill at St John's, Newfoundland, above the narrow entrance to the harbour, the house flags were hoisted on a yard-arm—James Murray, Shea and Co, Campbell and Smith, Rothwell and Bowring, James Baird: and beneath that fluttering welcome, announcing their arrival to the city far below, the weathered ships would beat in from the Atlantic, into the deep cold harbour behind the bluffs, while the Newfoundlanders hastened down their hilly streets to greet them at the quays.

On the Far East route the service had become almost institutional, so long and so regularly had the steamships been carrying Anglo-Indians to and from their dominions, the brisk young cadets so fresh, pink and assured, the brown stoop-shouldered veterans sickly from a thousand fevers. P. and O. and British India ran the service in partnership, each a company of profound and crotchety character. Kipling said British India offered 'freedom and cockroaches', while P. and O. acted 'as though twere a favour to allow you to embark':

> *How runs the old indictment? 'Dear and slow',*
> *So much and twice so much. We gird, but go.*
> *For all the soul of our sad East is there,*
> *Beneath the house-flag of the P. and O.*

It took about seventeen days to India—£50 up—and one of the great daily functions of the Victorian world was the passage of the British liners through the Suez Canal: black-hulled ships with high-sounding names, *Coromandel* or *Kaisar-i-Hind*, *Ophir*, *Bezwada* or *Pentakota*, their high superstructures spick and span above the sand, look-outs alert on their flying bridges, muslin and scarlet gaily at their rails and Red Ensigns fluttering one after the other down the waterway.

So much a part of Empire was their passage that the common abbreviation for the best combination of cabins on the India run (Port Outward, Starboard Home) had already gone into the language: Posh.

The British were obsessed with distance. It was Macaulay who had written, in 1848: 'Of all inventions, the alphabet and the printing press excepted, those which abridge distance have done most for the civilization of our species'—and he was thinking in particular, perhaps, of the steamships of the P. and O., which had only four years previously opened their Indian service.[1] To the later Victorians steam had 'annihilated distance'. In Macaulay's day the passage to India took four months, and merchants went out to settle there for life, sometimes never going home at all. Now they generally returned to England after five years, to marry; after ten years their children went home to school, their wives returning every other year to see them; and after twenty years, when they were important enough in the business, they were quite likely to retire to the English shires themselves, leaving the firm in the hands of junior partners, and occasionally pottering out to Calcutta on supervisory visits. For hundreds of British families the Eastern journey was part of life, like the beginning of term, or the annual session with the dentist. They generally met friends on board ship, and at Suez two imperial streams joined, the Anglo-Indians and the Anglo-Egyptians inspecting each other coolly, each finding the others insufferably provincial and, with their affectations of dress and language, their *tiffins* or their *suffragis*, their tarbooshes and ill-advised saris, often a little comic too.

The ships that maintained these imperial services were very small. The largest P. and O. boat was the *Egypt*, launched in Jubilee year: less than 8,000 tons, an ugly square-prowed ship with

[1] Thomas Macaulay (1800–59) spent three and a half years in India as a member of the Supreme Council under the East India Company, coming home in 1838 to write those *Lays of Ancient Rome* which were so to colour the ethos of Empire—

> *Then lands were fairly portioned;*
> *Then spoils were fairly sold;*
> *The Romans were like brothers*
> *In the brave days of old.*

two slightly leaning funnels, giving it a vacuous look. The biggest ship on the New Zealand run, the *Roxaia*, was less than 6,000 tons, and the Allan Line passenger liners to Canada were mostly 3,000 or 4,000 tons. Passengers were often wryly amused by the ponderous gentility of these little ships. G. W. Steevens, when he sailed to India in the 1890s, thought the green-tiled smoking-room of his P. and O. like 'a bedroom suite in the Tottenham Court Road'. The Austrian traveller Baron von Hübner, who made a long voyage in the British India liner *Dorunda* in 1885, recorded in near-despair the awfulness of a shipboard Sunday—no whist, no bezique, even smoking was unpopular. 'Young M. caught with a novel in his hand: a lady looks at him fixedly, utters the word "Sunday", takes away the novel and slips into his hand a hymnbook instead.'

Still, the shipping lines were intensely proud of their ships, and advertised them extravagantly. The Orient Line Guide records what life was like on one of the latest Australia steamers. The new *Ormuz* was 6,000 tons, a steamer with a trace of sail about her, in her four tall masts and complicated rigging. Her engines were so smooth, the book said, that it was sometimes difficult to believe the ship was moving at all, and her third-class arrangements were particularly complete, 'the object being both to insure the comfort of the steerage passengers, and also to avoid any annoyance to the travellers in the first and second saloons'. Pictures of the ship pungently suggest oiled wood, creaks, fairly stiff conversations and incipient flirtations. There was an organ in the picture gallery, and in each first-class cabin there was 'an arrangement by which the electric light can be turned on and off at pleasure by the occupant'. In the first-class dining saloon the passengers, in evening dress, sat in arm-chairs at heavily naped tables, waited upon by bearded stewards and surrounded by potted palms. In the second-class saloon they sat at long communal tables, rather like cocktail bars, with decanters slung on trays from the ceiling above their heads. The *Ormuz* was so powerful, we are told, that 'all the horses in use in the British Army, if we could compel them to join in a gigantic tug of war with the *Ormuz*, would be pulled over'. Passengers were advised to bring a deck-chair with them—'it should be plainly marked with the owner's name, in a conspicuous place, not on the

back'—and ladies would find 'what are called tea gowns' very convenient in the tropics.[1]

On the day of Queen Victoria's Jubilee the old Allan Line steamer *State of California* was making her last voyage from Liverpool to Canada. At dinner that night, in mid-Atlantic, they honoured the Queen with a banquet. The menu included Balmoral pudding, Victoria cream and Windsor biscuits, 'and through the generosity of the cabin passengers, a set of handsome prizes were competed for by the steerage in a series of athletic events that created great enjoyment and merriment'.

3

Elaborate systems of supply, defence and communication serviced these vessels along the imperial seaways, and the sole purpose of some British possessions was to keep the traffic moving: the South Atlantic coaling station of St Helena, for example, was ruined when the Suez Canal was opened. Vast supplies of coal were piled up at stations all along the route—fuel for their own ships figured largely in the British export statistics—and foreign shipping, too, depended largely upon British bunker supplies.[2] The British held key ports and maritime fortresses all over the world, and their instinct had always been to gain control of communications, before carrying sovereignty further. They occupied most of the Indian seaboard, before they extended their authority inland. They established great ports at Hong Kong, for the China trade, and Singapore, for the East Indies; Hong Kong's traffic was greater than Liverpool's, and

[1] The *Ormuz* sailed the imperial waters until 1912, when she was sold to a French company, renamed *Dovona*, and forgotten.

[2] When, in 1904, the brave and unhappy Admiral Rozhestvensky sailed his Second Pacific Squadron from Kronstadt to the China Sea to fight the Japanese, the British refused to allow his forty rickety warships to refuel at their stations on the way. He arranged with the Hamburg-Amerika line to refuel from colliers at sea, and his fleet laboured filthily across the oceans with coal crammed into every corner of every ship, piled high on deck, shoved into passages, between guns, even in officers' cabins. During long stretches of this tragic voyage pairs of British warships, impeccably clean and superbly seamanlike, shadowed the ramshackle Russian squadron as it sailed towards its virtual annihilation at Tsu-shima.

fifty lines of ocean shipping regularly used Singapore. They had recently acquired Mombasa, which they saw as the key to the riches of Central Africa, and they still hoped to wrest from the Portuguese the harbour of Delagoa Bay in South-East Africa, the nearest outlet to the goldfields of the Rand.

They were the arbiters of maritime affairs, and set the world's standards in matters like seaworthiness and navigational aids. The Greenwich Standards Department verified not only British weights and measures but United States and Russian standards, too. AI at Lloyd's was already a world criterion, and it was often British pressure that impelled foreign governments to erect lighthouses and moor lightships. For years the British tried unsuccessfully to persuade the Turkish Government to establish proper navigational aids in the Red Sea: in the end they erected lighthouses themselves —P. and O. built and maintained the lighthouse at Daedalus Reef, a coral strand in the northern Red Sea—and even manned some of them with British lighthouse-keepers.

So for the most part, by right or by effrontery, the British kept a firm hand upon the sea lanes. The one vulnerable thread in the system was the Suez Canal, through which the mass of the Eastern shipping passed. (More than half the Australian traffic used the Cape route, and other ships went round the Horn: but on the homeward passage, loaded with perishable cargoes, all these ships used the Canal.) The British Government owned 48 per cent of the Canal Company's shares, and the defence of the Canal was the responsibility of a British garrison in Egypt. Most of the traffic was British—Royal Mail steamships actually had priority of traffic, and the big India liners regularly paid up to £1,000 in dues. But there was £65 million of French capital in the Canal Company, compared with only £31 million British, and there were twenty-two French directors against ten British. They constantly squabbled about transit fees, the British always wanting them lower, the French higher. Worse still, the Canal was too small for British imperial requirements: large battleships could only go through by dismounting their heavy guns into lighters, and coaling at the far end of the canal. Suez was like an exposed nerve in the anatomy of the Empire. Sometimes the British thought of cutting a rival British canal

through the Sinai Peninsula, to link the Mediterranean with the Gulf of Akaba. But they never did.

4

Backwards and forwards along the imperial shipping lanes went a large proportion of Mr Stanley Gibbons's stamp catalogue (then in its thirty-second year), for the Empire's mail services were advanced and elaborate, and many of the British possessions were already issuing their own stamps. Most of them merely carried the Queen's head, but New South Wales had been issuing pictorial stamps for nearly fifty years, Newfoundland celebrated the Jubilee with engravings of icebergs, seals, caribou and ptarmigans, while the 16 cent North Borneo issue had a picture of the island's only railway train.[1]

When the Colonial Premiers met in London that summer most of them agreed to a penny imperial post for 1898. Until then the rate would remain at 2½d per half-ounce, for imperial as for foreign letters, and the mails were carried under contract by the great shipping lines, entitling them to prefix their ships' names with the initials R.M.S. The Royal Mail Company handled the West Indian mails, the Castle Line and the Union Steamship Company shared the South African. The P. and O. was paid £330,000 a year for conveying the Indian mails. Cunard carried a large proportion of the Canadian mail via New York: the Orient Line and P. and O. carried the Australian mail in alternate weeks. All was under the control of the Postmaster-General in London, the Australian and South African colonies contributing to the cost, and by the nineties well over 22 million letters and postcards went from Britain to her possessions in a single year.

To elderly Victorians the speed of the mail service was astounding. Only thirty-eight days to Sydney! Only seventeen days to India! Post a letter in London on Sunday, and it would reach Ottawa on Monday week! Even so, they were constantly experimenting

[1] The oddest imperial issues were those of Heligoland, a British possession until it was ceded to Germany in 1890. These had been printed for Queen Victoria in Berlin.

with new combinations of sea and overland mails. Rhodes hoped his Cape-to-Cairo railway would provide the fastest mail route between England and South Africa, and some people thought the German scheme for a Berlin-to-Baghdad railway would be a blessing to the British by shortening the time to India. They planned to drop the Australian mails at Fremantle, when an east-west Australian railway was built, and there was already a postal route to the Far East via the Canadian Pacific Railway. The direct Canadian mails were dropped at a hamlet called Rimouski, near the mouth of the St Lawrence, and whisked into the interior by train. The Indian mails went by packet-boat every Friday afternoon to Calais, where a train of two engines, three coaches and three mail-vans awaited them, with two British Post Office men on board: by Sunday night they had crossed the Alps and reached Brindisi, and one of the fast P. and O. Mediterranean packets, the 1,700 ton *Isis* and *Osiris*, then sped them to Port Said to catch the Bombay steamer—which had left London a week before the letters.

Since 1885 there had been an imperial parcel post—first of all to India, which had thus come within reach of the thousands of plum puddings, sprigs of holly, mistletoe berries and haggises sent out there annually ever since. Even this domesticity, though, had not taken the romance out of the imperial mails, which strongly appealed to the British sense of far-flung order. The English mail rattled into Johannesburg, with view halloos and whinnies, in two great wagons drawn by teams of ten horses apiece. It reached the Australian mining camps, as the poet Henry Lawson recalled, in Cobb coaches, as in the American west:

> *Oft when the camps were dreaming,*
> *And fires began to pale,*
> *Through rugged ranges gleaming*
> *Swept on the Royal Mail.*
> *Behind six foaming horses,*
> *And lit by flashing lamps,*
> *Old Cobb and Co, in royal state,*
> *Went dashing past the camps.*

In Rhodesia it was carried by runners, wearing khaki shorts and

fezzes, with an average bag of 40 lb and an average daily range of thirty miles. And what could be more resoundingly Kiplingesque than the Indian runner service, by which the letters of the Imperial post reached the last outposts of the Himalaya?

> *In the name of the Empress of India, make way,*
> *O Lords of the Jungle, wherever you roam,*
> *The woods are astir at the close of the day—*
> *We exiles are waiting for letters from Home.*
> *Let the rivers retreat—let the tiger turn tail—*
> *In the Name of the Empress, the Overland Mail!*[1]

5

The British had invented submarine cables, and by the 1890s had encompassed their Empire with them. Of the inhabited British territories, only Fiji, British Honduras, Tobago, the Falkland Islands, Turks Islands and New Guinea were not on a cable at all. The several imperial cable networks, upon which the Empire depended for its intelligence and its central control, were nearly all operated by private companies, though many of them received official subsidies, and most were possessed by the ambition to be All-British Routes, running exclusively across British landscapes or under British-dominated seas. Half the cables had been laid within the past twenty-five years, some of them by Brunel's gargantuan steamship the *Great Eastern*, originally designed for the Eastern service, but reduced at last to this humdrum chore: since 1870 the Colonial Office telegraph bill had risen from £800 a year to about £8,000.

To the New Imperialists the cables had a symbolic quality, and visionaries saw them developed into an absolutely British, earth-

[1] Sixty years later in Nepal, which had been a British sphere of influence at least since the 1820s, I used runners to send dispatches from the Sola Khumbu region, in the Himalaya, to the British Embassy (ex-Residency) in Katmandu. Two of them did the 180-mile journey in five days, including the crossing of three 9,000-foot mountain ranges. Whenever I watched them sloping away down the glacier, or melting into the wet mists of the monsoon, slung about with bags and trappings, long sticks in their hands, I had a very imperial feeling myself.

embracing system. 'Such a perfected system,' wrote one commentator, 'traversing the deepest seas, touching only British soil, protected at every point of landing by British vigilance and courage, would be as reliable for the direction of our navies, and for combined military action in time of war, as it would be useful in time of peace for the development of commerce and the interchange of thought and information on national affairs.' These majestic dreams excited Kipling hardly less than the Overland Mail, and he wrote a poem about them, too, called *The Deep-Sea Cables*—

> *They have wakened the timeless Things; they have killed their father*
> *Time;*
> *Joining hands in the gloom, a league from the last of the sun.*
> *Hush! Men talk today o'er the waste of the ultimate slime,*
> *And a new Word runs between: whispering, 'Let us be one!'*

In 1897 the network had its weaknesses. The transatlantic routes were secure enough, running direct to Newfoundland and Canada, and the seven American cables across the Atlantic called first at Canada, too, and could be commandeered, it was thought, in time of war. But the South American cable ran via Portuguese Madeira, and the two South African lines, down the west and east coasts, both crossed Portuguese territory. The line to Australia had to cross the Dutch island of Java; it ran by a special wire, worked by British operators, but still the Admiralty distrusted it, and pressed for an alternative line touching only at British relay stations. The line from Singapore to Hong Kong, via Labuan, was laid in 1894 specifically to avoid French Saigon, and on the China coast the British were perpetually scheming to evade the near-monopoly of Chinese cables held by a Danish company—the British cable from Hong Kong to Shanghai was worked from a hulk in the middle of the Min River, to avoid the several embarrassments of relay stations on shore.

But it was the route to India that chiefly preoccupied the imperial strategists. There were three lines from London to Calcutta, but none of them was altogether secure, and commercially the German and Russian Governments could prevent any reduction in the very

expensive tariff. This was because the first and most profitable of the routes began as a North Sea cable from Lowestoft to Germany. It then ran across Germany and Russia to Teheran (two minutes flat, as we know, from Buckingham Palace) and so to India. The German section of this cable was owned by the German Government, and the Russian by the Russian Government—neither of whom used it much, but both of whom, by the terms of their concessions, could keep its prices awkwardly high.

The second Indian route was also unsatisfactory. It ran across Europe to Constantinople, across Turkey to the Persian Gulf, and by submarine cable to Karachi (Kurrachee, as they spelt it then). It was never very effective, because of the murky inconsistencies of Turkish administration, and in 1870 the British had opened a submarine cable via Gibraltar, Malta, Alexandria, Suez and Aden—all safely Red—to Bombay. Even this, though, had to call at Spanish relay stations, and in fact most of its traffic went by land to Marseilles, picking up the big cable line in Malta. If all these three routes were cut, there was no southern link from India: the only alternative was the vulnerable line to Australia, through Java.

No wonder the safety and privacy of these lines gave the British so much anxiety. Keeping them open and efficient was one of the great technical tasks of Empire. The hazards were varied and sometimes violent: silt, uncharted currents, hostility from tribespeople or fishermen, winds—during the monsoon no Indian Ocean cable could be mended at all. Even the webs of the more portly tropical spiders could interrupt an imperial dispatch. The tariffs were understandably high. It cost 4s a word to send a cable at the standard rate to India, 4s 9d to Australia, 6s 9d to Sierra Leone: yet sometimes the demand was so feeble that the average traffic in and out of the West Indian island of St Vincent, for instance, was worth just 15s a day.

All over the world Englishmen were at work laying or maintaining these cables, or operating booster stations along the line. In every British colony the local cable manager was an important member of society, and in remoter parts his cable station became a focus of nostalgia, so evocative were the clickings of its Morse keys from across the oceans. Among the most suggestive of all must have

been the nine little repeater stations erected down the line that crossed Australia from the Northern Territory to Adelaide. Long before a road or a railway crossed the Outback, the Overland Telegraph was erected—2,000 miles of line, with 36,000 telegraph poles. Seven or eight men lived in each station, with 20 or 30 horses, a few cows and a flock of sheep. All around was wilderness, and the stations were protected by brick walls with loopholes, in case of aboriginal attack. At Barrow Creek, in 1874, two cable men were speared to death by Warramunga tribesmen,[1] and the aborigines were constantly stealing insulators to use as axe-heads, and wire for multi-pronged spears. Building the line had taken two years. As the gap between the two ends narrowed, messages were carried from one to the other by horsemen: the original charge was nine guineas for twenty words.

The central station of the Overland Telegraph was at Alice Springs, the first nucleus of that famous little town. It was a clump of shacks and a stone bungalow above the springs, themselves named for Alice Todd, wife of the chief engineer. This was one of the loneliest places in the Empire. It was a thousand miles north to Darwin, a thousand miles south to Adelaide—the nearest towns. For company the little group of cablemen had only themselves, their animals, the odd incoherent bushman, and the occasional grazier or overlander dropping in for a beer in a country where the hospitality of the pioneers was still a rule of life. At night especially the Alice cable station must have seemed a properly epic outpost. Then the wind rustled off the desert through the eucalyptus thicket, armies of frogs croaked in the fringes of the pool, the air was heavy with dust and gum-smell, and the horses stood silent beneath the pepper trees. Oil lamps shone through the windows of the huts, and sometimes a sudden chatter of the Morse machine miraculously linked the Alice, for a moment or two, with Calcutta, Malta and the imperial capital on the other side of the world.[2]

[1] They are buried outside the hotel at Barrow Creek, some 770 miles south of Darwin on the Stuart Highway—colloquially known in those parts as the Bitumen.
[2] The station is still there, a mile or two north of the present town, designated a National Park, but still, in the brilliance of the Australian night, a wonderfully evocative place.

6

All this vast expertise, of ships and mails and cable stations, had made the British prime masters of international movement. Nobody else operated on such a scale, and whether one wished to ship a boiler to Canton, send a Christmas telegram to Montevideo, or merely go on a holiday voyage in the Mediterranean, the chances were that Britons would be making the arrangements. Nobody symbolized this command more famously than Thomas Cook, the booking clerk of the Empire. The original Cook had died in 1892, but his son had succeeded him in the firm, and 'leaving it to Cook's' had gone into the language. Cook's had virtually invented modern tourism, and their brown mahogany offices, with their whirring fans and brass tellers' cages, were landmarks of every imperial city. They held the concession for operating steamers on the River Nile: all the way up to Abu Simbel the banks of the river were populated by Cook's dependants—keeping Cook's donkeys, growing Cook's vegetables, rowing Cook's boats or raising Cook's fowls, porters, waiters, washerwomen, stately fly-whisked dragomen wearing Cook's familiarly emblazoned jerseys. Cook's made the travel arrangements for the Queen-Empress herself, and that summer they were helping to move Kitchener's forces into the Sudan. Since 1880 they had actually been organizing pilgrimages to Mecca; their Eastern Princes' Department once arranged a visit to Europe for an Indian prince with two hundred servants, twenty chefs, thirty-three tigers, ten elephants, a thousand packing-cases and a howitzer.

CHAPTER FOUR

Migrations

How could you go? Whilst Spring with cuckoos calls,
With all the music in which wood-birds woo,
With hymning larks, and hedgerow madrigals
Girlish with sunshine, sweet with cushat's coo,
Bade you to dream; how did you dare to do?

Nay, rather, could you stay? Through warm red loam
Ran the sea-rover's path. A wild salt scent
Blown over seas, pierced through the apple bloom;
The dove's soft voice with Ocean's call was blent.
You could not stay; you could not be content.

Clive Phillipps Wolley

4

IT was a principle of the New Imperialism that this girdling of the world was a fertilization, and that the distribution of British authority everywhere was picking up pollen here, depositing it there, and making the earth blossom in new colours. The mystic-imperialist Francis Younghusband thought the wisdom of the Eastern religions might be disseminated through the world along the imperial trade routes, just as Christianity once flowed through Europe along the Roman roads. Lord Cromer thought precisely the opposite, and saw the Empire as a fructifying 'breath of the West'. Biological images recurred in the literature of imperialism—stocks, bloodstreams, grafts, thoroughbreds and Natural Selection.

In one sense it was true. The movement of people out of the British islands had transplanted the culture of the English all over the world—wherever the climate was temperate enough, and the resources were sufficiently tempting. The British were the most restless of the European peoples, and the greatest flow of emigration was still out of the British Isles, with Italy second and Spain a distant third. The flow varied, with the bad times and the good at home. Between 1840 and 1872—years of famine in Ireland and depression in England—about $6\frac{1}{2}$ million people had left the British Isles. Since then the pressure had slackened, and an average of some 200,000 had been going each year in the eighties and nineties. Most of them went because they were workless, landless or even starving. They did not greatly care whether they stayed within the Empire or not—the Irish, indeed, particularly wanted to be out of it—and three-quarters made for the United States, the most promising haven of all. The British colonies and possessions offered good opportunities for business and professional people, but appealed to working men chiefly at moments of boom or gold rush—it was not often the pioneering instinct that took poor people to the Empire,

only a desire for security and a fair chance. Australia was still tainted by its convict past, South Africa needed little unskilled labour, Canada seemed to most people only a second-class United States, New Zealand was essentially a farmer's country, with little scope for artisans. The New Imperialists were often disappointed by the British working man's reluctance to go adventuring in his Empire.

Still, some 10 million British emigrants were now distributed through the colonies, and they included all sorts. Edward Gibbon Wakefield, in the 1830s, had introduced planned settlement to Australia and New Zealand—his settlers went out as complete communities, with all the trades and professions represented.[1] Since then *laissez faire* had generally governed the imperial migrations, and the Empire found its own level: unemployed cotton workers, dispossessed Highlanders, Irishmen emaciated by generations of malnutrition, remittance men, dedicated missionaries, hopeful villains—the emigrant ships knew them all. It was big business for the shipowners and brokers, and to some British ports the ceaseless flow of the emigrants, never to return, was an everyday fact of life, a perpetual good-bye to one's own folk. The boarding-houses along Dock Road in Liverpool lived on the custom of the emigrant families, strolling excitedly along Merseybank in the evening to see their ship awaiting the morning tide: and high above the harbour at Queenstown, the port of Cork, the architect Augustus Pugin had built a tall valedictory cathedral, its steeple silhouetted above the little town and its bay like a last blessing from Ireland, as the emigrant liners steamed sadly into the Atlantic.

The most curious migrants of all were the groups of young women who, carefully chaperoned and segregated, went out in batches from England to the white colonies. The Queensland Government ran an official scheme for such Female Emigrants. Their passages were paid, and jobs were guaranteed for them at the other end, so long as they could prove themselves to be healthy, of good character, and more or less the right age. Every month the British

[1] Wakefield (1796–1862) first evolved his colonization theories in Newgate prison, where he was serving three years for the abduction of an heiress. He believed that land values in new colonies should be kept deliberately high, to encourage well-balanced settlements, and that revenues from land sales should be used to finance further emigration.

India boat to Brisbane carried eighty or a hundred of them, under the care of a matron and two under-matrons. They were scrupulously segregated aft, and discipline was strict. The girls messed ten to a table under the supervision of the eldest emigrant, known as 'the captain', and after breakfast each morning their cabins were inspected for tidiness by the chief matron. On deck they were separated by a double hand-rail from the rest of the passengers, and they were strictly forbidden to speak across it. Even if, as sometimes happened, a girl's parents or brothers were elsewhere on the same ship, she was permitted to visit them only once a week. Thus, refrigerated in purity, these perishable cargoes were shipped to the bounds of Empire, where lusty colonials presently defrosted them to perpetuate the breed.

2

Emigration to the Empire was officially popular. There were those who objected that the best and most enterprising of the British were leaving the islands, but it was pointed out that one British resident in Australia consumed as much British produce as ten British emigrants to the United States, and anyway imperial emigration, as the New Imperialists liked to say, was no more than 'a redistribution of population within the nation'.

The redistribution was essentially unplanned. Convicts and paupers were no longer transported to the colonies, and the British Government offered no subsidies to rid itself of its undesirables. In earlier years the emigration business had often been shady. Innocents were lured to the colonies with false promises, were shipped there in ghastly discomfort, and often trailed home to Britain again penniless and disillusioned, or joined the shambled riff-raff of failed emigrants which roamed the British possessions. By the 1890s it was better organized. There was an Emigrants' Information Office, officially financed, diverse charitable bodies concerned themselves with emigration, and several colonial governments offered assisted passages—one could go to Canada for £3. The colonies no longer accepted all comers; free movement within the Empire was not a right of citizenship. Their London agents

chose the people they wanted, and the British Empire never professed itself a haven for the tired, the poor, or the masses yearning to breathe free. In the last years of the century the British themselves were not anxious to go. The British birth-rate was dropping, conditions at home were better, and several of the colonies had been going through lean years. Of the 145,000 people who emigrated that year, some 50,000 went to the colonies. Nearly 30,000 went to the Canadian West, where 200 million acres of marvellous land, so the publicists said, were only awaiting cultivation: in two or three years most of them would either have taken the magic road to Manhattan or made good as prairie landowners.[1] The rest mostly went to South Africa, after gold. Hardly any went that year to Australia—the Australian colonies were in between booms, and for some time more people had left them than had entered: it was many a long year since Queen Victoria herself, more than usually exasperated by politics at home, had threatened to emigrate down under with all her little princelings.

The white colonials were, in effect, still Britons, and to most emigrants Britain was still Home. They could come back when they wished, and pick up the threads where they dropped them. The white colonies really did form a Greater Britain. Of the eleven colonial Premiers who came to London for the Jubilee, seven had been born in Britain, while the Premier of Tasmania had spent half a lifetime serving the Crown in the Indian Civil Service. British standards still generally applied in the white dependencies, things British were generally regarded as best, and the prestige of the British governing classes, socially and intellectually, remained unchallenged, however resolutely the earthier colonials sneered at 'the colonial cringe'.[2] The great festival of Empire raised few sniggers

[1] An achievement once defined by Halldor Laxness as 'clearing away boulders, uprooting tree-stumps or digging ditches, and then posing in collar and tie in a photographer's studio'.

[2] A sly Canadian political anecdote concerned Walter Scott, an early Premier of Saskatchewan, which acquired provincial status in 1905. Scott had hired a young English immigrant to drive him around his prairie constituency during an election campaign, often spending the night in tents. Said Scott one evening: 'Well, you'd be a long time in England before you could say you had camped with the Premier.' 'Yes,' the Englishman replied, 'but you'd be there a damn sight longer before you'd be Premier.'

in Ottawa, Durban or Sydney. To many colonials it was a welcome revival of British virility, in a country apparently emasculated in the lily-postures of its aesthetes. The Australians, perhaps a little patronizingly, sent a shipload of meat as a Jubilee present to the British poor.

The people of the oldest colony, Newfoundland, were among the most staunchly British of all. Along the fierce Atlantic coast of the island, up past Bristol's Hope to Twillingate and Leading Tickles, there were settlers whose forebears had come from Britain in the seventeenth century. They lived still in recognizably British cottages, talking a queer mixture of West Country, Irish and New England, and forming sprawling clans of fisherfolk and farmers, so that all the way around Conception Bay, for instance, you would find people called Dawes, scratching their potato fields, winching their nets, or silent beneath the toppled tombstones of their clapboard churches.[1] The senior settlement of all was Cupids, which had originally been called Cuper's Cove, and was founded by the Merchant Venturers of Bristol in 1609. It looked like a fishing town in one of the bleaker Scottish firths: austerely set upon its grey inlet, its waters icy, its rocky sheltering hills stubbled with moorland grass and conifers. In a wavering line its houses brooded around the water's edge, dominated by the United Church of Canada and the Orange Lodge. Nobody in Cupids was rich—it had proved a begrudging kind of paradise. Life was very simple, loyalties were secure, Union Jacks and lithographs of Queen Victoria were to be found in almost every homestead. Only occasionally did an inquisitive visitor bounce up the rocky road from St John's, to visit this birthplace of Greater Britain, and see what an emigrant looked like nearly three centuries after the event.[2]

[1] There are still many Dawes there, and by now their roots are far deeper than most Britons can claim at home. It was a Mr Dawes who, standing in his garden above Conception Bay, once pointed out to me across the water the spot where his forebears had first landed in the seventeenth century, and then, with a sweep of his arm, the successive hamlets into which they had spread over the generations. Not many families in Britain could view so wide a landscape with such dynastic intimacy.

[2] Cupids never made its fortune. It remains a straggle of wooden houses about the bay, with a one-man canning plant, a couple of shops, the United Church of Canada and the Orange Lodge.

3

If the Empire dispersed the British, it displaced many thousands of
their subject peoples, too. The movement of African slaves had ended
80 years before, but out through the imperial channels there still
spilled hundreds of thousands of Indians, like water overflowing
from a brimming bucket, to flood the perimeters of the Indian
Ocean, and trickle through to far more distant parts. They were the
migrant labourers of Empire. They went to Sarawak, Fiji, to
Trinidad in their thousands, to South Africa, even to British
Columbia. In many territories of the Empire Indian labour was
essential to the prosperity or security of the white colonists. In
Mauritius and the West Indies this was because the landowning
classes had never come to terms with the Negroes since their emanci-
pation from slavery. In Africa it was because the local peoples were
reluctant to work for wages, or for whites. In northern Australia
the climate was thought to be too hot for European manual labour.
In Burma the Burmese did not take to soldiering. In Ceylon the
Sinhalese did not take to plantation work. There were Sikh soldiers
in Nyasaland, Sikh policemen in Hong Kong. At least a million
Tamils had gone south to Ceylon during the past half-century, and
the colony of Aden, at the arid tip of Arabia, depended for its
existence upon its Indian craftsmen, builders and blacksmiths, first
taken there by the British when they seized the place in 1839.

The movement here and there of this manpower, together with
Chinese and Polynesians, had its affinities with slavery still—in the
1880s South Sea islanders had often been kidnapped to work on the
Queensland sugar plantations. Most of the Indian migrants were
indentured labourers: they agreed to go for a set number of years,
at the end of which they were either given a free passage home or
stayed where they were as free men. The traffic was officially con-
trolled. The Colonial Office arranged the movement of Indians to
the Caribbean sugar colonies, and British Guiana, Natal, Mauritius
and Fiji all had their immigration agents in Calcutta. There were
terrible abuses nevertheless. The Indians were so naïve, the em-
ployers so worldly, that unfair exploitation was inevitable. Re-

cruiters were often paid by head of labour, which encouraged them
to be unscrupulous, and planters sometimes treated their indentured
labourers virtually as private property. When, at the end of their
engagement, the Indians chose to settle on the spot, as they nearly
always did, they found themselves very unwelcome. In Australia
they were obliged to remain in the tropical north, to prevent
their tainting the European south, and in the West Indies they
were resented not only by the whites but no less by the
Negroes.[1]

To the British themselves it was only part of the immense sweep
of imperialism, which made the world their chessboard. The move-
ment of subjects from one part to another was organic to the
structure, and the cross-traffic of imperial migration was constant
and inescapable. You would find Australian jockeys in Calcutta,
shipped with their horses from Victoria for the Viceroy's races, and
Maltese mess-men on the British warships of the West India station.
Voyageurs from the Canadian rivers had navigated the Gordon relief
expedition to Khartoum, and the young men of Tristan da Cunha
habitually migrated to the Cape of Good Hope. When the Cey-
lonese coffee crop was ruined by disease in 1869 many Ceylon
planters moved on to Burma, Borneo, the Straits Settlements or
Australia, and there was a whole corps of adventurers that wandered
across the Empire from gold strike to gold strike. West Indian
soldiers were on imperial duty in West Africa. Irish priests and
schoolmasters were all over the Empire. It was a common practice
to exile dissident notables to distant imperial possessions: the

[1] It was of this system that the young Winston Churchill, when Parlia-
mentary Under-Secretary of State for the Colonies, told the Commons in
1906: 'It cannot in the opinion of His Majesty's Government be classified as
slavery in the extreme acceptance of the word without some risk of termino-
logical inexactitude.' What a legacy it has left to the world! The South
Africans have been trying to get rid of their Indians ever since, even offering
to pay their passages home to India: in 1932 the Union Government devised
a scheme to resettle them all in British Borneo, British Guiana, and British
New Guinea, but nearly half a million of them remain. Indians form the largest
ethnic group in British Guiana and are actually a majority in Fiji, and most
of the Indians in East Africa are descended from coolies brought over to build
the Uganda railway in the 1890s. Less than 5,000 Indians, however, live in
Australia today.

Egyptian nationalist Arabi Pasha was imprisoned in Ceylon—he chose the island himself, it is said, because to Muslims it was Adam's place of exile, when he and Eve were expelled from their Egypt.[1] A legendary character of the Indian Mutiny in 1857, still vividly remembered in Lucknow, was an African who was killed fighting on the side of the mutineers, and who was so good a shot that the British soldiers nicknamed him Bob the Nailer, until at last they nailed him.[2] The fact of the British Empire had done all this: had dovetailed all these different peoples, switched them east and west, made the Indian familiar in Trinidad and the Chinese in Australia—all in obedience to whatever hazy laws and instincts governed the energies of imperialism.

4

As for the flora and fauna, in many parts the existence of the British Empire had literally changed the face of the earth, by means which to some fundamentalists flew in the face of nature. Ever since Captain Bligh set sail from Tahiti with bread-fruit trees for the West Indies, the British had been busy, like so many fanatic geneticists, taking cuttings, crossing strains or transplanting hopeful hybrids. One of the several rationales of Empire was the theory that its complete range of climate must enable the One Race, beneath the One Flag, to make itself self-sufficient in foodstuffs. John Wilson of *Blackwood's Magazine* had observed seventy years before that the sun never set on the British Empire. Now the concept of imperialism was wider still, and the theorists had realized that somewhere in the Empire it was always summer, too, so that the imperial harvest might last the whole year through. Inspired partly

[1] He returned to Cairo in 1901, died in 1911 and is now, of course, an Egyptian national hero.

[2] Negroes often appear in unexpected imperial contexts. In the village of Alutnuwara in Ceylon a couple of old muzzle-loading guns are used as gate-posts. Nobody knows how they got there, but one story is that they were brought by a Negro regiment, commanded by a single British officer, which was transferred to Ceylon during a nineteenth-century rebellion. The officer, it is said, died of fever, and the Negroes gently melted into the environment, finding themselves local wives and living happily ever after.

by such stately insights, and partly by the need to live and make a profit, the British had freely experimented with the transfers of crops and animals from one territory to another, sometimes with great success, sometimes disastrously.

The most ubiquitous of these transplantations was the Australian gum-tree—the eucalyptus, which first left Australia in 1854, but which by the 1890s had been scattered across the world. It was supposed to prevent malaria; some thought the smell of its leaves did it, others the drainage of marshy soils by its roots. The British took it everywhere, and especially to India, where they planted it along thousands of miles of roads, around a hundred cantonments, in countless bungalow gardens, until it seemed to have been part of the landscape always, and the grey shine of its leaves appeared only to be a coating of immemorial Indian dust. Another great success was the rubber plant. This the British imported from Brazil to India, and they were the first to make a regular crop of it, the Brazilians having merely tapped the wild tree. They began with plantations in Ceylon, and later transplanted it triumphantly to Malaya, where it transformed the economy and the landscape, too. The British took tropical crops like pineapples, tea, bananas and sugar to newly exploited tropical countries—South Africa, northern Australia, Rhodesia, Nyasaland. They took familiar temperate crops to unfamiliar temperate zones—notably the potato to Nepal, where it probably spread from the garden of the British Resident in Katmandu to become the staple diet of the Sherpas. It was the Superintendent of the Calcutta Botanical Gardens who introduced tea-cultivation to Sikkim and Assam, and quinine was first grown in India, in 1862, from cuttings from the Royal Botanical Gardens at Kew. English furze and blackberry bushes had overgrown the Atlantic island of St Helena, while weeping willows *from* St Helena, reputedly cuttings from those that shaded Napoleon's grave, flourished in Australia. The Empire had introduced rice to British Guiana; coconuts to the Bahamas; cinnamon to the Seychelles; lilies to Bermuda; English grass, Kaffir corn, vines, apples, pears and wheat to Australia.

The entire domestic livestock of New Zealand was first shipped to those islands by the British. The only indigenous mammals were

dogs, bats and rats, and the Maoris were originally either vege-
tarians or cannibals: yet by 1897 there were 2½ sheep, 1½ head of
cattle, nearly half a horse and three-tenths of a pig for every human.
Most of Fiji's livestock was also taken there by the British, and in
the remote and windswept Falklands Welsh farmers had re-created
the sheep-runs of Caernarvonshire and Merioneth. Australia had
been stocked with millions of English sheep and cattle, not to speak
of blackbirds, and in the 1880s Indian camels had been shipped down
there as desert transport: often their Indian or Afghan drivers went
with them, and a familiar sight of the Outback was the camel-
wagon, heaped high with provisions, with a couple of camels dis-
piritedly hauling it across the waste, and an oriental in musty
draperies huddled on the high driving-seat.[1] Camels were also taken
to the goldfields of the Cariboo in British Columbia, and some of
them were once shipped up the Fraser River by stern-wheeler.

The Indian Army was a great market for Australian and Arab
horses—one of the sights of Bombay was the Arab stables, in the
Bendhi bazaar, where dealers from the Persian Gulf sold their horses.
Frogs and rats followed the Empire to St Helena, Irish donkeys
emigrated to South Africa. On Robben Island in Table Bay were
deposited, at one time or another, not only lepers, lunatics and
convicts, but a herd of English sheep and a colony of English rabbits
—nowhere to be found on the mainland of Africa.[2] The sporting
instincts of the British distributed across the Empire every manner
of shootable, huntable and fishable creature—hares, salmon, trout
and deer to hunting-grounds as varied as Tasmania, Ceylon and
the Andaman Islands. It was the British, in one of their less-
publicized works of usefulness, who took the toad to Bermuda.

[1] In 1965 the last of the Afghan camel-men lived in an old people's home at
Alice Springs. After some fifty years in Australia he remained a devout Mus-
lim, and asked many difficult questions about the state of the faith in the
world—how many mosques were there in New York, was there still a minaret
in Perth, was it true that Yugoslav Muslims ignored the rules about ablutions
before prayer? So deep was the impression made by these men upon the
Australians that to this day the transcontinental railway, the successor to
their camel-trains, is nicknamed 'The Ghan' in their memory.

[2] The lepers, the lunatics and the sheep have gone, the rabbits and convicts
remain.

5

It multiplied so fast that its progeny became a plague, for sometimes this tinkering with the balance of nature ended disagreeably. The English foxes of Australia persecuted the enchanting lyre-bird and cruelly harassed the koala—the more highly evolved placental mammals, brought by the British, proving more formidable always than the native marsupials. The mongoose, imported to the Caribbean from India to deal with the rats, took to chicken-hunting and became a scourge itself; in Jamaica it attacked lambs, kids, piglets, dogs and cats, exterminated virtually all the game birds, decimated several species of snakes and lizards, practically abolished the tortoises by eating their eggs, and in twenty years totally upset the equilibrium of island life.

In 1859 a consignment of twenty-four wild rabbits arrived from England at a property near Geelong in Victoria. There had already been English rabbits elsewhere in Australia, but they had never spread like the Geelong tribe. Finding itself without natural enemies, and taking to bearing extra litters, the rabbit presently became one of Australia's horrors, multiplying so appallingly that in many areas it actually seemed likely to defeat the human settlers, and take over for itself. By the 1870s rabbits were all over Victoria. By the 1880s they infested New South Wales. By the 1890s they had stormed right through Queensland almost to the Gulf of Carpentaria, in the extreme north. They ate everything, up to the flowers outside the farmhouse doors. Fences hundreds of miles long were erected in hopeless efforts to check them, and against the meshes thousands of rabbits could often be seen, dashing themselves in horrible frenzy. The New South Wales Government, blaming it all on Victoria, offered a prize of £25,000 for an effective remedy, and one grazier was said to have spent £40,000 of his own money, before he gave up and left the country. Rabbits were shot, trapped, poisoned with doctored carrots, assaulted by specially imported stoats and weasels: but they increased so fast that one traveller in the 1880s reported they scarcely bothered to move to let his carriage pass. 'They frisked about in troops, ran after each other on the sands, and

could be seen by hundreds sitting at the entrance to their holes.'
Louis Pasteur suggested introducing chicken cholera, which he had
used against rabbits in France, but the Australians fought shy of a
virus, and at the end of the century much of Australia was still
ravaged or threatened by the rabbit, in a more nightmarish plague
than ever the Egyptians invited.[1]

Diseases were often spread by the energies of Empire. Sometimes
the original explorers transferred them. In 1891 Frederick Lugard
led a force of some five hundred African soldiers, with wives,
children and followers, from the Congo into Uganda. With them he
took the sleeping-sickness, never before known in those parts, but
so deadly that by 1897 nearly two-thirds of the local population had
died of it, and the British still had no idea how to counter it. Almost
every year meningitis sailed from Calcutta with the coolie ships
for the West Indies, and in return the jigger insect, indigenous to
the Americas, found its way from Mombasa across the Indian Ocean
to Bombay. Hookworm was taken all over the world by indentured
labourers from India. British ships often took cholera to the Far
East, hidden away in bottles of holy water from the well Zem Zem,
one of the five holy places of the pilgrimage to Mecca.

6

Saddest of all, in their irrepressible impulse to control, instruct or
exploit the simple peoples of the world, the British all too often
introduced them to the ailments of the civilized condition. Cancer,
appendicitis and tuberculosis appeared for the first time in such
elysiums as the South Sea islands. The pleasures of sex were cor-
rupted at last by fears of syphilis and gonorrhea. Stout confident
peoples, ready to face any hazard of heat or jungle terror, found
themselves impotent before enemies they could not understand.
The Eskimos of northern Canada were slaughtered by measles and
smallpox. The Maoris of New Zealand, introduced to firearms,

[1] In the 1950s the rabbits were still costing Australia some £A60 million a
year. Myxomatosis then laid them low, but by 1967 they were reviving, and
the Australians were reduced to pumping into their warrens a foam impreg-
nated with carbon-monoxide from motor-car exhausts.

slaughtered each other, the death rate being compounded by ancient laws of blood-revenge. There were thought to be some 70,000 Indians in British Columbia in 1835: by 1897 there were 22,000.

The hierarchy of Britishness was extended. At one end of the Queen's scale stood the British themselves, casting their shadows across the world. At the other end were the aborigines of the Australian Outback, ravaged by white men's sicknesses, demoralized by white men's examples, a people so debased and disinherited by the Pax Britannica that they seemed almost ready to dissolve into the dream-time that was their conception of the afterlife, where the unborn babies danced in the spirits of rocks and springs, or were supervised upon the shores of eternity by that homely governess, the turtle.[1]

[1] Since then the Eskimos, the Maoris and the British Columbia Indians have all made remarkable recoveries. By 1967 there were more than 40,000 Indians, 11,500 Eskimos and nearly 200,000 Maoris, and the chief threat to all of them was only absorption into white society. Even the Australian aborigines are increasing.

CHAPTER FIVE

Pioneers

I pine for the roar of the lion on the edge of the clearing;
* For the rustle of grass-snake; the bird's flashing wing in the heath:*
For the sun-shrivelled peaks of the mountains to blue heaven rearing;
* The limitless outlook, the space, and the freedom beneath.*

William Hamilton

5

BENEATH a low kopje on the Makabusi River, 150 miles south of the Zambesi and 400 miles from the Indian Ocean, there stood at this time in fine rolling country a settlement of low brick buildings, with roofs of corrugated iron. Some had verandas, some were stark as shoe-boxes, and they were separated by wide strips of bare ground, worn by wagon-tracks and sometimes lined with scraggy trees. This was the township of Salisbury, Rhodesia, seven years old that summer, and only one muddy stage removed from the outspanning of the pioneers. Salisbury was a proper frontier town: a raw outpost of the British way, set in a territory largely unexplored and inhabited by African tribes so unpredictable that only a few months before the settlement had been in a state of siege, with the entire white population beleaguered in the police compound. Down the generations a long succession of such frontier posts had been created by the British, each maturing with time and stability, until their roads were paved, their savages restrained, their saloon toughs genteel in collars and ties and their natural avarice clothed respectably in municipal councils and benevolent societies. Salisbury was one of the latest, and was still making its way. Up at the cemetery a row of neat new iron crosses marked the graves of men killed in the Mashona rebellion a few months before. No epitaph was given them, nor even a home address: only the final imperial text: 'For Queen And Empire'.

Cecil Rhodes, the most visionary of imperialists, had decreed the foundation of Salisbury. As Prime Minister of the Cape, and one of the great mine-owners of the Kimberley diamond fields, he had looked northward from South Africa and seen that the territory of the Mashonas and the Matabeles, between the Limpopo and the Zambesi rivers, was ripe for the British touch. For one thing, he was dreaming of that All-Red route from the Cape to Cairo. For

another, he wished to turn the flank of the unfriendly Boers of the Transvaal Republic. Thirdly, he really did believe that the extension of British influence in Africa would be good for the Africans. Fourthly, he thought there might be gold up there. He had therefore induced King Lobengula of Matabeleland, who held some sort of sway over both the Mashonas and the Matabeles, to grant him a mining concession in those areas, and then persuaded the British Government to allow him a Royal Charter, authorizing him to govern and administer them. He formed a Chartered Company, the British South Africa Company, to occupy the country, and in 1890 he sent a column of pioneers northwards into Mashonaland.

Two hundred young men had formed the nucleus of this column, with an escort of five hundred police. They had been carefully recruited as the embryo of a new white colony, and included farmers, miners, engineers, lawyers, doctors, builders, artisans and miscellaneous adventurers. They had travelled under military discipline as soldiers, but when they reached Mashonaland they were disbanded and let loose as civilian settlers. A young pioneer called Frank Phillips, who travelled in many parts of the Empire in the 1890s, summed up their attitudes thus: 'There was much swearing at times, and a fond wish never to see old England again until pockets were pretty well lined with the needful.' The origins of Salisbury were therefore rough but not altogether ready—many of the pioneers were totally ignorant of Africa and the outdoor life. The concessions extracted from Lobengula were morally dubious, for he had little idea how much he was signing away, and the Company's right to administer the country at all, however confidently it had gained the imperial assent, was morally shaky. The local tribes, secretive Mashona, mercurial Matabele, repeatedly turned on the settlers, and Lobengula, finding himself dispossessed, proved a bitter enemy until his death in 1893. There had been two major wars against the Matabeles, and that summer the Mashonas were still in rebellion. Disease had ravaged the settlers' cattle. The gold reefs had proved disappointing. All in all things had not been easy, and Salisbury had developed a wiry, rather bitter, often bigoted kind of self-sufficiency, mud on its boots and guns on its shoulders.

2

It was a sign of the imperial times that Rhodesia, an enormous and carefully ill-defined slab of territory, should be governed by a Company. The New Imperialism was easily fired by dreams of freebooter and buccaneer, and was also much concerned with private profit: and prominent in its lore were the grand old companies which had created the original Empire, established the imperial routes and planted the first trading posts—the Levant Company, Hudson's Bay, the Gold Coast and Gambia Companies, above all the East India Company, a major power in itself, with its own armies, warships, diplomats and currencies. Inspired by these swashbuckling examples, the British conceived the idea of re-creating such companies of adventurers, both to blaze new trails and to administer new possessions of the Crown, as they had done long before. Since 1882 four Chartered Companies had been formed, and given sovereign rights in various unexploited parts of the Empire. The system was admirably suited to men like Cecil Rhodes, who saw in it the chance both of profit and of almost sovereign power, and his British South Africa Company was much the biggest and most ebullient of them all.

It was a company, but more than a company. You could not look it up in the Register of Companies, because it was not obliged to register under the Companies Act. In the field it could acquire territory, make treaties, administer laws, levy taxes and custom duties, coin money, maintain its own armed forces. Rhodes saw it partly as a means of exploiting the wealth of the country, but partly as a specific instrument of British expansionism. Its chairman, the Duke of Abercorn, said at its first annual general meeting that the shareholders were more interested in earning dividends than in any 'high political or philanthropic motives'. They hoped to be backing a new Rand. To Rhodes, and to the Imperial Government in London, the Company was also a convenient way of keeping foreigners out of the country, and binding the whole of Southern Africa more closely within the Empire.

The headquarters of the Company was in Kimberley, where

Rhodes had made his fortune, but its roots had been carefully planted in the British hierarchy. Two Dukes and a V.C. were on its board, and its air of realistic patriotism attracted the best kind of investor. Its all-embracing concessions extended half-way up the east coast of Africa, merging indefinitely with the British protectorate in Nyasaland: south of the Zambesi it dealt with London through the Colonial Office, north of the river through the Foreign Office. Its flag was the Union Jack with a lion in the middle and the letters BSAC. Its stamps showed the Company crest supported by springboks and surmounted by an imperial lion. Its motto was 'Justice, Freedom, Commerce'. It laid its own railways, built its own roads, ran its own courts of law, was served by its own district officers and telegraph services. The men who settled under its auspices were absolutely its subjects: every immigrant was bound to abide by its laws, and defend its possessions if called upon. In return the Company helped to settle them, supplied stock at reduced terms, distributed free seed and undertook to buy crops. It was a sort of feudalism.[1]

3

'As for us,' said the *Rhodesia Herald*, dutifully celebrating the Jubilee, 'in this distant corner of VICTORIA's domain, no matter what our troubles, we join in the deafening shout that will, today, go up in the space before St Paul's—"Long Live The Queen!" ' But elsewhere the paper was full of dispatches about the Mashona troubles, and in the shops they were selling Robert Baden-Powell's book on the Matabele campaign of the previous year ('guilty', the *Herald* reviewer thought, of 'glaring inaccuracies and execrable taste'). The air was full of bloodshed, grievance, and warlike rumour. 'I estimate there were considerably over 100 natives', reported Captain van Neikerk of the police, in a dispatch to the Chief Staff Officer in Salisbury, describing how he and four others had recently attacked a couple of Mashona

[1] The BSAC surrendered its sovereign rights to the British Government in 1924, but it remains a great financial power in Rhodesia, and the national police force is still called the British South Africa Police.

kraals. 'I managed, almost at the cost of my life, to capture the chief alive, he was very nearly putting an assegai through me. . . . Trooper Hellberg also captured a woman and three children. . . . I must bring to your notice the gallant and brave manner in which Sergeant Major Weeden, Sergeant McAdam and Trooper Hellberg behaved yesterday in the fight, considering the enormous odds the four of us had to contend with.'

Salisbury naturally felt tense. There were still only a thousand citizens. The railway had not yet reached the town, and all communication was by mule-coach or ox-wagon. The coaches, built like the Australian mail-coaches to the Cobb pattern, were dragged along by spindly sore-covered teams of animals, and were often jammed with twelve passengers inside and seven or eight on top. The wagon trains, sometimes of thirty oxen, hauled their covered wagons with fearful labour through the veldt, men and beasts co-operating to drag them across rivers or up precipitous bluffs. Even these tenuous links were threatened now by the rinderpest, a vicious cattle disease which had killed thousands of animals throughout East Africa that summer: the transport riders were desperately inoculating their oxen by soaking strings in the lung-fluid of a victim, and threading them through their tails—if the inoculation 'took' the tails presently dropped off, and the animals were immune.

The citizens of Salisbury were angered by their isolation. They thought it unnecessary. In 1896 they had sent a petition to Queen Victoria, asking her help in hastening the construction of a railway to the city, and there was an undercurrent of resentment against the British South Africa Company, for its failure to look after people who were, after all, its protégées. Salisbury was rather given to grumbling, like most company towns.

4

The Company had been, it is true, under a cloud since the Jameson Raid, in which it had been intimately concerned—its police force provided the posse. The first Administrator and senior citizen of Rhodesia, Dr Jameson, was unavoidably absent in London, where

the Select Committee was inquiring into his conduct, and Rhodes himself, the vicarious founder of Salisbury and eponymous father of the country, had been obliged to leave the Company's board. He had resigned his Premiership of the Cape, too, and sometimes seemed to be losing his grip upon the loyalty of the colonists.

But there was still no mistaking the nature of the place. The Government was still a Company Government. The police were Company police (though since the Raid an imperial officer had been appointed to keep an eye on them). The *Herald* incorporated the Company's official gazette. There was still almost no civic activity in which the name of Mr Rhodes (as he was universally known)[1] did not appear, despite the fact that he lived 800 miles away in Kimberley. He was President of the Mashonaland Turf Club. He was Honorary President of the Literary and Debating Society. In the 'Personal Pars' column of the newspaper paragraphs about Mr Rhodes's movements nearly always came first, even if they only announced that he was 'expected to visit Salisbury shortly'. It was a foregone conclusion that Engine No 1 on the Salisbury line, then being built in England, would be named *Cecil J. Rhodes*,[2] and when Collins the barber in Pioneer Street invented a new cure for dandruff he cast his mind through a fairly limited range of patent names and plumped for Rhoderine.

The settlers often chafed under this patronage, and wrote letters to the papers demanding more self-government: but when Mr Rhodes did turn up in Salisbury it was marvellous how their grievances shrivelled before the force of his presence. It was the peculiar nature of the administration that gave Salisbury its tang. There were imperial troops in Salisbury, helping with the wars, but there were no imperial governors—no liberal scholars from the Colonial Office, rationally debating the balance of power or the emancipation of the natives, no plumed pro-consul at Government House, lately transferred from Singapore or British Honduras, no stream of Whitehall directives binding Rhodesia to a wider imperial

[1] And still is. The handbook of Rhodes House in Oxford refers to him thus, and in Salisbury people sometimes speak of Mr Rhodes precisely as though he were still alive.

[2] It was: and the first passenger train, which arrived in 1899, also bore the slogan 'Rhodes, Railroads and Imperial Expansion'.

pattern. The settlers were inclined to be contemptuous of British imperial authority, distantly and occasionally though it was exerted: had not Lord Ripon, the Colonial Secretary, four years before, forbidden the disarming of the Matabele because they would need their weapons to deal with the baboons?[1] No lessons were drawn from the long British experience in India, no conclusions were exchanged with British colonial experts in London. Rhodesia was an irregular sort of country, and Salisbury a fairly irregular capital. In 1895 a hard-labour prisoner escaped from the city gaol and made his way to the remote northern territories; he was recaptured up there, but the country was so short of Civil Servants that instead of sending him back to prison they gave him a job in the administration.

Of course Salisbury had its social pretensions. Until 1891 it had been a bachelor community and half its citizens indulged in African mistresses. Since then many white women had arrived, and the town had acquired a streaky veneer of decorum. The bushier beards had been trimmed, the language was more restrained in company, visiting cards were printed. The social centre of the colony was Government House, a pleasant rambling bungalow in the Indian manner, with an iron roof and a wide veranda, and servants' huts around a yard.[2] There lived Lord Grey, described by his predecessor Jameson as 'a nice old lady', with his wife and his daughter Lady Victoria. The grandson of a British Prime Minister, Grey was a director of the Company, a fervent disciple of Rhodes and an ardent imperialist—'The Empire is my country', he used to write in autograph books, 'England is my home'.[3] In that crude setting his *ménage* was a paragon of cultivated order. An invitation to a dance at Government House was, for most Salisbury women, the great event of the year—though the dances

[1] When, in 1965, a booklet was published in Salisbury to commemorate Rhodesia's seventy-fifth anniversary, this directive was caustically recalled. Lord Ripon was demonstrating, said the booklet, 'that genius for sowing the seeds of future trouble which British politicians so often display when dealing with the affairs of remote communities'.

[2] It was later divided into rooms and apartments for old ladies, one of whom told me in 1966 that she had been born in an ox-wagon.

[3] This singularly charming man, an early champion of proportional representation, went on to be Governor-General of Canada and an eager advocate of Anglo-Irish reconciliation. He died in 1917.

themselves were more enthusiastic than correct, if only because the men still outnumbered the women by at least three to one. In the old days women had often improvised their dresses out of puggarrees, calico or curtain material. Now the shops were better supplied, and there were even one or two dressmakers in town, but in other respects the arrangements remained makeshift. Some guests rode up to Government House by bicycle, the ladies pinning up their skirts and riding in their petticoats, with their gloves and fans in basket carriers. Many took their babies along, to put down in a bedroom all among the wraps. A Mrs Mary Lewis went to one such dance, and had a delightful time. The house, she wrote home, was brightly decorated with fairy lights, the police band played lustily, and though the dance floor on the veranda sloped disconcertingly outwards, to draw off the water when they scrubbed it, Mrs Lewis thought this was rather like dancing on the deck of a ship at sea, and had no complaints. There were twenty-six dances during the evening, and she played for two of them herself on the Administrator's piano, while the band had its supper. Next day the newspaper reported the function, and announced that Mrs F. and Miss G. 'were in combinations of black and white'—a remark which, Mrs Lewis says, 'gave cause for a great deal of hilarity'.

5

These were the homely pleasures of a frontier town, given a touch of ironic finesse by the fact that this was British territory, with a British patrician in charge. Mrs Lewis's first three partners were the Administrator's aide-de-camp, a barber, and the chief of police: a girl never knew what to expect, for the original pioneer column had since been augmented by an astonishing collection of adventurers, soldiers, speculators and hangers-on. There was Fred Selous, the great hunter, who had wandered through this country shooting elephant long before Rhodes cast his eye on it: he had killed hundreds of elephant in his time, had won the Founder's Medal of the Royal Geographical Society, liked to travel through the bush wearing nothing but a shirt, a hat and a belt, and claimed to have seen an extraordinary animal called a Nandi bear, like a cross

between a hyena, a bear and a leopard.[1] There was George Pauling, the railway builder, a man of legendary strength whose favourite parlour trick was to pick up a horse and carry it around his billiards table, and who was once alleged to have shared with two friends a breakfast of a thousand oysters and eight bottles of champagne. There was Mother Patrick, the saintly young superior of the Dominican Sisters, who had been one of the first women to reach Salisbury, and was known mysteriously to the Mashona as 'the lady without a stomach'. There was Major 'Maori' Browne, so nicknamed because he talked so much about his experiences in the New Zealand wars, and little Father Hartmann, the Catholic priest, an Austrian cobbler by origin, five foot tall and dressed generally in a Norfolk jacket, a felt hat and very baggy riding-breeches. There were ill-explained aristocrats like Lord George Deerhurst, who ran a butcher's shop on Pioneer Street, or the Vicomte de la Panouse, popularly known as the Count, whose Cockney wife Bill had cheerfully travelled second-class on the ship out to Africa, while he lorded it aft. There was, intermittently appearing in town, an adventurer of vaguely ecclesiastical character who had chosen the brilliant pseudonym the Deacon of Hong Kong, and survived for some years upon the confidence of the cloth.

Nobody much cared, just yet, to inquire too closely into their neighbours' backgrounds, but there were already suggestions that Jameson, as the first Administrator, had unfairly favoured the English upper classes in distributing land grants. 'It is perfectly sickening', one observer wrote, 'to see the way in which this country has been run for the sake of hob-nobbing with Lord This and the Honourable That.' Slowly, even then, the English social divisions were forming, and the English protocols setting in. Lord Grey's all-red bicycle had a coronet on its back mudguard, and a municipal coat of arms was devised. It incorporated Mr Rhodes's own arms, while another quarter contained the Cape Colony arms, a third was filled up with native weapons, and the fourth contained Martini rifles, axes, and a gold bar across a field of green. (There

[1] Selous, author of *Sunshine and Storm in Rhodesia*, retired to Worplesdon in Surrey, but volunteered for the First World War and was killed in action in 1917 as a captain in East Africa—aged 66.

were no supporters. Rhodes had suggested a pioneer on one side, a Kaffir on the other, but the Mayor, while he was all for the pioneer, would have nothing to do with the Kaffir.[1]) The Salisbury Club, aloof among its little trees, was already hardening into a stronghold of officialdom. The Kopje Club in Sinoia Street was where the merchants went to grumble. Meikle's, the general store, was *the* place to do one's shopping, the Kettledrum in Pioneer Street the *only* rendezvous for ices and sticky cakes. Traditionally delicious scandals already attended the affairs of the Musical and Dramatic Society, and one may wonder whether the dramatic critic of the *Herald* was altogether unbiased, when he wrote that Mr Popplewell's performance in *A Pair of Lunatics* was not only a complete failure in itself, but put off all the other actors, too. The Salisbury Hunt Club, which chased jackals or buck with foxhounds, fox terriers and the odd kaffir-dog, had been posh from the start: its very first meet had been attended by Lady Henry Paulet, whose husband Lord Henry ran the town sawmills, and at whose wedding in Cape Town the best man had been, by special permission of the Dean, a dog called Paddy.[2]

Below the slowly cohering upper crust, and the incipient bourgeoisie that supported it, lay a sediment of poor whites, sporadically employed and disgruntled. The social fulcrum of the town was already shifting. Lord Bryce[3] reported in 1896 that 'some very pretty country residences, in the style of Indian bungalows, have been built on the skirts of the wood a mile or two from the town': the original pioneer streets were soon to fall into squalor, amidst which the whores of Salisbury, French and German flotsam of imperialism,

[1] The municipal arms, which did not gain the approval of the College of Heralds in England, have since been replaced by something less imaginative: but the civic motto was not changed, and remains *Discrimine Salus*.

[2] Lord Henry later succeeded his brother as Marquess of Winchester, and after becoming a director of the BSAC went bankrupt in the 1920s. When he was 90 he married his third wife, a daughter of the Parsee High Priest of Bombay, and he died in France in 1962.

[3] James Bryce (1838–1922) wrote books about the Holy Roman Empire, Turkey, the United States, South Africa and South America, besides climbing mountains in Iceland, Hawaii, Japan, Basutoland and the Carpathians, receiving degrees from thirty-one universities and becoming Chief Secretary for Ireland and British Ambassador to the United States.

sat on kitchen chairs outside their teashops, inviting male passers-by to 'take a bun on Pioneer Street'. Failed gold-prospectors loitered in these parts, and discredited promoters, and all the shifting galli-maufry of bagmen, petty thieves and even actors who made the long journey from the South African colonies in search of pickings. There was a small Indian colony, too, of traders and vegetable-growers, and a sprinkling of Jews—'Ah!' cried Rhodes, when shown the site of their synagogue, 'if the Jews are here the country's all right!' Sometimes a lean and bearded fossicker wandered into town on his mule, with a couple of pack-donkeys loaded with blankets and pro-visions, and a pair of skinny African servants shambling along behind: and into a saloon he would go, to order himself a lager, greet a friend or two, recall the fortunes he had so nearly made down on the Rand or on the Kimberley diamond fields, and look forward with a wistful if watery eye to the bonanzas still awaiting him upcountry, hidden away among the quartz in the unexploited reefs of Rhodesia. They had no illusions of glory or idealism, the poor Europeans of the imperial frontiers. When Rhodes was once declaim-ing upon the debt posterity would owe the Salisbury settlers, a Scottish tradesman replied for them. 'I wud ha' ye know, Mr Rhodes, I didn'a come here for posterity.'

6

But far lower even than the vagrants in the social scale of Salisbury were the black men of the country, shadowy presences on the peri-meters—butter-fingered houseboys, uncoordinated labourers, con-victs from the city prison ineptly weeding the flower-beds in Cecil Square. Relations with the black Africans were unfortunate from the start, and for the most part the tribespeople were regarded with suspicion and contempt. Rhodes set the official policy when he declared the aim to be 'equal rights for every civilized man': but here there was little of the evangelical spirit that was part of the New Imperialism at home, and not much compunction in deluding or exploiting the African. Rhodes liked to say that his proudest moment was his entry, alone and unarmed, into an indaba of the Matabele in the Matopo hills, when he made peace with the

Matabele chiefs after the 1896 rebellion, and earned the tribal title *Lamula 'mkunzi*—'Separator of the Fighting Bulls'. Most Rhodesians, however, thought of the African either as a savage or as a slave. This was White Man's Country—in climate, in opportunity, in fact.

Such glory as there was to the frontier was provided by the hostility of the black men, as fundamental to the folk-lore of Salisbury as was the legend of the fighting Indian to the American West. In the early Rhodesian allegories the forces of evil were represented always by the tribespeople, ambushing innocent prospectors, murdering lonely farmers and their wives, treacherously going back on their word and calling upon old skills of sorcery and mass delusion to incite the tribes against the white man. We read about 'hordes of blood-maddened savages', white men 'isolated in a raging black sea', 'shadowy black forms of natives'. A well-known photograph shows the witch Nyanda, the instigator of much violence against the settlers, brought in to Salisbury for her trial. A small group of men and women stands motionless in an empty square, with low-verandahed houses in the background, and a few sticks and stones littering the unpaved street. Native Commissioner Kenny, booted, spurred and bow-tied, stands in relaxed assurance on the left, a cigarette in his hand, a wide-brimmed scout hat on his head. Eight barefoot African policemen stand vacantly to attention behind, slung with bandoliers and holding rifles at their sides. In the foreground are four little bareheaded Africans, with cloths around their loins and shoulders: two sad old sages, a crop-haired woman with dangling breasts, and in the very centre, the smallest figure of all yet much the most compelling, the witch herself, with a queer little pursed-up, puzzled face—a figure at once pitiful and arrogant, emerged from some shadowed and impenetrable backwood, as alien to the European understanding as a little black goblin.[1]

The Rhodesians saw their successive conflicts with these primitives as a fight for survival against odds. Two episodes in particular, the Mazoe Patrol of 1896, Wilson's Last Stand in 1893, were already enshrined in the colony's pride. The first was a do-or-die run

[1] Nyanda was hanged. Though she looks enigmatically subdued in this photograph, she went to her death wildly, ululating in defiance on the steps of the gallows.

through sixteen miles of ferociously hostile territory, made during the Mashona Rebellion by thirty men and three women. The women travelled in an iron-plated wagonette with a rifleman on the roof and a fighting escort all around, and so they plunged and clattered through the rebel country from the Alice Mine at Mazoe to safety in Salisbury. The second epic was a tragic stand made by Major Allan Wilson and a patrol of thirty-two men during the wars against the Matabele. Wilson and his men were pursuing Lobengula himself when they found themselves surrounded on the bank of the Shangani River by an impi of several hundred Matabele. When they had run out of ammunition, according to Matabele accounts of the episode, the survivors shook hands and sang *God Save the Queen*, before being speared or shot to a man. Their memory was made familiar to every Rhodesian by a painting, 'There were No Survivors', by Allan Stewart, showing them shrouded in gunsmoke in a wood, with barricades of dead horses around them, and Wilson himself bareheaded in front.

Such memories so close behind them, with rumours of bloodshed reaching them every day from the outstations, and the Africans of Salisbury still so close to the bush that most of them wore nothing but loin-cloths and none of them could write—so many barriers between the European and the African meant that not many Rhodesians seriously considered the black people as fellow subjects of the Queen. There were church services for natives, and even a night school: but the human contact was fragile and testy, few settlers bothered to learn the languages of the country, and it would be generations before Salisbury people forgot or forgave the wars with their black neighbours.

7

Salisbury was scarcely a sentimental town. It took what it could, and stuck by the survival of the fittest. Grey, the gentle and high-minded Administrator, was shocked by the reluctance of the British settlers to do much work for themselves while they had natives at hand to do it for them. 'Monsieur Vicomte de la Panouse,' he wrote, '*sang bleu* and a great Gentleman—you may see him in his

garden digging and trowelling, and the kaffir boy holding the seeds, but the Englishman, no.'

There was no denying the settlers guts and courage. It took guts to go to Rhodesia at all, and many of them were now performing prodigies of land development in the bush, sticking it out in danger-ous loneliness, learning the hard way to improvise and experiment—the water-wheel used to crush ore at the Liverpool mine, on the Umtali River, was made out of old whisky boxes. But too often they had a blind spot about manual, or menial, labour. That was black man's work. Caste was strong among the Rhodesians already, and it could easily harden into evil. Grey thought he would use the festival of Empire, that celebration of imperial brotherhood and self-reliance, to set a contrary example. It had been hoped to celebrate the occasion at the same time as a final victory over the Mashona: but the final victory was not yet won, so Lord Grey announced that the big festivity—a games meeting—would be postponed until September. In the meantime June 22 itself would be a tree-planting day. 'Every stalwart who wishes to show his loyalty to the Queen and plants his tree on the Queen's day must dig his own hole. No black or paid labour allowed, as the labour required for the digging of the holes is to be regarded as a voluntary act of individual homage to the Queen.'

A few days before the Jubilee Grey was to be seen in his shirt-sleeves digging a hole in the grounds of the hospital, watched by clusters of curious Africans. 'I am glad of the opportunity,' he observed, 'of showing by my personal example what damned non-sense this is.' But the pioneering spirit did not respond to this chal-lenge. Hole-digging held no symbolism for the frontiersmen of Rhodesia, who 'didn'a go there for posterity'. When Jubilee Day came round, the only tree planted in homage to Queen Victoria was the Administrator's gum-tree.

CHAPTER SIX

The Profit

Their shining Eldorado
Beneath the southern skies
Was day and night for ever
Before their eager eyes.
The brooding bush, awakened,
Was stirred in wild unrest,
And all the year a human stream
Went pouring to the West.

Henry Lawson

6

THE infatuated British public did not greatly concern itself with the motives of the Pax Britannica. It had happened. It was splendid. It was part of that divine order which had made Britain supreme and Victoria sixty years a Queen. The pragmatic tradition of England, like the climate of the island, was antipathetic to clear-cut analyses, the definition of principles or the formulation of intentions. Besides, the various pieces of the Empire had accrued so gradually, often so imperceptibly, like layers of molluscs clinging to a rock in the ebb and flow of the tide, that the process seemed altogether motiveless. It had not exactly been achieved. It was more properly ordained—a charismatic anointment of the British, like a Higher Summons.

In fact, one imperial end was basic to all others: profit. Many nobler and subtler motives played their part, and many passionate imperialists did not stand to gain at all, but the deepest impulse of Empire was the impulse to be rich. It had always been so. Loot of the more respectable kind had been a fundamental of British imperialism since the first adventurers went to India in search of spices or indigo, or Humphrey Gilbert realized the wealth of the Newfoundland fisheries. Romantics now saw their Empire as a cornucopia from which good things flowed along the seaways to their islands—gold and furs from the western possessions, gold, skins, diamonds, wines and feathers from the south, silk, rice, tea and precious stones from the east, ivory from Africa and food from all quarters. Wool, wood, rubber, cotton, tin, iron ore, zinc—all these essentials of British prosperity, produced within the Empire, flowed back to Britain in a safe sure stream. 'The tropical and temperate possessions of the Empire', wrote Flora Shaw[1] in her article on the

[1] The head of the colonial department of *The Times* and a friend of Cecil Rhodes, Flora Shaw had been implicated in the Jameson Raid and was an

British Empire in the *Encyclopaedia Britannica*, 'include every field of production which can be required for the use of man', and a third of all the miners and quarrymen of the world worked in imperial soil.

2

In the 1890s this atavistic view of imperial profit was paramount, and there was a Spanish streak to the New Imperialism. These were gold-rush years. Some of the most powerful forces behind the expansion of Empire in Africa were the gold and diamond corporations of South Africa and the City of London, and nothing excited the public more than the news of another fabulous gold strike in yet another corner of the Queen's possessions. Within the past few decades they had found gold and silver in Australia, in New Zealand, in India, in Canada, in South Africa. Tens of thousands of emigrants, many of them educated men, had sailed from Britain for these imperial goldfields. In Australia the silver deposits of Broken Hill had not only lured away almost the entire labour force of the New South Wales railways, but had half cleared the South Pacific of those thousands of beachcombers, odd-job men and confidence tricksters who formed a peripatetic population for the islands. In Canada armies of prospectors were labouring over the passes to the new goldfields of the Yukon—a journey so frightful that often, when at last they reached the diggings of Bonanza Creek, they turned in relief and went home again. In South Africa the British had built the gold metropolis of Johannesburg, were prospecting north of the Zambesi, and had created in the Big Hole at Kimberley one of the most astonishing memorials to the impetus of avarice.

Nothing expressed the opportunism of Empire better than the Big Hole, in the days before the big combines bought out the small miners. The site was divided into hundreds of smallholdings, separated by roadways. As the frenzied miners dug away to the very edges of their holdings, so the roadways collapsed, the pit grew deeper, and the only way to extract the diamond ore was by rope

eminent figure of the New Imperialism. She married Frederick Lugard, the African administrator, became a Dame of the British Empire in 1918, and died in 1929.

pulleys, from the diggings themselves to the lip of the hole. Soon every miner had his own ropeway, and the whole vast mess of the Big Hole was covered in a mesh of ropes, gently shimmering in the hot wind like an enormous spider's web, or swaying with the weight of innumerable buckets—at the top of each thread a barrow or a truck, at the bottom, far down in the chasm, a sweating imperialist. In a single year nearly 50,000 men came to scrabble in and around this pit, fighting each other, drinking too much, gambling wildly, dossing down in sleazy boarding-houses and occasionally making fortunes, until at last Cecil Rhodes, the greatest fossicker of them all, bought them all out with the most valuable cheque ever written: 'Five Million, Three Hundred and Thirty-Eight Thousand, Six Hundred and Fifty-Eight Pounds—Only'.[1]

The prospector was one of the familiars of the British Empire. He was a classless creature, deserter or bishop's son, Honourable or wanted, and often an eccentric, too: a Mr John Derbyshire had travelled to the Kimberley diggings from the Natal coast on a tricycle fitted with a triangular sail, and when Bryce visited the boom town of Johannesburg in the nineties he was struck by the number of cultured men to be found there, incongruous among the shanties, the dusty streets and the unlovely yellow piles of the mine dumps. Many English remittance men took their chance in the Yukon that year, and one of the most striking outfits to set off from Edmonton for the goldfields was that led by Lord Avonmore, with a group of gentlemanly associates, numbers of servants and ten thousand pounds of supplies.[2] The legend of Australia was largely created by its myriad prospectors, often to be found half-wild in the wastelands, looking for tin, gold or silver, shacked up often enough with an aboriginal bushwoman, living on kangaroo steak and sweet

[1] The Big Hole, disused since 1914, became the largest man-made hole in the world—a mile round the top and nearly 700 feet deep. It is now filling up with water at the rate of 12 feet a year.

[2] He came of unconventional stock. His father, the fourth earl, was the defendant in the celebrated Yelverton case, in which a woman he was alleged to have married sued him for restitution of conjugal rights, persisting in the suit for nine years, and taking it unsuccessfully to the House of Lords. Our Lord Avonmore, who was nicknamed in Canada 'Lord Have One More', did not make his fortune on the Klondike, for he ignominiously failed to get there.

potatoes, sometimes striking it rich and hastening into Kalgoorlie or Broken Hill for an orgy of gambling and drinking, more often reduced to destitution, packing up his pans, his pots and his woman and stumbling off towards another elusive Eldorado.

The possibility of instant fortune, every man his own Rhodes, was essential to the mystique of Empire. Stephen Leacock's Mariposa went wild, when the mining boom hit Ontario, and young Fizzlechip 'came back from the Cobalt country with a fortune, and loafed around in the Mariposa House in English khaki and a horizontal hat, drunk all the time, and everybody holding him up as an example of what it was possible to do if you tried'.[1] In London agencies thrived by arranging passages to the goldfields for hopeful adventurers, and one day that summer the *Daily Chronicle* printed a spirited gold-rush ballad:

> *Klondike! Klondike!*
> *Libel yer luggidge 'Klondike'!*
> *Theers no luck dawn Shoreditch wye,*
> *Pack yer traps and be orf I sye,*
> *An' 'orf an' awye ter Klondike!*

This was very much in the spirit of the New Imperialism, and the excitement of the new African Empire was largely a gambler's kick. The great South African mining corporations, City-backed and often Jewish-run, approached the whole subject of Empire rather in the manner of the wayward prospector, subjugating all else to the main chance. For many Englishmen the imperial climax was soured by get-rich-quick. 'All this Empire-building,' cried the Radical John Morley. 'Why, the whole thing is tainted with the spirit of the hunt for gold.'[2] Hoggenheimer the Randlord became a

[1] Leacock, born in England in 1869, 'decided to go with them' when his parents emigrated to Canada in 1876. His *Sunshine Sketches of a Little Town* is about Ontario life around the turn of the century. In the story I quote, *The Speculations of Jefferson Thorpe*, Fizzlechip later shoots himself and Thorpe the barber loses almost all he has.

[2] Morley, the biographer of Gladstone, was as consistently anti-imperialist as his subject, though he was twice Chief Secretary for Ireland and once Secretary of State for India. As Lord Privy Seal he opposed Britain's entry into the First World War and withdrew from public life, dying as Lord Morley of Blackburn, aged 85, in 1923.

familiar butt, while the new plutocracy created by the influx of South African gold was frequently lampooned in *Punch*, indulging in grotesque and ignorant ostentation.

3

Trade was a steadier imperial impulse, and if it did not excite the public quite so spectacularly, gave to the British Empire much of its presence and solidity. High on Victoria Peak above the harbour of Hong Kong lived the taipans, the grandest of the imperial merchants, riding the crest of the China trade. Above their palaces their house flags flew majestically, and in immaculate barouches they drove down the twisting island roads to their offices on the waterfront. They were successors to a long line of British merchant princes, and all over the world they and their peers were part of the imperial scene, richly and comfortably entrenched in profitable fields of commerce. The greatest commercial asset, Rhodes once said, was the British flag: and if a stream of raw materials and natural products flowed back to Britain from the colonies, she in return sent them everything undeveloped countries needed to catch up—machinery, steel, clothing, arms, carriages, railway equipment, books, and every kind of manufactured luxury. The Empire was in no sense a private market. The British were committed to Free Trade, and for nearly fifty years their Empire had been open to all comers. But they did enjoy obvious advantages in their own possessions, and the anti-imperial economist J. A. Hobson considered the whole imperial movement to be a British sales device, necessitated by an excess of production over home demand, and a consequent need to find profitable markets and fields of investment abroad.[1]

To travellers along the imperial routes British commercial supremacy must have seemed overwhelming. The British merchant

[1] Hobson thought oversaving by the rich and investment abroad to be the chief cause of unemployment at home. This brilliantly original and readable theorist, concerned as much with social welfare as with finance, was never offered an academic post, but found some of his theories vindicated, and his name honoured, in the 1930s. He died in 1940.

was ubiquitous, and the imperial economic services were unchallenged. In every port Lloyd's agent was at your service. In every capital a bill on London was instantly honoured. When a liner captain approached Port Said, whatever his nationality, he knew for certain that already awaiting his vessel there, loaded deep with piles of coal and blackened half-naked men, would be the coal-rafts of the Port Said and Suez Coal Company, British owned and managed, and geared to refuel the transient ship with best South Wales coal at the rate of eight tons a minute. To many parts of the Empire the arrival of a British bank, generally on Scottish lines, set altogether new standards of method and reliability (though in India they sometimes lived more racily by making loans to improvident native rulers, and exploiting the fluctuations in the unstable local currencies).

As for the traders, they were inescapable, princely as the taipans or modest as Collins the hair-lotion man in Salisbury. Far up the steamy Niger you would find the flag of the Royal Niger Company floating listlessly over a mud and thatch hut; and all over the lakes area of Central Africa you would come across 'Mandala'—the generic name given by the Africans to every trading post of the African Lakes Company, after the glint, we are bafflingly told, in the spectacles of an original Scottish partner. Hong Kong in the nineties seethed with new British companies, floated to exploit the promising China market: all over the Pacific British entrepreneurs, shippers and schooner captains tapped the island trade, coconuts to Singapore, pineapples from Fiji, or deckloads of indentured Polynesians for the Queensland sugarfields. The commerce of India was largely in British hands, and they had made Calcutta one of the great commercial cities of the world, street after street of grave business houses like huge neo-classical factories to process the trade of the interior. The agents of the Hudson's Bay Company knew more about the Canadian North than anyone else; the Company was the greatest landowner in the north-west, owned half downtown Winnipeg, retained a monopoly of the fur trade and had retail stores all over Canada. Luke Thomas, the principal shipping and trading agent in Aden, was a great-grandson of one of the original British merchants there, and was sensitive to every nuance of trade throughout the

Red Sea area.[1] Many of the more horrific accounts of the Masai tribesmen, emanating from the interior of Kenya in the 1890s, were put about by adventurous traders anxious to keep new markets to themselves.

The free ports of the Empire—Gibraltar, Aden, Singapore, Hong Kong—were hubs of trade for their respective regions, within which barter, currency exchange, smuggling and all the ancillary arts of the entrepreneur were profitably practised beneath the protection of the Union Jack. In many parts of the Empire coastal trade was virtually a British monopoly. Nobody else had much chance, for example, around the coasts of India—even the Indians themselves, who occasionally tried to compete: the Indian Ocean was virtually monopolized by the ninety ships of the British India line, which had begun operations on the Calcutta–Burma run and gradually swept all rivals off the seas from Rangoon to Mombasa. The greatest commercial asset was the flag.

A young English trader named Harry Martin has left an account of his arrival in the Gold Coast to work for the firm of F. and A. Swanzy, in the newly valuable cocoa trade. At Addah, at the mouth of the Volta, he was lowered over the side of his ship in a wicker garden chair, and swept perilously through the surf on an African longboat. Soaked through and distinctly shaky, he was carried bodily up the beach by the bosun to be greeted by a large genial African, 'Mr Micah, the Agent', and given a meal of 'Roast Chicken, White Bread, Boiled Yam and a tin of Dutch Butter'. The very next day he was handed a cash-box containing £300 and told to take it, in a rickety old launch, sixty-five miles up the Volta River to the Company factory.

It sounds a daunting introduction to merchant venturing. The boat repeatedly broke down, the mosquitoes were dreadful, Martin sweated heavily and constantly wondered 'when someone would come along and murder me and take the money'. Once at the factory, though, he found life rigidly ordered. Swanzy's had been

[1] Hudson's Bay is still a power in Canada, and its great department stores have become so much a part of Canadian life that often when people go shopping they say merely that they are going 'down the Bay'. Luke Thomas and Co still thrive, too, with offices overlooking the Aden public gardens in which, until its removal in 1967, there stood a Jubilee statue of Queen Victoria.

in Africa for 180 years, and had acquired a kind of tribal status. The firm even had its own ceremonial mace, like a tribal totem, which its agents sent into a chief's presence before entering a village—it was a six-foot malacca cane with a silver unicorn at its head. The handful of Englishmen at the factory lived in some formality: the contract lunch for junior employees provided two glasses of light French wine. The labourers were mostly indentured Kroomen imported from Liberia, who arrived filthy and virtually nude, were given names at random like Teapot, Bignose or One Day Gentleman, and were locked into their compound at night. Competition with local German and French traders was intense—each morning buyers were sent out along the country roads to entice cocoa-sellers back to the factory yard—and relations with the local Africans seem to have been dignified: for in those days, Martin writes, 'the Gold Coast natives were in every way scrupulously honest, reliable and their morals good'.[1]

Behind the trade lay the capital: British money sunk in the imperial goldfields, plantations, trading companies, railways, insurance firms, shipping lines. Britain was banker and moneylender to all her Empire. Her capitalists had cash to spare. The railway boom at home was over, the rate of industrial expansion had slackened, and the second or third generation of industrialists looked around for profitable opportunities elsewhere. There was a wide choice of developing foreign countries, and into nearly all of them British money went, but a field of profit at once secure, worthy and patriotic was offered by the Empire. There was nothing rude then to the epithet of capitalist. It was thought very proper for the British moneyed classes to plough their cash into Indian railways, African mines or Polynesian copra. Not only did it pay interest, and help the recipient countries to develop, and bind the natives closer within the family circle: it also ensured, by financing ports, docks and railways, that a flow of food and raw materials came back to Britain in return—for the gulf between the rich peoples and the poor was so immense that most imperial loans were necessarily repaid in kind.

[1] Swanzy's became, after many amalgamations, the United Africa Company, later acquired by Unilever. The firm's ceremonial staff was given to the British Museum, and thus disappeared from human knowledge.

4

It was a common belief among the late Victorians, if we are to go by
the literature of the New Imperialism, that all these imperial activi-
ties had made their country rich: more than a belief, an assumption,
for just as they did not often define their motives, so they did not
generally analyse the economic situation very precisely. To the
public the extension of Empire seemed more or less to have coincided
with a fabulous increase in Britain's wealth, and they assumed it to
be cause and effect. Britain was still the richest of nations. Her
exports were running at more than £216 million a year, compared
with £181 million for the United States and £148 million for Ger-
many. Her overseas investments were worth something like £1,700
million—15 per cent of the national capital, bringing in some £100
million interest each year. British gold reserves were much the
largest in Europe, and the pound was the strongest and most stable
currency.

Much of this was imperial profit. Trade often had followed the
flag, and the colonial commerce was very important to Britain. The
transplanted Britons of the white colonies still preferred British
goods, from sentiment as from habit, and the main imperial trade
routes all led to England. Colonial Governments naturally did much
of their buying through their agents in London; colonial companies
raised their capital in the City as a matter of course; much of Lon-
don's big re-export business was in colonial goods. There were parts
of the Empire—Cape Colony was one—where British exporters and
importers enjoyed a virtual monopoly, and almost everywhere else
officialdom tended to favour the British businessman over his
foreign competitor. In earlier years the flow of goods from India had
been altogether one way—they were paid for by taxes raised on the
spot.

The New Imperialists represented British progress as a cycle of
imperial expansion. They reasoned that the wealth of India, a
century before, had provided the capital for the Industrial Revolu-
tion—which had enabled the British to acquire their new Empire
elsewhere—which was itself now paying dividends. They backed

their arguments with figures which pictured the whole Empire as an economic unit. It was, they liked to say, 'first among the Powers' in wheat, wool, timber, tea, coal, iron, gold. In steel it was exceeded only by the United States and Germany. In tobacco it was second only to Spain. It produced a third of the world's coal, a sixth of the wheat. Its volume of trade had consistently grown, as the Empire itself grew. In 1820 British foreign trade had been worth £80 million: by 1897 the Empire's total foreign trade was worth £745 million. Britain's terms of trade, too, had consistently improved—which is to say, she paid less for the things she bought, and got more for the things she sold. 'Selling dear, buying cheap' seemed to be one of the perquisites of Empire, if only because by controlling so many of the sources of supply, the British could keep the price of raw materials down.

The flow of commerce within the Empire somehow seemed particularly heartening, as though so many eager vassals were working away there, year by year, exchanging their commodities backwards and forwards for the indirect benefit of their suzerains. The popular statistics of the time are full of 'inter-British' trade figures. They contributed mystically to the aspiration of a self-sufficient, all-inclusive Empire, impervious to the designs or catastrophes of the world at large. Australia sent her silver to India. India sent her rice to Natal. Canada sent her manufactured goods to the West Indies. The New Zealand grassland industries existed entirely to satisfy imperial markets. As Flora Shaw pointed out in the *Britannica*, 'the butter season of Australasia is from October to March, while the butter season of Ireland and northern Europe is from March to October'. The New Imperialists foresaw an Empire self-supporting in everything—a world of its own, with Britain herself as a vast smelter, processor or refiner at the centre.

5

Such was the profit-mechanism of Empire, as the activists saw it in 1897. Since it seemed, from the vantage-point of the Jubilee, to be a tremendous success, the instinct of the time was naturally to make it more so, and especially in the last of the unexploited continents,

Africa. The more land you possessed, surely the richer you were. The more people you ruled, the greater your labour force. The more directly you controlled a country, the safer was your investment there, and the more generous the dividends it was likely to pay.

In Africa there were still territories to be annexed, labour forces awaiting employment, resources to be tapped and markets to be created. The New Imperialism in Britain, the apogee of the idea of Empire, was above all manifested in the scramble for Africa. India, the West Indies and the white colonies had, it seemed, always been there, part of the background of the Englishman's life. It was the new magic of Africa that set the tone—Cape-to-Cairo all red, Wilson's last stand on the Shangani River, those swaying pulley-ropes above the Big Hole at Kimberley, Cooks' white steamers paddling past pyramids into desert sunsets. Powerful economic lobbies pressed the British Government into African adventures.

The profits were not always immediate. Rhodes's British South Africa Company had not yet paid a dividend,[1] and the Imperial British East Africa Company never paid one from start to finish. But long-term benefits, it was thought, were assured, and it was the duty of the Government to make them possible. Such a duty had long been accepted. Palmerston had declared it the business of Government to 'open and secure the roads for the merchant'. Joseph Chamberlain thought it was the task of the Foreign Office and the Colonial Office to 'find new markets and defend old ones', while the War Office and the Admiralty protected the flow of commerce. Abroad, national power was properly used to further private trade and investment— by forcing other countries to reduce their tariffs and abolish their monopolies, by opening up such decayed and shuttered organisms as the Turkish and Chinese empires, and by creating new markets for British goods. 'Our burden is too great,' Gladstone once complained to the rampantly expansionist Rhodes. 'We have too much, Mr Rhodes, to do. Apart from increasing our obligations in every part of the world, what advantage do you see to the English race in acquisition of new territory?' 'Great Britain is a very small island,' was Rhodes's reply. 'Great Britain's position depends on her trade, and if we do not open up the dependencies of the world which are at

[1] Its first, 6d on each £1 share, was paid in 1924.

present devoted to barbarism we shall shut out the world's trade. . . .
It must be brought home to you that your trade is the world, and
your life is the world, not England. That is why you must deal with
these questions of expansion and retention of the world.'

The expansion and retention of the world! In terms less glori-
ously flamboyant, the British as a whole now echoed Mr Rhodes.
What the business community really wanted was the Open Door—
the opportunity to trade freely everywhere, irrespective of sove-
reignty. If they could not have this, in a world which would not
accept the principles of Free Trade, very well then, Empire it must
be. It might at first sight, Adam Smith had written, seem very
proper for a nation of shopkeepers to found a great empire with the
sole purpose of creating more customers: and there were many
businessmen still who thought it a very proper end of imperial
policy. If another country seized an African territory, instantly a
tariff was imposed to keep out British goods: it was the duty of the
British Government to get there first. The Empire, Rhodes also said,
was a bread-and-butter question, and its expansion was essential to
the equilibrium of Britain. 'In order to save the 40 million inhabi-
tants of the United Kingdom from a bloody civil war, our colonial
statesmen must acquire new lands for settling the surplus popula-
tion of this country, to provide new markets for the goods produced
in the factories and mines.'

6

So all these various instincts and impulses of profit were forcing
outwards the frontiers of Empire.—'*God Who made thee mighty make
thee mightier yet!*' And the bigger it was, the bigger it had to be. If
the first cause was generally commerce, investment, or raw materi-
als, the second was the need to protect the stake: from the seacoast
into the hinterland, from the exposed plateau across the mountains,
from India into Burma, from Egypt into the Sudan, and everywhere
to the next islet, headland or river basin, the one the Empire could
not safely afford to be without.

In some of their suppositions, as we shall later see, the New
Imperialists were deluded. The profit instinct was not infallible:

foreigners were barging into those cherished colonial markets, Empire in Africa was a very different thing from the Raj and the white colonies, Britain's wealth was not so imperial as they thought. But rightly or wrongly, the urge to profit lay at the root of the New Imperialism, just as it had impelled the adventurers of England out of their cramped islands from the start. Already there were formidable critics of the movement—not only liberal politicians and journalists, but economists, too. The most forceful of them all was Hobson, who argued that if all this money, all this enterprise had stayed at home, ordinary English people would have benefited more. Easy money for capitalists and traders, he reasoned, did not mean better homes, schools or health for the British masses.

He preached to an unresponsive audience. In Russia the young Lenin heard him, and believed. In England few listened. The rich did not approve of such unorthodoxies, and the poor were all out in the streets, waving their flags for Jubilee.

CHAPTER SEVEN

The Glory

England, England, England,
Girdled by ocean and skies,
And the power of a world and the heart of a race
And a hope that never dies.

Wilfrid Campbell

7

THE means of profit were for the few, but the hope of glory was almost universal. Empire and Imperialism, wrote the journalist W. F. Monypenny,[1] filled the place in everyday speech once filled by Nation and Nationality—the national ideal had given way to the imperial. The existence of the Empire, and its expansion, seemed to satisfy some national psychological need. In 1878 Lord Carnarvon, then Colonial Secretary, had felt obliged to ask what the word 'imperialism' actually meant.[2] The *Oxford Dictionary* gave an answer: 'the principle or policy of seeking, or at least not refusing, an extension of the British Empire in directions where trading interests and investments require the protection of the flag, and of so uniting the different parts of the Empire having separate Governments as to secure that for certain purposes, such as warlike defence, internal commerce, copyright and postal communications, they shall be practically a single State.' By 1897 nobody was likely to need a definition. So cataclysmic had been the explosion of the new ideas, so carried away was the nation, that everybody knew the meaning of imperialism now.

Two very different poets had between them expressed the popular interpretation. The first was the balladeer G. W. Hunt, whose most famous music-hall song had given a word to the language:

> *We don't want to fight, but, by Jingo, if we do,*
> *We've got the ships, we've got the men, we've got the money too.*

[1] Himself a working imperialist—editor of the Johannesburg *Star*, soldier in the Boer War, Nile traveller and biographer of Disraeli. He died in 1912.

[2] Carnarvon (1831–90) was twice Colonial Secretary, and once Lord Lieutenant of Ireland: he introduced the British North America Act which established the Dominion of Canada, was an early proponent of South African federation, and edited Dean Mansel's *Gnostic Heresies of the First and Second Centuries*.

We've fought the Bear before,
And while Britons shall be true,
The Russians shall not have Constantinople.[1]

By no means everybody, even in this brash heyday of the creed, found Jingoism tasteful. Chauvinism was an old British trait, but this aggressive conceit was something new. Queen Victoria, contemplating the national vainglory with some disquiet, once observed that she could not quite understand 'why nobody was to have anything anywhere but ourselves'. To most Britons, nevertheless, the spirit of Empire was essentially acquisitive, and Jingoism itself was one of the motives of imperialism.

The second poet was Alfred Austin, who apostrophized his country in loftier metre:

Thou dost but stand erect, and lo!
The nations cluster round; and while the horde
Of wolfish backs slouch homeward to their snow,
Thou, 'mid thy sheaves in peaceful seasons stored,
Towerest supreme, victor without a blow,
Smilingly leaning on thy undrawn sword!

Fewer would quarrel with this image of the imperial presence, a magnanimous Galahad of the wheat fields, friend and protector of all. The British saw their country as a special kind of Power, *sui generis*, making rules of its own and legitimately imposing them on others. To the British Empire no conventions applied. Command, authority, privilege were natural rights of the British people. The world measured its longitude from Greenwich, and the postage stamps of Great Britain, alone in the world, did not bother with a national title, but simply bore Victoria's head. Take it, the British seemed to say to the world, or leave it.

To this specialness the Queen herself no doubt subscribed, just as her person summed it up. It was Disraeli, thirty years before, who had made an imperialist of Her Imperial Majesty. He saw the Empire

[1] The song was made famous, at a time of tense Russophobia, by 'The Great Macdermott'—G. H. Macdermott (1845–1901), a former Royal Navy rating who was for twenty years a lion of the London music-halls. Hunt himself, a painter as well as a popular composer and lyric-writer, died in 1904, of softening of the brain, in Essex County Asylum.

as an Eastern pageantry, a perpetual durbar, summoning the British people away beyond the dour obsessions of Europe to a destiny that was spiced and gilded. Under his seductive influence Victoria, like so many of her subjects, found herself bemused by the exotic allure of Empire. The Queen had a horror of John Bullism, by which she meant arrogance and bullying in diplomacy: but the older she grew, the more she grew accustomed to the imperial stance, until by the time of her Diamond Jubilee her very appearance among her satraps, mercenaries and imperial commanders seemed to give sanction to the idea of the British Empire as a divinely sponsored phenomenon—By Appointment to God.

2

The Empire was at its zenith, the Crown glittered as never before, magnificently in the centre of the world lay England, home and glory. With such a background of national self-esteem, it was difficult not to be pugnacious. The late Victorians were plumper and more complacent than their fathers had been, but they still had plenty of *élan*, and the history of the past century had inspired them with a happy contempt for all adversaries. Their society was stable. Their inventive genius was everywhere acknowledged. The superiority of their arms seemed to have been permanently established by the twin victories of Trafalgar and Waterloo. There had been setbacks, of course, generally when a gallant company of cruelly outnumbered Britons had been caught unfairly by surprise: but even the blunders of the Crimea had been redeemed by the effortless conquest of Egypt, and by a score of successful small colonial wars. Nowadays, when a British soldier marched into some unknown and potentially hostile territory, he marched in the almost certain conviction that he was going to win. The British armies of the day fought ferociously, matching barbarism with brutality, and seldom hesitating to employ the most terrible of weapons, the Maxim gun or the expanding Dum-Dum bullet, against the most primitive of enemies—'Butcher and Bolt' was the army's own nickname for punitive expeditions. But it was all in a good cause. As Austin exclaimed in another irresistible poem:

Who would not die for England! And for Her
He dies, who, whether in the fateful fight,
Or in the marish jungle, where She bids,
Far from encircling fondness, far from kiss
Of clinging babes, hushes his human heart,
And, stern to every voice but Hers, obeys
Duty and Death that evermore were twin.

So the taste for power inflamed the imperial violence. It must have seemed so easy. In India the Forward School of strategists constantly pressed for the extension of frontiers northward and eastward through the passes—to confront the enemy, Russian, French or Chinese, muzzle to muzzle on ground of British choosing. In the Pacific the virile Australians wanted to create a Mare Nostrum, excluding other European Powers and keeping the Asiatics where they belonged. In Africa the British seemed to be storming belligerently everywhere, seizing territories or abasing chieftains for reasons that were basically economic or strategic, but were often sublimated on the spot into the sheer love of a scrap. Austin was once asked to define his idea of Heaven. It was, he said, to be sitting in a garden receiving news by alternate messengers of British victories at sea and British victories on land. The British were not really a belligerent people—few nations were more *civilian* than Victorian Britain—and they had not been engaged in a life-and-death struggle since the defeat of Napoleon. But a generation of easy victories had gone to their heads, and they were drunk with glory. Sometimes they yielded to surges of vindictive anger. Gladstone himself had ordered the bombardment of Alexandria, after the revolt of Arabi Pasha the nationalist in 1882, confounding those who forecast that he would only intervene with the Salvation Army. The boys at Eton unanimously voted that Arabi ought to be hanged for his patriotism, and Queen Victoria agreed with them.

3

Dreams of private glory, too, forced the imperial play close up to the net, and helped to keep the pugnacity aboil. J. S. Mill once

called the British Empire 'a vast system of outdoor relief for the
British upper classes', and certainly the native energy of the British
needed outlets.[1] With 40 million people in their islands, a country-
side tamed by railways and roads, and a newly educated generation
reaching maturity, the more adventurous of the British felt cramped.
They pined for more elemental environments, where climate, terrain,
opportunity and the pitch of everyday life could all be more extreme.
Most Britons emigrated, as we have seen, because they needed to, but
many more were just in search of space, danger and responsibility
and open air—and some, so sophisticated commentators suggest,
were obeying a kind of sexual compulsion, a reaction to the celibate
frustrations of the British public schools. Fame and fortune could be
made out of imperial adventure. *Punch* once suggested a coat of
arms for the reporter-explorer Henry Stanley, Livingstone's puta-
tive rescuer, containing in one quarter 'two dwarfs of the forest
of perpetual night proper, journalistically exploited to the nines,
with the motto *Eminent Travellers Rescued While You Wait*'.

For others the inducements were less immediately romantic.
There were jobs to be found in the Empire less prosaic than their
equivalents at home. The clerk could aspire to a merchant's desk in
Barbados or Singapore. The journalist could follow Kipling to the
Pioneer at Allahabad, or write off *on spec* to the Toronto *Globe*, the
Melbourne *Age* or the *Cape Times*—all sound imperialist organs
which welcomed able Englishmen. Doctors, lawyers, accountants,
even the occasional artist, could pursue their professions less
conventionally and often more profitably in colonial cities, while for
working men, Lord Rosebery once assured the Trades Union Con-
gress, the Empire provided 'a variety of guarantees and opportuni-
ties . . . which can be offered by no other country in the world'.
Standards of living were often much higher than at home. In the
tropics especially servants were cheap and plentiful—even sergeants'
wives had maids and houseboys, while private soldiers in India
invariably employed Indians to clean their buttons and boots.

[1] Like his father James, the historian of India, the philosopher-politician
John Stuart Mill was an employee in London of the East India Company,
and it was he who, in 1856, drew up the Company's petition to Parliament
protesting against its own dissolution. The petition failed, and Mill accord-
ingly retired in 1858 with an annual pension of £1,500.

To a really ambitious man the highest posts of Empire could bring most of the satisfactions of politics without the degradations of hustings or debate. Great splendours of position attended the successful imperial administrator. The chance of a truly regal status in life, such as a Colonial Governor enjoyed, with his own court and etiquette, his palace on the hill, a subject people at his feet and the Union Jack at his flagstaff—the mere possibility of such an elevation was enough to make a susceptible bureaucrat imperialist to the last gunboat. In the old days the Marquis Wellesley, though voted a grant of £20,000 for his services in India, died embittered because the Government refused to create him Duke of Hindustan. By the 1890s ambitions were less gorgeous, but were still compelling enough to create an interested lobby for the extension of Empire. Sir George Campbell, one of the most liberal of late Victorian imperialists, and himself a former Lieutenant-Governor of Bengal, thought the existence of a large and increasing class of people wanting to fulfil themselves abroad 'reason and justification for foreign extensions where they can legitimately be made'.

4

What incentives they were! The smell of the veldt, the illicit delight of a sabre-slash in the sunshine, a drum-beat out of the forested hills, the first sod turned on your own homestead, with a million acres to come; the wheezing breath of your dear old bearer, as he lit the juniper fire in the morning, and brought the teapot steaming to your bed; the never-sated excitement of tigers, the pride of red tunic and swagger stick in the bazaars, the thump of the band behind you as you clattered, the Colonel's lady, in your spanking tonga through the cantonment, or the dull gleam of a nugget in the clay, Twelve Below Discovery on Bonanza Creek: gracious acceptance of curtsies, on the lawn for the Queen's Birthday—sparkle of brass polished thin, as your carriage braked precariously down the tree-shaded road from the Peak—sudden tap of Morse in the silence of the Outback—first place for the Royal Mail on the convoy through Suez—unexpected promotion to be officer in charge of the Ex-Amir of Kabul—'*the Ship cannot dock at Addah owing to the surf, but*

Mr Micah our Agent will be on the beach to welcome you from the Surfboat, and I remain, Dear Sir, Your Faithful Servant, p.p. F. and A. Swanzy'. The cloud of dust and jingle of accoutrement, as the dispatch rider swept in with an ultimatum for the paramount chief; the gleaming plates of the entrepreneurs on the waterfront at Singapore; flowers and brown arms in the Pacific evening; flash, and fire, and black men all around you, and great ships steaming, and curry on the train at Sher Shah junction, and the Admiral's pinnace chugging across Esquimalt Bay, and the surreptitious glance at the *Gazette*, over the breakfast table before morning inspection, on the day they announced the Birthday Honours. All these fortified the pugnacity of Empire: and filtered back along the trade routes, distilled in the heady patriotism of home, they laced the policies of State.

5

Many years before Dr Livingstone had laid another trail of glory. When he first penetrated the interior of Central Africa he set a standard for his compatriots. He was the best of men. He was very brave. He was contributing to human knowledge. He was opening the way for trade and probably dominion. Above all he was serving God, and revealing the Christian truth to people miserably denied it.[1] Christian philanthropy was seldom altogether absent from the imperial enterprises of the Victorians. The one universally admired achievement of Empire was the abolition of the West African slave trade. The ideal imperial general was Gordon, England's pattern of a Christian hero. Even Rhodes was a clergyman's son, one was relieved to remember, and scrutinizing every imperial policy, sometimes censorious, sometimes eagerly in support, stood the watchdogs of humanitarianism—the Anti-Slavery Society, the Aborigines Protection Society, and many another staunch old institution. Ruskin once spoke of the colonies as 'motionless navies', but he

[1] The incomparable David Livingstone (1813–73) had in fact broken with his original African sponsors, the London Missionary Society, because they thought he spent too much time exploring. By the 1890s most of the country he explored had been annexed by the British Empire. Chitambo, where he died, was now in Rhodesia, and he was buried in the nave of Westminster Abbey.

corrected his metaphor—'or rather, in the true and mightiest sense, motionless churches, ruled by pilots of the Galilean lake of all the world'. In that last heyday of Christian power the British had no doubts about the superiority of their civilization and its faith. They believed it to be their duty, however arduous or expensive, to distribute it among the heathen and the ignorant. Time and again the spokesmen of imperialism appealed to Providence, as the ultimate source of British power: they had been chosen for this task, and were in a kind of ecstasy.

Bigness, Seeley had preached, was not necessarily greatness. 'If by remaining in the second rank of magnitude we can hold the first rank morally and intellectually, let us sacrifice mere material magnitude.' By the nineties the British generally believed they could occupy both ranks, but they did not abandon the claim that their principal aim was the dispersion of Christian morality. The best of them saw the profit and power of Empire only as appendages to this high purpose. 'In the Empire we have found,' George Curzon once magnificently announced, 'not merely the key to glory and wealth, but the call to duty, and the means of service to mankind.'[1] Even Joseph Chamberlain, who saw the Empire primarily as a profitable estate, declared that British imperial rule could be justified only if it added to the happiness, prosperity, security and peace of the subject peoples—'in carrying out this work of civilization we are fulfilling what I believe to be our national mission'. 'Take up the White Man's Burden!' cried Kipling, when the Americans were debating whether or not to acquire the Philippines:

> *Take up the White Man's Burden—*
> *In patience to abide,*
> *To veil the threat of terror*
> *And check the show of pride;*

[1] At 38 Curzon had already travelled widely, written three important books about Eastern affairs, married the daughter of an American millionaire and served as Parliamentary Under-Secretary at the India and Foreign Offices. In the following year he became the most dazzling of India's Viceroys, only to resign in 1905 after bitter differences with the India Office at home. He returned to public life in the First World War, became Foreign Secretary in 1919, and died in 1925 after a career full of irony and vicissitude.

The Glory

By open speech and simple,
An hundred times made plain,
To seek another's profit,
And work another's gain.

To much of the world this was fearful hypocrisy. Not to the British, even at their brashest heights of Jingo. They saw themselves sometimes as masters of the world, but sometimes as servants—public servants, like policemen or schoolmasters. When the young Thomas Russell went out to join the Egyptian police he thought of himself as standing towards the Egyptian people 'as an old-fashioned headmaster of an approved school stood in relation to those whose criminal tendencies he must correct'.[1] Queen Victoria's own definition of the imperial mission was 'to protect the poor natives and advance civilization'.

The missionary urge in its most basic sense—the conversion of heathens to Christianity—had acquired several new possessions for the Empire. The missionaries were seldom consciously colonizers, but their old ideas of establishing independent native theocracies had withered in the face of Africa's pagan awfulness, and now they were generally for the expansion of British rule as the best available medium for the reclamation of savages. And it was a true Christian zeal that still inspired the British in their campaigns against slavery —by no means ended yet, for the Royal Navy was still chasing slave-runners in the Red Sea, slave-columns were still travelling out of Africa to the coast, and often escaped slaves would stumble into the courtyard of the British Consulate at Muscat to throw their arms around the flagstaff and claim their freedom. That very year the Sultan of Zanzibar, whose country had been a British protectorate since 1890, was induced to abolish the legal status of slavery: In Livingstone's day this island had been the chief clearing-house of African slaves, destined for the markets of the whole Muslim world, and its streets swarmed with captive humans, painted and paraded

[1] He became, as Russell Pasha, perhaps the most successful of Anglo-Egyptians, and sixty years later his structure of internal security was still the basis of Gamal Abdel Nasser's régime. Russell's last task in Egypt was to prepare, from his hospital bed, a report on the burning of Cairo in 1952, and he died in London two years later.

around the town for the inspection of buyers, slumped hopelessly in stables, or packed by night below decks on the dhows, to run the gauntlet of the Royal Navy offshore. Now it was all ended, and the foundation stone of the Anglican Cathedral of Zanzibar was laid upon the site of the last slave-post in the market.

Of course, the imperialists were thinking partly of their own salvation. Empire was a means of moral self-elevation, too. As capital punishment had a brutalizing effect on the hangman, and should therefore be abolished, so helping the heathen had an inspiring effect on the imperialists, and should therefore be encouraged. Disraeli claimed that he had developed the Empire 'believing that the combination of achievement and responsibility elevates the character and condition of a people'. Dilke maintained that the British were chiefly interested in Africa 'through their traditional desire to suppress the evils of the slave trade, and to pay conscience money in these days for the sins, in connection with slavery, of their predecessors'. To some idealists this was a back-handed way of attaining perpetual glory—there were evangelists who considered the Indian Mutiny a divine punishment for the failure to make the Bible compulsory reading in Indian schools. To others the scouring or purifying effect of the imperial mission was more straightforward, and might be summed up in the motto of the Rand Pioneers' Association: 'They Did Their Level Best'.

6

The evangelical mood was now past its prime, and agnostics were asking if it was really proper to chivvy natives out of their own certainties of fetish and taboo into Christianity's dim sanctuary. A less debatable moral impulse was the urge to spread good government throughout the world. The British were convinced, not without reason, that they had developed a unique mastery of the art of Government—towering supreme among scenes of peace and plenty. 'We happen to be the best people in the world,' Rhodes once roundly declared, 'with the highest ideals of decency and justice and liberty and peace, and the more of the world we inhabit, the better it is for humanity.' Chamberlain, too, once publicly expressed

his belief that the British was the greatest governing race the world had ever seen. These gifts, the imperialists felt, they had a mission to employ. They knew best, and if other peoples resented the imposition of British standards, they would learn later in life that it had all been for their own good. Monypenny thought that in the end the Empire, properly unified, might become 'the central or regulating State' of the entire world.

To men of this persuasion the Pax Britannica was like a great surgical clamp, an elaborate device of joints and fittings which, adjusted properly on its straps and trolleys, kept any dislocated limb stoutly on the mend. It had cured many of the evils of India, where peace really had been universal since the end of the Mutiny forty years before, and where the ferocious old antagonisms between race and race, creed and creed, rajah and mogul, were now only colourful sagas in the folk-memory. It had apparently healed the breaches between the British and the French in Canada, where the new Confederation was a delicate equilibrium between the two. It had brought order to the quarrelsome sultans of the Malay Peninsula, ended the piracy of the Persian Gulf, reduced the cannibals of Australia to shirts and wage-rates, and for eight hundred years kept the unruly Irish under control. This was the British speciality: like doctors under the spell of some incantatory oath, the imperialists felt mystically impelled to find new patients.

It was odd that the longer the British stayed in a country the more likely it seemed that order would collapse the moment they left. In the early years of the century the most eminent administrators of the East India Company, then the sovereign power in British India, had openly declared that in a century or so they would be able to hand over an orderly, peaceful, modern nation to the Indians. By the end of the century most people assumed, not least the public and the policy-makers at home, that an India without the British would fall apart in communal violence, and relapse into the chaos from which the Empire was supposed to have rescued it. It was the same in Egypt. When the British occupied that country in 1882, leaders of both political parties said they would withdraw again when a stable local Government had been established, to protect the interests of foreign investors, and ensure the security of the Suez Canal.

They meant it: but as the years passed, as the British dug themselves deeper and deeper into the Egyptian sands, as the Thomas Russells of the day matured from aloof supervision to fascinated involvement, so it seemed ever more reprehensible to leave a job half done, until by 1897 the British presence in Egypt seemed permanent, and the more imaginative of the British administrators already saw themselves in the historic line of the Pharaohs.

But in theory self-government was seen as the end of good government. Ancient British principles demanded it. It must have seemed remote indeed, in the swamps of the Sudanese sudd, or among the naked Indians of the Guiana jungles, but there were many imperialists who carried Darwin's ideas yet a stage farther, and saw the whole grand progress of the Empire in evolutionary terms. Britain was, of course, the fulfilment, *populus sapiens*. The self-governing colonies were great apes among the species. Many lesser colonies, mostly with a white settler class, had achieved some representative institutions and were thus learning the way out of the ooze. And down at the bottom, inchoate and utterly dependent, lay the primitive territories of Africa and Asia, dressed in scales. Teaching nations how to live had been a British vocation for centuries: one of the grand visions of imperialism presented the Pax Britannica as a stupendous progress towards universal democratic liberalism—God making man in his own image, or enabling the world, as Younghusband thought, 'to become all that heart and mind know there is in it to be'. It was unfortunate but inevitable that the first step in the process should so often be one of conquest. At this cathartic moment of their history, the British seers were thinking in terms of generations, centuries even, and the absorption of an African tribe, or the humiliation of an Asian culture, was no more than a chip in the slate.

7

On a Governmental level the New Imperialism was largely defensive, and the glory came extra. There had been a time when Britain's material strength was more or less equal with that of her principal rivals—first the Dutch, then the French. A brilliant period of

scientific discovery and energy had, in the earlier years of Victoria's reign, given the British their commanding lead. Supreme in technology, and spared the fearful expense of great standing armies, Britain was not only able to enrich herself as workshop of the world, but by building the biggest of navies, and thus gaining complete security at home and unique advantages abroad, to feel herself a citadel, unassailable.

Times were now changing. Britain's technical lead was shortening. Her economic progress was slowing down. Her rivals were building great navies of their own, and hungering for empires, too. When Kipling travelled for the first time outside the British Empire he was astonished first to discover the vigorous maturity of Japan, so breezily different from India after two centuries of British rule, and then to find, in the United States, the nucleus of a nation which would one day far overshadow the power of Britain—the 'biggest, finest and best people', he foresaw, on the face of the earth. Such premonitions forced the British into expansion, and especially into the scramble for Africa. On the surface all was bombast, beneath there was much anxiety. The British saw their markets, their communications, even the security of their own islands, threatened for the first time since the Napoleonic Wars. The voluminous literature of the New Imperialism was full of warnings about Britain as a second-rate Power.

For Britain was the most envied and disliked of the great states. Her competitors were all too eager to abase her. To some percipient observers there was to the gathering of foreign notables in London that summer the faint first suggestion of jackals assembling. The Jubilee celebrations were specifically designed to keep them at bay, or send them 'slouching homeward to their snow'. Britain was not finished yet, ran the message, and imperialism, properly exploited, could keep her indefinitely supreme. The British nations scattered around the globe, supported by all the manpower and minerals of the tropical Empire, would one day constitute a super-Power to dwarf all opposition. Before the end of the twentieth century, the economist David A. Wells forecast, the population of Australia alone would number about 190 million, if the present rate of increase were maintained. In the meantime vigorous expansion would be the rule.

If there were territories waiting to be annexed, Britain must annex them, or other nations would. Glory was more than a luxury, or even a satisfaction. It was a national need.

8

And there was one more stimulus to splendour: patriotism, kind and guileless—not arrogant, vicious or greedy, not Jingoism, but simply love of country, like love of family, or love of home, in an age when soldiers unquestioningly fought for their country right or wrong, because they did not think it could be wrong, and there breathed few men who ne'er had said this was their own, their native land. The British were among the most patriotic people of all. They were immensely proud of their country, trusted it, and believed it to be a force for good in the world. The stronger England was, the safer and sounder the world would be. If there were peoples who opposed her dominion, they were probably led by wicked men, or knew no better.

CHAPTER EIGHT

Caste

It is with nations as with men—
One must be first, we are the mightiest,
The heirs of Rome.

John Davidson

8

IN *Murray's Handbook to India*, the Baedeker of the Raj, the separateness of the British cantonments was vividly demonstrated. The maps in that indispensable guide were beautifully produced, and delineated in three or four colours the detachment of the British from their subjects. There in the centre of 'Agra And Environs' is the red splodge of the Indian city, shapeless, solid, raggety at the edges, relieved only by suggestions of stinking back streets. Hygienically to the south of it, separated by a patch of green and linked to it by Hastings Road as by a causeway, is the neat enclave of the cantonment, with its churches, its Government Gardens, its High Bungalow, its banks, its Government Slaughter House and its Metcalfe Testimonial—the usual buildings, as the guide says, of a British station, with a club the traveller really ought to join, 'if he knows a member to introduce him'. Just the look of it on the map suggests the absolute self-sufficiency of the cantonment. It was a world apart. The memsahib and her children need never visit the old city from one furlough to the next, and in the green expanse of the Government Gardens, or on the hopefully sprinkled lawns of the club, a stray native of the country must have felt horribly out of place.

There were down-to-earth reasons why a British garrison, or a British community, should not live in the heart of a tropical town. Plagues and tropical diseases were little understood, women and children were less self-reliant then, the most broad-minded of colonels would hardly wish his soldiers to associate too easily with the bazaar whores. But the detachment of the cantonments had a deeper meaning, for whatever the motives that sent the British out of their islands, a deep instinct kept them perpetually apart from their subjects of other races. The great ideal of Roman citizenship was only half-heartedly approached by the British. In theory every subject of the Queen, whatever his colour or skull formation, enjoyed

equality of opportunity, and fifty years before Lord Palmerston, springing to the defence of Don Pacifico, a Greek merchant of Portuguese Jewish origin but British nationality, had almost plunged Europe into war. There was nothing to stop an African or an Indian going to Britain and becoming a bishop, a peer of the realm or Prime Minister.[1] In practice, however, it was a racialist Empire—what *was* Empire, Lord Rosebery had once rhetorically asked, but the predominance of race?[2] Awkwardly lying between the lines of the Jubilee manifestos, with all their warmth of family feeling, were ineradicable instincts of racial superiority, inherited perhaps from the slave-masters of the earliest English colonies, and fortified in Victoria's day by pseudo-scientific theory and fuzzy-wuzzy wars. 'An anthropological museum', is how the *Daily Mail*, during an unguarded gap in the lyricism, described the colonial procession of the Jubilee, and this is how its star reporter Steevens, a scholar of Balliol, once responded to the Lascar seamen on board a British liner: 'They are a specimen of the raw material. Their very ugliness and stupidity furnish just the point. It is because there are people like this in the world that there is an Imperial Britain. This sort of creature has to be ruled, so we rule him, for his good and our own.'

2

The joke that 'niggers began at Calais' was not entirely a joke. Cloudy conceptions of Race and Heritage coloured the outlook of the British the moment they crossed the Straits of Dover, and, coupled with the confidence bred by the period of splendid isolation, made the average Briton feel a different being even from his contemporaries across the Channel. There were few foreign-born

[1] The first Afro-Asian peer was Sir Satyendra Sinha, who became Lord Sinha of Raipur in 1919.

[2] Rosebery, though Gladstone's Foreign Secretary, and Liberal Prime Minister himself in 1894–5, was the most eloquent of imperialists, and probably invented the phrase 'Commonwealth of Nations', in its British imperial sense. His views gradually estranged him from his party, and he died in 1929 a political independent, imperialist to the end and a famous stylist.

citizens in Britain then: the nation was homogeneous, and though people of intellectual tastes no doubt felt as close to Europe as they do now, the British were generally contemptuous of foreign things. Their prejudices had been compounded by the rise and fall of the Aesthetic Movement, that outrageously talented renaissance of art and literature, led by Oscar Wilde and Aubrey Beardsley, which had drawn its inspiration so freely from France, and had collapsed with such ignominy when Wilde was imprisoned for homosexual behaviour in 1895. 'In my opinion', wrote Admiral Sir John Fisher to his wife, looking across the celestial lake from his hotel in Geneva that same year, 'it's a very second-class place. It doesn't compare with Portsmouth for shops, nor is there any view equal to the sunset at Portsmouth, looking up at the old hulks up the harbour. I will never come abroad again.' In its Jubilee issue *Punch* offered a Conversation Book—'Some Idiosyncratic Questions and Probable Answers'—for foreign visitors to the celebrations, and offered the following sketch of a foreigner visiting a cabman's shelter.

'Good afternoon. I hope I do not disturb you, Sir, but I have been waiting here two (three, or four) hours. Could you tell me if there is a likelihood of your being discharged today? I trust you will not charge by the hour for the time I have been standing here?' 'Look 'ere, Jim, 'ere's a blooming furriner expecs me to put 'im dahn on my waitin' list for nothing! Go 'ome and eat coke!'

Go 'ome and eat coke! The lesser breeds were not all coloured, and the racialism of the British was tinged with many shades of superiority—social, material, moral. '*Cheek!*' scribbled Chamberlain in the margin, when a dispatch from the Niger told him of a French territorial claim in Africa, and Thomas Cook, the travel agent, once expressed a severe opinion of the Can-Can—not as a tourist spectacle, which Heaven forbid, but as a French national phenomenon. It was, he said, performed with 'an unnatural and forced abandon'.

3

But to be coloured was something else. Admiral Fisher himself,

however orthodox his opinions on Abroad, was sometimes looked on with suspicion because of his mandarin face, with its high Mongolian cheekbones and Gobi eyes—rumour suggested he had a Sinhalese mother.

The British had not always been quite so colour-conscious. In the early days of the East India Company social intercourse between white men and brown had been easy and respectful, and imperialists of the nineties must have viewed with mixed feelings a splendid picture that still hung prominently in Fort St George at Madras: attributed to Chinncry, it showed the plump adventurer Stringer Lawrence,[1] who went to India in 1748, amicably walking with the Nawab of the Carnatic like a pair of poets on a picnic—the Englishman florid and thick-set, the Indian marvellously shining with jewels, and the two of them promenading side by side across the canvas in a kind of springy minuet. It was not the association of the two men that must have struck a jarring note—there were many friendships still between Britons and Indian princes. It was the picture's suggestion that here was a meeting between absolute equals, each representing a great and attractive civilization, consorting to music in the sunshine.

In those days, when Englishmen went out to the tropics alone, concubinage was one of life's solaces. Most Englishmen in India took mistresses, and thus got close to the life and feelings of Indian people in a way that their successors seldom could. An entire race of Eurasians had been brought into existence by these practices, forming a social and vocational stratum of their own. Elsewhere in the Empire, too, earlier generations of imperialists had happily miscegenated. There was Scottish blood in the *métis*, the half-caste Indians of Manitoba who had rebelled against the British in 1870, and cross-bred aboriginals were found wherever the white men camped in Australia. In Burma there were commonly legal marriages between British and Burmese, while the white Rajah of Sarawak,

[1] This splendid fellow (1697–1775), who probably began his military career in the ranks, was unknown until he arrived in India at the age of 50. He made his name in the wars against the French, and is honoured by a spirited effigy in Westminster Abbey—and by this picture, which still hangs in the Fort St George Museum in Madras.

Charles Brooke,[1] had publicly suggested that the best population for the development of tropical countries would be a cross-breed of European and Asiatic: for his subordinates he preferred compliant local mistresses to burdensome European wives, and he believed physical intercourse to be much the best way of preserving the Empire.[2]

4

By the nineties the attitude had hardened. For one thing, there were far more Englishwomen in the tropical Empire. The steamship had seen to that, and the Empire-builder now found himself confined far more closely within the cocoon of cantonment and family life. Baron von Hübner, remarking upon the higher moral tone of Anglo-Indian life in the later years of the century, wrote: 'It is the Englishwoman, courageous, devoted, well-educated, well-trained—the Christian, the guardian angel of the domestic hearth—who by her magic wand has brought this wholesome transformation.' John Ferguson, a well-known British journalist in Ceylon, agreed with him, and wished it had happened sooner. 'I am convinced that the presence of his sister would have saved many a young fellow, in the pioneering days of the tropics, from drink and ruin'—'ruin' habitually meaning, in these austere imperial contexts, *intercourse with natives*. In the multi-racial Empire the white woman now occupied rather the same semi-divine status she had enjoyed in the slave states of the American South—the centre and circumference, as a Georgia toastmaster once put it, diameter and periphery, tangent and secant of all affections.

[1] Charles Brooke (1829–1917) was the second white rajah: his uncle James, an East India Company servant, had gone to Sarawak on an official mission in 1839, had put down a rebellion and been made ruler of Sarawak by its suzerain, the Sultan of Brunei. Charles, under whose rule Sarawak became a British protectorate, was succeeded by his son Charles Vyner Brooke, until in 1946 the country was annexed by the British Crown.

[2] There were corners of the Empire where these happy-go-lucky philosophies were never adopted. One was the Caribbean island of Grand Cayman, which was settled by the black descendants of slaves and the white descendants of buccaneers and castaways. Even in such circumstances an all-white *élite* arose, and to this day the Bowdens, Ebanks, Edens and Merrens of Grand Cayman can claim absolute European descent.

Newly emancipated herself, she took to India or Africa or the South Seas her own frilled and comfortable culture, patting the cushions as the muezzin called in the twilight, and receiving once a week. Fresh and fragile, pink and white, innocent by convention and inviolable by repute, among the dark skins of the subject peoples she must have seemed exquisitely distinct. To those subjects she remained, for the most part, benevolent but aloof; as one memsahib of the nineties wrote, 'It is best to treat them all as children who know no better, but . . . they are proud of their lies and the innate goodness of the Empire is not understood by them'. The Englishwoman wove a white web around her menfolk; and though there were still unrepentant reprobates to steal down to the bazaars, or lie in another sweet bosom on the scented shore, still she did drive a wedge between ruler and ruled, breaking the physical contact, and hurrying the Briton home along Hastings Road for his bridge. Englishmen evidently preferred their women white, anyway: in Calcutta, Mandalay, Hong Kong and Rangoon, as along Pioneer Street in Salisbury, European prostitutes thrived (though they were very seldom British).

The Indian Mutiny, too, had tainted British attitudes towards coloured people. It had occurred in 1857, and was one of the few imperial events which had gone into the English folk-myth, on a par with the marriages of Henry VIII, say, or the murder of the princes in the Tower. It was a favourite horror story. The British saw it in terms of cowering white ladies in fetid cellars; goggle-eyed Indians, half blood-mad, half lustful, creeping unawares upon sweet English children in lace pantaloons; the massacre of innocent hostages, ambushes, orgies, treachery. Since the Mutiny British Government in India had lost much of its old humanity, that comradely ease of Stringer Lawrence with the Nawab. The British had never felt quite the same again about the coloured peoples, and all over the Empire a multitude of memorials stoked the bitterness—like the terrible monument in St James's Church, Delhi, which recorded the deaths of a deputy collector of the city, his wife, his mother, his brother, his mother-in-law, three brothers-in-law, five sisters-in-law, eight nephews, three nieces and three grandchildren, all killed in the Mutiny.

The British had put down the rising with an uncharacteristic savagery. 'The first ten of the prisoners were lashed to the guns,' wrote an eyewitness of the punishment parade of the 55th Native Infantry, 'the artillery officer waved his sword, you heard the roar of the guns, and above the smoke you saw legs, arms and heads flying in all directions. Since that time we have had an execution parade once or twice a week, and such is the force of habit we now think little of them.' The British colonel of the 55th shot himself, so aghast was he at the disloyalty of his own soldiers; and something sour went into the Empire. In England those who believed the East could be westernized, that a man was a man for a' that, were disillusioned. In India the Government recoiled into a new correctness, and the merchants and planters developed a new arrogance. G. O. Trevelyan, travelling there soon after the Mutiny, met no European, outside the Government, 'who would not consider the sentiment that we hold India for the benefit of the inhabitants of India a loathsome un-English piece of cant'. Dilke, at about the same time, reported that a common notice in Indian hotels read: 'Gentlemen are requested not to strike the servants,'[1] and forty years later British soldiers fresh to India were warned by the old hands not to hit natives in the face, where the bruises would show.

Another cause of racialism was fundamentalist religion, with its shibboleths about hewers of wood and drawers of water—those allegedly divine proscriptions, those appeals to the pedigrees of Ham and Shem, which were so often propagated by missionaries, and which had such effect in the days when the Bible was taken literally by people of all classes. Darwinian ideas, too, while they seemed to show that every word of Genesis need not be taken as simple fact,

[1] Striking the servants, in an off-hand way, died hard in the Empire. In 1946, during my first week in Egypt, I boarded the Cairo train at Port Said with an English colonel of particular gentleness of manner and sweetness of disposition. As we walked along the corridor to find a seat we found our way blocked by an Egyptian, offering refreshments to people inside a compartment. Without a pause, apparently without a second thought, the colonel kicked him, quite hard and effectively, out of our way. I was new to the imperial scenes, and I have never forgotten this astonishing change in my companion's character, nor the absolute blank indifference with which the Egyptian accepted the kick, and moved.

at the same time convinced many people that the blacker a skin looked, the nearer it was to sin and savagery: ape or angel, is how Disraeli interpreted the alternatives of human origin, and it seemed only common sense that a Negro was more a gorilla than a Gabriel. Besides, in the past couple of decades so many horrors had come out of Africa: the human sacrifices of Benin, the death of Gordon, the Matabele atrocities, the slaughter or mutilation of an Italian army at Adowa, in Ethiopia, only a year before. Black men, it seemed, were only debatably human—and most of the Negroes seen in England had either been slaves or freaks. In the eighteenth century there are said to have been 14,000 African slaves in the British Isles, many of them later shipped to the settlement for freed slaves in Sierra Leone: and elderly Londoners still remembered the two Bushmen from South Africa who were publicly displayed in 1853, often in partnership with Professor Sinclair (The Wizard of All Wizards)—they were said to have no language of their own, to subsist upon insects and plants in underground burrows, and to have eyes which were both microscopic and telescopic.

Microscopic, telescopic, Bushmen or Sioux, black, brown or yellow: in the public mind the colours and peculiarities blurred. It infuriated Queen Victoria to hear her Indian subjects called niggers,[1] but to the man in the street in London the distinction was shadowy between a porcelain princeling from Rajasthan and some swathed worthy out of Ashantiland. Nor was anybody very self-conscious about race. The word 'native' was only beginning to acquire its undertones of mockery and condescension. The natives themselves were not often sensitive to racialism—only among educated Indians and Chinese did the idea of white supremacy much rankle, and even the most terrible of the African potentates recognized that the fittest to survive mostly seemed to be white.

5

The immediate problems of race arose only in the tropical Empire.

[1] It was in 1857, the *Oxford Dictionary* says, that the word was first applied to dark-skinned people other than Negroes, but perhaps the Mutiny was the reason. Certainly it was in 1858 that the Queen recorded in her journal her abhorrence of the usage.

In the temperate zones of white settlement there were, for most purposes, no subject peoples. The Red Indians of Canada were either shut away dispirited in their reserves, or else were fast being assimilated into the white culture. The aboriginals of Australia were no more than weird familiars of the Never-Never. The last of the Maori wars had ended in an inevitable British victory thirty years before, and there were now Maori representatives in the New Zealand Parliament. The Eskimos were irrelevant. The Irish did not count.

Elsewhere in the British Empire a few thousand white men ruled or worked among several hundred million coloured people: throughout the dependent Empire racial supremacy and imperial supremacy were synonymous. Racial separation was employed by the British as an instrument of Government, and there were few places in the tropical Empire where rulers and governed lived side by side in partnership. The British kept their distance now—paternal nearly always, fraternal very seldom, sisterly almost never. Cruelty was rare, and almost never official. Those mutineers were not shot dead from guns because it was a particularly horrible death, but because the British considered it more soldierly than hanging. Private Britons, trafficking in Asian labour or blazing themselves a trail in Africa, might do terrible things to their natives. Schooner captains commissioned to take indentured labourers home to their South Sea islands, at the end of their service in Australia, sometimes did not bother to make the voyage at all, but simply dumped their passengers on the first available atoll. British private soldiers in India often behaved abominably towards Indians, hitting them at small provocation, and forcing them to salaam and remove their shoes before entering a mess-hall or barracks-room. But Britons in the civil services were horrified at such conduct. Physical violence was seldom to their taste, paternalism was their forte, and anyway to be distant was enough. Their most vicious weapon had always been contempt. 'Foreign conquerors have treated the natives with violence,' wrote Thomas Munro of the East India Company as long before as 1818, 'and often with great cruelty, but none has treated them with so much scorn as we.'

Nobody, of course, denied that natives could be clever. Old

Thomas Cook, introduced to a Sudanese magnate called the Mudir of Dongola, thought him 'one of the ablest and cleverest men I have ever met'. No, it was *character* the coloured peoples were thought to lack—steadfastness, fairness, courage, sense of duty, such as the English public schools inculcated in their pupils. 'Don't you believe that the native is a fool', a colliery manager told Kipling in the Giridih coalfields of India. 'You can train him to everything except responsibility.' Nothing irritated the British more than a veneer of Western education without, as they thought, any real understanding of the values it represented. The emergence of Western-educated Indians, speaking a flowery English of their own, casually failing to recognize their own pre-ordained place in the order of things—the arrival on the scene of these bouncy protégés did nothing to draw the British closer to their wards, but only exacerbated their aloofness.

6

Yet this very class of Anglicized Asians and Africans was a deliberate product of the British imperial system. The Education of the Native was one of the basic purposes of philanthropic imperialism, and the British had long ago decided that a Western education was the only kind worth giving him. It was Macaulay who had defined the object of educational policy in India as being 'to form a class of interpreters between us and the natives we govern, a class of persons Indian in blood and colour but English in tastes, in opinions, in morals and in intellect'. From this conception had sprung the use of English in public instruction in the Empire, and ever since the purpose had been to produce a gentlemanly *élite* of pseudo-Englishmen, subjects in their rulers' image, who would eventually perpetuate the Britishness of the Empire, and in the meantime act as imperial subalterns or under-masters. Elementary and technical education was neglected almost everywhere in the dependent Empire. In India, after half a century of Crown rule, there were only 12 million literate people in a population of about 300 million: only 1 per cent of Indians of school age went to school at all, and three out of four Indian villages had no school anyway. In Africa, where the production of an Anglicized *élite* generally seemed premature, the

primary education of the natives was left almost entirely to missionaries, a cheap system with mixed results.

But all over the Empire there were private boys' schools in the English manner, generally Anglican of atmosphere, with blazers and rugby caps, first elevens and prefects, corporal punishment and even fagging—the whole oddly twisted or foreshortened, so that with their pallid expatriate masters, their fragile natives or husky young white colonials, they were like English public schools seen in a distorting mirror. They were assiduous and highly successful brainwashers. As the Anglo-Oriental College at Aligarh said of its curriculum, its object was not merely the formation of character and the encouragement of manly pursuits, but the fostering among the boys of 'an active sense of their duty as loyal subjects'. Often the anti-intellectual prejudices of the lesser English schools were faithfully reproduced, as was the Spartan discipline: when a new headmaster turned up at Trinity College, Kandy, in Ceylon, he found 100 boys waiting to be caned as an opening duty.

From school, with luck, the chosen vessel went on to university —if not in England, then to one of the colonial universities, on British lines, then springing up elsewhere in the Empire. In India there were five, originally simply examining bodies, later full-blown teaching institutes. There, all too often, the system flagged: manly pursuits were neglected, and the sense of loyal duty often went awry. At best the Indian universities were simply crammers, at worst they were sordidly corrupt. Some Fellows of Bombay University could not sign their own names. Intellectually examinations were all that counted—socially, too. With a degree a young Indian could claim a higher dowry with his wife: an M.A. was worth substantially more than a B.A. Students who failed in their examinations commonly killed themselves, for as one of the Calcutta vernacular newspapers asked in 1897: 'What is a failed candidate? He is a doomed man! He is as doomed as a life convict. He knows he is not wanted in society.'

The British distrusted the product of this system, but their reasons were complex. On the one hand they saw him, perhaps, as an eventual threat to their own supremacy. On the other they were repelled by the spectacle of a familiar culture grafted on to an alien

root. And in these reactions, too, they were confused, because for the most part they did not think the indigenous cultures worth preserving. Macaulay, again, had set the pattern. To him the sciences, languages and literatures of the east were contemptible —'medical doctrines which would disgrace an English farrier, astronomy which would move laughter in the girls at an English boarding-school, history abounding with kings thirty feet high and reigns thirty thousand years long, and geography made up of seas of treacle and seas of butter'. Macaulay's prestige was towering still, and his influence lingered. For the most part the British could not take the subject cultures very seriously. In his travel book *From Sea to Sea* Kipling mischievously throws in a characteristic Anglo-Indian assessment of the city of Jaipur, that pink prodigy of Rajasthan: 'A station on the Rajputana-Makwa line, on the way to Bombay, where half an hour is allowed for dinner, and where there ought to be more protection from the sun.'

The British cheerfully appropriated, without malice, the monuments of conquered civilizations. Government House in Lahore was the former tomb of Muhammad Kasim Khan, cousin to the great Emperor Akhbar: the British Lieutenant-Governor of the Punjab entertained his guests in a noble domed room that had once been the sarcophagus chamber. In Mandalay, the former royal capital of Burma, the private audience hall of the Burmese kings was occupied by the Upper Burma Club, while the throne room became the garrison church. A few weeks before the Jubilee a British punitive expedition attacked and burned the city of Benin, south-east of Lagos, a place of dreadfully bloodthirsty custom which had nevertheless produced the noblest sculptural art of negro Africa. The British were rightly horrified at the tales of barbarism the expedition sent home, with all their deliciously macabre embroideries of twitching corpses, skulls and witch-doctory, but their disregard for the art of the place was absolute. You would never guess, from the newspaper accounts of the affair, that anybody in Benin made anything skilful or beautiful at all. African history seemed to the British, as an Oxford professor once put it, no more than 'unrewarding gyrations of barbarous tribes in picturesque but unrewarding corners of the globe'.

This celestial detachment led to insensitivity. Often there creeps into the reports and debates of Empire a tone of frigidly impersonal lordliness, and the traditional British concern for the welfare of aboriginal peoples seems to be in abeyance. 'The advantage of limiting our rivalry to an Asiatic or African tribe,' Lord Salisbury once remarked dryly to the House of Lords about some imperial initiative, 'is one which those who are engaged in these enterprises appreciate very highly'—and thus, with a bloodless quip, he reduced the indigenous inhabitants of the tropical Empire to faintly comic insignificance. Lord Kimberley often wondered whether African disputes were worth taking seriously, since they mostly concerned 'barren deserts of places where white men cannot live, dotted with thinly scattered tribes who cannot be made to work'. The Government of India announced, during the famines of 1899, that 'while the duty of the Government is to save life, it is not bound to maintain the labouring population at its normal level of comfort'. It was this cold superiority that was most disliked about the British imperialists. They too often forgot the need to preserve face, common to all humiliated peoples, whatever their colour and culture.

But in an Empire so firmly based upon racial differences it was inevitable that people were sometimes treated as less than human. The British once coolly proposed to transfer several thousand Maltese to Cyprus; they habitually played the destinies of African tribes as bargaining counters in the diplomatic game. The superb Masai of the Kenya highlands were forcibly moved away from the line of the Uganda railway 'because they did not need railway facilities'—and white settlers did. The aboriginal prisoners shipped to the island of Rottnest, off the coast of south-west Australia, died in their hundreds—twenty-four in one day—because the British, unable to think of such convicts in altogether human terms, condemned them to a strange diet in an unfamiliar climate, their tribal customs ignored and their taboos unwittingly defied.

7

Among the settlers and planters of the tropical Empire there were harsher reasons for aloofness. The Empire had been built upon a

plenitude of native labour willing to do manual work, and no anxious for a share in Government. However liberal the theorists at home, or the career men of the administrative services, the settlers on the spot were determined to keep it thus. In the West Indies. in South Africa, in the plantation areas of India, in tropical Australia. men were already alarmed by the dangers of race. The old Caribbean sugar colonies had never recovered from the unhappy reconstruction period which had followed the emancipation of the slaves: segregation was so complete that when Anthony Trollope visited Jamaica the Governor's was the only table in the island where white men and black dined together. The catchwords of racial fear—'yellow peril', 'miscegenation', 'white civilization'—were already commonplace: there were 372 million people in the British Empire, but only about 50 million were white.

This was a dilemma never to be resolved: how to have your cake and eat it; how to induce your coloured labour to work for you, but not live among you; spend money, but not earn profits; mend the public highway, but not vote in the public elections. In the tropical Empire the pioneers, however humble their circumstances at home, soon came to regard themselves as a master race. The process was familiar, almost allegorical. Boldly the Briton had hacked his way through bush or jungle, to find some hospitable spot for settlement; and sooner or later the spindly natives crept furtively out of the trees in loincloths or tiger-skins; and presently some enterprising primitive, bolder than the rest, sidled into camp to examine a billy-can or wonder at a wagon-wheel; and before long two or three were there, helping with the dishes; and almost before the scrub was cleared the British had a labour force. Soon they began to feel that scrubbing pans or washing laundry was not proper to their dignity: in a year or two no white man, still less a white woman, would even consider manual labour: and so the gulf that already existed between the races, of colour, and climate, and religion, and custom, and language, and experience, was irremediably deepened by a rift of caste.

There was no pretence at equal pay for all races, except at the highest level in India. It did not often arise anyway, for the skills of the coloured people were mostly so rudimentary that all the

better-paid work was necessarily done by whites: but as time passed what had been logic became dogma. By the end of the century, in most parts of the tropical Empire, the difference in rates of pay was so great that a white man could not accept one of the simpler jobs without cutting himself off from his own fellows, and degrading himself alike in European and in native eyes.

It is curious to see how low in the social or technical scale these prejudices applied. In Canada, Indian pilots were employed on the St Lawrence River, but in India the Bombay and Calcutta pilots were all very British—important men with substantial salaries, some of them from old Indian Army families, bronzed and moustached in their blue uniforms, and often awe-inspiring to the less assertive masters of small ships from minor maritime nations. In the technical branches of the Indian railways the white cadre went down as far as signalmen and platelayers. A European mail driver of the East India Railway in the nineties was paid 370 rupees a month (rather more, incidentally, than the Viceroy's aide-de-camp): his Indian colleague, confined to shunting engines and petty branch lines, earned 20 rupees a month. In Johannesburg the newsboys of the *Transvaal Mining Argus* were all tough and gay little white urchins, wearing floppy hats like cricketers at English preparatory schools. In the West Indies a class of poor whites had, since the emancipation of slaves, replaced the black men in the most menial office jobs. In the Gold Coast, where a sizeable class of educated Africans existed, it had been decreed in 1893 that a third of the doctors should be Africans, but the system was soon abandoned—it was 'pretty clear to men of ordinary sense', Chamberlain himself commented, that British officers could not have confidence in native physicians.

The white inhabitants of Salisbury, in 1891, had sent a petition to the Administrator demanding that no further contracts should be given to Kaffirs while white artisans were unemployed: the Administrator accepted the argument at once, declaring that he 'fully recognized the prior claim for consideration of the white population'.[1]

[1] It was only in the colonies of southern Africa that a substantial British working class settled among a coloured majority: as they were the most obviously vulnerable of the imperialists, so in the end they proved the most intractable.

In most British colonies there was little hope of a coloured employee, however educated, becoming anything more than a junior clerk: sooner or later he was confronted by a defensive barrier which no amount of push or ability would enable him to surmount—the barrier of self-interest (which, having probably come from a society in which the hierarchical divisions were much more rigid than anything in Britain, he perfectly understood). The most notable exceptions occurred in West Africa, where a ghastly climate kept European numbers down, and many Africans held responsible commercial jobs.

In their older possessions the British were still able to depend upon Europeans for many of the services of life. In Calcutta, which the Empire had virtually created, there was a sizeable British *petite bourgeoisie*, down to English shop assistants in the more delicate departments of the big stores. The principal boarding-houses were those kept by Mrs Walters, Mrs Pell, Mrs Monk, Mrs Baily and Mrs Day—some of them Eurasian ladies, some authentic lodging-house British. There were two English lady doctors in the city, and at least six English tailors, besides dressmakers, opticians, photographers, hoteliers, house agents, dentists, chemists, lawyers, booksellers, jewellers and gunsmiths.[1] It was settlers, rather than transient rulers, who chiefly supported this expatriate Englishness. Settlers all over the Empire fought hard to keep their own little Englands intact, and were often at odds with the imperial authorities, whom they considered 'soft' on race. In 1883, when Lord Ripon

[1] Some survive, notably along Old Court House Street, where one or two jewellers and gunsmiths, with diamond rings in dusty showcases, and the gleam of gunracks among tiger-masks and horned heads, piquantly evoke imperial extravagances of long ago. Spence's Hotel, too, a favourite of the Victorians, thrives in air-conditioned modernity: it is claimed to be the oldest hotel in Asia, founded in 1830, and its telegraphic address is 'Homeliness'. All over India and Pakistan establishments still announce themselves in fading letters to be By Appointment to the Viceroy and Vicereine, and no imperial legacy lives on more strongly in the subcontinent than the tradition of the English boarding-house. Many of the smaller houses still bear the names of their old proprietors. Mrs Davis of Rawalpindi left her boarding-house to one of her male servants, but such was the commercial value of her name and sex that he adopted the professional pseudonym of *Miss* Davis, and prospered for many years.

was preparing a reform—the Ilbert Bill—which would give Indian judges the right to try European accused, the Assam tea-planters were so infuriated that they hatched a plot to kidnap the Viceroy, and opposition in Bengal was so intense that the Bill was drastically modified.[1]

During their Jubilee visit to London the Colonial Premiers discussed the free circulation of British subjects throughout the Empire, but they did not reach agreement. They knew that their electorates would never tolerate the free entry of Indians, Africans or Chinese into the temperate colonies. The Canadians had already passed their own legislation to prevent the immigration of Asians, and the Australians were even alarmed by the numbers of Lascar seamen on British ships putting into Australian ports. How did those digger troopers feel, one wonders, 5 feet 10½ inches and 38 inches round the chest, when they found themselves marching through the imperial capital with such a pack of brown, black, and yellow men?

8

A vassal could qualify for respect, if not for power or promotion, if he possessed certain specific qualities the British admired. East was East and West was West, and never the twain would meet—

But there is neither East nor West, Border, nor Breed, nor Birth,
When two strong men stand face to face, though they come from the
ends of the earth!

There were certain subject peoples who habitually showed these qualities to advantage, and were always favourites of their rulers. In particular the streak of romantic chivalry in the British, fortified perhaps by the immense popularity of Tennyson's *Idylls of the King*, induced them to cherish a brave enemy. They admired the magnificent Zulus of Natal, who had fought with such lordly skill in the

[1] Nor was Ripon's attitude forgotten. When, in 1915, his statue was erected in Calcutta, it was financed entirely by Indian subscription—no European subscribed.

wars of the 1870s, and the chivalrous Maori of New Zealand—'Keep your heads down, Sikkitifif', came a voice across the battlefield to the 65th Regiment, during one engagement with those stalwart enemies, 'we're going to fire!'[1] They respected the manlier Indian tribes of Canada, and liked the strapping Sudanese, whose killing of General Gordon had been despicable indeed, but whose soldierly gifts surely showed that a Christian education would redeem them.[2] They had an overwhelming affection for the tough little mountain peoples of the Himalaya, and the fighting tribesmen of the Punjab—those swaggering Sikhs in turbans and whiskers, those irrepressible Pathans and Afridis of the North-West Frontier, rogues always worth the fighting, whose Nelsonic dash and quixotic generosity were all the British liked to imagine in themselves.

The British recognized the strength of the Chinese. Even in Australia, Baron von Hübner reported, the Chinese were admitted to be 'the best gardeners, the best agricultural labourers, the best workmen of every sort, the best cooks and the most honest and law-abiding people'. Kipling was astonished, when he first visited Singapore, at the extent to which the Chinese ran the colony—yet 'England is by the uninformed supposed to own the island'. The British worked well with the Parsees of Bombay, Zoroastrians of great business acumen who seemed to think more or less in the European manner, and were the first natives of India to play cricket: Parsees had even built ships for the Royal Navy, and so impregnable

[1] Above the harbour of Tauranga, in the North Island of New Zealand, are buried the British dead of the battle of Gate Pa, one of the early engagements of the Maori wars. Among them there lies a Maori chieftain, Rawiri Puhiraki, whose epitaph says of him that he gave drink to the enemy wounded, protected the unarmed and respected the dead. 'The seeds of better feeling thus sown on the battlefields have since borne ample fruit.'

[2] In 1898, when he had completed the conquest of the Sudan, Kitchener tried to provide it by raising funds for Gordon College, Khartoum. He soon got bored with the project, but Kipling celebrated it with an invocation to the Sudanese themselves:

Go, and carry your shoes in your hand, and bow your head on your breast,
For he who did not slay you in sport, he will not teach you in jest.

The college survived nevertheless, and renamed Khartoum University is today the chief centre of higher education in the Sudan.

was their social eminence in Bombay that the British themselves found it hard to buy houses on the Ridge at Malabar Hill, where the Parsee patricians lived. The Burghers of Ceylon, half-caste Dutch left behind by a previous Empire, were liked for their solid, unassuming good sense. In South Africa and Canada the British much respected the German, Slav and Scandinavian communities which had also settled there under the Flag: the only numerous marriages between Britons and subjects of other races were those with the Swedes and Ukrainians of western Canada.

Of course they also cultivated useful allies. In India they were generally friendly with the princely caste, if only because its members were grand, rich, powerful and often educated in England. They were sometimes overawed, indeed, by the horsy opulence of the Rajahs, who carried Englishness to unapproachable extremes: but they generally preferred Muslim to Hindu princes, because the Muslim creed offered a code of conduct that seemed not so very far from their own ideal of Godly cleanliness and courage. Feudatories of this kind were often buttered up with high-sounding imperial decorations, Grand Crosses of the Star of India, Victorian Orders or Orders of St Michael and St George, and were honoured guests at governors' tables, polo matches and jubilee processions. In the field the anglophile subject was often an irritation: in England he was always fêted, and the most popular visitor to London that summer, one of the very few whose faces were generally recognized, was Wilfrid Laurier, the conciliatory French Canadian Prime Minister of Canada.

Clearly the British responded most warmly to what they would think of as Nordic qualities. In several parts of the Empire they also worked closely with Jews. In South Africa Jewish capitalists and speculators were eager allies of the British in their bid for the Transvaal goldfields, and in India one of the most celebrated of Anglo-Indian families sprang from the Persian-Jewish clan of the Sassoons, great men in Bombay: in the very heart of the Poona cantonment, just down the road from the club and the Anglican church, stood the high pinnacled tomb of David Sassoon, its sarcophagus elaborately carved by Samuel of Sydney Street, Mile End Road, with the crest of the Sassoons at its feet, and the Poona

synagogue respectfully outside the window. The Jews of other countries remained Jews, observed the *Jewish Chronicle* apropos of the Jubilee celebrations. The Jews of the British Empire became true Englishmen.

9

On the banks of the Hooghly River in Calcutta a grand and curious monument stood, across the road from the equestrian statue of Lord Napier, and within sight of Fort William's glowering redoubts. It was an oblong pavilion of Ionic columns, a little thicket of pillars above a jetty, severely classical in origin, but given an oriental flourish by its shaded profusion of columns. Behind it the ships steamed up and down the river, and passengers arriving at Calcutta sometimes disembarked at its landing-stage, to take a gharry into the city. In a capital notable for its monuments to generals, proconsuls, engineers and great administrators, many people assumed this memorial, too, to honour some man of imperial steel. In fact Prinsep's Ghat commemorated the young Anglo-Indian who, in the 1830s, first translated the rock edicts of Asoka: James Prinsep, who died in his forty-first year after twenty-two years in the Indian service.

It would be unfair to end a chapter about British racial attitudes with the implication that all was arrogance or condescension. Even in that glaring noon of Empire, much generosity and respect still gave nobility to the Pax Britannica. We have been speaking of the general: the particular was often far more attractive. The Liberal party was out of power, but the liberal instinct was still alive, and the higher motives of the imperialists were not all humbug. The Colonial Office in London consistently stood for fair play towards the subject races, often against bitter criticism from white men on the spot. The Indian Civil Service still recruited men of compassionate integrity—there were even a few multi-racial clubs in India. The liberal intelligentsia fought every overbearing gesture with honourable zeal, and there were still men of all political parties, undazzled by the flash of the New Imperialism, who thought of the Empire as a trust—support for settlers in distant lands,

protection for innocent primitives, a guarantee of honest government.

Countless individual acts of kindness had entered the legends of Empire. In Australia aborigines still remembered how Sir George Grey, when Governor of South Australia, had been recognized by an old woman of the Bibbulmum tribe as the spirit of her dead son, and had gently and smilingly allowed her to embrace him crooning the words, '*Boonoo, Boonoo! Bala ngan-ya Kooling!*'—'It is true, it is true, he is my son!'[1] In the Punjab a sect called the Nikalsaini actually worshipped the memory of John Nicholson, 'the Lion of the Punjab', one of the great men of the North-West Frontier before the Mutiny. If few such reputations were being established at our particular moment of the imperial history, at least there lay beneath the cant and gasconade older and gentler traditions of Empire. Queen Victoria herself was their living symbol, and stood recognizably in the line of Wilberforce and Livingstone, maternally caring for the coloured peoples. She detested the Boers, because they were so cruel to black Africans. She thought it unfair that in the casualty lists of frontier wars British soldiers were named, but seldom natives. She very much wished the Zulus could be allies rather than enemies—not only were they honest, merry and brave, but they did not smoke. She often felt for the Queen's coloured enemies as much as she did for the Queen's white men. She kept an eagle eye on Kitchener's armies that year, as they fought their revengeful way up the Nile,[2] and when she was once told that the fierce Afridis were again about to attack her soldiers on the North-West Frontier of India, her first response was to wonder

[1] Grey (1812–98), who went on to be both Governor and Prime Minister of New Zealand, was not so successful with white settlers—Matthew Arnold's brother Tom, then living in New Zealand, noted that there was 'something less manly about him than I expected'. In life he constantly antagonized them, and in death he bequeathed them a fateful phrase of his own invention: 'One Man One Vote'.

[2] But she was unable to prevent, in the following year, the barbaric destruction of the tomb of the Mahdi, whose bones were thrown into the Nile, and whose skull Kitchener proposed to send to the Royal College of Surgeons to be exhibited with Napoleon's intestines. The Queen thought this medieval—after all, the Mahdi '*was* a man of a *certain* importance'—and in the end the skull was secretly buried by night at Wadi Halfa.

why: 'I fear that the poor people are suffering from the necessity of supplying horses and ponies and cattle to us . . . which comes heavily upon them after their famine and plague.'

She was an outspoken admirer of Indian art, too—some might say ostentatious, for she had one room at Osborne fitted out entirely as a Durbar Room, with murals by Rudyard Kipling's father. Despite the disregard for Asian and African cultures which was ingrained in the nature of British imperialism, there were always individuals to cherish the conquered civilizations: Prinsep's Ghat was paid for by public subscription among the British of Calcutta. It was not a fault of the British to destroy alien cultures for the sake of mere uniformity. Their innate respect for tradition, bred by so many centuries of continuity at home, obliged them to tolerate most native ways, unless—like human sacrifice, suttee, or infanticide —such ways offended the conscience even of the humanist. Throughout the British presence overseas there had been scholars and artists eagerly devoted to the laws, the religions, the art, the folk-lore of the east. Once, when Lord Napier invaded Ethiopia with an avenging army in 1867, the British deliberately tried to emulate Napoleon, attaching savants of several specialities to their armies, and producing the most thorough studies till then of the Abyssinian civilization —at least 500 precious manuscripts were taken home to England.[1] The Ajanta Caves, those prodigies of Buddhist art, were first appreciated in modern times by British soldiers of the Indian Army,[2] and it was the British Archaeological Department of Ceylon which rescued from the jungle the stupendous temples of Anuradhapura. The officers' mess of Queen Victoria's Own Corps of Guides, perched on a high ridge at Mardan, near the Afghan frontier, was decorated with a remarkable series of Graeco-Buddhist sculptures, reminders of Alexander's conquests in those regions: they had been found during the digging of the Swat Canal, and were lovingly preserved by the soldiery.

[1] Among the other loot was the gold crown of the Emperor Theodore. It remained in England until the Emperor Haile Selassie was exiled there in 1936, when King George V gave it back to him.
[2] Though Indians claim the British later used the Ajanta statuary for target practice.

10

For it was not viciousness, nor even simply conceit, that fostered the general aloofness of the British. It was partly a sense of ordained separateness, partly the natural reserve of islanders, and partly no doubt the awkwardness people feel when they do not understand a foreign caper, or more especially do not speak a foreign language. Many a British official, his life spent in the imperial territories, learnt to love his charges with a passionate sincerity—even Tommy Atkins, Alfred Milner wrote from Cairo in 1893, regarded the Sudanese 'with half-amused, half-admiring and inoffensively patronizing affection'. Sometimes the sympathy was so complete that the imperialist genuinely thought himself a son of the country, like those many colonial administrators who could never bear to leave, but settled upon their retirement in cottages called *Mon Repos* or *Journey's End*, in fragrant alcoves of Darjeeling or beside the Pyramids road. 'Ah India, my country, my country!' Kipling had cried, in the middle of a travel essay, and there were many Britons to whom the whole vast panoply of Empire really was a community, multi-coloured, inconceivably dispersed, yet still a brotherhood of sorts, in which it was a man's job to encourage the backward, comfort the neglected and honour the Queen. A faint irony sometimes salted these high-minded attitudes, as the Briton considered how extraordinarily obtuse some of his brothers were, but in such men it was not contemptuous, only wry. This is how a balladeer calling himself Brer Rabbit, writing in *The Pioneer* of Allahabad that year, described a leave in Europe:

> *I hied me north to Como where the lake is azure blue,*
> *Where you loaf about on steamers quite content with naught to do.*
> *But upon the mountainside I saw a Sadr Kanungo*
> *With patwaris and the Khasras all for me to 'janch karo'.*
>
> *Then I took a train for Avignon, but gazing from the car*
> *I perceived upon the platform my old friend the chaukidar.*
> *The 'brave gendarme' had vanished, the 'gorait' was in his place,*
> *With his 'waradat ka notbuk' and a grin upon his face.*

Next I flew across to Monaco in Maxim's new machine—
After all these misadventures for a gamble I felt keen
But a sub-inspector met me with a smile upon his face—
He'd 'chalaned' 2,000 gamblers, and I'd got to try the case!

I said 'Das roz tak Hawalat' and off to Naples fled
(That I had not jurisdiction never came into my head)
But in 'Napoli' that's 'bella' but can beat Cologne for smells
A Vaccinator asked me to inspect his cleaned out wells.[1]

In Ceylon they even had Natives playing cricket for the colony, and in 1894 Alan Raffel took 14 for 97 against the visiting M.C.C. Arrogance, indeed!

11

Steevens's unspeakable conceit might speak for the New Imperialism, as it spoke for the *Daily Mail*: 'This sort of creature has to be ruled, for his good and our own.' An older conception of Empire, and one likely to prove more resilient in the end, had been expressed seventy years before, by Stamford Raffles, the founder of Singapore, and still had its adherents throughout the Pax Britannica: 'Let it still be the boast of Britain to write her name in characters of light; let her not be remembered as the tempest whose course was desolate, but as the gale of spring reviving the slumbering seeds of mind and calling them to life from the winter of ignorance and oppression. If the time shall come when her empire shall have passed away,

[1] At Como this infatuated servant of the Raj thought he saw a headquarters revenue official (*Sadr Kanungo*), with his clerks, bringing the land ownership records to be inspected; at Avignon the spectre of an Indian watchman, holding his incident notebook, grinned cheerfully at him on the railway station; at Monaco he ordered ten days in the lock-up (*das roz tak hawalat*) for the prosecuted gamblers. 'Maxim's new machine' was presumably the steam-driven flying machine which, in 1894, Hiram Maxim persuaded to rise a few inches from the ground at Bexley in Kent. Maxim (1840–1916), a British-naturalized American, was an imperial figure himself, for his machine-gun was the standard automatic weapon of the British Army: he was knighted in 1901.

these monuments will endure when her triumphs shall have become an empty name.'[1]

[1] And when Kipling spoke of those 'lesser breeds', if we are to believe George Orwell, it was not the coloured peoples that he meant. The phrase, Orwell thought, 'refers almost certainly to the Germans, and especially the pan-German writers, who are "without the Law" in the sense of being lawless'. Certainly in the context of the verse, from the poem *Recessional*, it is hard to see how Kipling could have had powerless subject peoples in mind:

> *If, drunk with sight of power, we loose*
> *Wild tongues that have not Thee in awe,*
> *Such boastings as the Gentiles use,*
> *Or lesser breeds without the Law—*
> *Lord God of Hosts, be with us yet,*
> *Lest we forget—lest we forget!*

CHAPTER NINE

Islanders

Though like a speck upon the sea
Our Island may appear to thee
We lack not loyalty:
We'll try what's in our power to do,
Our love and loyalty to show
At this thy Jubilee!

R. G. McHugh
The Voice of St Lucia, June 22, 1897

9

A' GLAMOROUS weakness of the Empire was its dispersal. If they could have willed a miracle, the New Imperialists would doubtless have squeezed all its component parts into a shapelier and simpler whole. Not, though, into a land mass, for half the glory of the Pax Britannica was its far-flungness, spangling the seas with forts and islets as the power of some great stained-glass window issues from a thousand petty parts. There was a high romance to the ocean outposts of Empire, most of which suggested to the British, not always very clear just where their possessions lay, rollicking piratical adventures of the Spanish Main. Gibraltar they knew, of course, and Malta, and Aden vaguely, and St Helena historically: but how thrillingly unfamiliar sounded Bramble Cay, the Amirante Islands, Yuma, Montserrat and the Grenadines— British every island, sun-baked beneath the Flag in one ocean or the next!

One such dimly comprehended possession was the island of St Lucia, which not one Briton in a thousand could place on the map, and scarcely one in a million could pronounce properly (it should be St Loosha). Few islands better fulfilled the dream of a tropical paradise. St Lucia lay among the Windward Islands, looking southwards to St Vincent and the Grenadines, washed on one side by the bluff waves of the Atlantic, on the other by the gentle Caribbean. It was a volcanic island, crowned by the striking twin peaks of the Pitons, like miniature wooded Matterhorns above the water, and most of its small expanse was covered with a delicious tropical foliage, frogs croaking, parrots brilliantly on the wing, green lagoons in shadowy recesses of jungle. The centre of the island was mountainous. Around its perimeter palm-trees leant crookedly over white beaches, and creeks ran between high brush-covered bluffs as in a hotter Devon. St Lucia was some 3,500 miles from London.

There was, as we already know, a file about it in the Colonial Office.

2

Like many another island fortress it had endured an uncertain history, and had been passed from France to Britain, Britain to France, fourteen times in all, as the one Power or the other gained supremacy in the West Indies. The British had finally won it in 1814, but it was still Frenchified in manner. Its population, mostly Negro or mulatto, spoke a queer patois of antique French warped by a rustic kind of English. Its laws were partly French, and so was its cooking, crabs in rich sauces and spiced flying-fish. Its countryside was full of names like Trois Gras Point, Grande Palmiste Bay, Vieux Fort and Mount Grand Magazin. Its capital finally settled for the name Castries, after an eighteenth-century French Minister of Marine, having spent some time as Le Carénage and some as Feliciteville, during a spell of French revolutionary rule. The administrative units of the island were still French quartiers. Most of the schools were run by the Roman Catholic church, and the *élite* of the island was a small landed gentry of French creoles, who still lived in a style more French than British, and sometimes sent their children to school in France.

Upon this lovely alien place the British Empire had stamped its presence with bloodshed and heroics. St Lucia rang with the ships' bells and bugles of the Napoleonic Wars. Great names of the imperial past were blazoned on the island rolls, and heroes abounded. Rodney sailed from St Lucia to win the battle of the Saints in 1782. St Vincent took the island in 1794, when Queen Victoria's own father, the Duke of Kent, planted the British colours upon the fortified plateau of Morne Fortuné. Moore of Corunna subdued the revolutionary creoles of St Lucia in 1796. It was because of a false message from St Lucia that Nelson, in 1805, sailed south to Trinidad in pursuit of Villeneuve, allowing the French another few months' grace before the battle of Trafalgar. Impetuous bravery, heavy slaughter, long terrible struggles, undiminished ardour, courteous foes—these were the phrases of St Lucian history, as the British read it in the shuttered dim cool of the Castries library.

3

It was a colony exceptional in its beauty, but in status much like many another. There were forty-seven thousand people on the island. At least forty thousand of them were Negroes or mulattoes. Between three and four thousand were creoles. Perhaps two thousand were Indians, brought across the world as indentured labourers for the sugar plantations. Rather fewer than two hundred were the British, the rulers of St Lucia. They were mostly merchants and Civil Servants. Not many British people had bought property on the island, and the plantations were mostly owned by creoles. St Lucia had none of the transplanted Anglicism that made Barbados, across the water, one of the most ineradicably British places on earth, and after eighty years of permanent possession it still felt more a garrison than a settlement. The paladins of the island were the senior British officials, but in many ways power was really in the hands of the rich creoles, whose roots went far deeper into the island's past, and who were there to stay. It was they who had been the slave-owners of St Lucia until, sixty years before, slavery had been 'utterly and for ever abolished and declared unlawful throughout the British Colonies, plantations, and possessions abroad': and their spare and haughty persons, sipping very dry aperitifs on the terraces of plantation houses, commanded a respect different in kind from the remote loyalty St Lucians offered the British.

The official community revolved around Government House, which may stand for a score of such lesser mansions, in a long roster of such infinitesimal colonies. It was a building very different from the sloping floors and iron roofs of Government House in Salisbury, for though new it was instinct with old traditions of authority—British power had been implanted in the Caribbean for more than three hundred and fifty years, and Britons had long been familiar with the pace, the climate and the Elysian ease of these parts. The house had been built two years before to the design of Mr C. Messervy, Colonial Engineer to the island, and was a pleasant white building with a tower and a wide veranda, ornamented with white-painted iron griffins and surrealist external plumbing. An office was

attached to the side of it, and there was stabling around a modest courtyard. On the lawn stood a couple of old brass guns, polished weekly by prisoners from the gaol, and the Union Jack flew upon a terrace, grandly surveying the harbour far below, where it could be seen by all the mariners coming and going, and saluted by the more punctilious of captains. The house looked spanking and wind-scoured, but its predecessors had not always been healthy. Four Governors had died in previous Government Houses, besides one who was buried in the rubble when the house fell down in 1817, and a favourite St Lucian anecdote told the tale of a parsimonious Governor greeting an episcopal guest with the words: 'I suppose your Lordship has heard of the insalubrity of this place? Every room in the house has witnessed the death of a Governor, but none of them has had the honour of killing a Bishop.' The big glass doors inside the *porte cochère* were engraved with the royal arms, suggest-ing the entrance to a railway hotel, and the hall was decorated with a collection of bayonets, arranged in florid patterns on the wall.

The last occupant of this agreeable house[1] had been Brigade-Surgeon Valerius Skipton Gouldsbury, M.D., C.M.G., whose wife had been At Home on Thursdays, but who had gone home in 1896 leaving his office vacant. He was the thirty-eighth British governor of the island, but was technically only an Administrator—a senior officer was Governor of the whole Windward group, and was liable always to sail into Castries in his yacht to see how things were going. Moreover the Administrator was advised by a Legislature, officially nominated and subject to his veto, but nevertheless, in a colony whose local gentry was neither English by origin nor docile by temperament, sometimes irritatingly persistent. The Admini-strator's job was no sinecure. St Lucia had passed through some cruel vagaries of fortune, even in Gouldsbury's six years of office. Hurricanes were not infrequent, the wooden houses of Castries repeatedly burnt, the fall in sugar prices had caused much hardship and the demand for logwood had lately fallen off. Local criticism of the administration was often fierce. Relations between the Negroes and the whites had never been altogether happy since the emancipa-

[1] Which still stands, virtually unaltered. A British Administrator still lives in it, and convicts still polish the guns.

tion of the slaves—which had half-ruined many of the planters, and embittered some of them still. (In the British Caribbean colonies, at the end of the eighteenth century, a slave could be hanged for the theft of 1s 6d, or lashed and castrated for striking a white servant.)

4

It was quite an elaborate little Government that the Administrator supervised—at a salary of £800 per annum, plus £100 entertainment allowance. Although St Lucia was part of the Windward group, it fell itself into the category of possession known as a Crown Colony. Constitutionally it had no real autonomy whatever: everything had to be approved by London, or by London's representative on the spot. In practice the imperial authorities at home did not often interfere. They had greater things to think about, and provided imperial grants-in-aid were not required, generally left the St Lucias of the Empire to look after themselves. Local laws could be passed by the St Lucia Legislature; the island drew up its own budget; if there was ever a revenue surplus, it remained on the island—since 1778 it had been a principle of Empire that a colony could not be taxed for imperial purposes.

Even within the Windward group each island had its own institutions and laws, subject only to a common appeal court at Grenada. St Lucia was thus a tiny nation of its own, disbarred from relations with foreign Powers, totally within the power of London, but in everyday affairs much its own master. A glance at the St Lucia *Gazette*, the official journal, gives one some idea of the bureaucratic method in such an unnoticeable possession of the Crown. The Protector of Immigrants, Mr Cropper, having completed his quarterly inspection of the sugar estates, reports how much money was sent home to India by the indentured labourers, the number of letters they sent and received, and their daily earnings (the average was 1s a day, and nobody earned more than £18 in the year). The Acting Inspector of Schools reports that discipline at Canaries Roman Catholic Mixed School is 'mild, but not on the gentle system': he complains that children too often pronounce 'ship' as 'sheep', and regrets to say that 'too many attempts are made at copying a neighbour's

knowledge'. The St Lucia Library, with eighty subscribers, has given up *The Field*, we learn, and opened subscriptions to *Notes and Queries* and *Black and White*: the Administrator has presented the *Bulletin of Kew Gardens*, Mr T. D. Gordon has given *The Wesleyan Watchman*, and Mr L. F. Howard ('an excursionist on board one of the American steamers') has given a life of Napoleon in five volumes.

The Town Board of Castries seems to have been extravagant. In the past year it has spent £6 17s 6d on Barometers, has given a £75 subsidy to the Philharmonic Society and spent £2 8s 3d on Entertaining the Band of the Leicester Regiment. The Choiseul Town Council accounts more soberly, in brackets, for its expenditure of £2 5s 0d on sanitary expenses: ('*Dead Whale*'). The Castries Steam Fire Engine has been giving trouble again; five rural policemen have been dismissed from the force; Mr Garroway the Treasurer offers for auction thirty-four gallons of rum and nine pounds of snuff seized by Her Majesty's Customs. The slaughterer's monthly report shows that he killed 122 cattle, fifty-two sheep, two goats, twenty-one pigs and two turtles. The First District Court reports fifteen charges under the Masters' and Servants' Act, including Acts Relating to Indentured Coolies. One or two announcements originating in London remind us that even St Lucia is part of a greater diplomatic whole, and that, for instance, the copyright agreement with Austria-Hungary, to which St Lucia was willy-nilly a subscriber, will not apply to Natal.

British expatriate officials were a small minority, as they were in most of these island colonies. The Colonial Surgeon was British (and a Fellow of the Royal College of Surgeons), but the nine other Government doctors came from several parts of the Empire, and included one with a Maltese degree. The nine Inspectors of Nuisances were all St Lucians, creole or mulatto. We notice that Mr Cropper is momentarily doubling as Inspector of Schools, and that among thirty-two Justices of the Peace are the Colonial Surgeon and his three senior assistants, the Attorney-General and Mr Cropper. Anything to do with money, though, was closely watched by the British cadre, for the St Lucians, like most of the West Indians, had a bad name for petty graft. The licensing system, especially, was open to cheerful abuse—in an island where slavery was still remembered,

and most people lived in shacks of planking and palm-thatch, one had to have a licence to conduct an auction, sell cocoa or tobacco, keep a market stall, sail a boat, have a dog or a stallion, operate a still, sell petroleum or make a living with a house of refreshment. A marriage licence was only needed if one had neglected to have the banns called, or could not wait: even so, of 1,824 births in St Lucia in 1897, 1,099 were illegitimate.

There was a Temporary Government Lunatic Asylum, whose attendant was paid £3 per annum, and the Government also sold ice at 1d a pound, ran a savings bank and administered estates. St Lucia issued its own postage stamps, but since 1841 English coinage had been currency on the island, replacing a queer old currency called, in a mixture of Spanish and old French, *fonds*, *Mocos* and *dogs*.

5

A mile or so from Government House, on the plateau of the Morne above Castries, a monument recalled the great day in May 1796 when the men of the old 27th Regiment, under Sir John Moore's command, had stormed and captured Fort Charlotte from the French, fighting so well that before the British colours were raised above the fort the regimental flag was allowed to flutter there in glory for an hour. The 27th had since become the Royal Inniskilling Fusiliers, but the battle had never been forgotten, and once a year the regimental flag was hoisted up there again, keeping alive the pride of the Inniskillings, and helping to give an air of ancient continuity to the presence of the British in St Lucia.

The island was both a miltary and a naval base, and service affairs were very important to its character. Strongpoints, forts and storehouses studded the environs of Castries, and the town was overlooked by the rambling yellow barracks of the Morne, whose bricks had been brought out from England as ballast, and whose long low buildings, with their shallow roofs and wide verandas, were built to an Indian pattern long since distributed all over the Empire. In a deep trough around the Morne lay the great guns, embedded in stone, with their ammunition bunkers burrowed in the hill behind, and a field of fire commanding the harbour entrance.

Generations of British servicemen, mostly victims of tropical disease, slept in the old graveyard on the flank of the hill, shaded by feathery Caribbean trees, and all around Castries stood the bungalows of the senior officers, in whose dusty yards, we may suppose, giggling St Lucians in blinding fineries were jollied by orderlies towards a swifter peeling of the Colonel's potatoes. Thirteen British regiments bore the name of St Lucia on their colours: the Northumberland Fusiliers wore a white plume in their hats because here, in 1778, their men had triumphantly plucked the white favours from the headgear of the defeated French.

To the Royal Navy, St Lucia was no less familiar. Castries was one of the finest natural harbours in the world, and St Lucia was traditionally the key to the command of the Caribbean. 'His Majesty's squadrons stationed in St Lucia', Rodney had written, 'will not only have it in their power to block every port in Martinique, but likewise the cruisers from St Lucia can always stretch to windward of all the other islands and intercept any succours intended for them. St Lucia in the hands of Britain must, while she remains a great maritime Power, make her sovereign of the West Indies.' St Lucia was an Imperial Naval Coaling Station, and fifteen ships of the Royal Navy called at Castries in an average month. *Statio Haud Malefida Carinis* was the island's motto—the Never Unfaithful Anchorage; it was a familiar but always stirring sight to see a British warship steaming in through the narrow harbour entrance, flags flying everywhere, respectfully saluted by the passing merchantmen, and glittering with the special white and brass éclat of the North America and West Indies Station.

Hazily, perhaps lazily, with a love for old traditions and familiar stations, the imperial strategists still thought of St Lucia as the key to West Indian sovereignty, kept those guns greased in their mountings and sent their cruisers proudly down to Castries for fuel and a night ashore. The old bogy of the French still haunted the British military mind, especially in the West Indies—on a clear day you could see Martinique, the birthplace of Napoleon's Josephine, from the barracks on the Morne. Also the British supposed that if ever the Panama Canal were completed the island might give them some control over its entrance, as Cyprus and Aden covered Suez

and Port Said. It was true, as Admiral Fisher used to say, that the British naval forces in the Caribbean were generally too weak to fight and too slow to run away, and that the island garrison was so small as to be meaningless: but there, St Lucia had a proud military tradition, its installations might come in useful one day, and though the soldiers were not encouraged to go sea-bathing, in case it caused malaria, still it was a popular station. Besides, the garrison would be sadly missed, in an island neither rich nor very worldly. Often the Garrison Adjutant invited tenders for the supply of oats, green forage, kerosene oil, wicks, or the purchase of empty biscuit tins: and sometimes the officers gave a ball in their suave mess above the harbour, with smooth soft lawns above the sea, a string band, and pleasant terraces for sitting out and cursing sand-flies on.

6

Often, when a merchant ship approached the entrance to Castries harbour, a pair of pinnaces were to be seen racing each other boisterously to meet it, oars flashing rhythmically in the sunshine, spray sweeping from their bows. These were the salesmen from Messrs Peter and Messrs Barnard, ferociously rival establishments, competing for a fuelling order. With water at 3s a ton and the best South Wales coal piled high on the wharves, there were handsome profits to be made: a constant watch was kept on the lighthouse at the head, where the approach of a ship was signalled, and so much depended upon being first alongside that racing oarsmen were specially imported from Barbados, and more than once the crews came to fisticuffs as they arrived in dead heat alongside a client.

To the Administrator in his little palace St Lucia was perhaps a far-flung gem in the imperial diadem. To the merchants, the planters, the few professional men—to the five English officials of the Colonial Bank—to MacFarlane Moffatt and Co, the Oldest Establishment in St Lucia, Special Agents for John Brown's Selected Three Star Whisky—to Messrs Peter's and Barnard's anxious sales managers—to the business and commercial classes the island was essentially a coaling station. Since the decline of the sugar industry it had lived chiefly by its coal, placed as it was safely and

conveniently on the trade routes between North and South America, with the best deep-water docks in the West Indies. In 1897 947 ships entered Castries, 620 of them steam, and in tonnage handled Castries was the fourteenth most important port in the world. Night and day the stalwart island women, singing jolly shanties, trudged up and down the gangplanks with baskets of coal on their heads— 109 lb of coal apiece—and to thousands of sailors St Lucia meant above all the smell, filth and back-breaking toil of a coaling ship.

The pace of business was set by the handful of British merchants in Castries—resented often by the old French landowners, not always welcomed by the snootier officers of Government, but doggedly making their fortunes none the less. Socially St Lucia tended to dwell upon a past that seemed to get more gracious every year—a whirl, it appeared, of balls and soirées, carriages perpetually at the door, French comedies, mazurkas swinging among the fire-flies and duels in the blush of the morning, in the days when the planters lived in paternal and cultivated ease among their slaves and sugar-canes. Now it was mostly coal. Balls were infrequent, except in the mess, and were rarely graced, as the old ones had so often been, by visiting Marquises of exquisite sensibility. The Peters, the Barnards and MacFarlane Moffatt set more down-to-earth standards, and the creole landowners had withdrawn into their own inbred society, seldom appearing at functions in the town. The polo field and the racecourse existed mainly for the garrison. The British community was there either to rule or to make money: or else it always had been.

For many of the most British inhabitants of the British West Indies had not been born in Britain. Some were planters themselves, men of substance, relics of the days when these sugar islands were the most valuable possessions of the Crown. Jamaica had its own English aristocracy, living in decayed splendour in lovely old country mansions: Barbados had provided several eminent soldiers for the Empire, besides bishops, statesmen and an editor of *The Times*. Many more of the island British were poor white, scattered through these golden territories like castaways of history. These people were coloured a chestnut brown, from generations in the sun, and they talked with a gentle and baffling lilt, a dialect very nearly proper

English, but somehow not quite. There was often some Negro in them, and they were often to be found gaunt and high-cheeked on the verandas of rickety sun-bleached cottages, sunshine parodies of Englishmen, washed up on these shores by war, commerce or exile—for many of Monmouth's supporters had been banished to these parts, and other 'unruly men' from England, sold as servants for seven years' service, never went home again.

A small educated middle class had also come into being, over the years, and few expatriates need now be summoned from England to fill the middle ranks of business and official life. The Peters and the Barnards were fast becoming St Lucians themselves, and the Rector of Castries was John Robert Bascomb, a tall brown man with a patriarchal beard, whose father had been a clergyman in the neighbouring island of Grenada, and who had been born in the West Indies himself, and educated at a school for clergy's sons in Barbados. Bascomb had married into a well-known Castries family, the Coopers, and was as absolute a native of these parts as any creole patrician or wild voodoo-man of the forests.

7

St Lucia's Diamond Jubilee accordingly had a tang very different from the overwrought festivities of London. The island was a long way in space from Buckingham Palace, and a long way in temperament from the pomp of the New Imperialism. The triumphs of Benin or the tribulations of the poor Afridi must have seemed inconceivably remote, seen through the columns of the *Voice of St Lucia*. The pioneers of St Lucia had not been British at all. The cultural loyalty of the St Lucian *élite* was still to Paris rather than London.

The colony celebrated none the less. 'We lack not loyalty', declared the editor of the *Voice* in his Jubilee poem:

> *We'll try what's in our power to do,*
> *Our love and loyalty to show*
> *At this thy Jubilee!*

The pulpit at Holy Trinity Church had been draped in Union Jacks

by the Misses Cooper, when the five hundred men of the West India Regiment ('the Westies') marched in for the celebratory service—dropping their Catholic comrades off at the church of the Immaculate Conception, and their Wesleyans at the Mission House. Father Claustre, in his sermon, said it was a matter of pride to feel oneself a part of 'such a great nation, which sent up that day a united prayer of thanksgiving from every corner of the earth', while the Reverend Thomas Huckerby, at the Mission House, observed that the progress of Great Britain was based upon 'that righteousness which maketh a nation'.

In the evening there was a soirée at the Government Buildings in Castries, with clog dancing and singing, and everyone turned out to see the big picture of the Queen in Columbus Square—some of the remarks heard in the crowd, the newspaper reported next morning, being 'quaintly pathetic, while the demeanour of all was affectionately reverent'. Donkey and sack races were run, and baskets of buns were distributed among the children. There were bonfires on the beaches, drums in the dusk, dancers frolicking into town out of the mountains, children singing *Rule Britannia*. Hundreds of poor people sat down to a free Jubilee dinner, many others sent along their pots and pans to be filled, and the streets rang, we are told, with ceaseless cries of *Vive La Reine Victoria!* All through the night the guests danced up at Government House, and there the Queen's health was drunk in bumpers of champagne, 'to the accompaniment of subdued but fervent ejaculations of "God Bless Her"'. Mr J. T. Rea celebrated the hour with an apostrophic ode:

> *O world historic isle, where sea and shore*
> *Resound with echoes of the bugle's call*
> *And clamour of ancient strife and all*
> *The bloody combats of the days of yore!*

—and the whole was capped with a monumental bonfire on the top of the Morne, with a *feu de joie* by the garrison.

8

But then a *feu de joie*, commented the *Voice* sourly, was 'the only form

of explosive rejoicing which red tape permits on this island'. The Jubilee was not greeted in St Lucia with a welcome unalloyed. The British islands of the West Indies all had grievances, for in a sense they were the has-beens of Empire. They had been left high and dry by a succession of circumstances—the abolition of slavery, the adoption of free trade, the collapse of the sugar market. Most of them were no longer of real importance to the Empire, and some the more hard-headed imperial administrators in London would happily have abandoned (the British did not yet know that ridding oneself of an Empire is at least as difficult as acquiring one).

St Lucia, as a base and a coaling station, still had an imperial function, but it shared with the other islands a bitterness that had never quite subsided since the emancipation of the slaves, when the interests of the local white people and their distant imperial over-lords had for the first time diverged. St Lucia itself had never en-joyed representative government under the Crown, but several other Caribbean colonies had, losing or giving up their privileges because of the long depression and uncertainty that followed eman-cipation, and St Lucians of the old school perhaps harboured a sense of unfair deprivation, and a premonition of racial troubles to come. French St Lucians still resented the British conquest. British St Lucians thought they might do better left to their own devices. The unofficial community sniped enviously at the official—at the Jubilee Races the Colony Cup had been renamed the Makeshift Stakes, reported the *Voice*, 'because the Honourable Members of the Legislature had refused to vote a cent to the Race Fund'. The com-monalty fell back upon an old St Lucian proverb, '*Duvan poul ravett pa ni reson*'—'In front of a big man, little men are never right'.

What had the Empire done for St Lucia? asked a critic on the always fractious *Voice*. Freed the slaves, thus ruining the sugar economy and inciting social and political troubles which were only just beginning. Built a few roads, at the cost of a corps of Public Works Department officials 'earning large salaries for doing no-thing', while allowing the excellent old French roads to disintegrate. Consistently raised taxation, at a rate ten times faster than the rise in incomes. Progress in education had been feeble, there had been no political progress for a century, nothing had been done to

encourage a varied agriculture. Progress in medicine, said the writer darkly, had only driven 'the Bush Man, the Mesmerist and the Obeahman to seek fresh fields', and down at the docks the vice was worse than ever. St Lucia was 'an undeveloped estate of the Empire': they were still building military installations indeed, but already there were suggestions that one day the Royal Navy, reconsidering its strategies, might recall its weak squadrons from such specks upon the imperial seas, and reduce the circumstances of the property still further.

The *Voice* was doubtless exaggerating the discontent—its editor, R. G. McHugh, was an argumentative man. But he was expressing a basic imperial truth: that unless such a minor possession was economically valuable or strategically necessary, its membership of the Empire would not bring it much advantage. Only too often these outposts had been acquired merely to keep a rival out, or in pursuit of some forgotten tactical purpose: romantic though they looked on the imperial gazeteers, not much thought or money was expended on their welfare. It was an imperial dogma that colonies must be, as far as possible, financially self-sufficient. There were no imperial development funds or technical programmes. Free Trade might be abandoned by the big self-governing colonies, but these little places were altogether at the mercy of whatever economic theory was fashionable in England, and their British markets were in no way protected against foreign competition.

It was one of the merits of the New Imperialism that all this was changing, and that Joseph Chamberlain saw the Empire partly as a development agency, dedicated to technical and economic improvement everywhere. But for the moment Mr McHugh had a point: the poorer a British colony was, the poorer it was likely to remain.

9

Brigade-Surgeon Gouldsbury never returned to St Lucia, for he died in London soon afterwards. One guesses somehow that perhaps for him, as for Mrs Gouldsbury, the island had palled a little: that he seemed to have heard just once too often about the splendour of those ancestral chateaux in Burgundy; that when you had read one

leader in the *Voice* you had read them all; that really, he never wanted to hear another word about that wretched Steam Fire Engine; that those damned mongooses were a perfect curse; that he did wish Rea wouldn't keep spouting odes at him; and that by Heavens, at least in England he was unlikely to run into that confounded excursionist Howard again, the one who never stopped talking about Napoleon.

CHAPTER TEN

Imperial Order

I am that Freedom; I that made you great;
I am that Honour, and uphold you still;
I am that Peace, and bound you, State to State,
Even as the stars are bound to one high will;
I am that One, and made you one in Me,
Reign by that law which sets all nations free.

Alfred Noyes

10

'NO Caesar or Charlemagne,' Disraeli once said, 'ever presided over a dominion so peculiar. Its flag floats on many waters, it has provinces in every zone, they are inhabited by persons of different races, different religions, different laws, manners, customs.' How to govern this prodigious sprawl was one of the great political challenges of history. Fifty years before most Englishmen would have preferred to decline it: the colonies were considered a nuisance then, and the general view was that the sooner they dropped off the family tree, the better. Now the New Imperialism welcomed the challenge, and fostered a response. The Empire was to be consolidated, and it was to be given System.

Disraeli's vision of the British Empire was still valid in the 1890s. He frankly recognized its precarious diversity. There was a core of white colonies bound to Britain by blood, taste and common history: but there was an equal mass of territories, mostly tropical, whose allegiance had been imposed upon them, and whose people had nothing in common with the British except the fact of sovereignty. Some of these peoples, as Disraeli saw it, were bound to Britain because it was British power that secured their personal liberties. Some were bound by 'material as well as moral considerations'. Many more were bound because they had to be, because they recognized 'the commanding spirit of these islands that had formed and fashioned in such a manner so great a portion of the globe'.

The commanding spirit was still there. Legally there was no such thing as a British Empire. It had no constitutional meaning. Physically, too, it was a kind of fiction, or bluff, in that it implied a far stronger power at the centre than really existed. But in the 1890s the British were determined that this heterogeneous structure had logic to it, and that it could be rationalized or emotionalized into order.

2

The one immovable thing about it was the Crown. This was a Royal Empire, and the idea that people could share in the Pax Britannica without paying allegiance to the monarchy would have struck the New Imperialists as unnatural, or worse still perfectly senseless. Everywhere in the Empire the symbol of the Crown, on post-boxes and dockyard gates, on postage stamps and above newspaper mastheads, sombrely surmounting the judges' bench or gaily glittering at the warship's head—everywhere the Crown stood for the one overriding authority, almost beyond human reach, which linked one part of the Empire with the other. There was no people in the Empire, advanced as Canadians or backward as Bechuana tribesmen, who did not dimly recognize the power of the Crown. In every territory the Queen's representative enjoyed a regal consequence himself, lifting him far above petty politics: in India a Viceroy, in Canada a Governor-General, in Jamaica a Captain-General, in the Turks and Caicos Islands a Chief Commissioner, in St Vincent an Administrator. Splendid and full of symbolism was the aura of command surrounding such men, reminding the people that the Governor was the voice of the Queen herself, as the priest speaks for God. The Governor of Natal, in his mansion at Pietermaritzburg, was attended by barefoot Zulu servants, wearing white linen jackets hemmed with yellow. A Fijian waited upon the table of the Governor of Ceylon. Government House at Melbourne, modelled upon Queen Victoria's house at Osborne, in the Isle of Wight, had a ballroom eighteen feet longer than the great hall of Buckingham Palace.

Grandest of all was the Viceroy of India, Victoria's shadow in the greatest of her dominions. The title was little more than an honorific, the power of the office arising from the subsidiary rank of Governor-General: but it had an imperial ring to it, and was borne by only one other dignitary of Empire—the Queen's man in Ireland. There had been ten Viceroys of India since the Crown took over from the East India Company in 1858. The tenth was Victor Alexander Bruce, 9th Earl of Elgin and 13th of Kincardine, the son of

another Viceroy of India (who was buried in India), and the grandson of Lord Durham, author of a celebrated report on the Canadian Constitution. Elgin was educated at Eton and Balliol, under the famous Dr Jowett, and had married a daughter of the Earl of Southesk. In 1893 this tremendous swell had reluctantly accepted the Viceroyalty. He thought himself incompetent for the job, and, wrote Sir Frank Brown in the *Dictionary of National Biography*, 'his recognition of his own limitations was so far justified that he cannot be reckoned among the outstanding governors-general of India'.

At least he assumed his dignities as to the manner born. To anyone with a background less gorgeous than that of a British aristocrat at this opulent moment of British history, the Viceregal circumstances might have seemed daunting indeed. In Calcutta the Viceroy lived in a palace fit for any king.[1] Huge lions surmounted its gates and sphinxes couchant guarded its doors, together with cannon on pale blue carriages, and one borne on the wings of a dragon. Brilliant Indian lancers clattered through the courtyards, thirteen aides-de-camp deferentially awaited instructions, servants in liveries of gold and crimson padded down vast corridors beneath the trophies, treasures and monumental portraits assembled during the three centuries of the British presence. In the marble-floored dining-room six busts of Caesars, taken from a captured French ship, reminded Lord Elgin of his imperial status, even over the soup.

A portrait of the Viceroy's own father, the 8th Earl, hung in the Council Room, along a wall from Clive and Warren Hastings, and there were portraits, too, of Louis XIV, an eighteenth-century Shah of Persia, an Amir of Kabul and several English kings and queens. The ballroom was upstairs, with a vast chandelier originally intended as a present from the King of France to the Nizam of Hyderabad, and artlessly displayed upon an anteroom table were a sheaf of ancient treaties—with Hyderabad, with Mysore, with Seringapatam, agreements which had first consolidated the British Raj in India, and thus laid the foundations for all this splendour.

From this house the Viceroy moved magnificently through India,

[1] It was modelled upon Kedleston Hall in Derbyshire, and when in 1898 Lord Curzon of Kedleston became Viceroy he found himself particularly at home.

resplendent with all the colour and dash of the vast Empire
at his feet, with his superb bodyguard jangling scarlet beside his
carriage, silken Indian princes bowing at his carpet, generals
quivering at the salute and ceremonial salutes of thirty-one guns—
independent Asian sovereigns were only entitled to twenty-one,
and even the Queen-Empress herself only got 101. He had a
pleasant country house at Barrackpur, twenty miles up the Hooghly
River, with moorings for the Viceregal yacht: and when the summer
came, and the heat of the Indian plains became incompatible with
the imperial dignity, up he went with his army of attendants to the
hill station of Simla. There on a hill-top his summer palace awaited
him, scrubbed and gleaming for the season, its major-domos,
secretaries, chefs and myriad maidservants immaculate and expect-
ant in their several departments—a sprawling chalet set in a deli-
cious garden, where a Vicereine might stroll in the mountain evening
spaciously, as a great chatelaine should, and the pines, streams and
crispness reminded visitors that these were rulers from the distant
north, sent by royal command to govern with such grandeur the
sweltering territories of Asia.

3

The Crown at the very summit, with the Queen-Empress to sign
the imperial decrees, and such superb courtiers stationed across the
Empire: below it something very different, Parliament. The British
Parliament in Westminster stood as trustee of the Pax. The supreme
source of imperial policy was the elected assembly of the British
people, which had nothing celestial to it at all, wavered inconsis-
tently from view to view, was quite likely to reverse its entire
imperial attitude from one general election to another, and had
been until recently notoriously uninterested in imperial affairs
anyway. This was the legislative authority of Empire, and its
executive heads, under the Queen and the Prime Minister, were the
Secretaries of State for India and the Colonies, politicians appointed
to those offices as stages in a public career.

Parliament had traditionally left the running of the Empire to
the executive, and in imperial matters generally did what the

Government asked. Ireland, the one exception, had been a running passion of parliamentarians throughout the century, but India seldom aroused a debate. 'The real trouble is', as the Duke of Wellington had remarked long before, 'that the public cannot be brought to attend to an Indian subject.' In the nineties there was rather more interest at Westminster, thanks to the popularity of the New Imperialism, and several active lobbies kept the issues of Empire in Hansard's columns, even between imperial crises. The philanthropic lobby nagged the conscience of M.P.s with questions about the mistreatment of Kaffirs, or the Indian opium monopoly, or slave-running in the Persian Gulf. The financial lobby urged the interests of the chartered companies, the military activists pressed for a Forward Policy on the Afghan frontier, retired colonial administrators fought against suggestions of weakness or withdrawal. Sometimes parliamentarians actually went out to the colonies to see for themselves, and to earn the contempt of those who, like Kipling, despised the instant expert.

For the run-of-the-mill politician, however, at more run-of-the-mill moments, the issues of Empire were mostly glamorous irrelevances, whose effect on domestic politics was normally peripheral, and whose meaning in terms of votes had never been thoroughly examined. It was a paradox of history that so tremendous an Empire lay at the disposal of such fluctuating wills and interests: for Parliament could pass laws binding in every single imperial possession, even the self-governing colonies, and colonial laws were void if they clashed with Westminster's Acts. It was not called an Imperial Parliament for nothing (though in fact the title was only adopted when, in 1800, the Dublin Parliament was abolished, and Westminster assumed its duties too).

4

From the graceful little iron suspension bridge that spanned the lake in St James's Park one of the most celebrated views in London could be obtained. It was a delectably frivolous spot in the very centre of the capital, and had been for centuries a favourite place of dalliance and promenade. A Venetian smell of water and damp earth

hung about the bridge, and the skyline was brushed with ornamental trees. Geese strutted magnificently across the lawns; the famous park pelicans flapped their great wings upon their rock. Beyond the wooded island at the east end of the lake sat a rustic lodge, the home of the park-keeper, and towering above it rose the halls of Authority: to the right, through the trees, Big Ben and the towers of Westminster Abbey, to the left the exotic cupolas of the Horse Guards, and in the centre, ponderous and elaborate, the offices of Empire, with a square tower and a plethora of flagstaffs.[1]

Below Parliament, and subject to its Secretaries of State, two professional departments presided over the British Empire. They were both housed in George Gilbert Scott's Italianate Government offices in Whitehall, south of Downing Street, east of St James's Park. The building had been the subject of a famous architectural controversy of the fifties—Scott wanted to build it in the Gothic style, but Gothic had come to be identified with Toryism, and when the Whigs returned to power in 1857 Lord Palmerston insisted on Renaissance. The structure stood there now in tremendous mediocrity, vast but uncompelling. The Colonial Office, in the north-west corner of the block, was decorated with symbolic figures of Empire, together with portrait medallions of nine former Colonial Secretaries: the India Office had a tower overlooking the park, and was embellished with Governors-General, emblems of Indian rivers and cities, Indian racial types and loyal feudatories. The Colonial Office, furnished in dark mahogany and deep leather, with smoky coal fires and high narrow corridors, possessed a fireplace, taken from the waiting-room of its old premises in Whitehall, before which Nelson and Wellington had warmed themselves during their only meeting, shortly before Trafalgar. The India Office contained fine collections of imperial statuary, clocks, old furniture and pictures, inherited

[1] The bridge, which could be seen from the windows of the India Office, was the last work of James Rendel (1799–1856), engineer of the East India Railway and father of Alexander Rendel (1829–1918), one of the greatest Indian railway-builders. It was wickedly demolished in 1957, but the view from its successor, though modified by taller buildings in the background, remains as magical as it was in 1897. The imperial buildings now house the Foreign and Commonwealth Offices: the Colonial Office has been absorbed into the latter, and of the India Office only the magnificent library survives.

from the East India Company and now disposed about its immense staircases, its library and its majolica-ornamented covered courtyard. Each department was run by a Permanent Under-Secretary from the Home Civil Service, but each had its own pronounced character and body of tradition. There had never been a single imperial administration, just as there was never a Minister of Empire.

The Colonial Office was established in 1854: until then the colonies were thrown in with the armed forces under the Secretary of State for War and the Colonies. It was organized in five territorial departments: the West Indian; the North American and Australian, to which Cyprus and Gibraltar were attached; the West African, which also handled Malta; the South African; the Asian. India was outside the office's concern, and several protectorates of the Empire were administered by the Foreign Office (elsewhere in the same building). It was a very small establishment to govern such a domain: like a comfortable and unpretentious club. Many of its senior members were bachelors. They all knew each other well, nobody called anybody 'sir', one entered a colleague's room without appointment, without even knocking on the door. There were only twenty-three first-class clerks, as its senior functionaries were called, and to administer the Empire in detail they would have required an encyclopedic familiarity with matters ranging from tropical crop-rotation to the circumcision of females. Fortunately they normally left the colonies to run themselves. Most colonial governors were professionals, many of them former first-class clerks themselves, and if things went reasonably smoothly in St Lucia, Fiji or Ceylon it was the prudent practice of the Colonial Office to leave well alone.

Since the days of Sir James Stephen, Colonial Under-Secretary from 1836 to 1847, the bias of the Office had generally been towards a liberal generosity. Stephen ('Mr Mother Country', 'Mr Over-Secretary') had been a leading figure of the anti-slavery movement—one of the only two Sabbaths he ever deliberately broke was spent in drawing up the Abolition Bill of 1833—and since its inception the Colonial Office had, in an often timid but generally consistent way, regarded itself as a trustee for the underdogs of Empire. It was often blamed for sickly weakness by the more hell-for-leather class of

colonist, and there were settlers from Jamaica to Bulawayo to whom its very name spelt a betrayal of white interests, of *imperial* interests, in the name of fuddy-duddy philanthropy. If ever an African tribal leader felt impelled to appeal over the heads of the local British authorities to the distant metropolitan power, it was the Colonial Office to which, buying himself a frock-coat and a top-hat, and packing the insignia of his decorations, he trustfully made his way. The Colonial Office was also, in a way, the London embassy of the colonies. Under its wing were the Crown Agents for the Colonies, who represented the dependent possessions, and the Agents-General of the self-governing colonies. The Colonial Office was the Empire's link with Westminster, and all the official cables from Ottawa, Perth, Colombo, Durban or Wellington were handled by its clerks, or its new corps of 'lady type-writers'.

The India Office was altogether grander and more stately. It, too, was really an agency: India was ruled from Calcutta, and its practical executive was the Viceroy. But the India Office, his link with the Imperial Government, was an *alter ego* of the Raj. All the departments of Indian Government had their microcosms there in Whitehall, and the Office had its own stores depot, audit office and accountant-general. The Colonial Office was less than half a century old: the roots of the India Office lay deep in the romantic past of the East India Company, with its London headquarters at India House in Leadenhall Street. The Office was financed out of Indian revenues, and its officials were advised by a body called the Council of India, consisting of retired generals and administrators with Indian experience. Its authority was concentrated: Lord Bryce once wrote that the whole course of legal reform in India in the nineteenth century, a profound and historic codification, had been arranged by two or three officials in Whitehall and two or three more in Calcutta.

Everything about the India Office reflected Britain's ancient association with the East. From the walls gazed down the faces of eighteenth-century administrators, heroes of the Mutiny, generals and pro-consuls: at the street door stood the ex-Army commissionaires, Indian campaign ribbons on their chests, ready to greet visitors in the rough-and-ready Hindustani familiar to generations

of British soldiers. In the library a succession of eminent Sanskrit and Arabic scholars had guarded the great collections of Indian literature—priceless Tibetan and Burmese manuscripts, a Sanskrit series that was probably the finest in the world, a modern deposit library that had a statutory right to every book published in India, in any language. The India Office was not a clubbable society. It was old, sombre, powerful and legalistic. It moved at a grand despotic pace. With its splendid library, its immense accumulated experience, its constant flow of dispatches, its innumerable visitors from the East, it perhaps knew more about India than any office of government, anywhere, had ever known about another country.

These were the two metropolitan departments of State which, from their gloomy but grandiose headquarters beyond the park, sent out their young men to rule the Empire.

5

It was an imperial maxim that the administrators of Empire should be chosen by the authorities in London, not by their seniors in the field. The intention was to avoid jobbery: one of the results was that both the India Office and the Colonial Office recruited their men overwhelmingly from the same stratum of society—the upper middle classes, stamped to a pattern by the public schools and the ancient universities. There was, though, no single method of entry to the imperial services. The two departments selected their people in very different ways.

The Indian system was developed from the methods of the old East India Company. It was designed to raise a dedicated caste of professional administrators, intellectual, well paid, far above petty parochial controversies, and apparently as permanent and invulnerable as the sun itself. The purpose had a classical purity, and the selection was by a fairly stiff academic examination. Suppose a young man with a recommendation from his headmaster, and a good word from his tutor at Oxford, decided one day to have a shot at the Indian Civil—in those days one of the plum prizes of undergraduate ambition. Up he would go to London, if he were not under 21 nor over 23, and he would sit down to an examination in which

he was offered twenty-one different papers, any one of which he could try if he liked, but none of which was compulsory. They ranged from Sanskrit to Logic and Mental Philosophy, and were of different value: advanced mathematics could earn a maximum of 900 marks, but Roman History was worth only 400. Seven papers were offered under the heading Natural Science, and there were papers in Arabic, French, German and Political Science. The set books for English Literature had been announced the year before: in 1897 they were two Shakespeare plays, two Ben Jonson plays, *Paradise Lost*, the poems of Marvell, Dryden's *Absalom and Achitophel*, Bacon's essays and Browne's *Religio Medici*. In addition a candidate who took this paper was expected to have a 'general acquaintance' with twenty-five standard British authors, Chaucer to Macaulay.

All this invited 'cramming', and many private tutors specialized in bringing a young man up to the mark for the Indian Civil. If, against heavy odds, he succeeded, he then spent a year's probation at an English or Scottish university, and a second examination followed. This time he must take compulsory papers in Indian penal code and procedures, the principal language of one of the Indian areas, and the Indian Evidence and Contract Acts: he must take a paper in either the code of civil procedure or Hindu and Mohammedan Law, plus a choice of papers in Sanskrit, Arabic, Persian, Chinese and the history of British India. He was also tested in horsemanship, including 'the ability to perform journeys on horseback': if he failed this, he could go to India anyway, but he would get no rise in salary until he passed his equestrian tests out there, generally under the effectively ferocious eye of a cavalry riding-master.

The Colonial Office was much less thorough, and looked for men of a different character. Civil Servants for Malaya, Hong Kong and Ceylon took the same examinations as those for India, but jobs in Africa and the lesser tropical colonies went by a kind of patronage. The private interview was the chosen method, and a quiet word in the right quarter often helped. Men were picked for a particular appointment, and they were likely to stay in the same colony all their lives, unless they reached the highest ranks (governors were moved every five years). There was no training programme—men

were expected to learn their trade on the spot: many subtleties of native life and custom escaped this slapdash novitiate, and British colonial officers were frequently ignorant about complexities like customary law and land tenure. As a whole the Crown Colonies were ruled by willing all-rounders of very varied quality—what ambitious man, in the days before malaria control, would wish to devote a career to Sierra Leone? They were recruited more for character than brain-power: it was said that a candidate with a first-class degree would actually be regarded as suspect. The Colonial Office had woven a mesh of contacts with university tutors and headmasters, and found its men quietly and privately on what the British would later call 'the old boy net'. 'Our methods were mole-like', wrote one Colonial Office official in retrospect. 'We learnt to eschew publicity and to rely on personal contacts in the most fruitful quarters: quiet, persistent and indirect.'

6

Steeped in the traditions of the team spirit, slightly glazed perhaps by the intoxications of the High Anglican revival, aglow still with the privileged pleasures, strawberries and Alpine reading parties of the English universities at their happiest, the young imperialist generally boarded his ship at Tilbury or Liverpool welcoming the worst that flies or savages could do to him. If the Indian Civil Service cadet knew he was joining a service of venerable order and regularity, the recruit off to Africa could hardly know what to expect, having no idea what his duties would be, still less how to perform them.

It was rare to find two entries in one year from the same school, but the Empire was administered very largely by graduates of the ancient universities. Against their permissive background, where a man could do as much or as little work as he pleased, the imperial administrators were expected to stand out in diligent distinction. Once in the field, they must be very hard-working indeed. The Conduct Rules for Indian Government Servants specified that Government was entitled to twenty-four hours a day of its employees' time, and often it was very nearly claimed. In those days

the classic picture of the junior Empire-builder's life was accurate enough. Often he really did sit in a leaky mud hut, several days from anywhere, all on his own with a few hundred thousand subjects. He really was policeman, judge, doctor, vet, handyman and oracle, all in one. Petitioners might come to his bungalow day and night, pleading for his help in solving a family dispute, dealing with a crop blight, or killing a man-eating tiger. From dawn to midnight he was seldom at leisure. He probably spent the morning as a magistrate, presiding over his own court; he spent the afternoon surveying his estate, inspecting crops, interviewing overseers; he spent the evening studying the local languages, receiving petitions, writing reports and letters. With luck he had a few other Englishmen at hand: a couple of traders on the river, perhaps, an engineer building a bridge, a missionary or an area doctor. If not, he considered himself alone, often without a telegraph, only a runner or his own horse to keep him in touch, and natives for company.

All over the Empire these administrators, like members of some scattered club, shared the same values, were likely to laugh at the same jokes, very probably shared acquaintances at home. An Australian governor, an Indian provincial commissioner, an officer of the North-West Mounted Police, busy Mr Cropper in St Lucia, beefy Philistine or grave classicist—place them all at a dinner table, and they would not feel altogether strangers to each other. To the outsider this sense of social or professional collusion could be intensely irritating. To the administrators themselves the easy fraternity of class, background and experience seemed an essential factor in the imperial system, giving strength to the web of Government, and providing consolation for lonely lives. Beneath the disciplines of convention and efficiency, an unexpectedly easy relationship linked senior and junior men. Although promotion was nearly always by seniority, outside the normal run men often reached positions of great responsibility in the Empire at surprisingly early ages. Egypt in 1897 was effectively ruled by three Englishmen, the Agent-General, the Sirdar of the Egyptian Army and the Financial Adviser: the first had assumed office at 41, the second at 40 and the third at 37.

7

Top jobs in the Empire sometimes went to grandees outside the two services. The Viceroyalty of India was a political appointment, governors of colonies were frequently noblemen or generals. For the rest the Indian Civil Service and the Colonial Service ran the dependent Empire, holding both political and administrative power in the colonies. In effect this was a State ruled by its own bureaucracy. Below the permanent secretaries in London came the governors on the spot; below them the chief secretaries; below them again the provincial commissioners and district officers. No tropical colony enjoyed any real degree of self-government, despite a few propitiatory sops. White settlements apart, the Empire was a vast despotism—or rather a group of despotisms, for liaison between region and region, or even perimeter and centre, was tenuous. We must imagine the different imperial branches like sections of a cloistered university: each faculty supremely knowledgeable in its own remote speciality, but seldom familiar with, or even interested in, the exercises of the philosophers, botanists or mathematicians across the quadrangle. Among colonial servants loyalty to colony, to region, to tribe was intense, and often exclusive: just as there were classicists, in those days, to whom the higher mathematics was upstart vulgarity, and probably slipshod at that.

A heavy thoroughness linked them all. The bureaucracy of Empire was overelaborate. 'Round and round like the diurnal revolutions of the earth went the file, stately, solemn, sure and slow': so Curzon wrote of an Indian proposal, and stateliness, solemnity, sureness and slowness were attributes of British imperial government almost everywhere. 'Documents no longer needed may be destroyed,' ran an apocryphal imperial directive, 'provided copies are made in duplicate': and in the Colonial Office List for 1897 there really was an advertisement for red tape. The annual General Index to the Administration of Aden gives us a glimpse of the ruling style. 'Lady type-writers' had not yet reached the tropical outstations, and the Index was written in a huge and splendid copper-plate hand that suggested Dickensian clerks on high stools, beneath the slowly

creaking punkahs of the forenoon. Here are some characteristic entries, not always scrupulously spelt:

Compressed Hay: enquiries regarding the practicability of obtaining from Italy.

Engine Driver: entertainment of an, for the Steam Launch *Rose*.

Ewes: purchase of Abyssinian, for Government Farm at Hyderabad.

Exumation: of the body of M. Boucher, late Commandant of the French gunboat *Etendard*.

Fee: sanction for payment of a, of Rs 200 for a surgical operation performed on a relative of the Abdali Sultan.

Mails: *re* fumigation of, Aden to Mauritius.

Opium: agents B.I.S.N.Co. petition for a reduction of transhipment fees levied on, to China *via* Bombay.

Pecuniary arrangements: Governments servants prohibited from entering into, with members of the department to which they belong in connection with the resignation of appointments held by them.

Pilgrims: copy of an unfinished report by Consul Moncrieff on the alleged ill-treatment of, at Camaran Island.

Slave girls: Home Government requires particulars regarding two, made over to the Good Shepherd Convent.

There is the ring of omniscience to such a list, written in such a script, in such a huge thick-leaved register of Empire. By and large only Britons from Britain were considered suitable for the senior imperial posts. There were exceptions: Australians administered New Guinea, New Zealanders the Cook Islands, a few Indians had succeeded in entering the higher ranks of the Indian Civil Service and a few Sinhalese shared in the Government of Ceylon. In the West African colonies there were some African senior officials, but they were soon to be replaced. This was a burden for white men, and candidates for the senior branch of the Colonial Service had to be 'of pure European descent'.

8

The law was different. To administer the imperial justice the British had to enlist the help of their subjects. In several parts of the Empire natives were acting not only as barristers but as magistrates and judges, too. The British could scarcely resent their participation, though nobody annoyed them more than a really litigious native lawyer, because the legal system of the Empire was so immensely involved, so interwoven with customary law and the codes of previous authorities, that often the local lawyer was the only person who really understood it.

The Common Law of England did not necessarily obtain throughout the Queen's Dominions. The principle was that an Englishman took with him 'as much of law and liberty as the nature of things would bear'. Acts of Parliament after the foundation of a colony only applied there if they expressly said so, and if a colony had its own laws before the British arrived, they remained in force until they were specifically superseded. A myriad different codes supplemented, modified or replaced the Common Law in different parts of the Empire, inherited from previous rulers or evolved as safety and common sense demanded. Even in the white self-governing colonies, those mirrors of England, the law was often locally modified: the Australians had changed the marriage law, and the New Zealanders had repealed the Statute of Uses, one of the most important statutes in English conveyancing.

In general the British respected indigenous laws, where they made sense, and seemed just: within their own islands, after all, they allowed a quaint degree of legal latitude to the Scots. British imperial scholars were the first to clarify and define the Islamic and Hindu laws of India—a memorial in Calcutta Cathedral proudly portrayed Sir William Jones, the great oriental jurist, with the tablets of the law in his hands, and Muslim and Brahmin sages respectful at his feet. Customary law was generally honoured, unless it was especially horrible, and even slavery, though legally abolished in the British possessions more than sixty years before, was not flatly forbidden everywhere: in countries actually annexed it was seldom

tolerated, but in Protectorates only its legal status was abolished—it was not an offence for a native to keep slaves, but slaves' children were born free, and a slave could always claim his freedom.[1] The advent of English law did not much affect the more advanced branches of native civil law in India, which were essentially religious, and the baffling procedures of West Africa, with all their rituals of fetish and oblation, were mostly left undisturbed, if only because few Britons could master them.

All this made for a dizzy variety of legislation. British India had its own superb Penal Code, drawn up by Macaulay. Stephen once described it as 'the criminal law of England freed from all technicalities and superfluities, and systematically arranged': anyone who wanted to understand the criminal law of India had only to read the Penal Code 'with a common use of memory and attention'. The French Canadians kept their archaic version of French law, as it had been before the Revolution, while Mauritius and the Seychelles had the Napoleonic Code. Sicilian law applied in Malta, Roman Dutch in Ceylon and Cape Colony, Ottoman in Cyprus. Traces of Spanish law still applied in Trinidad, and faint remnants of the old Brehon law in Ireland. In Sarawak, a British Protectorate, the White Rajah very often made the law up as he went along: generally with liberal intent, in an island where, for example, if an unmarried pregnant girl refused to reveal her lover's name, she was traditionally left to starve in the forest. In Jersey the *clameur de haro*, an ancient appeal to the Crown, could still be raised by a really determined litigant in the island assembly, and lawyers still went for their training to the University of Caen in Normandy.

Sometimes the law, whatever its nature, applied equally to rulers and ruled, English or native. Sometimes the imperialist found himself subject to special rules of his own, set apart from the laws of the country he ruled. In theory there was a special court in England to deal with offences committed by Englishmen in India. It was established in 1784, and consisted of three judges, four peers and six members of Parliament. It was a conscious copy of the tribunal of

[1] This led to an odd paradox. If an Englishman, subject to British law, returned a runaway slave to his owner, he was guilty of participation in slavery: if a native returned him, it was common assault.

Roman senators which, in the second century B.C., had been established to try offences committed by Roman officials against provincials: but it had never been summoned.

9

Loftily above it all, the supreme fount of imperial justice, sat the Judicial Committee of the Privy Council. As the Crown was to the administration of the Empire, the Judicial Committee was to the law. It was the supreme court of appeal for the entire British Empire, outside the United Kingdom. The origin of this eminence was curious. When William of Normandy conquered England his subjects of Normandy and the Channel Islands retained, to differentiate them from the conquered Saxons, particular legal access to the King's person, by way of his Privy Council. Normandy was presently lost, but the Channel Islands kept this ancient privilege, and it was later extended to all the overseas dominions. (Citizens of the United Kingdom had the right of appeal to the House of Lords: in practice the two courts had become virtually identical.)

Oddly enough, in an Empire devoted to pomp and pageantry, the Judicial Committee flaunted few of the trappings of English law. Its members, half a dozen eminent jurists, met in modest upstairs chambers in Downing Street—John Buchan thought the premises 'shabby—the majesty of the imperial law seemed poorly recognized'.[1] They wore no robes or wigs, only plain dark suits, and sat at a semicircular table, the barrister addressing them standing at a lectern in the middle. It was only a committee, not officially a court of law. Its duty was to give advice to the sovereign, so that no dissenting judgements were delivered—it would have been improper to offer the Queen conflicting advice—and no verdict was pronounced: the judges merely declared that in their opinion the

[1] Buchan was still at Oxford in 1897, but was already imperially minded—he won the Newdigate Prize with a poem about the Pilgrim Fathers. He was to become, by way of administrative service in South Africa, Governor-General of Canada and a leading exponent, in many popular novels, of the Empire's stiff upper lip. He died as Lord Tweedsmuir in 1940, and is buried outside Oxford with his faithful manservant near by—across a hedge.

appeal should be dismissed or upheld, 'and they will humbly so advise Her Majesty'. Sometimes a judge from Canada, South Africa or Australia attended a hearing: but there was nothing very imperial to the circumstances of the Judicial Committee, and visitors to its meetings were often disappointed.

Yet this was, in the range of its powers and jurisdiction, the most powerful court of the modern world. It might only offer its humble advice to the Sovereign, but the advice was invariably accepted. A quarter of the inhabitants of the earth were ultimately at its mercy, and when the Kols hill tribe in India were once involved in a dispute with the Government about forest rights, their elders were surprised sacrificing a kid to propitiate a distant but omnipotent deity. 'We know nothing of him, but that he is a good god, and that his name is the Judicial Committee of the Privy Council.' Nothing was more properly romantic, in the complex structure of the Pax Britannica, than the existence of this tremendous tribunal, perhaps the one imperial institution that smacked authentically of the Caesars. The laws of half a dozen conquered civilizations were laid before it, and its members must interpret them all both by their own values, and by the values of the imperial British. They might have to declare an opinion, against which there was no further appeal, upon the legal meaning of the Koran, or the Hindu Manu, or a clause of the Napoleonic Code modified by Canadian practice, or even the law of the Kingdom of Kandy, that last stronghold of the Ceylonese monarchs, hidden away in the forested interior of the island. Once an English lawyer had pleaded before them, on behalf of orthodox Hinduism, against the abolition of suttee, the burning of widows alive: more than once the Committee had dealt with cases in which property had been entailed in the person of a temple idol.

Some of the greatest British jurists had presided over the Judicial Committee, and its roll of members included many of the ringing honorifics of the realm—the Lord Chancellor, the Lord Chief Baron, the Lord Chief Justice, the Master of the Rolls, the Vice-Chancellor of England and all the Lords of Appeal in Ordinary. Among them in 1897 were Lord Halsbury, whose *Laws of England* was the standard digest of English law, and Lord Macnaghten, the

most eloquent jurist of his day.[1] There was no sniffing at such a body, at a moment when the prestige of English law, by whose standards all else was ultimately to be judged, stood at its highest. When a Chinese lawyer argued his case from Hong Kong, or a Jamaican litigant appealed to the fair play of the Crown, when an East African Muslim pleaded the legal significance of the Meditations, or the Kols hillmen slit the throat of another kid—as the members of the Committee looked out from their table across their quarter of the world, it must sometimes have seemed that the dream of a universal civilization was half-way to fulfilment.

10

Not the law as such, but the rule of law, was the one convincingly unifying factor in imperial affairs. The British subject, whether he be Kaffir, Maori or French Canadian, automatically acquired those private civil rights which the English had evolved for themselves since the time of Magna Carta. It took the Romans many generations to extend civil rights throughout the Roman Empire, because it was done in stages: the British granted such rights the moment they annexed a territory. One day a tribesman might be absolutely subject to the fickle despotism of his hereditary chieftain, with no personal liberties whatever: the next day he had a constitutional right to take a suit before Lord Halsbury, or stand for the Imperial Parliament. Most people, in most parts of the British Empire, would probably have agreed that on the whole, and certainly by the standards of its predecessors, it offered its subjects justice. Wherever the British went, as they threw down railway lines and erected Anglican churches, so they set up courts: and though the magistrate might only be an anxious youth a year or two down from the university, or a beery old veteran soaked for a quarter of a century in sun and the lesser vices, still the hearing was likely to be fair and the

[1] The best-remembered example of his eloquence was his advice to the shady Mr Gluckstein, defrauded by his own accomplices, in the case *Gluckstein v. Barnes*: 'He can bring an action at law if he likes. If he hesitates to take that course or takes it and fails, then his only remedy lies in an appeal to that sense of honour which is popularly supposed to exist among robbers of a humbler type.'

judgement impartial. To many of the Queen's native subjects this was the first advantage of the Pax—more important than prosperity, efficient government, even better health. Asked in 1896 to name the first benefit of British rule in Egypt, a Cairo newspaper editor replied that now a peasant could not only bring a lawsuit against a pasha, but actually win it.

Simple benevolence was not a general trait of the British imperial system, but its fairness was generally recognized. As Emerson once wrote, 'the English sway of their colonies has no roots of kindness in it. They govern by their arts and ability: they are more just than kind.' If an imperial idealist had to choose a text of Empire, he might have done worse than select the original instructions of the East India Company to its judges in the east. In those days the state of the law in India was fearfully muddled, a welter of religious and customary law only thinly reinforced by English practice, but the Company's justices knew how to behave. When there were no positive or acceptable rules to follow, they were told, they must consult two simple principles: 'Equity or Good Conscience'.[1]

[1] 'Whichever', cynics used to add, 'is the less.'

CHAPTER ELEVEN

Imperial Complexity

Across the wave, along the wind,
Flutter and plough your way,
But where will you a Sceptre find
To match the English Sway?
Its conscience holds the world in awe
With blessing or with ban;
Its Freedom guards the Reign of Law,
And majesty of Man!

Alfred Austin

II

TWO celebrated monuments stood near the lake in Kandy, the
sweet mountain capital of the last Ceylonese kings, toppled
off their thrones only thirty years before. One was the Temple
of the Tooth, a confectionery structure of white marble, in whose
moat guardian crocodiles loitered, and in whose inner shrine a large
discoloured chunk of ivory was claimed to be a tooth from the
mouth of the Lord Buddha. The other was the audience chamber of
the Kandyan kings, an unpretentious but beloved structure, built
with the skills of Portuguese captives in the seventeenth century,
and so a monument to the lost power of the kingdom. Around these
two buildings the life of the little city fragrantly revolved, the
monkish litany echoing across the lake at dawn, the aromatic
shambles of the bazaar, the fireflies wavering haphazard in the
shrubberies as the sun went down: but immediately beside them,
overshadowing the one and not in the least abashed by the other,
the British built the headquarters of their administration in central
Ceylon—a vaguely Palladian, four-square, sensible office block,
deposited there with uncompromising firmness, as if to say that no
memory of vanished kings, no relic layered in gilt and sandalwood,
could logically resist the power of the Raj.

One feels among the writings of the New Imperialists a hunger
for this sort of absolutism, as they tried to reduce the complexities
of the Empire to some comprehensible order. But there was no true
order to the thing. It had no real logic to it, no very definable pur-
pose, no formula. It was, as Richard Ford wrote of Spain, a kingdom
of exceptions. Even in Kandy the nature of British rule was not so
clear-cut as the juxtaposition of those three buildings seemed to
imply, for down the road there was a fourth, a wooden kiosk beside
the lake, which was the headquarters of the village headmen—
Ceylonese of substance and inherited dignity who had been

absorbed into the British system of government, and were almost as important under Queen Victoria as they had been under King Wikrama Raja Sinha. Very peculiar, Disraeli had thought this Empire. What was true of one colony was seldom true of another: and there were, in 1897, forty-three separate governments within the British Empire, displaying every degree of independence and subjugation, and all manner of idiosyncrasy.

2

At one end were the great self-governing colonies, virtually nations in their own right. Their emancipation had come easily, because until a decade or two before the British had been chiefly anxious to reduce their imperial burdens, relied upon Free Trade for their continuing prosperity, and were very willing to release colonists who were only British anyway. The last thing London wanted was another Boston tea party. There were eleven of these semi-nations: Canada, the six Australian colonies, New Zealand, Cape Colony, Natal and Newfoundland. None of them was absolutely independent. Their foreign policies were still decreed by the Imperial Government, whose diplomats represented them in foreign capitals, and they still depended upon Great Britain for their security at sea. But they were not obliged to go to war for London, and they had their own local defence forces, their own agents in England, and their own tariffs, sometimes directed against imports from the United Kingdom. These outstations of Greater Britain had two-chamber Parliaments, faithfully reproducing the rituals of Westminster, and they appointed all their own public officers, except only the Queen's representative (though even in the choice of Governors they had their say, generally suggesting noblemen of limitless pedigree and resource).

Below them came the Crown Colonies, in almost every stage of development. Some had no legislature at all, but were ruled simply and squarely by the Governor and his officials: such were Gibraltar, for instance, and St Helena. Some, like Gambia or the Seychelles, had legislatures whose members were all officially nominated. Some, like Jamaica or Malta, had legislatures that included some elected

members. Barbados and Bermuda had fully elected Assemblies—relics of the self-governing constitutions, like those of the old British colonies in America, which they had enjoyed before the emancipation of the slaves. But in all the last word lay with the Governor, who could veto all legislation anyway: and in most the degree of public intervention could be manipulated easily enough by a switch of the franchise, reducing it as often as not to that airy upper-crust likely to be in sympathy with imperial ideas. (In Malta the franchise was limited to about one-eighteenth of the population—as the geographer Hereford George wrote, 'so important a military station is necessarily governed, to a certain extent, in accordance with the needs of the Empire').

Many imperial territories were officially Protectorates, and technically foreign countries still. Most of them were run, nevertheless, more or less as Crown Colonies, except that since their citizens were not British subjects they were conveniently unentitled to British legal rights—your Ashanti agitator could not cry habeas corpus, when the district officer decided to let him cool off in the lock-up for a day or two. In three territories—Rhodesia, North Borneo, Nigeria—chartered companies were paramount, as all-powerful agents of Empire: the charter of the Royal Niger Company, granted without any reference to Parliament in London, declared that the kings, chiefs and peoples of the Niger basin, 'recognizing the virtues of the Company', had ceded the whole of their territories to it, and that the British Government had authorized the company to govern them, and to acquire 'by all lawful means' other territories in the same region.

And magnificently separate as always was India, which was an Empire of its own—vast and unmanageable almost beyond conception, a third of it ruled by native princes under British suzerainty, the rest governed by the British themselves as an unwavering autocracy. 'Whatever is done *for* the people,' Bryce wrote of India, 'nothing is done *by* the people': British rule there, somebody else said, was 'a gigantic machine for managing the entire public business of one-fifth of the inhabitants of the earth without their leave and without their help'. In British India, more colossally than anywhere, the Crown was absolute.

3

Nothing was uniform. Consider the Government of Ceylon, which was thought to be the ultimate refinement of the Crown Colony system. Ceylon was not the sort of possession that could reasonably expect self-government. Its native population was half Tamil from India, half indigenous Sinhalese, part Lowland part Kandyan, partly Buddhist partly Hindu, with Muslim and Christian minorities and a sizeable white community. Beneath the authority of the Governor was an officially nominated council intended to reflect at once this diversity of the Ceylonese and the grand fact of British domination. It comprised the commander of the imperial forces in the island; the Attorney-General; the principal Collector of Customs; two senior District Officers; the Director of Public Works; and representatives of the Tamils, the Sinhalese, the Muslims, the Kandyans, the Burghers, the Europeans and the merchant community. Eight Government Agents, one for each province, translated the decrees of Governor and Council into action: they and their senior assistants were nearly all British members of the Ceylon Civil Service, but below them the ancient hierarchy of headmen and village councils still held local authority. This was held to be a model administration. It gave the natives a share in the running of things, it respected indigenous tradition, it allowed every local faction a voice at Government House: but just as there was no mistaking which of those buildings in Kandy was of most immediate consequence, so there was no mistaking the fact that the British were absolute rulers of Ceylon.

Other possessions were less tractable—Burma, for instance. Ceylon was a compact, fairly developed, accessible island on a familiar trade route, a genial and easy-going kind of colony. Burma was described by Sir George Scott, the principal British authority on the country, as 'a sort of recess, a blind alley, a back reach'. Much of it was still wild and unmapped, and its people had never really accepted the values of the Raj, remaining remotely detached, seldom volunteering to serve the Flag, and never demeaning themselves with second-hand Western manners. Lower Burma the British

knew well enough; upper Burma contained large tracts of jungly tribal territory where successive British missions had been massacred or molested. Though it was governed as a province of British India, Burma was accordingly split into several different kinds of possession. On the one side a straightforward colonial administration governed the settled areas—commissioners, deputy commissioners, assistant commissioners, township officers down to village headmen. On the other side a queer congeries of arrangements was devised to keep the tribes quiet and happy. In the remote tribal territories British rule was rudimentary, and local power was left in the hands of chieftains—the Sawbwas, Myozas and Ngwekunhmus of the Shan States, the Duwas of the Kachins, the tribal paladins of the Chin peoples, the red Karens, the Bwè and the Mano. Some of these principalities were vast—Kengtung was as big as Belgium: some were the size of large private estates in England. All were allowed, in varying degrees, to look after their own affairs, the Raj only interfering when necessary to keep the peace or enforce justice.

Yet the whole was one province of Empire, from the ordered logic of the Rangoon municipality to the head-hunting country of the Wa, only once penetrated by Britons, where the villages of the Wild Wa were approached by avenues of human skulls, the Intermediate Wa, so Scott tells us, indulged only in 'fits of head-hunting', and the Tame Wa actually wore clothes. Indirect rule, the employment of existing authorities to do the governing for you, was not always popular among the New Imperialists. It clashed with their theme, and meant that people went on living in the old way, denied the full elevating benefits of white civilization. This was a very large Empire, though, its British cadre was small, it was growing constantly, and in many parts the British found it expedient to modify their civilizing mission and enlist the authority of a myriad chiefs, kings, emirs and paramount princes. In Africa they would try, more subtly than they ever did in Asia, to weld the ancient orders into the structure of Empire, exactly fitting each measure of responsibility into an imperial pattern, so that the pettiest pagan wizard could play his part in the grand design. But by these visionary means nobody was satisfied. The Empire lost part of its point, and the Africans found themselves stuck in a bog of tradition, from

which before long all the more intelligent ones did their best to escape.

4

Consider the island of Ascension, 7° 53′ S., 14° 18′ W., half-way between Africa and Brazil in the South Atlantic Ocean. Acquired by the British, 1815, as a garrison island. Area 38 square miles, length 7½ miles, breadth 6 miles, circumference 22 miles. Population 380, with 60 women and children, consisting of seamen and marines with their families, and Kroomen labourers from Liberia. No indigenous vertebrate land fauna. No industry. No known minerals. Half covered with lava.

Ascension was eight hundred miles from the next British territory, St Helena, and not particularly on the way to anywhere else. In deciding how best to administer the place, the British accordingly took a practical if unorthodox step: they declared it to be a ship. It was borne on the books of the Admiral Superintendent, Gibraltar. Darwin described it as 'a huge ship kept in first-rate order', when he visited the island on the *Beagle* in the 1830s; it was the only British possession under the control of the Admiralty (though the French Ministry of Marine had once governed most of the French Empire). Ascension had enjoyed a brief importance as a coaling station, before the opening of the Suez Canal. Now it was a naval sanatorium and a cable station on the South African line—its traditional function in a way, because for centuries mariners had left mail in bottles on this island, to be picked up by ships passing in the opposite direction, and there was a headland still known as the Letter Box.

A captain of the Royal Navy was normally in command, though sometimes it was a colonel of marines. He enforced and occasionally made the laws, punished offenders, presided over inquests, kept the registers and was president of nearly as many local societies as was Cecil Rhodes in Salisbury. The military garrison had long been withdrawn, but in 1897 there were still ten naval officers aboard Ascension, and everything about the island was nautical. The Commander lived in Admiralty Cottage, the light outside the police station

was an old ship's lamp, every wall of St Mary's Church was crammed with naval memorials. On the long track up Green Mountain, the parkland of the island, two sawn-off gigs acted as milestones—'One Boat' and 'Two Boats'. The Navy had brought tons of earth and innumerable trees to soften that austere volcanic landscape: gums from Australia, yews from the Cape, castor-oil from the Caribbean, Scotch firs and Port Jackson willows. On the summit of the mountain they had made a dewpond, with frogs and goldfish in it, and a farm with roses, geraniums and English vegetables—it was a tradition that every officer posted to Ascension took with him some useful plant.

The island was orderly, surprisingly homely, and modest. When one naval officer's wife arrived there, legend said, she accosted a seaman on the jetty and asked haughtily where Government House was, and where the Governor's carriage would be awaiting her. 'There's the Captain's cottage, ma'am', he replied, 'and this here is the island cart.'[1]

5

Here are a few less spectacular anomalies of Empire. Gibraltar, Malta, Bermuda, Guernsey and Jersey all had military governors, appointed by the War Office. Cyprus was governed by a High Commissioner, because it was ostensibly still part of the Turkish Empire: there were Mudirs and Mukhtars in its administration, the Turkish Majlis still had a say in taxation, and Cypriots were liable to conscription in the Turkish Army unless they paid a poll tax. The New Hebrides were governed as a condominium by an Anglo-French naval commission. Tristan da Cunha was more or less run by the chaplain of the Society for the Propagation of the Gospel. Sarawak, though a British Protectorate, was still ruled by the White Rajah. British Guiana had a legislature called a Court of Policy, inherited from the Dutch, and in Gibraltar the only local authority of any kind was the sanitary commission. Guernsey and Jersey had their own *Etats*, Norman assemblies older than Parliament itself. The

[1] Ascension, now a dependency of St Helena, is today less a ship than a radio programme, for the BBC maintains a large transmitter there.

internal laws of the Isle of Man were framed by an archaic assembly called the Tynwald, Ireland was divided into baronies, relics of the septs and clans of Celtic antiquity. On the Burmese frontier the British rented territory from China. At Quetta the greatest of all Empires was the tenant of the Khan of Kalat, at a quit-rent of 25,000 rupees a year.

6

And oddest of all the imperial phenomena was Egypt, which Napoleon had called 'the most important country', and which possessed for the British an almost pathological fascination. To them it seemed to hold a mysterious, treacherous grip upon the jugular of the Empire. Egypt stood astride the way to India, and it had long been inextricably linked in the British mind with the story of the Pax Britannica: Nelson at the Nile, the romance of the Overland Route, Gordon's death, Gladstone and Alexandria, the passage of the liners down the Suez Canal—all these spelled Egypt for the British, and made them always aware of the place. It was alternately a beacon and a blind spot.

In theory Egypt was not part of the Empire at all, though the British had run it for fifteen years. It still owed allegiance to the Sultan of Turkey, and its nominal ruler was the Sultan's vassal, the Khedive Abbas II. There was an Egyptian Prime Minister, an Egyptian Cabinet, an Egyptian Parliament, an Egyptian Army, an Egyptian flag. British sales to Egypt appeared in the official statistics as exports to a foreign country, and when a British ship dropped anchor in the Suez roadstead, to pick up a French pilot, invite the British garrison commander on board for a drink, welcome Thomas Cook's man or send a telegram to book a room at Shepheard's in Cairo—as it paid these practical respects to reality, it honoured the fiction, too, by hoisting the Egyptian ensign on its topmast.

In two respects the government of Egypt really was out of British control. The national finances were in the hands of an international board of experts, the Caisse de la Dette; half the national revenue was taken by this body to pay the interest on Egypt's foreign debts, while the other half was used to finance the

administration. Then Egyptian jurisdiction over foreign residents had been surrendered to a whole series of capitulatory courts, one for each consulate, whose machinations often made a mockery of justice, and were surrounded by labyrinths of hidden interests, claims and skullduggeries. For the rest, Egypt was virtually the personal responsibility of the British Agent and Consul-General, Lord Cromer, who had been in command almost since the occupation began, and whose stature was by now so towering that he was known simply as 'The Lord'. Cromer paid proper court to the young Khedive, and he scrupulously allowed the façade of Egyptian sovereignty to stand—only one British official, the Financial Adviser, attended Cabinet meetings, and he did not vote. Laws were decreed by the Council of Ministers, and sealed by the Khedive. Administrative orders were signed by His Highness's Ministers, and executed mostly by Egyptian officials. But nothing of real importance could be done without British sanction, and it was British imperial initiative that set most things moving in Egypt, from the reorganization of the tax system to new schedules for the Nile steamers. The Khedive was hardly more than a puppet. When 18,000 of his own soldiers were once sent down to the Sudan to fight the Mahdi, he only heard about it from the Austrian Archduke Ferdinand, who was on a visit to Egypt, and had been told the news by a drunken British officer the night before. The wittiest of Anglo-Egyptians, Lord Edward Cecil, once described how the British presence made itself felt at an Egyptian Cabinet session: the merry in-sparring among the pashas, the exchange of innuendoes, the touches of farce, the suggestions of cultured nepotism, and at last the appeal to the opinion of the solitary Englishman present, who said he'd sleep on it and let them know.

A formidable team of Britons ran Egypt under Cromer. Many of them had Indian experience, and they were recruited by Cromer himself. In all the Ministries, in every key post in the field, at the desk of the Sirdar of the Egyptian Army or discreetly settled in rooms above the Alexandria dock police station, one would find Englishmen. Upon them the Government of Egypt really depended —when one man retired, resigned or changed his job, confusion often momentarily followed: and so individualist was the system, so

unregulated by the usual conventions of seniority or decorum, that competition among the British themselves was cut-throat. It was, as one of its most successful practitioners[1] said, plain survival of the fittest.

This cell of English officials, backed by six thousand men of the British Army of Occupation and a substantial British commercial community, so set their mark upon Egypt that to the world at large it became a British dominion. They did very little to prepare Egypt for the absolute self-government so piously foreseen in 1882; they failed, as the British did nearly everywhere, to give the country a proper system of education; they never succeeded in making themselves popular—Dilke said in 1893 that nobody of weight wanted the British to stay in Egypt except the British themselves. But by great engineering and irrigation works they gave new hope to Egypt's peasants, and by force of character they turned Cairo into a new kind of capital, part Arab, part African, part Levantine, part imperial British. The French influence had been strong in Cairo ever since Napoleon's day, and that part of the city which did not look orientally medieval looked seedily French: but upon it the British had imposed four-square institutions of their own. High on Saladin's citadel, above the glorious minarets and courtyards of the old city, the Union Jack flew vastly above the fortifications, and the screw-guns of the British garrison commanded the whole of Cairo. Down by the Nile the brown slab of the Kasr-el-Nil barracks echoed with bugle calls, throaty commands and clattering rifle-butts, like a power-house of Empire, and through the streets each morning marched the guard squads, brilliant in khaki drill and white sun-helmets, their belts dazzling with pipe-clay, the bayonets on their Lee-Mitfords glittering in the sun.[2] The British hotel was Shep-

[1] Eldon Gorst (1861–1911), born in New Zealand, who was in 1897 adviser to the Ministry of the Interior. He survived so well himself that in the end he succeeded Cromer.

[2] Kasr-el-Nil barracks, now demolished to make way for the Hilton Hotel, was still the centre of British military power in Egypt during the Second World War. In 1897 a traveller reported that the favourite marching song of the British troops, as they moved from the barracks to the Citadel, was '*When I was bound apprentice, in famous Lincolnshire*'. By the 1940s the flavour of the occupation had changed, and much the best-known Anglo-Egyptian song, performed with cheerful disrespect on every route march, began with

heard's, one of the most famous in the world. The British suburb was Zamalek, an island in the Nile, where the Empire had established its own familiar society, with its calls and its soirées, its gossip and its private feuds, its favourite Copts and its few flattered Muslims. The international winter season, now exceedingly fashionable, was dominated by the British, with Lord Cromer moving through the balls and picnics like a grave *deus ex machina*. Alexandria was virtually a British port—of the 940,000 tons of steamer traffic cleared there in 1896, 800,000 tons were British. The police force was organized to a British pattern, the trams were fresh-painted, the trains had British rolling-stock, the telephone service was the envy of visiting Europeans, and comfortably up and down the River Nile ran Cook's famous steamers.

Those steamers! In the summer of 1897 many of them were far upriver, taking Kitchener's soldiers and supplies towards the capture of Khartoum, but in normal times, as they paddled serenely from one Pharaonic prodigy to the next, they were happy embodiments of Empire in themselves. Most of them were built in England, and they were repaired by Cook's own Cairo boatyard, on the Nile at Boulak. They generally carried a European manager, and they were kept as spick and span as any Atlantic flyer—paddle-boxes blinding white, chintz curtains in the saloon windows, flowered toiletries in every cabin. At the breakfast table the passenger, whatever scorched reach of the Nile his steamer was chugging through, would find his morning paper and his personal mail laid neatly beside the marmalade, just as though he were home in his own club. There was a strong symbolism to one of these little ships, as she steamed between the changeless sands, so trim, so polished, so energetic, with her sailors in blue jerseys, and so many splendid moustaches upon her promenade deck (for not the least of Britain's emblems in Egypt was the moustache of the Sirdar, Kitchener himself, the cynosure of soldiers everywhere, and shamelessly copied on the spot).

the words: '*King Farouk, King Farouk, 'Ang 'is bollocks on a 'ook. . . .*' Farouk was a first cousin once removed of the Khedive Abbas. When Gamal Abdel Nasser's revolutionaries forced him to abdicate in 1952 he appealed for help to the British forces on the Suez Canal. But they let him go.

7

Paddling up the Nile with Oxford marmalade and the *Egyptian Gazette*: one might suppose that to be British in those days was very heaven, and that the Englishman wandering through his Empire would find his path eased everywhere, subservient lackeys always to hand, ordered efficiency always at his instruction. It was not so. The imperial system did not succeed in disciplining all the Empire into the predictable common sense of Surrey or Nova Scotia. Even better-ordered parts of the Pax Britannica often looked, to the disillusioned traveller, a fearful shambles, and contemporary guidebooks are full of warning, in the most thoroughly British of possessions, against the Neapolitan hazards of pester, larceny and impertinence. The British presence might enable you to walk unscathed through the deserts of Sind or the prairies of the Six Tribes, but it did not protect milord against the pickpockets of Calcutta. The flashy larrikins or city roughs of Melbourne were the bane of every genteel visitor—loud-mouthed, quick-fisted and apparently quite beyond the control of Authority. '*Touts*', runs an entry in Murray's Indian handbook: 'travellers are warned against these individuals, who torment the stranger from morning till night trying to persuade him to patronize his employers. They should be treated, as far as possible, with indifference.' Nor would it always do much good complaining to the imperial police—in India the native constables were frequently corrupt, and anyway visitors from England were not always very welcome to their Indian estates. There were parts of the British Empire indeed where ordinary Britons were forbidden to go at all, and often the Empire-builder in the field seemed to think that the Empire was not so much the property of the British people as of his particular branch of the colonial administration. Even native employees of the Raj caught this infection. The story was told of a formidable peer, a member of the Viceroy's personal staff, who found himself pointedly ignored by the Indian booking-clerk at a railway station. He cleared his throat and tapped his fingers, but the babu took no notice. Finally the peer lost his temper. 'Look here,' he said, 'damn it, I don't think you know who I am. I'm Lord So-and-

So.' 'Oh my Lord God,' the clerk cried without looking round, and fell backwards off his high stool to the floor—but the interesting part of the anecdote was not his final discomfiture, but his studied rudeness in the first place. Just to be British was clearly not enough.

The imperial complexity was all too apparent. No soothing uniformity of procedure greeted the traveller at British ports. The Union Jack above the ramparts, fluttering from Gibraltar to Vancouver, was a false promise: nothing was the same from colony to colony, currencies and tariffs varied everywhere, the forms to be completed were never the same twice, and the uninitiated stranger seldom knew whether he was disembarking at a Crown Colony port (Valetta, for instance), a Protectorate port (Mombasa or Kuching), an Indian Empire port like Aden, a port of a self-governing Dominion or a port like Alexandria which defied any succinct classification, flying the green Egyptian flag but apparently run by British officials in tarbooshes. Other Empires—the Roman, or the French—stamped their dominions with the hall-marks of unity. Not the British. They did not much care about appearances. Their Empire was, so J. L. Garvin[1] once wrote, 'the most complex and plastic political organism the world had yet known', and plastic it must indeed have seemed to the voyager stepping ashore into the squalor of Georgetown, British Guiana, all huddled wooden shanties beside the Demerara, or the leers and babel of Port Said, or the internationally notorious muddle of Madras—where the beach was littered all over with coal, timber, crates of liquor, sacks and railway sleepers, and it took so many weeks or months to clear a consignment that often before one ship's cargo could be removed another would be dumped on top of it.

Picture postcards of imperial scenes in the nineties generally seem to show the cities of the Empire leisurely, uncrowded, and bathed in benign sunshine. This is perhaps because they were taken on fine Sunday afternoons with police protection. In fact, as travel memoirs of the time reveal, a British imperial city could be as

[1] Garvin (1868–1947) was the son of an Irish immigrant to England, and in his youth a brilliant exponent of Irish Home Rule. He was so thoroughly converted to the imperialist creed that by 1936, as editor of the *Observer*, he was ready to support Mussolini in the invasion of Ethiopia.

ghastly a hole as any other. Paved streets in the Indian cities were very rare, and some of the fortress colonies were universally detested. Aden seemed to live in a constant and highly uncomfortable state of semi-siege: the eight or nine fierce tribes of the hinterland were only kept quiet by bribery, and one traveller of the nineties, pausing there on a voyage to India, described the faces of the British soldiers as 'shrivelled up—a pathetic sight to see'. Gibraltar, topographically the most splendid British possession of all, turned out to be, when you landed at the docks, only a fly-blown, dingy and smelly barracks town, haunted by urchins fraudulently claiming to be Cook's guides, or Spanish hawkers wandering from door to door with straggly flocks of turkeys. The lady of legend was right when, told her ship would be calling at Gibraltar, she exclaimed that the one thing she wanted to see there was the Rock.

8

It was all bits and pieces. There *was* no System. The Mother Country was an audacious euphemism, applied to such immense and ancient organisms as India or Nigeria, and the whole terminology of Empire had become so confused that often the New Imperialists could not even use the word 'nation' without an explanatory footnote. 'When we have accustomed ourselves', Seeley had written, 'to contemplate the whole Empire together and call it England we shall see that here . . . is a great homogeneous people, one in blood, language, religion and laws, but dispersed over a boundless space.' Such saws of ancient prophets only confused the issue further: Seeley could not have foreseen the imperial assault on Africa in the eighties and nineties, and he thought in terms of a white Greater Britain with a single docile dependency, India.

In fact the very essence of this Empire was its formless improvisation, its stagger. Four million people of British stock lived in the six self-governing colonies of Australia. British settlers had been there for rather more than two hundred years, and the organization of affairs was entirely theirs. They had started from scratch. The six colonies had six different sets of tariffs, mainly directed against each other. They had six separate postal and telegraph services, and six

uncoordinated defence forces. The judicial processes of one colony could not be enforced in another. The railways were built to different gauges. If an inventor took out a patent in Queensland, it did not protect him in Victoria.

All six, that Jubilee summer, sent their Premiers to London, where they basked in the effulgence of the New Imperialism, kissed the hand of the Queen-Empress, and made many well-received speeches about Imperial unity, historical fraternity, and the advantages of British method.

CHAPTER TWELVE

Imperialists in General

Come of a right good stock to start with,
Best of the world's blood in each vein;
Lord of ourselves and slaves to no one,
For us or from us, you'll find we're MEN!

Robert Reid

12

WHEN Kipling first went east from India, he noted that though the stinks of Lahore and Calcutta had something in common, the stink of Burma was different: he was struck by the numberless energies of the Chinese, and the startling vigour of Japan: but wherever he went in the eastern Empire he observed that the British appeared to be exactly the same. 'It was just We Our Noble Selves', he wrote sardonically of a party in the barracks above the botanical gardens at Singapore. 'In the centre was the pretty Memsahib with light hair and fascinating manners, and the plump little Memsahib that talks to everybody and is in everybody's confidence, and the spinster fresh from home, and the bean-fed, well-groomed subaltern with the light coat and the fox-terrier. On the benches sat the fat colonel, and the large judge, and the engineer's wife, and the merchantman and his family after their kind—male and female met I them, and but for the little fact that they were entire strangers to me, I would have saluted them all as old friends.' They were just the same people as he knew in India, except that they were pale from the Singapore climate, 'and the veins on the backs of their hands are printed in indigo.'

2

Nobody, of course, runs so true to type as that. The subaltern probably cherished a passion for the poetry of Baudelaire, the spinster spoke fluent Cantonese, the merchant and his kind were Seventh Day Adventists. To the stranger nevertheless the British in their Empire do seem to have been instantly familiar, whether they were the stiff, pomaded or parasoled representatives of the gentry or irrepressible soldiers of the line. Britishness was very strong in Victoria's later years, and British people were unmistakably British.

For the most part they were bigger and fitter than other Europeans. A prosperous century had made even the poorer classes so, and several hundred years of success had filled out the gentry: according to Florence Nightingale, London was the healthiest city in Europe. The tall stature and upright bearing of the English gentleman was proverbial, and is confirmed in every old photograph of regiment, First XV or Union committee. Five members of Lord Salisbury's patrician Cabinet were more than six feet tall. Salisbury himself was six feet four inches, and Henry Chaplin, his President of the Local Government Board, weighed 250 lb.[1] The average height of Army recruits in 1897 was five feet seven inches and their average chest measurement was 34 inches—substantially bigger than the conscripts of the Continental armies. It was a time of British athletic supremacy; only the Americans could compete. The public school idea of *mens sana in corpore sano* was percolating, in a desultory way, into the upbringing of the masses, and no other people in Europe was so keen on sport—sportsmen on the Continent merely copied what the English did.

These physical advantages were sustained by a detachment of bearing. The most rabid of the New Imperialists were quite proud of the fact that the British were not liked: certainly it was no part of the national ambition to be loved. The British were aware that of all the peoples of the earth they were the most commonly resented, but a shell protected them, composed of pride, duty, shyness and a sense of membership. An Austrian traveller in Egypt at about this time describes the remote composure of a young Cook's official, when a German threatens to sue the company for the loss of his trunk—wildly valued at £200. The Englishman instantly guarantees to pay £200 compensation if the trunk does not show up within an hour. Ten minutes later it arrives, the German is all abashed, and the Austrian ruefully compares affairs in his own Empire: 'How

[1] It was of Chaplin (1840–1923) that Lord Willoughby de Broke once said: 'No one was half such a country gentleman as Henry Chaplin looked.' In 1864 he had been jilted by Lady Florence Paget, who eloped and married the Marquis of Hastings: when Chaplin's horse Hermit won the Derby at 66 to 1 three years later, Hastings lost £140,000 on the race. They lived imperially then.

many underlings and how many Councillors of the Imperial Court would have been needed to register and deal with such a complaint, and how big their file would have grown within six months, and how sure we are that, even six months later, that claim would not be settled!' G. W. Steevens, travelling to Egypt in 1897, describes the all-British company on the mail train to Brindisi: 'Fair-haired, blue-eyed, spare-shouldered and spare-jawed, with puckered brows and steadfast eyes that seemed to look outwards and inwards at the same time, they were unmistakably builders—British Empire builders.' Can one not imagine them, this trainload of bronzed aliens, sharing their private jokes, exuding their particular smells of tweed, tobacco and lavender, as they presented their hand baggage to the customs officials at Modane? It is as though they were encapsuled there, snug in their own ways, honouring their own club rules and rolling securely across Europe to catch their P. and O. Foreigners and subject peoples alike recognized this separateness, and it was essential to the character of the Pax Britannica. This was not so much a haughty Empire as a private one.

3

The aristocracy of Empire was the official class, together with the landed gentry of British planters: in Crown Colonies the two classes often intermarried (in Mauritius and Guiana, so Royal Commissions reported, a prime cause of bad laws and harsh administration). It was not a very aristocratic aristocracy. Viceroys and Governors were often noblemen, and their wives Society beauties—Lady Horton, wife of a Governor of Ceylon in the 1830s, was the subject of Byron's *She Walks In Beauty Like The Night*. British regiments posted overseas contained their quota of young bloods. But the great mass of the imperial service, like the officer corps of the colonial forces, was pre-eminently upper middle class. The English aristocracy played no great part in the everyday running of the Empire, having greener dominions of its own at home, and Eton was low on the list of schools that educated the imperial administrators. '*Here's their ground*', Kipling wrote of India's British rulers:

Imperialists in General

They fight
Until the Middle Classes take them back,
One of ten millions plus a C.S.I.[1]

They were the children of a unique culture, that of the English public schools, with its celibate discipline, its classical loyalties, its emphasis on self-reliance, team spirit, delegated responsibility, Christian duty and stoic control. One did not cry when one said good-bye to Mama at Paddington station. One did not, as a general rule, wish to appear too clever, or too enthusiastic. One loyally upheld the prefectorial system, while realizing that certain rules were made to be broken. The public schools, greatly expanded in the second half of the century, and ever more dedicated to their own code of conduct, lay somewhere near the heart of the imperial ethic. 'It would be terrible to think of what would happen to us', wrote Eustace H. Miles, amateur tennis champion of the world, 'if our public school system were swept away, or if—and this comes to very much the same thing—from our public school system were swept away our Athletics and our Games.' A man's best proof of fitness to rule in India, Miles thought, was to have been a captain of games, and certainly the public school system was well suited to the imperial needs. It produced men of high spirits, courage and assurance, ready to rough it and unafraid of responsibility. If it was intellectually narrowing and chauvinist, well, this was an Empire that survived by the separateness of its rulers, their conviction that what they did was right, and that all else was second best. The public school man was generally able to see the other person's point of view, provided it reflected his own values—civilized values, he would say. His inability to grasp the aspirations of Indians, Africans or Malays stemmed from his absolute certainty that their whole manner of thought or way of life was, through no real fault of their own, misguided. At his worst the public school man was a snobbish hearty: at his best he combined authority with Christian kindness and what he would have called *grit*: the rarest of his virtues was human sympathy, the rarest of his vices cowardice.

[1] Commander, that is, of the Most Exalted Order of the Star of India. In 1967 there were, by my count, seventy-seven living members of this chivalric order, but there will be no more, for conferments ended with the Raj in 1947.

And the most irritating of his traits, at least in the imperial context, seems to have been smugness. From the memoirs of the imperial Civil Services there generally breathes an air of conscious rectitude—disguised often in jollity and boyish dash, but seldom altogether absent. The Empire-builders were very pleased with themselves. 'No country has ever possessed a more admirable body of public servants than the Civil Service of India', wrote Sir John Strachey, a distinguished Indian Civil Servant himself. 'How is it', another Anglo-Indian asked of himself and his colleagues, in a rhetorical question addressed without a blush to his fiancée, who must have loved him dearly—'how is it that these pale-cheeked exiles give security to a race of another hue, other tongues, other religions which rulers of their own people have ever failed to give? Dearest, there are unseen moral causes which I need not point out. . . .'[1] G. W. Forrest, another Indian Civil Servant, once observed how difficult it was for a stranger to disentangle the different social sets of Calcutta—their laws of procedure, their jealousies and their relations with each other. The Official set, however, was easily recognizable: their position was 'by Royal enactment assured', and their wives 'viewed from an eminence' the Mercantile circle below. The imperial protocol was strict and all-embracing—in India, sanitary commissioners and inspectors-general of jails shared seventy-sixth place in order of precedence—and von Hübner tells us that if ever 'members of the lower classes', other than grooms, showed up in Singapore, the Government found means of returning them to Britain, if necessary at its own expense. White prestige must be maintained, and caste was in the air of Empire.

People of grander imagination often disliked these official airs. Bryce thought the average Indian Civil Servant pretty boring—'a good deal of uniformity . . . a want of striking, even marked individualities . . . rather wanting in imagination and sympathy . . . too conventionally English'. Kitchener infuriated the Official ladies of Egypt by his preference for the society of glamorous Levantines.

[1] He was William Hunter (1840–1900), who rose to eminence as administrator and historian, and was knighted. I cannot resist another apposite quotation from his letters home: 'It is useless talking of the poverty of a country's literature unless you do your best to encourage men of letters by buying their works. I have impressed this on my chum, Gribble.'

Winston Churchill, who was in India in 1896 and 1897, did not at all take to Anglo-Indian society. 'A lot of horrid Anglo-Indian women at the races. Nasty vulgar creatures all looking as though they thought themselves great beauties. I fear me they are a sorry lot. . . . Nice people in India are few and far between. They are like oases in the desert. . . . I have lived the life of a recluse out here. The vulgar Anglo-Indians have commented on my not "calling" as is the absurd custom of the country. I know perhaps three people who are agreeable and I have no ambitions to extend my acquaintance.'

4

Poor Anglo-Indians! Twenty-one and very new to the country, Churchill was applying to their provincial attitudes the standards of his own background, glittering with the wealth and genius of London and New York. Life in the official circles of Empire may not have looked exciting to him, but it pursued a staid and comfortable course, much in the tennis-party tradition of the lesser British gentry at home. The scale of things was often grotesquely swollen, though, so that a married couple in India might easily have a staff of twenty-five servants, imposed on them by a caste system even more rigid than their own: bearer, children's nurse, cooks, table-servers, a tailor and a laundryman, a water-carrier, gardeners, grooms and grass-cutters. In camp, if a fairly senior official took his wife on tour, the establishment might grow to fifty or more dependants. Living in what was virtually a private village with this immense *ménage*, the imperialist forfeited any kind of privacy—the servants knew everything—and the manner of life remained supremely orthodox. The planting community of Ceylon, for example, formed as serenely exclusive a community as any county society at home. Planters nearly always married into one another's families, when they returned from their education in England, and they lived a well-ordered country gentry's life. People were normally At Home once each week, and there were frequent calls, and dances at the Queen's in Kandy, and golfing week-ends at Nuwara Eliya, and the bungalows were lofty and cool and lapped in lawns, and there was an English vicar at the church

up the road, and all seemed changeless, useful and very agreeable. The family tradition was strong in the imperial service. The same names appear repeatedly in the honours lists and church memorials, and fathers' footsteps were loyally followed. The two Napier brothers in the Indian Army were the sons of Lord Napier of Magdala, who had served in the Mutiny and virtually created the hill station of Darjeeling. General Henry Rundle, Kitchener's chief of staff in the Sudan, was the son of Joseph Rundle, who had first planted the British flag on Aden soil in 1839.[1] Generations of Stracheys had served in India, and there had always been a Skinner in the 1st Bengal Lancers, since Colonel James Skinner[2] founded the regiment as Skinner's Horse in 1803.

This imperial *élite* was, as conquerors go, well behaved. Its values were solid. Its rules were mostly sensible. Corruption was rare, and what Churchill thought vulgar was often no more than a dogged determination to stick to the habits and traditions that gave the Empire its stability. *Fin-de-siècle* London was rich in scandals of fraud and bankruptcy—the Mundella scandal, the Hooley scandal,[3] the disreputable failure of the Liberator Building Society. Few such disgraces marred the recent record of the overseas Empire. The graft was almost always petty, and there are worse sins to a ruling class than thinking yourself more beautiful than you are.

[1] Rundle (1856–1934) later became Governor of Malta, but his father might not have liked the *Dictionary of National Biography*'s estimate of his military genius: 'He never took a risk, and was rewarded by never meeting a reverse.'

[2] This glorious adventurer was the son of Hercules Skinner, a Scottish soldier in India, by his Rajput mistress. He was apprenticed to a printer in Calcutta, but ran away and joined the Mahratta Army, transferring to the British flag in 1803. Skinner's Horse was originally a body of deserters from the Mahratta forces, placed under Skinner's command, but the title was later transferred to the 1st Bengal Cavalry and Skinner ended his days in respectable glory, Commander of the Bath and landlord of a large estate granted him by the Indian Government. The family have lived in India ever since.

[3] Anthony Mundella (1825–97) had been President of the Board of Trade in Gladstone's last Government: he was a director of the New Zealand Loan Company, and when that company went into liquidation in doubtful circumstances, was forced to resign from office. Hooley was a financier with wide industrial and trading interests: when he went bankrupt it turned out that he habitually bought the names of eminent noblemen, to give respectability to his boards. Scandalous indeed.

5

'They walk dolorously to and fro under the glare of jerking electric lamps, when they ought to be sitting in shirtsleeves around little tables treating their wives to iced lager beer.' So wrote Kipling of Calcutta's commercial community. By now the merchants of Empire, no less than the governors, were mostly men of habit and convention, conservative men who honoured the proprieties. It was not the thing to smoke in the streets of Calcutta, and in the evening, in that city of slums and emaciation, the richer British box-wallahs emerged in top-hats and frock-coats to promenade the Madan, driving steadily here and there in broughams, hansoms and victorias, exchanging bows and transient assessments. There was, however, much more variety to the unofficials of Empire. They come from a wider range of backgrounds, and from the photographs of the time they glare out at us—for there is often something accusatory to their expressions—with striking suggestions of force and originality.

Let us look at a few faces from the imperial gallery of the nineties, chosen at random from a railway camp, a *Spy* cartoon, an African police station and a settlement of the Australian Outback. Here, for a start, is Ronald Preston, the railhead engineer of the Uganda Railway, then under canvas with his gangs half-way to Lake Victoria from the sea. We see him sitting at the entrance to his tent with his wife Florence, wearing a linen suit and a shirt without a tie, and holding a gun across his knees. He has prominent teeth and large ears, and all around him are trophies of the hunt—zebra skins, antelope horns, tiger hides. He looks lean, loose-limbed, a little sad, as though he has been condemned to live for ever under canvas, building railways and shooting animals: and beside him his wife, in a long skirt, mutton-sleeves and a little black boater hat, gazes forlornly out of the picture into the surrounding wilderness, very faintly smiling[1].

It is the White Rajah of Sarawak, Sir Charles Anthony Brooke,

[1] She had reason to look forlorn. The Prestons had already spent half a lifetime building railways in India, and they were never to go home for long. Preston died in Kenya in 1952.

who returns our stare so urbanely from the *Spy* cartoon in *Vanity Fair*. What kingly ease of deportment! What perfection of buttoned frock-coat! How exquisitely symmetrical the heavy white moustaches and the curled grey hair above the high forehead! Brooke has prominent white eyebrows, bags beneath the eyes, a wrinkled turtleneck and a bulky cleft jaw, but above all it is the expression of the face that holds our attention—the expression of a man who makes his own rules, in a sphere of action altogether unique, dealing in subjects that we know nothing whatsoever about, and would be wise not to make foolish comments on.

Haughty in a very different kind is 'Bobo' Young, an employee of the British South Africa Company in north-eastern Rhodesia, who was previously a private in the Scots Guards, and a cook in the Bechuanaland Border Police, and who policed his tribes with a ferocious sang-froid—he once killed twenty-five natives in a single fight. He is pictured sitting with his arms folded, against a prison-like background of a brick wall, wearing a high-collared military tunic, and squinting sidelong at the camera, so that his face looks one way and his eyes another: he has a waxed moustache like a drill sergeant's, his eyes are fiercely gleaming, and his mouth is set in a sardonic, slightly contemptuous smile, such as might shrivel an African chieftain to insignificance, or in another incarnation wither an importunate customer in the cab queue at the Savoy.[1]

And finally a great lady of Empire, Mrs Daisy Bates. Mrs Bates first set eyes on Australia in the middle nineties, a young Irishwoman of literary leanings and polished manners. She had married an Australian cattle-rancher, but was to spend her life in the service of the aborigines, whose fate as a people she assumed to be sealed, and whose last generations she wished to comfort. She was a woman of truly Victorian resolution, and did nothing by half-measures, living for years alone among the tribes, learning their languages, accepting the squalors of their society, and never passing judgement. In our picture we see her setting off by camel-buggy for a particularly ghastly journey around the Great Australian Bight. Beside the two

[1] Young died in England, while watching a cricket match, soon after the First World War, and Lake Young, in the Chinsali district, has reverted to its old name of Shiwa Ngandu—The Home of the Crocodiles.

camels stands a tall and heavily bearded aborigine, smoking a pipe, with a linen hat pulled down over his ears. On the driving-seat, hung about with baggage, pots and pans, is an aboriginal woman all in black, shaggy matted hair protruding from her bonnet: and immaculate beside her sits Mrs Daisy Bates. Her face is stern, her neck is stiff, her hands lie lady-like upon her lap. She wears a high-collared blouse fastened with a ribbon, a severe black coat and skirt down to her ankles, and a white straw hat with a fly-veil over her face. She seldom, indeed, wore anything else: and if the strength of the White Rajah lay in his facial expression, the power of Daisy Bates was in her posture: high up there on her rickety buggy, with aboriginals for company and camels to tow her, she sits superbly, flamboyantly erect, as if to show that a good British upbringing, with sensible corsetry, could fortify a woman against hell itself.[1]

Powerful figures all four, full of sap or gristle, who brought to the developing Empire a vigour all too often tamed by red tape and the hope of promotion, in the secretariat buildings up the road.

6

Among the white settlers everywhere the Englishman had undergone some metamorphosis, making him taller, or broader, or cockier, or coarser, than before. In Canada he was already half an American, neither quite an Englishman nor quite a Yank, and a little conscious of deficiencies in both. In South Africa his accent was beginning to acquire the queerly distorted diphthongs of the Afrikaner. In New Zealand, we read, he was already of a darker complexion, a quicker speech, a livelier manner, a more sociable disposition and a more argumentative turn. In Australia, where he was most conscious of the freedom and freshness of the colonial life, the release from all the old bonds of convention, he was still pre-eminently a man of the open spaces, not yet buttoned by the city ways of the seaboards. The physical splendour of the young Australians was already a legend,

[1] They fortified her for half a century in the Outback. When she died in Adelaide in 1951, aged 90, she knew more about the Australian aborigines than anybody else, and her papers now form part of the Australian National Archives.

and their dialect was rich and beguiling. 'Where are you off to?' asks a character in Tom Collin's novel *Such Is Life*. 'Jist as fur back as I can git,' is the answer. 'But you'll stay in Echuca tonight?' 'Didn't intent. But I'd like to have a pitch with you, sposen I wouldn't be in your road.'

The migrants had taken with them, none the less, old seeds of social consciousness. There were snobs in the colonies too, and in some parts the settlers were evolving class distinctions peculiar to themselves. In New Zealand the English rural hierarchy had suffered a sea-change into orders of a different kind: the gentleman farmer had become the run-holder, the yeoman was the cocky, and yesterday's yokels were the musterers, shearers and drovers of the South. The *élite* of Canada, especially in the Maritime provinces of the east, was provided by descendants of the Empire Loyalists, those unshakeable Tories who had trekked northwards into Canada rather than remain in the American Republic: they often lived beautifully, in white colonial mansions with negro servants and horses, but were by now more like patricians from New England than from Old. In Australia there was a class awareness of a very different kind. There the people known as 'exclusives' were those who had no convicts in their ancestry: among the others, the squalid origins of New South Wales were not often mentioned. 'It is a sore that is not yet healed,' one lady told von Hübner. 'Take care how you touch it: never utter the word "convict".' Even in that free-and-easy nation, the normal social ambitions were stirring, too. By the nineties few of the emigrants to Australia were down-to-earth working men, and urban, bourgeois standards were beginning to count: girls arriving in Australia on immigrant ships often found themselves engaged for domestic service by telegram before they even docked.

For the colonists were British still, brought up in a tradition of social respect. Their ingrained deference towards the manners and customs of the English upper classes did not evaporate when they unpacked their bags in Queensland or Manitoba. They knew that the word 'colonial' often had pejorative undertones in England— suggestions of hick, bumpkin or even criminal—and some of them were already self-conscious about the inadequacies of the colonial cities, so grand and bustling to local innocents, so provincial to

visiting dudes from the Mother Country. The Australian Arthur
Patchett Martin wrote a poem, *My Cousin from Pall Mall*, about
this feeling, describing the arrival in Melbourne of a particularly
superior new-comer:

> *On the morrow through the city we sauntered, arm in arm.*
> *I strove to do the cicerone—my style was grand and calm.*
> *I showed him all the lions—but I noted with despair*
> *His smile, his drawl, his eyeglass and his supercilious air.*
>
> *As we strolled along that crowded street, where Fashion holds proud sway,*
> *He deigned to glance at everything, but not one word did say;*
> *I really thought he was impressed by its well-deserved renown,*
> *Till he drawled 'Not bad—not bad at all—for a provincial town.'*

7

The maverick patrician escaped all this: Lord Henry Paulet with his
Salisbury sawmills, 'Lord Have-One-More' on the Klondike trail,
or Sir Drummond Dunbar, the eighth baronet, whose home at this
time was an uninviting shack in Johannesburg. So did the roving
company of the imperial bums, those loiterers, beachcombers and
scavengers who roamed the Empire from end to end, occasionally
pretending to be Americans when the law was at their heels, but
generally recognizably British. We meet them everywhere. The
sweep of their indigence was marvellously wide, and the same
rogue Briton might turn up in Queensland and Borneo, Egypt and
Rhodesia, wherever the presence of the Empire gave him some
nominal protection and privilege. In the Transvaal, where the
protection was most nominal and the privilege non-existent, most of
the Uitlanders were British, and a wild lot they were—'wanglers',
wrote one contemporary observer,[1] 'workers of snaps', 'fixers-up',
Artful Dodgers and Slick Sams. 'They bribed, they lied, they

[1] Vere Stent, a journalist who accompanied Rhodes on his peace-making
mission in the Matopos, and who described in *Environs of the Golden City and
Pretoria* the impact of the Uitlanders upon the Biblical pastorialism of the
Afrikaners.

swindled. They lived at the best hotels and drank champagne at eleven o'clock in the morning. When not involved in some sordid financial intrigue, they spent their time making open and indecent love to the maids behind the bars set up at almost every corner.'

In the Yukon that summer hundreds of such adventurers were stumbling over the high passes towards the Bonanza creek, many of them fresh from England, many others from Australia or the older goldfields of British Columbia, and hundreds more were wandering through the Outback or the High Veldt, surviving as often as not by grub-staking—pledging a share of any claim they pegged in return for supplies in the meantime. In India many old soldiers of the East India Company army, still drawing a pension of 1/- a day, wandered from job to job, barracks to barracks, often with half-caste wives. Here and there across the Empire we come across the trail of somebody who has deliberately turned his back on his own kind, an imperial renegade, a mystic. The original of Browning's Waring became Prime Minister of New Zealand,[1] but there were others who really did choose 'land-travel or sea-faring, boots and chest or staff and script', and wandered off to be Avatars in Vishnu-land. In a small kraal between King William Town and East London, in South Africa, a blind English lady lived at this time with the Kaffirs, who treated her with kindly courtesy: occasionally they took her into town to beg from the white people, but in the evening she always returned to the kraal, and shared her profits with her hosts. And sometimes the English children of Simla crept up the hill of Jakko, high above the town, to the temple of Hanuman the monkey-god: and there beneath a tree, alone among the monkeys, they would see a young Englishman dressed in the yellow robes of a *sadhu*, with a head-dress made of a leopard skin. He was Charles de Russet, son of a well-known local contractor, who had abandoned his family and his faith to become a disciple of the Jakko fakir. For two years he sat there, all alone. Sometimes an attendant came from the temple, to give him food: and sometimes the children, peering through the brush, would hear the old priest calling his monkey-

[1] He was Alfred Domett (1811–87), who eventually retired to London with a C.M.G.—

Oh, never star was lost here but it rose afar!

children by name to their victuals—*Ajao! Ajao!*—and away they would bound, Raja and Kotwal and Budhee and Daroga, helter-skelter through the undergrowth, leaving the Englishman silent and solitary beneath his tree.[1]

[1] De Russet, 'the leopard fakir', was still in Simla in the 1920s; by then he had apparently forgotten the English language, and lived in a temple below the town.

CHAPTER THIRTEEN

Imperialists in Particular

Oft as the shades of evening fell,
 In the schoolboy days of old—
The form work done, or the game played well,—
Clanging aloft the old school bell
 Uttered its summons bold,
And a bright lad answered the roll-call clear
 'Adsum,—I'm here!'

Heaven send, that when many a heart's dismayed,
 In dark days yet in store,—
Should foemen gather; or, faith betrayed,
The country call for a strong man's aid
 As she never called before,—
A voice like his may make answer clear,
Banishing panic and calming fear,
 'Adsum,—I'm here!'

<div align="right">

A. Frewen Aylward

</div>

13

OF these assorted British Empire-builders, perhaps twenty million were scattered across the world, as settlers, administrators, merchants, soldiers. Yet it was an anonymous Empire. The British public could scarcely name one of its Governors. Laurier was the only Colonial Premier whose name they vaguely knew. Over the past half-century of unprecedented imperial expansion only a dozen heroes had arisen to command the public's loyalty, and many of those were dead. The activists of Empire were remarkable men, but few, and no more than a handful of those alive in 1897, were famous at the time, or would be widely remembered after their deaths.

2

The age of the great explorers was almost over, but there still lived in England one or two of the giants. Sir Henry Stanley, deliverer of Livingstone, impresario of darkest Africa, namer of lakes and discoverer of mountains, was an inconspicuous Liberal-Unionist backbencher, whose election platform had been 'the maintenance, the spread, the dignity, the usefulness of the British Empire'. He was 56, a bullet-headed man with a truculent mouth and a walrus moustache, broadly built and very hard of eye. Nobody in England had led a more extraordinary life. Born John Rowlands in Denbighshire, North Wales, he spent nine years of childhood in the St Asaph workhouse, his father dead, his mother uninterested, under the care of a savage schoolmaster who later went mad. He ran away, worked on a farm, in a haberdasher's shop and a butcher's, and in 1859 sailed as a cabin-boy from Liverpool to New Orleans. In America he was adopted by a kind cotton-broker, and took his name, only to be left on his own again when the elder Stanley died.

A life of staggering adventure followed: war, on both sides of the American Civil War, in the Indian campaigns of the West, in the United States Navy; journalism, with Napier in Abyssinia, in Spain during the 1869 rising, in search of Livingstone for the *New York Herald*; African exploration of the most sensational kind; wealth, great fame, and the long slow struggle for recognition and respect in England. By the late nineties his fighting days were over, and he had become an eminent citizen of mild benevolence, reassuming British nationality, and marrying very respectably in Westminster Abbey. Though the British Empire had not yet recognized his services with a knighthood, he was at least loaded with honorary degrees, and Queen Victoria had herself commissioned a portrait of him, to hang in Windsor Castle. We hear nothing of him in the Jubilee celebrations, though we may assume he joined his fellow M.P.s to watch the procession go by: but it is enthralling to think of him there at all, with his memories of workhouse and celebrity, the colossal journeys into the heart of Africa, the meeting with Livingstone that was to go into the folk-lore, the expedition to rescue Emin Pasha, beleaguered by the Mahdi in the Sudan, which cost 5,000 human lives. Stanley's journey across Africa in the 1870s had led directly to the 'scramble for Africa' which was the mainspring of the New Imperialism. He was the greatest adventurer of the age, an imperial monument in himself.[1]

Edward Eyre was still alive, an imperial specimen of a different sort, whose name had been given to a large bump on the southern Australian shoreline, Eyre Peninsula. Eyre was a Yorkshireman who emigrated, aged 17, with £400 to Australia. He farmed for a time, served as a magistrate and 'protector of aborigines', and discovered a livestock route from New South Wales to the new settlements in South Australia. Then, in 1841, he set off on one of the most desperate of all exploratory journeys, from Adelaide around the Great Australian Bight to King George's Sound in the extreme south-west. One white man and three native boys started with him, but pre-

[1] Before he died in 1904 he asked to be buried beside Livingstone in Westminster Abbey, but this was refused him, and his grave is in the churchyard at Pirbright in Surrey. It bears his African name, Bula Matari, and a single word of epitaph: *Africa*.

sently two of the boys murdered the white overseer and absconded with most of the supplies. Eyre was left with a single aborigine, forty pounds of flour, some tea and some sugar, with five hundred miles of waterless desert behind him, and six hundred ahead. For eight weeks the two men laboured across that terrible slab of country. Often they were reduced to gathering the morning dew in a sponge and sucking it between the two of them: once the aborigine found a dead penguin on the beach, and ate it at a sitting. At Thistle Cove they were picked up by a French whaler, and rested for ten days on board, but Eyre insisted on finishing the journey, went ashore again, and after five months on the march stumbled at last into the settlement at King George's Sound—soaked to the skin, after so many waterless weeks, by rainstorms. It was a perfectly useless adventure, as it turned out. Nothing was discovered, and nothing proved: but Eyre had made his name as one of the most intrepid of the imperial explorers.

By 1897 he was unfortunately best known in England for other reasons. Eyre became Lieutenant-Governor of New Zealand, Governor of St Vincent, and finally Governor of Jamaica, and there, in 1865, he put down a Negro riot with unusually ferocious zeal, killing or executing more than six hundred people, flogging six hundred more, and burning down a thousand homes. He became a figure of violent controversy at home. Ruskin, Tennyson and Carlyle were among his supporters: John Stuart Mill and T. H. Huxley were members of a committee that secured his prosecution for murder. The Eyre Defence Committee called him 'a good, humane and valiant man'. The Jamaica Committee, supported by a strong body of what Carlyle called 'nigger-philanthropists', hounded him for ten years with accusations of brutality. The legal charges were dismissed, and Eyre's expenses were officially refunded, but he was never offered another post. In 1897 he was living in seclusion in a Devonshire manor house, a strange, always dignified and self-contained man. Through it all he had hardly bothered to defend himself—as though the sandy silence of the Outback had muffled his soul.[1]

[1] Eyre, 'the first of the overlanders', died in 1901, and is buried at Walreddon, near Tavistock in Devon.

3

There were only three British soldiers whose personalities had caught the fancy of the public. By the nature of things none had held command in a major war, against equal enemies: but they had all distinguished themselves in campaigns against black, brown or yellow men, and their fame was raised to theatrical heights by the new martial pride of the British.

The first was Garnet Wolseley, Commander-in-Chief of the British Army, who had been fighting small wars, on and off, for forty-five years. He was Anglo-Irish, and loved a good fight. 'All other pleasures pale', he once wrote, 'before the intense, the maddening delight of leading men into the midst of an enemy, or to the assault of some well-defended place'. The first business of any ambitious young officer, he thought, was to try and get himself killed, and this intent he himself pursued in the Burma War of 1852, the Crimean War, the Indian Mutiny, the China War of 1860, the American Civil War, the Canadian rebellion of 1869, the Ashanti War of 1873 and the Zulu War of 1879—in his first twenty-five years of Army life he tried to get himself killed in a war every three years. In 1882 his supreme moment came. Arabi Pasha rose in rebellion against the Egyptian Government. The British intervened, and in a brilliant brief action Wolseley, attacking Arabi from the Suez Canal, defeated him handsomely at Tel-el-Kebir, occupied Cairo, and established the British presence in Egypt. He was given a Government grant of £30,000, created Baron Wolseley of Cairo and Wolseley, and became a popular hero. It was Wolseley who was celebrated as 'The Modern Major-General' in Gilbert and Sullivan's *Pirates of Penzance*, and in the slang of the day 'All Sir Garnet' meant 'all correct'. Even his failure to reach Khartoum in time to rescue Gordon in 1884 did not cost him his public popularity, though it made him many enemies in the Army.

Wolseley was the late Victorian soldier *par excellence*. Technically he was a reformer and something of a prophet. Temperamentally he was arrogant, snobbish, insensitive. Intellectually he was not only exceedingly methodical, but also deeply religious, with a sense of

dedication never quite fulfilled. He relied on favourites in the Army, erecting around himself a 'Wolseley Ring' of officers who had served with him in old campaigns, and who came to dominate, in the absence of a General Staff, the conduct of the late Victorian colonial wars. Some military critics thought Wolseley a fraud, some believed him to be the only great commander of the day, who would in action in a great war, have proved himself a Marlborough or a Wellington. By 1897, at 64, he was a disillusioned man. He thought his luck had turned with his failure before Khartoum, and he was very conscious of his waning powers. Even his reforming zeal, once so virile and direct, seemed to have lost its bite, and jogging along in the Jubilee procession we see his long melancholy face rather like the White Knight's, a little flabby at the jowls—its moustache, its eyebrows, the shape of its eyes, the hang of its mouth, all drooping sadly with advancing age, beneath the plumed cocked hat of a Field-Marshal. He was Commander-in-Chief of the British Army, but not, as he was once said to have imagined himself, Duke of Khartoum.[1]

The second soldier of the Empire was Field-Marshal Lord Roberts of Kandahar, Commander-in-Chief in Ireland and the most popular man in the British Army. Where Wolseley was daunting, Roberts was endearing. Where Wolseley pressed for change and efficiency, Roberts stood for the old traditions. Wolseley's professional appeal was to experts, or to his own tight circle of intimates: Roberts was above all beloved of his private soldiers, who called him Bobs. Wolseley was tall and overbearing. Roberts was small, simple, sweet-natured. If Gilbert caustically honoured Wolseley with *The Modern Major-General*, Kipling serenaded Roberts with *Bobs*:

> *There's a little red-faced man,*
> *Which is Bobs,*
> *Rides the tallest 'orse 'e can—*
> *Our Bobs.*
> *If it bucks or kicks or rears,*
> *'E can sit for twenty years*

[1] Wolseley died in 1913 and is buried in St Paul's. He is remembered by his admirers as having laid the foundations of the British Expeditionary Force which restored the glory of the British Army in 1914.

With a smile round both 'is ears—
Can't yer, Bobs?

Roberts was another Anglo-Irishman, the son of a general, educated at Eton and Sandhurst, and destined to spend his entire life in the imperial service. Until he assumed his Irish command, in 1895, he had never served in Europe—such was the range of a British military career in those days. He was old enough to have taken his commission in the East India Company's Bengal Artillery. He served in the Indian Mutiny, in a campaign obscurely remembered as 'the Umbeyla campaign against the Sitana Fanatics', in Napiers' Abyssinian expedition, and in 1878 he commanded the army that occupied Afghanistan in the second British attempt to master that intractable Power. When, in 1880, the Afghans fell upon the British garrison at Kandahar, Roberts took ten thousand men on an epic relief march from Kabul. As Tel-el-Kebir was to Wolseley, the march to Kandahar was to Frederick Roberts. It caught the public imagination. Mounted on his white Arab, the very horse we have already seen in the Jubilee procession, the trim little image of Bobs rode down the imperial sagas, smiling and imperturbable under the gaunt Afghan hills, with ten thousand faithful Tommies at his heels and a horde of brown savages waiting to be routed at the other end. Roberts became Commander-in-Chief in India, devoting several years to the problems of imperial defence against the Russians, and after forty-one years' Indian service he came home a hero, devout, happily married, victorious and teetotal—

> *'E's a little down on drink,*
> *Chaplain Bobs;*
> *But it keeps us outer Clink—*
> *Don't it, Bobs?*
> *So we will not complain*
> *Tho' 'e's water on the brain,*
> *If 'e leads us straight again—*
> *Blue-light Bobs.*[1]

[1] 'Bobs', after turning the tide against the Boers in the South African War, became the last Commander-in-Chief of the British Army—the office was

And behind these ageing marshals stood the third of the imperial soldiers, and the most formidable: Herbert Kitchener. He was yet another Anglo-Irishman, another soldier's son, but in no other way did he resemble his peers. Set beside Wolseley's languid elegance, or the neat genial precision of Bobs, Kitchener looks a kind of ogre. He was only 48 in 1897, but around him a mystique had long arisen, a glamour which set him apart from other soldiers, and made him one of the figureheads of the New Imperialism. He was huge in stature—six feet two inches in his socks—and terrible of visage, and his life was powered by an overriding and ceaseless ambition. He was aloof to women. He did not care whether his colleagues, his subordinates or his common soldiers loved or loathed him. He had made his early reputation by a series of romantically mysterious adventures among the Arabs—first in Palestine, then in the Sudan, in which he improbably posed as an Arab himself, and under-took various dashing intelligence missions. He had fought under Wolseley in the unsuccessful campaign to relieve Gordon; he had become Sirdar of the Egyptian Army; he was now, with heavy-footed thoroughness, slowly moving up the Nile, month by month, cataract by cataract, towards the capture of Khartoum.

Kitchener was not, like Wolseley and Roberts, a familiar figure in England. His allure was remote and enigmatic. He fascinated some women by his cold detachment; he maddened many colleagues by his ruthless determination to succeed. He was a great organizer but a plodding and sometimes irresolute general, and seen over the perspective of the years he seems, far more than the two Field-Marshals, to have been emblematic of his times. He was too large for life. He was like a great idea somehow overplayed, so that it has lost its edge. He had never in his life fought against white men, and there was to the ferocity of his eye, the splendour of his famous moustache, his immense bemedalled figure and his utterly humourless brand of imperialism—there was to Kitchener, though

abolished in 1904. He spent his last years campaigning for compulsory military service in Britain, and died while on a visit of inspection to the Indian troops in France in November 1914. He is buried in St Paul's.

one might hardly dare say it to his face, something faintly absurd.[1]

4

Alone among the admirals of the imperial Navy stood Sir John Fisher, 'Jacky', Third Sea Lord and Controller, but about to raise his flag in the battleship *Renown* as Commander-in-Chief of the North America and West Indies Station. Fisher was the most brilliant, the most disliked, the most beloved and the most extraordinary of the many remarkable officers of the late Victorian Navy. He was a raging individualist in a service full of eccentrics. He was also one of the few British naval officers to approach the problems of his profession intellectually, to interest himself in the higher strategy as in the new technology, in the social structure of the service and its part in the *real-politik* of the times. Fisher was at once a reformer of violent enthusiasm and a sentimental traditionalist. His personal saint was Nelson, one of his many slogans was *Think in Oceans, Sink at Sight*, and it was he who, asked one evening at the dinner table by Queen Victoria what all the laughter was about at the other end, replied instantly without a blush: 'I was telling Lady Ely, Ma'am, that I had enough flannel round my tummy to go all round this room.'

Fisher's life had been inextricably imperial. He was born in Ceylon, where his father, having retired from the Ceylonese police, had a small coffee estate: and his yellowish complexion and mandarin features seemed to give substance to the legend that his mother was a Sinhalese princess (she was in fact the granddaughter of a Lord Mayor of London). His godmother was the Governor's wife—that

[1] In South Africa old Afrikaners still accuse him of putting ground glass in the concentration camp porridge, during his laborious and implacable campaign against the guerrillas during the last two years of the Boer War. Kitchener became Commander-in-Chief in India, where he crossed angry swords with Curzon, and on August 3, 1914, was appointed Secretary of State for War. He created the New Armies of 3 million men which made Britain a great military Power once more, and was drowned in 1916 when the cruiser *Hampshire*, which was taking him on a visit to Russia, struck a mine off the Orkneys. He never married, and lies as forbiddingly in death as he lived in life, in an effigy of icy white marble just inside the doors of St Paul's.

Lady Horton whom Byron had apostrophized. His godfather was commander of the garrison. Two of his brothers entered the Ceylon Civil Service and two more became naval officers. Before he was 40 Fisher had served in the Mediterranean, the West Indies and the Channel Squadron, had helped to attack the Taku forts on the Peiho River in China, and had commanded the battleship *Inflexible*, the greatest of her day, in the bombardment of Alexandria. But though the Empire had made him, and he was fast becoming one of the most powerful men in the kingdom, he was hardly a New Imperialist. His ebullience was tauter than the rather rambling enthusiasms of the Greater Britain school. He thought of Britain essentially as a European Power, faced always by potential enemies across the Channel, as she had been in Nelson's day. The imperial duties of policing the seas, showing the flag and overawing petty potentates did not excite him, for he knew that when the Pax Britannica was finally challenged it would survive only by the most modern naval expertise. He wanted to concentrate the Navy's scattered strength in three or four massive fleets. He gave the destroyer its name. He was concerned always with gunpower, speed, new kinds of boiler and fuel, with the menace of the submarine and the aircraft. He had blatant favourites and *bêtes noires*, devoted disciples and unforgiving enemies. He made shameless use of the Press. Wherever he went, whatever command he assumed, he turned things topsy-turvy, and shook officers out of their comfortable lethargy. When he commanded the cruiser *Northampton*, so his second-in-command complained, 'we had 150 runs with Whitehead torpedoes in the last 10 days, and the whole Navy only had 200 last year'.

Yet in his person this marvellous man, so obsessed with the severe techniques of his profession, represented almost better than anyone the style of the British Empire, its pungent mixture of quirk, arrogance and good nature. Fisher was a man of tremendous personal charm. He had a passion for dancing: if no women were present he would dance with a brother officer, whistling his own music. He loved sermons, and was often to be seen in garrison churches hunched formidably in the front pew, eye to eye with the quailing preacher. He gloried in show: the flurry of foam at the stern of the Admiral's barge, as it reversed with a flourish to the

gang-plank, the splendour of British battleships sliding into Malta at daybreak, the boyish pleasure of things biggest, fastest, newest. 'The Royal Navy always travels first class,' he liked to say: it was the best navy in the world, serving the best of countries, and Fisher was never ashamed to show it.

And so transparent was this patriotism, so bluff its expression and so fascinating Fisher's personality that to foreigners he seldom gave offence. He was an Admiral of the Royal Navy, and that was that. More still, by the expression on his face, the effortlessly peremptory pose of his body and the irresistible twinkle in his eye, he seemed to exemplify in his person all that the Navy meant to the world. The Sultan of Morocco, once paying a visit to Fisher's flagship, was asked afterwards what had most impressed him, and replied without hesitation: 'The Admiral's face.' To anyone meeting Fisher for the first time the British Empire must have seemed perfectly impregnable. There he sits in his chair, a thick-set man holding his sword hilt, with his cocked hat across his knee, a cluster of medals on his chest and a belt-buckle embossed with the Admiralty crest. He is twisted a little in his seat, looking over the visitor's right shoulder, and his face is an indescribable mixture of sneer, defiance and humorous bravado. His thick-lipped mouth turns down at the corners. His hair is carefully brushed in a cowlick across his forehead. His nostrils appear to be dilated, like a bull's, and the diagonal creases running down from his nose make him look as though he is finding life perpetually distasteful. Yet if you place your hand over the lower half of the face, you will find that the upper half is alive with laughter: there are laugh lines all around the eyes, the big clear forehead looks sunny and carefree, and there is something about the expression that makes you feel even now, across the gulf of so many years, that if Fisher's aboard, all's well.[1]

[1] If I have dwelt too long on Fisher, it is partly because I love him, and partly because he was in a sense to prove the most important man in the Empire. As First Sea Lord he created the battle fleets which won, or at least did not lose, the First World War. Recalled to the Admiralty in 1914, he quarrelled with Churchill, then First Lord of the Admiralty, over the Dardanelles, and resigned furiously in 1915. When the German Fleet steamed in to its surrender at Rosyth, Fisher, the chief architect of its defeat, was not invited to the ceremony. He died in 1920, and is buried in the church at Kilverstone Hall, near Thetford in Norfolk.

5

Of the proconsuls in the field of Empire that summer, two in particular would be remembered: Cromer of Egypt, in his prime, Lugard of East Africa, awaiting bigger things—the one a Baring of the banking Barings, the other the son of a chaplain on the Madras establishment.

Frederick Lugard was 39 in 1897, and already famous. Born inside Fort St George in Madras, he had failed the Indian Civil Service examination, and helped by his uncle, Edward, Permanent Under-Secretary at the War Office, joined the Army instead. But he was not cut out for soldiering. A small, wiry, nervous man, he was adventurous in a solitary kind, a fine shot and an irrepressible big-game hunter, and the first ten years of his adult life were unsatisfying. He served under Roberts in Afghanistan, but was ill, and saw little fighting. He fought with Wolseley in the Sudan, and in Burma in the campaign to unseat Thebaw, the last of the Burmese kings. He tried unsuccessfully to join the Italian forces preparing, in 1887, to fight the Abyssinians for the possession of Massawa. He was short of money, and in poor health, when in 1888 he was invited to join a force raised by the African Lakes Company to protect its interests on Lake Nyasa against the raids of Arab and Swahili slave-traders.

At a stroke Lugard became a convinced and dedicated imperialist. He never went back to the Army. Instead he joined the Imperial British East Africa Company, and at 32 became virtually the father of British Uganda. He defeated the slavers, established a series of stations from the coast to the Nile, ended the wars between Muslims and Christians, made treaties with the local chiefs and finally persuaded the British Government to assume responsibility for the whole country. He became the trouble-shooter of British Africa. In Nigeria he forestalled the French in the occupation of a place called Kikku, beating them to it in a lightning march, and securing the British position in western Nigeria. In Bechuanaland he made a fearful journey across the Kalahari Desert, 700 miles through country devastated everywhere by the rinderpest, to explore a mineral concession. But through all this derring-do he was evolving

a new theory of imperial government, a concept of indirect rule which would enable the natives to maintain their own social and political forms, refined rather than destroyed by the imperial authority. Under his inspiration indirect rule was carried in Nigeria to a pitch of subtlety and complexity never equalled elsewhere. Lugard began as a mercenary of Empire: but he was already acquiring the habits of an apostle, a dedicated champion of imperial trusteeship, of a paternal imperialism which would allow the native peoples to develop, not in their own time, but at least according to their own cultures—while ensuring that the resources of their territories were developed for the benefit of the world as a whole. He was a kind and lonely man, bad at sharing responsibility, excellent at shouldering it. He was one of the very few British theorists of Empire to apply his ideas in the field—the very antithesis of the proper, unobtrusive bureaucrat the Indian Civil Service might have made of him.[1]

What a world away was Cromer, whose power we have already glimpsed in Cairo, and who was now, at 56, in his fourteenth year as para-Pharaoh! Cromer was born to authority, the son of an M.P., the grandson of an Admiral, and a member of one of London's most distinguished banking families—German, probably Jewish, by origin. He was a ruddy-faced man, with short white hair and trimmed moustache, wearing gold-rimmed spectacles and rather nattily dressed. He looked like a surgeon, or perhaps a reliable family solicitor, a serious, calm and balanced man. The wild vagaries of Egyptian life only threw his composure into greater relief. It was Cromer who, fairly and without excitement, had been at the receiving end of Gordon's feverish hates and enthusiasms, telegraphed downriver from the Palace at Khartoum; Cromer who stood halfway between Gladstone and Lord Wolseley, during the tragic campaign of 1884; Cromer to whom the great Kitchener had sent an urgent cable, only a month or two before the Jubilee, asking what he ought to do next, when faced with a tricky military situation up the Nile.

[1] Lugard married, in 1902, Flora Shaw, the famous colonial editor of *The Times*, and reached the height of his fame as Governor-General of Nigeria, by then the largest British Crown Colony. He almost outlived the African empire he did so much to create, for he died, as Baron Lugard of Abinger, in 1945.

Cromer had started life as a soldier himself, serving first in the Ionian Islands in the days when they were a British protectorate, then in Malta and in Jamaica. He went out to India as private secretary to the Viceroy, his cousin Lord Northbrook, and spent a few years in Egypt, before the British occupation, as British member of the Caisse de la Dette. Then, in 1883, he followed Wolseley into Cairo and began his life's work—the reformation and reconstruction of Egypt. He was very grand indeed. In India they had called him Overbaring. In Cairo they nicknamed him 'Le Grand Ours'. Wilfrid Blunt,[1] then resident in Cairo, said his reports were written in a 'first chapter of Genesis style'. He moved with an air of ineffable superiority, and disapproved, as D. G. Hogarth[2] wrote, of 'fantasy, rhapsody and all kinds of unstable exuberance'.

It was his fate to live in a country where every kind of exuberant instability was part of the very climate—a country described by Alfred Milner, Cromer's Director-General of Accounts, as 'unalterably, eternally abnormal'. The longer he stayed in Egypt, the loftier Cromer became. 'The Egyptians', he wrote, 'should be permitted to govern themselves after the fashion in which Europeans think they ought to be governed'—and when he spoke of Europeans he unquestionably thought first of himself. His mandate of power was indeterminate. His use of it was masterly. He was in practice the absolute ruler of Egypt, in whose presence nationalist aspirations repeatedly withered—giving office to any leading nationalist, Cromer thought, would be 'only a little less absurd than the nomination of some savage Red Indian chief to be Governor-General of Canada'. Cromer knew what was best for the country, and to the intense irritation of many of his contemporaries, generally seemed

[1] W. S. Blunt (1840–1922), the son of a Guards officer and the husband of Byron's granddaughter, began life as a diplomat, but was converted to a career of passionate and artistic anti-imperialism by a visit to India in 1883. He was briefly gaoled for sedition in Ireland, and in Egypt, where he had a winter home, was a well-known scourge of British officialdom. He was buried in a wood, without religious rites, at Southwater in Sussex.

[2] Hogarth (1862–1927) was an archaeologist who became Director of the British-organized Arab Bureau in Cairo during the First World War, and helped to sponsor the exploits of T. E. Lawrence. He played an influential part in moulding British imperial policy towards the Arabs, before returning to his peacetime job as Director of the Ashmolean Museum at Oxford.

to be right. Under his command Egypt escaped from bankruptcy and actually produced a surplus. Great irrigation projects were launched. The Aswan Dam was begun.[1] The Egyptian courts were reformed, forced labour was abolished, the railways were rebuilt, the Army was disciplined. It was paradoxical that in Egypt, the most tenuously indirect of British possessions, British imperialism should have come closest to the classic form of the ancient conquerors: a personal despotism, that is, characterized by the imposition of a new order upon a demoralized people, and the building of great engineering works. Almost alone Cromer left this mark upon Egypt, like an off-stage Alexander—for from first to last his official rank was that of Consul-General of Great Britain, and his modest palace was only the British Consulate. The Egyptian Princess Nazli Fazil was once visiting her cousin the Khedive of Egypt when they heard a policeman's shout far down the street, and the rattle of wheels. The Khedive paled. 'Listen,' he said, 'I hear the cry of the runner in front of Baring's carriage. *Who knows what he is coming to tell me?*'[2]

6

Two politicians of very different stamp set the pace and style of the New Imperialism: Lord Salisbury, who was both Prime Minister and Foreign Secretary; Joseph Chamberlain, the Colonial Secretary. They were the two most striking members of the Conservative Unionist Government which had, in 1895, so overwhelmingly defeated the Liberals: but in many ways they were antipathetic to one another, and they sometimes seem like men from different ages, joggled out of sequence.

Lord Salisbury was almost the last of the hereditary Prime Ministers of England—Prime Ministers, that is to say, whose claim to leadership had been inherited from generations of landowning

[1] It was completed in 1900, and has been successively heightened since, and provided with hydroelectric turbines. It stands downstream from the High Dam begun by a later 'Le Grand Ours', Gamal Abdel Nasser.

[2] Cromer remained in Egypt until 1907, and did little else in life beyond writing his magisterial memoirs, *Modern Egypt*, and fitfully presiding over the commission that inquired into the débâcle of the Dardanelles. He died in 1917.

forebears. He was also the last to sit in the House of Lords. He was a Cecil, the third Marquis, who had been Prime Minister twice before, and who stood supremely above convention, sham or even political intrigue. It did not seem to matter much to him whether he was Prime Minister or not. He was an astringently intellectual man, passionately interested in science and religion, fearfully short-sighted and intermittently depressed. He disliked sport, and lived superbly at Hatfield, the seat of the Cecils, where he entertained almost nobody, but worked in his private laboratory, tinkered with his electric lighting, and prayed in his private chapel each morning before breakfast. Salisbury was 67, and a disillusioned believer in the *status quo ante*—the privilege of rank, the rights of power. With his high domed head, his sad accusatory eyes, his great tangled beard and his shabby clothes, he stood uncompromisingly for the patrician superiority of Britain, defying the advance of democracy. He did not bother with discretion. He was intemperate, sarcastic, moody. Beneath his hand the great Empire itself seemed to lie like a family property, managed more shrewdly than you might suppose, and brooking no damned impertinence from neighbours.

There was nothing vulgar to Salisbury's conception of imperialism. He was a European by taste—he wintered at his house in France—and Empire was not, to his mind, an end of itself. It was an instrument of national policy, to be exploited this way or that as British interests demanded. It was under his direction, in previous Conservative Governments, that Britain had dominated the partition of Africa, extending her possessions east and west, and establishing in effect a totally new Empire, different in kind from the old dominions. Salisbury did not see the process, though, as a land grab. He was thinking always of Britain's traditional concerns—the security of her routes to the east, the balance of power in Europe. Flamboyant visions of universal power did not appeal to him—he described the Cape-to-Cairo railway as 'a very curious idea lately popular', and very willingly scotched it by allowing Germany to move into East Africa. 'British policy', he once said, 'is to drift lazily downstream, occasionally putting out a boathook to avoid a collision.' It was Salisbury who sanctioned the reconquest of the Sudan, the acquisition of Uganda, the seizure of upper Burma: but

glory *per se* never egged him on, and they were cold and reasoned impulses that guided his policy.

He manipulated the bargains of Empire like a stockbroker: he swapped Heligoland for Zanzibar, swapped Bornu for parts of Algeria, recognized France in Madagascar in exchange for French recognition of a British Protectorate in Zanzibar. His transactions in West Africa formed a delicate web of diplomatic give-and-take, conducted always with larger purposes in mind. He defied the Monroe Doctrine when there was a dispute with Venezuela about the frontiers of British Guiana. He forced the Portuguese to recognize British suzerainty over Matabeleland. But all was done with a meticulous reserve—no flag-wagging, no tub-thumping, only an old professional skill, that touch of almost Renaissance finesse which was to give the British Foreign Office, for so many years to come, a reputation beyond its merits. Salisbury loathed sentimentality, cant, purple passages. No thrilling cadences of imperial romance emerged from his Parliamentary speeches. He lacked the gift of popular inspiration, if only because the public did not greatly interest him. But behind all the jingo of that time, somewhere behind all the calls to duty, the civilizing mission, the Flag, the Race and the White Man's Burden, Salisbury's fastidious mind controlled the energies of Empire, keeping it always within the limits of the possible, the rational and the peaceful. It was only a phase in the island history. England had neither lasting friends nor lasting enemies, nor even a providential destiny: only interests.[1]

Salisbury was a remote enigma to the British public. The front man of his Government was indisputably 'Joe' Chamberlain. In an administration of patricians, Chamberlain was a bourgeois—an ex-Mayor of Birmingham, who had made his fortune with a screw factory: but he had a gift of attracting attention, and he had made his own the dazzling cause of the New Imperialism. He had seen it for what it was, the most promising political vein of the day, and

[1] Salisbury stuck out the years of the Boer War as Prime Minister, resigning in 1902 after a total Premiership of thirteen years and ten months. A year later he died, and was buried in the churchyard at Hatfield, where Cecils had lived since 1608—as they still do.

when he was invited to join Salisbury's Government, astutely chose for himself the Colonial Office. He was a Liberal-Unionist, who had parted company with Gladstone over the issue of Home Rule for Ireland—an obvious bridge to the haven of the New Imperialism. By now he was associated in everyone's mind with Greater Britain, the Expansion of England and the other catch idioms of the movement. They called him 'Minister for Empire', and he had long since learnt, so he said, to 'think imperially'. This was no politician's pose. Chamberlain had once been a fervent anti-imperialist, but he had come to believe that the expansion of the Empire, and its consolidation into one immense Power, should be the first end of British policy, the one sure way of keeping Britain among the great Powers. 'It seems to me that the tendency of the time is to throw all power into the hands of the greater empires, and the minor kingdoms— those which are non-progressive—seem to be destined to fall into a secondary and subordinate place. But if Greater Britain remains united, no empire in the world can surpass it in area, population, in wealth, or in the diversity of its resources.'

Chamberlain was not a product of the gentleman's culture. He was not at Oxford, Cambridge, or one of the great public schools. He was a Unitarian by faith, a radical in domestic politics. He stood alone in that ultra-gentlemanly administration: as Arthur Balfour said of him, 'Joe, though we all love him dearly, does not form a chemical combination with us.' He was more like a colonial politician than a colleague of Lord Salisbury, and he held an irresistible appeal for the masses of the nineties, who loved flash. He kept the Colonial Office, once so dim and musty, blazing in the limelight— and even persuaded those chaste first-class clerks to welcome the change. He invested his own money in a 20,000-acre sisal estate in the Bahamas, and sent his son Neville to manage it. He concerned himself with colonial finance, colonial trade, tropical medicine, and the world's hostility at the time of the Jameson Raid only strengthened his vision of a united Empire, ready to take on all comers. 'Let us do all in our power by improving our communications, by developing our commercial relations, by co-operating in mutual defence, and none of us will ever feel isolated.' It was Chamberlain who coined the phrase 'trade follows the flag', and so

passionately did he come to believe in the Empire as a whole that he once exclaimed: 'England without an Empire! Can you conceive it? England in that case would not be the England we love.' He stood for a Greater Britain ostentatious in its power. 'I don't know which of our many enemies we ought to defy,' he wrote in 1896, 'but let us defy someone.'[1]

In bizarre tandem this able man worked with Lord Salisbury in the aggrandizement of Empire. Beside Salisbury's dishevelled melancholy, Chamberlain stood preternaturally elegant, an orchid in his buttonhole, a monocle in his eye, beautifully tailored and, in an era of ponderous whiskers, clean-shaven. Salisbury was magnificently nineteenth century, but Chamberlain would have looked, if remarkable, at least not blatantly out of period thirty years later. It is hard to believe they liked each other, and certainly Salisbury was often repelled by his Colonial Secretary's strident kind of patriotism. He once complained that Chamberlain wanted to go to war with every Power in the world, and had 'no thought but Imperialism'. The combination of the two men, nevertheless, was very effective. Salisbury's calculated policies steered Great Britain carefully and quietly through some exceptionally treacherous waters, enabling her almost incidentally to seize a lion's share of Africa without a European war. Chamberlain's spectacular vision of grandeur convinced the electorate that this was the proudest moment of all British history, not merely a culmination, but a threshold of still immenser triumphs.

7

The men Kipling called 'the doers' were mostly unknown: the engineers and the prospectors, the merchant princes and the tropical doctors. Two of them only had achieved an international reputation —or notoriety: Cecil John Rhodes and his assistant and protégé, Leander Starr Jameson. In the summer of 1897 these two men were

[1] When the Government resigned after the Boer War, Chamberlain threw himself into the cause of imperial unity. He died in July 1914, happy to see that young Neville, a leading member of Birmingham City Council, was already on the way to political distinction.

both half-discredited by their parts in the Jameson Raid, but to many New Imperialists they were heroes still, and the Raid was seen only as an endearing excess of boyish dash. Rhodes and Jameson scarcely figured in the celebrations of the Jubilee, but they expressed for many Britons the grand fling of the Empire, roguery and all.

,Jameson was as odd a doctor as ever took the oath. The son of a Scottish lawyer, the grandson of a Scottish general, an M.D. of University College, London, he would seem on paper cut out for a life of cautious convention—a sound Edinburgh family physician, perhaps, or the trusted confidant of lairds. Instead his life was one of rip-roaring excitement, catastrophic ups and downs. He broke away early. He was a successful young doctor in London when, at 28, he sailed to South Africa for his health, and set up a practice in the mining town of Kimberley. It was a risky decision, and proved characteristic. Jameson was a neat, witty, good-looking young man, with the gift of charm, but he was above all a gambler. He was more like an Irishman than a Scot. Legend says he once lost all his possessions in a poker game, but won them back later in the evening: and as he plunged into politics, and the work of Rhodes's British South Africa Company, the headstrong bidding of his card-playing was applied to greater stakes. Jameson achieved all by his winning ways. He charmed the hard mining community of Kimberley into being his devoted patients—'Dr Jim', they called him. He charmed Rhodes into patronage. He charmed poor Lobengula into allowing Rhodes's pioneers to cross his territory. He charmed the squabbling settlers of Salisbury out of successive attacks of dudgeon. He charmed half England when, at the commission of inquiry into the Jameson Raid, he observed with touching candour: 'I know perfectly well that as I have not succeeded the natural thing has happened: but I also know that if I had succeeded I should have been forgiven.' Jameson was always frank about his part in the Raid. He had launched it prematurely, and had hopelessly failed in what was really a squalid error of judgement. He was charged in England with an offence under the Foreign Enlistment Act, and spent some time in Holloway Prison, where he nearly died: but he had the born gambler's resilience, and by the summer of 1897 he was past the worst of his ignominy, and at

44 was already planning a return to profit and politics in South Africa.[1]

He had something of Quixote to him, tilting away so endearingly at his windmills. Beside him Rhodes appears a powerful Sancho, so solid, so practical, so ready nevertheless to indulge in airy fancies and absurdities. There was something almost unreal to the scale of Rhodes. He was nicknamed the Colossus, of course, and of all the New Imperialists he most looked the part. He had a Roman face, big, prominent of eye, rather sneering—just such a face as a police reconstruction might compose, if fed the details of one who was both a diamond millionaire and a kind of emperor. There was a shifty look to Rhodes, but it was shiftiness in the grand manner, as though he dealt in millions always—millions of pounds, millions of square miles, millions of people. He was distrusted as often as he was admired, not least by British colonial officials. In 1891 Sir Harry Johnston, 'Commissioner and Consul-General for the territories under British influence to the North of the Zambesi', named a new British strongpoint in Rhodes's honour: but it was noted that he chose one of the least important and most pestilential outposts in the whole of the slave country. (When, a few years later, it was taken within the territories of the South Africa Company, its name was hastily changed to Kalungwishi.)[2]

Rhodes was first of all a money-maker. A millionaire before he was 35, he took five years to get his pass degree at Oxford, because he spent so much time supervising his diamond interests in Kimberley. The fifth son of an English country parson, he first went to South Africa to help his brother grow cotton in Natal, where the climate was thought to be better for his asthma: it was only in the second half of his life that he conceived a vision of Empire in some ways more naïve, in some ways nobler, and in all ways more spacious than

[1] To wit, presidency of the B.S.A.C., premiership of the Cape, a baronetcy and membership of the Privy Council. He died in 1917, in England, but after the First World War his remains were transferred to Rhodesia to be buried beside those of Cecil Rhodes in the Matopo Hills. Kipling honoured him with *If—*.

[2] It survived until 1908, when it was abandoned because of the tsetse fly, and of this original Rhodesia there is now not a trace, on the ground or on the map.

anyone else's. To Rhodes the British Empire was to be one of the revelations of human history, a new heaven and a new earth. In 1877, at 34, he made his first will, leaving his money for the formation of a secret society to extend British rule across the earth. He then foresaw the occupation by British settlers of the entire continent of Africa, the Holy Land, the whole of South America, the islands of the Pacific, the Malay archipelago, the seaboard of China and Japan. The United States would be recovered, the whole Empire would be consolidated, everybody would be represented in one Imperial Parliament, and the whole structure would form 'so great a power as to hereafter render wars impossible and promote the best interests of humanity'.

Rhodes's achievements fell pitifully short of these Olympian prospects. He failed to build his Cape-to-Cairo Railway, or even to unite South Africa under the British flag. His one great political creation, Rhodesia, was presently to prove a perilous anachronism —a white State set defiantly in a black continent. In 1897 he was 44, and had fallen to a nadir in his affairs. He was seen by more restrained imperialists as a mere shady speculator, extending his unsavoury activities from diamond-mining to statesmanship, and masking all in high talk. His grand idea, though, survived it all. He really thought of the Empire as an instrument of universal peace. There was nothing niggling to his imperial sentiments: he got on well with Boers and with African chiefs—he had obvious affinities with both—and he even contributed funds to the Irish Home Rulers, the bitterest of all the Empire's opponents. He hoped his name would be associated always with an idea 'which ultimately led to the cessation of all wars and one language throughout the world': and all the time, through all the fluctuations of his fortune, he was perfecting his scheme for the Rhodes Scholarships, which would take 'the best men for the world's fight' from the English-speaking countries of the earth, send them to Oxford to be polished in England's civilization, and distribute them through the Empire to fulfil his dreams. Of all the New Imperialists, Rhodes was the most genuinely inspired, and in the end most nearly justified his vision. William Blane, the South African poet, wrote truly of this misleading man:

Imperialists in Particular

Not from a selfish or sordid ambition
Dreamt he of Empires—in continents thought:
His the response to that mystic tuition,
From the great throb of the universe caught.[1]

8

There were other exceptional imperialists, of course, waxing or waning in Britain then—politicians like Dilke and Rosebery; future proconsuls like Curzon and Alfred Milner; George Goldie, the Rhodes of the Niger Basin; Frank Swettenham, the Raffles of Malaya—not to speak of the handful of seers and artists and journalists who had given the imperial idea its transcendent glamour. Our twelve celebrities, though, may stand as champions for them all, the stars of the imperial show, a strange and gaudy company of performers, above whose nodding plumes and ruthless ambitions there sat only the one supreme imperial presence, Victoria R.I. The Queen-Empress was the image and summit of Empire, revealing in herself many of the strains of the British imperium—proud and often overbearing, but with an unexpected sweetness at the heart; suburban and sometimes vulgar, sentimental, in old age less beautiful than imposing; girlishly beguiled by the mysteries of the Orient, maternally considerate towards the Natives, stubbornly determined to hang on to her possessions; seduced by high words, dazzling persons, high-arching projects, colours; impatient of things small, meticulous or self-effacing; a formidable lady indeed, but old, very old, and portly in her long dresses, so that when she sat sculptured on her throne, in the public gardens of Aden or Colombo, Kingston or Melbourne, she seemed less a person than some stylized divinity—a goddess inescapable, glimpsed through screens of

[1] Rhodes never overcame the stigma of the Jameson Raid, but in 1899 Oxford, stifling its scruples, awarded him an honorary degree. This he amply repaid by signing a new will, a few days later, which left the University enough funds to establish 160 scholarships for colonial, American and German students. Rhodes died in 1902, and was buried at a site of his own choosing in the Matopo Hills in Rhodesia, which he called The World's View. There, in a place of silent beauty, he lies with his friend Jameson and the dead of Allan Wilson's Shangani patrol—all the heroes of Rhodesia, awaiting one fears not the Last Trump but the next régime.

banyan trees or rising tremendous above banana groves; goddess of wealth, age, power, so old that the world could hardly remember itself without her, and an era already bore her name. She *was* the Pax Britannica, and geography recognized the fact, with towns called Victoria in West Africa, Labuan, Guiana, Grenada, Honduras, Newfoundland, Nigeria, Vancouver Island, with Victoriaville in Quebec, the Victoria Nile in Uganda, the Colony of Victoria in Australia, with six Lake Victorias, and two Cape Victorias, with Victoria Range, Bay, Strait, Valley, Point, Park, Mine, Peak, Beach, Bridge, County, Cove, Downs, Land, Estate, Falls, Fjord, Gap, Harbour, Headland and Hill—setting such a seal upon the world, in cartography as in command, as no monarch in the history of mankind had ever set before.

CHAPTER FOURTEEN

Proconsuls

The sense of greatness keeps a nation great;
And mighty they who mighty can appear.
It may be that if hands of greed could steal
From England's grasp the envied orient prize,
This tide of gold would flood her still as now.
But were she the same England, made to feel
A brightness gone from out those starry eyes,
A splendour from that constellated brow?

William Watson

14

NORTHWARD from the Punjabi village of Kalka a winding and precipitous tonga road ran into the foothills of the Himalaya, the air becoming sweeter, the heat less oppressive as it climbed. There were pines and deodars about, and monkeys. High on a ridge to the east the traveller could see the military sanatorium of Daghshai, two or three barrack blocks and a very English church, poised on a narrow ridge overlooking the plains, and breathing the mountain air from the north. There was the bazaar town of Solon to pass on the way, where the local beer was brewed, and where swarthy hill-men, turbans fluttering, strode with sticks through scented market alleys: and then the road ascended steadily, in loops and double-tracks into the hills. It was a busy road throughout the summer, as the tongas of the British, blowing their horns, clip-clopped smartly through the labouring strings of mules, carts and livestock: and for one period of every year it became the most important road in India. Then, at the beginning of the hot season, the Viceroy himself took it, to escape from the miseries of Calcutta: and with his guards and his secretariat, his private staff and his public attendants, his Army headquarters, his Foreign Office, the envoys of foreign Powers, the Lieutenant-Governor of the Punjab, the representatives of the Indian Princes—with an infinity of files, an army of wagons, garries and chaises, the memsahibs with their carriage trunks and excited children, hangers-on of every kind, adventurers of every aspiration—bands and flags, foreign correspondents and Tailors By Appointment, military observers, Thomas Cook's men, bank clerks and estate agents and visiting parliamentarians—with all this caravanserai before and after him, up the Queen's Viceroy went to Simla, the summer capital of the Indian Empire.

2

Simla in 1897 was one of the most extraordinary places in the world. It was small, and set delectably in a bowl of the hills, in tiers on the south side of a ridge like an English watering-place, except for the grand mass of the Himalaya behind. From a distance it looked archetypically Anglo-Indian. Scattered among the wooded hills were the chalet-bungalows of the senior officials, and properly on an eminence stood the Gothic tower of Christ Church, with a bell made out of a mortar captured in the second Sikh War. There were pleasant gardens about, and a comfortable esplanade meandered along the ridge, with tea-shops here and there, and Wine, Spirit and Provision Merchants of Quality, and Hamilton's the jewellers from Calcutta (Established in the Reign of George III), and Phelps and Co., Civil, Military and Political Tailors, in their establishment at Albion House. A little lower a smudge of smoke and shanties marked the location of the Indian bazaar, and the town spilled away down the hillside in diminishing solidity, petering out in huts and shacks, until only the road itself was left threading a way through the trees to the distant plains below. At first sight Simla looked exactly what one would expect of a British hill station —quiet, sedate, and logically laid out.

This was not its style at all. Simla was a very brilliant, savage, ugly little town. The air was electric, thin enough to make you pant upstairs at first, sharp enough off the snows to keep you un-naturally alert and vivacious, almost feverish. No carriages were allowed in the centre of the town, except those of the Viceroy, the Commander-in-Chief and the Lieutenant-Governor of the Punjab, so when you arrived there a porter hoisted your baggage on his back and led you stumbling up steep steps and winding lanes to your hotel: and when you strolled out through the lights of the evening for a first look around Simla, somehow the place did not feel quite solid. It was like a stage set, quivering, full of charac-ter actors, walking fast and talking hard. There were the British themselves, of course, glowing with the thrill of the move to the mountains, marvelling in their escape from the sultry oppression

of the plains and the sea-coast, looking forward to the balls and parties of the season, and pulling their wraps wryly around their shoulders as the evening chill set in. There were the hill Indians of the north, whom the British loved, warlike and confident people, with beards and gay colours on them, no nonsense about political rights and a steady hand with a rifle. And here and there in the streets, giving Simla a tantalizing hint of unknown places beyond the mountains, there strode groups of swarthy Tibetans—wide-set eyes and perpetual laughing chatter, bottle-green gowns open to the waist, pigtails, entrancing babies on their mothers' backs and a smell of untanned leather. There was an Italianate fizz to the piazzas of Simla after dark, as the evening crowds swung here and there, the lights shone out from shops and theatre, and down the steps off the Mall the bazaar people moved in silhouette against their flickering fires, in a haze of spice and woodsmoke.

3

In the morning Simla seemed different again, for in the brilliance of the mountain sun one could see with an awful clarity the monuments of its power. The style the British evolved for their offices in Simla was brutally functional. It depended upon girders. Each huge block, surrounded by open verandas, was held together with iron stanchions, like a bridge. This suggested to different observers, at one time or another, piles of disused tramcars, monstrous toastracks, or the remains of junkyards salvaged by economical military engineers and put together wherever pieces could be found to fit. Stark, square and enormous, these preposterous buildings stood about the ridge with an air of plated aloofness, like armadillos, facing this way and that, with roofs of corrugated iron and complicated external staircases. Physically they cast a blight upon the town: and there was something dismal to the thought of the scribbling hundreds inside them, the cogs of an Empire revolving in so many iron boxes on a hillside.[1]

[1] When Sir Edwin Lutyens (1869–1944) went to India in 1913 to build the new imperial capital at Delhi, he inspected Simla first and was appalled. 'If one was told the monkeys had built it all one could only say, "What wonderful monkeys—they must be shot in case they do it again. . . ." '

The Mall ran among them, gently undulating, sometimes opening out into a square in the Venetian manner; and sheltering demurely out of the limelight, up garden paths lined with dahlias or lupins, were the houses of the great, with names like Snowdon, Knockdrin, Hawthorne and The Gables. The Commander-in-Chief lived in one, the Foreign Secretary in another, the Manager of the Mercantile Bank in a third, and above and beyond them all, with a private chapel and sundry staff houses, was the Viceroy's new palace, finished in 1888 and decorated throughout by Messrs Maple and Co., of Tottenham Court Road.

It was a surprisingly long way from one end of Simla to another —from Barnes Court, say, where the Lieutenant-Governor of the Punjab lived, to the Viceregal estate behind its monumental guardhouse at the western extremity of the ridge. A few old *jhampans* could still be hired—curtained sedan-chairs like four-poster beds, carried by four coolies apiece: but the normal means of public transport was the four-man rickshaw, a wickerwork vehicle on high spindly wheels, which was propelled at dizzy speed through the streets, its crew alternately heaving, braking, swivelling and pushing with the desperation of tobogganers, and reaching a climax in their kinetic energies in propelling the thing fast enough down one hill to get it up the steep slope of the next.

4

Seven thousand feet up, eighty miles from a railway line, 750 miles from a port, Simla was the oddest and most inaccessible of the world's great capitals. The mails were conveyed to railhead at Kalka by two-pony tongas, at breakneck speed, but the road was so rough that they sometimes had their springs packed with bamboo wrappings to lessen the jolts, and when the rivers near Kalka were flooded elephants sometimes had to be commandeered, to convey the imperial dispatches across the waters to the Viceroy.

From Simla were directed the affairs of 308 million people—two and a half times the population, by Gibbon's estimate, of the Roman Empire at its climax—protected by the greatest army in Asia, and forming a pendant to Britain itself in the immense balance of

Empire. The world recognized that India was a great Power in itself. It was an Empire of its own, active as well as passive. Most of the bigger nations had their representatives at Simla, and the little hill station on the ridge cast its summer shadow wide. Its writ ran to the Red Sea one way, the frontiers of Siam the other. Aden, Perim, Socotra, Burma, Somaliland were all governed from India. Indian currency was the legal tender of Zanzibar and British East Africa, Indian mints coined the dollars of Singapore and Hong Kong. The proliferation of India, as we have seen, was represented by hundreds of thousands of her citizens scattered across the oceans, and the Indian Army, too, had seen service in many parts of the world. When Indian troops were sent to Malta in 1878 it aroused a furore in England, and Disraeli was accused of selling the Empire to the barbarians. Since then the use of Indian troops in other parts of the Empire had become a commonplace. In the past half-century Indian soldiers, under British officers, had served in China, Persia, Ethiopia, Singapore, Hong Kong, Egypt and East Africa, and in 1897 they were advancing up the Nile with Kitchener. It was the possession of India that made the Empire a military Power—'an English barrack in the Oriental seas', Salisbury had once called it. Its Regular Army was not large—some 160,000 men—but it was all voluntary, and it was recruited chiefly from the martial peoples of the north, Sikhs, Punjabis, Pathans, whose fighting qualities were celebrated everywhere.

It was from Simla, in the summer-time, that the British supervised the eastern half of their Empire. Upon the power and wealth of India depended the security of the eastern trade, of Australia and New Zealand, of the great commercial enterprises of the Far East. The strength of India, so many strategists thought, alone prevented Russia from spilling through the Himalayan passes into south-east Asia, and the preoccupations of the generals in Simla were important to the whole world. 'Everything is so English and unpicturesque here', the artist Val Prinsep[1] wrote during a visit to Simla, 'that

[1] Prinsep (1838–1904) was the son of a well-known Indian administrator, and a nephew of James Prinsep of Prinsep's Ghat. Born in Calcutta and destined for the I.C.S. himself, he took up art instead, returning to India only to paint, on Government commission, a picture of the great Durbar of 1877, when Victoria was proclaimed Queen-Empress.

except the people one meets are those who rule and make history—a fact one can hardly realize—one would fancy oneself at Margate.'

It *was* hard to realize, but it was true. There was substance to the fantasy of Simla. The British did their best to live up to the grandeur of their position, and though the town was commonly known to disrespectful juniors as The Abode of the Little Tin Gods, still a good deal of solid splendour surrounded the arrangements up there. The Viceroy himself was to be glimpsed on Sunday mornings resplendently driving to church in his carriage, a weekly second coming. His palace on the hill was so luxurious that many people thought Indian income tax, introduced in 1886, had been devised to pay for it. Its household staff comprised 300 domestics and 100 cooks, and in one recent season the Vicereine had presided over twelve big dinners (up to fifty guests), twenty-nine small ones, a State ball, a fancy dress ball, a children's ball, two garden parties, two evening parties and six dances of 250 people each. The guards at the gatehouse, inspired by all this display, used to salute with such a reverberation of small arms that more than once the horses of eminent visitors had been known to turn tail at the clash, and bolt headlong back along the Mall.

In this capital as in any other, the social graces and felinities intensely thrived, and the suburban instinct of Victorian life, fostered so paradoxically by the Queen-Empress, found its strangest expression in Simla. The houses of the Field-Marshals and Foreign Secretaries were not, as foreigners might expect, replicas of great country houses at home, such as might be said to illustrate the patrician flowering of England. Still less did they model themselves upon the palaces of earlier Indian conquerors. They were essentially villas, often done in half-timber and plaster, with decorous gardens and gravel drives, ferns in hanging wire baskets, and gates with their names upon them. With their mullioned windows and the ramblers entwined about their porches, they looked all lavender leisure: except for the swaggering Sikh guards who paced, with scimitars and tremendous beards, up and down outside the threshold.

Brittle, vivid, snobby, like all centres of power Simla seethed with ambition and intrigue. Society was overwhelmingly official—only Army officers and Civil Servants, for example, could be full

members of the principal Simla club—and there was a hot-house feeling to the place. Peliti's restaurant, beside the bridge at the eastern end of the Mall, was the traditional hotbed of gossip, where an excellent view might be obtained of the current scandal, and the latest handsome arrival from the Frontier, or winsome bride fresh out from Hertfordshire, might be viewed and analysed to advantage. This was the hunting-ground of Kipling's allegorical Anglo-Indian chatelaines, those *grandes dames* of Empire, with the adoring young subalterns and civilians at their feet, and their private channels of communication, via Tony or dear Major Lansdowne, direct to the Secretariat itself. Kipling, heightened his effects, but there really was a good deal of philandering, gambling and heavy drinking in Simla: if visitors from England thought it like Margate, to innocents from upcountry, where the nearest thing to vice was often a round of gin-rummy over a hurricane lamp, it sometimes seemed a very Paris.

The English in Simla knew each other, for the most part, all too well. They had grown up together in the imperial service, and they had few illusions about each other or each other's wives. It was the outsiders who were taken aback by the place: the Vicereines, who had often never been to India before, and generally loathed Simla, or the young girls fresh from England, to whom this high and startling place, rich with scarlet uniforms and brown young English faces, must have seemed one of the most exciting towns imaginable. Everything was overdrawn at Simla. Eight balls and dances at the Viceroy's Lodge alone! Even the monkeys were so bold that they habitually came through people's windows to steal fruit, and could often be heard thrumming with their feet on the iron roofs above: and constantly through the gossip and the music of the string orchestras ran the murmur of great power, a *basso profondo* to Simla's frivolities.[1]

[1] Simla, now the capital of a hill province called Himachal Pradesh, has changed surprisingly little, though it has not been the summer capital of India since the Second World War. Its size is much the same, and there are still no wheeled vehicles, rickshaws excepted, in its central streets. The Viceregal Lodge is now the Indian Institute for Advanced Studies. The great Government buildings are military headquarters of one kind or another, or provincial offices. The Tibetans in the streets have been augmented by

5

The British Government in India was a despotism of great efficiency, in which the Indians had virtually no say. The lower echelons of the administration were filled mostly by Indians, those babus whose humble respect, elaborate Welsh-sounding English and pitiful efforts to Westernize themselves so amused and irritated their rulers. In the middle ranks there were many Indians in minor executive positions, office superintendents, assistant secretaries, extra assistant commissioners. But the Indian Civil Service proper, the senior branch of the Government, was almost locked. Indians were free to compete in the I.C.S. entry examination, but the odds were heavily weighted against them. Their education was not geared to the examination, the papers were in English, they had to go to London to sit—the journey itself was against the tenets of Hindu orthodoxy, and some of the earliest Indian candidates dared not tell even their own parents that they were going. By 1897 only a few very clever Hindus and Parsees had managed to get in, and were acting as assistant magistrates and collectors: for the rest the I.C.S., the real Government of India, was absolutely British.

At the top of it stood the Viceroy, who combined the offices of a President and a Prime Minister, was responsible only to London, and was generally a nobleman with no previous Indian experience, appointed on political grounds for a five-year term. He enjoyed some of the privileges of an independent ruler. India decreed its own tariffs, for example—British officers arriving to serve in India had to pay customs duty on their saddlery—and in the years 1896 and 1897 there was no legislation at Westminster dealing with Indian affairs. The

hundreds of refugees from over the mountains, and most of the tea-shops, tailors, gunsmiths and Crown jewellers have vanished with the Raj. The greatest change, though, has been the arrival of the narrow-gauge railway, which reached Simla in 1903: this is still served, in 1968, by a truly Viceregal motor-carriage, painted a spotless white, and looking like an elegant cross between a snow-plough and a beautifully maintained Vintage Rolls—shiny leather seats, spade-handles on its doors, and on the front an enormous brass starting-handle. Only the imperial crest is missing.

Viceroy's Council was in effect a Cabinet, and almost all its Ministers were Civil Servants, each the head of a Government department. It is true that the Commander-in-Chief attended as an extra member, and that sometimes the Viceroy, by summoning a dozen extra members, turned the Council into a legislative assembly, when the public was admitted to its sessions, and sat on a row of dining-room chairs. But the Viceroy could override its decisions anyway, and the power of the bureaucracy remained unchallenged.

Defence, foreign affairs, national finance, the railways, posts and telegraphs were all looked after by this Central Government. In other ways India was administered by the provincial governments, no less completely in the hands of the I.C.S. The seven provinces were run almost as separate States. Two of them, the Presidencies of Madras and Bombay, had kept not only their pre-Mutiny titles, but also the right to communicate directly with London, without reference to the Viceroy, who sometimes heard what was happening there only by reading the newspapers. The provinces had been carved out, by history and politics, in shapes that bore little relation to geography, ethnography, or even language, and they had been disciplined into entities by the British. In each the head of the administration— Governor, Lieutenant-Governor or Chief Commissioner—had his own council of Civil Servants and nominated legislature, and the system of government was elaborate. In Bombay, for example, there were departments of Public Works, Justice, Land Records, Municipality and Cantonments, Revenue Survey, Politics, Education, Police, Forests, Medicine, Finance, Gaols, Posts, Telegraphs, Customs, Salt, Opium, Excise, Income Tax, Stamps and Stationery, Registration, besides a Marine Department, an Archaeological Survey, an Inspectorate of Steam Boilers and Prime Movers, and a Directorate of the Government Observatory. All these departments had British chiefs: multiply them by eight or nine, and you will have some idea how many positions of great administrative authority were held by Englishmen in the India of the nineties.

Every I.C.S. man first went through the mill of the districts. India's provinces were subdivided into some 250 districts, each presided over by an officer called sometimes a collector-magistrate, sometimes a deputy commissioner. The district was the basic

administrative unit of British India, and it was complete in itself, its head being responsible for almost anything that happened in it. He was the local representative of the Crown: all over India, on Jubilee Day, the district officers held their own local Durbars, and received their local notables, the petty chieftains, the Brahmins or the great landlords, graciously in a marquee on behalf of the Queen-Empress. The district officer was also the tax official, which is why he was sometimes called a collector. 'The main work of the Indian Administration', it was officially declared, 'is the assessment of the land tax', the chief source of revenue, and the man in the district spent much of his time inspecting crops, checking measurements, allotting ownerships and listening to the arguments of rival land-lords. He was at once the chief of police and the chief magistrate of the district, a combination that was often criticized. On most working days of the week he presided over his court, sometimes in a musty town courthouse, blazing hot and bursting to the doors, sometimes in a tent in the field, with prisoners and litigants loitering on the grass outside, and a stream of spectators wandering in twos and threes from the village along the track.

Such a camp court was everybody's image of the White Man's Burden. The magistrate was often absurdly young, and his court equipment consisted of a couple of camp chairs and a collapsible desk. On the ground before it his clerks sat cross-legged, each with an ink-horn, and at the door his orderly stood peremptorily on guard, dressed in a scarlet coat and sash. Into this simple setting, the furthest and humblest preliminary to the Privy Council, filed the prisoners and the applicants, bowing low to the representative of the Raj—villains in irons, deputations of villagers, people who wanted to argue about the water rates, or demanded an audit of the village accounts, or accused their neighbours of witchcraft, or thought they were entitled to a rebate of last year's land tax—murderers occasionally, thieves nearly always, deserted soldiers, poor old women with no visible means of support, lost children and argumentative local lawyers. The district officer must have answers for them all. The clerks scratched away in their big books; the orderly ushered them in with pompous command, like a sergeant-major; and when the court was over the district officer and his staff packed up the desk,

the chairs, the tent and the law books in camel carts, and plodded across the plains to the next session.

6

So from top to bottom, Viceregal Lodge to portable courthouse, the Indian Civil Service ruled India. This was a land of fabulous variety, a world of its own. At least 800 languages were spoken there, including tongues like Karen, Mon, Shan, Bhil, Garo and Halbi, which not more than a handful of scholars elsewhere in the world had ever had the opportunity to learn. There were 9 million Indians classed still as aborigines, and there was a dizzy profusion of more advanced minorities: jangling stalwarts from the Rajput States, noble Sikhs from the north, the clever and disputatious Bengalis, Pathan warriors from the north-west frontier, people from Assam, Sikkim and Bhutan with a Mongol slant to their eyes, exquisitely fragile Dravidians from the south, strange men from the distant Andamans, the Nicobars, the Shan Hills or Baluchistan. Across this marvellous country the inflexible order of the I.C.S. was laid, province by province, the whole governed by an all-embracing code of rules, moving to a sure and tested rhythm of novitiate, experience, promotion and protocol. Mahatma Gandhi called the I.C.S. 'the most powerful secret corporation the world has ever known', and in India as a whole it had acquired a prestige so towering that to many simple people it seemed infallible, if not divine.

The Central Government of this system was heavily formal, rigid with bureaucracy and protocol—'Do you know Mrs Herbert of Public Works?' the Anglo-Indian hostesses used to say. 'May I introduce Miss Entwhistle of Irrigation?' The I.C.S. had not much changed its method for half a century, and its main arteries were a little clogged. Its duties were much wider than the duties of a contemporary Government at home: in some ways India was almost a Socialist country, so involved was the State in matters like land-ownership, transport, forestry, education, medicine and police work, and in running the official monopolies of salt and opium. All this led to a vast subsidiary establishment—there were nearly 3 million employees in the public service—and a proliferation of paper work.

Life was short in India, transfers from office to office were frequent, and the only way of maintaining continuity seemed to be to write everything down. On the Indian trains the ticket collecter wrote down the number of your ticket on a piece of paper, to be consigned eventually, with millions more, to Heaven knows what mysterious and meaningless archive. Everybody made fun of the bumbling bureaucracy of Simla, even sometimes its own bureaucrats, so seriously did it take itself.

In theory there was almost no contingency for which the files did not provide a precedent, or the regulations decree a solution. Take, for example, the regulations laid down for Joining Time, the time allowed to an officer to proceed from one station to another, when he was transferred. 'Joining Time is calculated as follows, subject to a maximum of 40 days. (Sundays not actually spent in travelling are not included in the calculation.) Six days for preparation, and in addition thereto, for the portion of the journey which the Officer travels, or might travel, a day for each: by railway, 200 miles, by Ocean Steamer, 150 miles, River Steamer 80 miles, Mail Cart or other public stage conveyance drawn by horse, 80 miles, or any other way, 15 miles, or any longer time actually occupied in the journey. During that time the Officer will draw pay or salary which he drew in his old appointment, or that which he will draw on joining his new appointment, whichever may be less.'

In the field the system was far more flexible. Though India had a surfeit of senior British officials, the British cadre as a whole was very small. There were perhaps 20,000 Britons in India in the nineties, not counting soldiers of the British forces stationed there. About half were business people, and another 3,000 British officers of the Indian Army. A few hundred Britons worked in the lower ranks of the public service, as engine drivers, port technicians, postmasters. There remained some 1,300 British members of the I.C.S., upon whose shoulders rested the responsibility for governing 300 million souls. At the centre all might be done by the book. On the perimeters the district officer generally had to make up his own mind, without reference to precedent or senior opinion—in Mymensingh, East Bengal, one district officer was responsible for 6,000 square miles of territory and 4 million people, which left him little time for

consultation. In dealing with sudden emergencies, in arbitrating un-expected disputes, in instant decisions on matters of life and death, the British ruler of India was expected to obey his common sense, and do what he thought was right in the long run—fortified as he was by those values of manly self-reliance without which the Indian Civil Service would probably never have accepted him in the first place.

7

But however original the young officers in the field, the Raj did emanate a certain worthy dullness. Nearly every visitor felt it, and contrasted it ruefully with that gift for graceful hedonism and skullduggery which legend had long since bestowed upon the early adventurers of British India. Fortunately for the dazzle of India, not so far from any district officer's bungalow there was sure to be a Native State, where Joining Time did not apply, and the public school code was not so scrupulously enforced. When they talked of British India then they were not merely blowing a trumpet. India was all red on the map, but redder in some parts than others, for embedded in the whole were more than 600 Native States in whose territories the British did not directly govern. India and British India meant two different things. In British India the Queen's rule was direct to the point of starkness. In the Native States—generally those which had submitted peacefully to the Raj, instead of fighting back—the British had tried their first experiments in indirect rule.

The States varied in size from villages to nations. They contained 77 million inhabitants altogether, about a quarter of the whole, and by the nature of British history in India only a few insignificant States possessed an outlet to the sea. The Raj fenced them in. Ostensibly they were independent Powers, really they were puppets, whose rulers would be rash indeed to disregard the wishes of the Raj, and in whose capital there lived a British Resident or Adviser, in a palace of his own, as a reminder of the power behind the throne. This was described as being governed 'with the help, and under the advice, of a British political officer', and it was said that while some of the States were almost completely independent, 'others

require more assistance or stricter control'. It was largely the presence of these princely feudatories, vast and rich like Mysore and Hyderabad, petty and indigent like Thonk, which gave to India still some of the surprise and splendour of the Moguls, with their caparisoned elephants and their jewelled audience chambers.

The authority of each prince, we are told, was limited by his treaties with the suzerain Government, which 'interferes when any chief misgoverns his people; rebukes, and if needful, removes the oppressor; protects the weak; and firmly imposes peace upon all'. The treaties varied from State to State. Mysore, which was advanced enough to have a kind of Parliament, agreed simply to 'act in conformity with the advice of the Resident in all important matters'. Lesser States, nearly all medieval autocracies, found their obligations spelt out in fussier detail. They could not, for example, employ British subjects without the sanction of the British Government, and British applicants for jobs were carefully screened for subversive tendencies. Governesses for princely households were actually supplied by the Raj, for part of the system was an imperial grooming of young princes. Often this was astonishingly successful. Moulded by nannies, tutors, advisers, the example of visiting officials and perhaps the schooling of Eton and Oxford, many of the princes became quasi-Englishmen themselves—English aristocrats buffed to an oriental polish. Such a magnificent heightening of their own taste much appealed to the English, who greatly coveted invitations to the grander Indian principalities, to shoot tiger or play polo. It was Sir Roper Lethbridge, K.C.I.E., who compiled *The Golden Book of India*, A Genealogical and Biographical Dictionary of the Ruling Princes, Chiefs, Nobles and Other Personages, Titled or Decorated, of the Indian Empire—'probably destined to take rank', *The Times* said, 'as the recognized *Peerage of India*'. Life in the States appealed to the Indians, too. The administration was generally shaky, and personal liberties could be precarious, but there was a steady flow of immigrants out of British India into the Native States—some escaping to easier penal systems, but many just pining for colour, variety and a little inconsequence.

Let us, too, excuse ourselves for a moment from the order of British India, and slip across the frontier to one of the most cele-

orated and colourful of the States, Jaipur—generally spelt Jeypur in those days, and lying almost in the heart of northern India, among the rocks and flaming sands of Rajputana. The Maharajah of Jaipur possessed an estate of some 15,000 square miles, with 2½ million tenants, and he governed it according to the most dashing traditions of his Rajput forebears, descended from the epic heroes of medieval India. The Muslim conquerors of India had never been able to subdue the flare of these Hindu princes, and the British Raj had scarcely toned them down.

The capital, Jaipur itself, had been planned by an eighteenth-century Maharajah of astronomical interests, Jai Singh, and it was laid out with noble precision, and plastered throughout in a soft pink. The centre of the city was occupied by the sprawl of the palace, with shaded gardens and terraced arcades, trees full of monkeys, a marble audience chamber and a majestic series of stables: the Maharajah kept rather more than a thousand horses, each with its personal groom—one eminent horse had *four* grooms. Behind the palace stood a famous Hindu temple, in front was Jai Singh's observatory, a field of strange quadrants, pits and towers. Immensely wide streets intersected this capital, and along them the people streamed in perpetual pageantry—a cavalier citizenry; swathed about in scarlet and turbans, the men tall and handsome in a predatory style, the women slim and scrawny, jangling from head to ankle with bangles, amulets, bracelets, necklaces and gold chains, so that every movement was an orchestration, and one heard their approach in rhythmic clankings round the corner. Sometimes a gold-hung elephant trundled by, its liveried mahout high above the street crowds, and sometimes a great nobleman passed in a palanquin, with a train of servants at the trot behind. Beyond the city walls lay the ancient capital of Amber, with a deserted palace on one hill and the Maharajah's army poised in their barracks on another: all around stretched the deserts of Rajputana, camel trains loping towards the city gates, and fluttering knots of peasants hastening to market.

No city in Asia could be much more Asian, and it was often a relief to take the train to Jaipur, when the symmetry and rectitude of British India seemed more than usually lowering, or one really could not stand another evening of bridge with the Thompsons

of Revenue Survey. But it was an illusion. Implanted deep in the heart of Jaipur was the authority of the Raj. Despite exotic appearances, the British had been the real power in Jaipur for more than sixty years. The British Resident lived in a substantial mansion conveniently close to the Rustom Family Hotel, and it was to his office that one applied for permission to travel about the State, view its antiquities, or do business with its merchants. He would issue passes to view the Maharajah's stables (the English trainer there had, of course, been appointed with his approval). He would arrange introductions to notables of Jaipur. If one wished to visit Amber, the Resident would, 'as a rule, kindly ask the State to send an elephant to meet the traveller'.

The handful of Englishmen living in Jaipur had, under the patronage of the Maharajah, left a characteristic mark upon the place. 'The Maharajah gave the order', said Kipling of the lovely palace pleasure gardens, 'and Yakub Sahib made the garden'—Yakub Sahib being a Mr Jacob, of a well-known Anglo-Indian name. Two Englishmen had built the vast and awful museum, named the Albert Hall and surrounded by ornamental gardens, and an Englishman ran it. Englishmen managed the State railways, manned the electric light plant, trained the Maharajah's forces, and in the centre of the public gardens stood a large statue of Lord Mayo, Viceroy of India in the 1860s. Even if the visitor missed all these intimations of power, had no need of the Resident and evaded the Albert Hall, even so he could not ignore the hovering omnipotence of the Raj: for high and very large above the city of Jaipur the single word WELCOME had been painted in white letters on a hill, to commemorate a recent visit to this Protected Native State by Edward Prince of Wales, heir to the Queen-Empress.[1]

[1] Jaipur is now the capital of the Indian province called Rajasthan, though its Maharajah is still rich and powerful. There are few signs that it ever owed allegiance to the British, beyond the Albert Hall and the photographs of polo-playing princes in the best hotel (itself one of the Maharajah's properties). Perhaps, in a place of such fiery character, the suzerainty of the Raj was more flimsy than it seemed in 1897. When Bishop Heber the hymn-writer visited the State earlier in the century, he was given a present by the Maharanee consisting of two horses and an elephant. The elephant was so vicious that nobody could go near it, and of the horses one was 'as lame as a cat' and the other at least thirty years old.

8

The Viceroy knew that his was a unique imperial trust. Even in 1897, one suspects, the British might have abandoned most of the Empire with reasonable sang-froid. India was a separate case. It seemed to the British that their greatness, their wealth, even their very character depended upon the possession of this distant prodigy. India was the justification of Empire by force—the imposition of standards upon a weaker people, for their own good as well as Britain's. 'The true fulcrum of Asiatic dominion', Curzon had written in 1894, 'seems to me increasingly to lie in Hindustan': the secret of the mastery of the world was, 'if they only knew it, in the possession of the British people'. Since the Indian Mutiny India had seemed, too, a peculiarly royal sort of dominion. Victoria once noted in her diary, before the end of the East India Company, 'a universal feeling that India should belong to *me*'. The British agreed with the poet William Watson, that England could never be the same without India, that brightness in her starry eyes, that splendour on her constellated brow.

India was certainly a valuable piece of property, and mostly self-sustaining, for the cost of governing and defending it was borne out of Indian taxes, and even the Indian Army, constantly though it served in imperial causes elsewhere, cost the British scarcely a penny. The British had sunk a lot of money in India—more than £270 million, or a fifth of their entire overseas investment—and 19 per cent of their exports went there. In the more liberal years of the century the British had often looked askance at the authoritarian rule exerted on their behalf in India. 'Public opinion does not know what to make of it,' Seeley had written, 'but looks with blank indignation and despair upon a Government which seems utterly un-English, which is bureaucratic and in the hands of a ruling race, which rests mainly on military force, which raises its revenues, not in the European fashion, but by monopolies of salt and opium and by taking the place of a universal landlord, and in a hundred other ways departs from the traditions of England.' But political values were coarser now, India did not much disturb the public conscience at home, and the Viceroy was seldom plagued by radical questions

in the House of Commons, or worse still radical parliamentarians on his doorstep. He knew that public opinion now overwhelmingly supported absolute British rule in India: there were, after all, parts of Calcutta worth £40,000 an acre, and one did not play fast and loose with such stakes.

Protecting the Indian stakes, indeed, was one of the prime purposes of British foreign policy. British Governments were no longer afraid that their representatives in India would break away from Whitehall's control altogether, to set up some astonishing republic of their own. They were, though, always afraid that another Power might grab the country, or cut it off from London. Lord Rosebery once declared that British foreign policy was essentially an Indian policy, 'mainly guided by considerations of what was best for our Indian Empire'. Certainly the creation of the new Empire in Africa was largely impelled by anxiety over the routes to India. The military planners in Simla were perpetually obsessed with the safety of this immense dominion, so thinly ruled and guarded, and in particular with the menace they supposed to come from the Russians along their northern frontiers.

Much of Victorian imperial history had depended upon the fear of Russian intentions—it was Russia, you will remember, that the music-hall audiences had in mind when they first sang the Jingo song. The most vulnerable frontier point of all lay in the north-west corner of India, in the tangled country around Afghanistan—Alexander's gateway to India. It was a double anxiety. Afghanistan itself was a very unreliable neighbour, and the frontier area was inhabited by lawless Muslim tribes owing no very definite allegiance to anybody, and making it exceedingly difficult to establish a firm line of defence. This was the country of the Great Game. Behind it, or so the British supposed, the Russians were moving inexorably east and south, absorbing one after the other the Khans of Central Asia, and preparing the encirclement of India. They were already building a railway across Siberia to the Far East, and rumour had them railway-building in Turkestan, too, and planning an annexation of Tibet—whose southern frontier, theoretically drawn along the summits of the Himalaya, ran actually within sight of Simla. Twice Britain and Russia had almost come to blows—in 1885

the Stationery Office had gone so far as to print documents declaring a state of war. Twice the British had launched campaigns against the Afghans to secure the gap. Repeated scares and crises kept the north-west always in their minds, and rumours of Russian mayhem among the tribes percolated constantly through Simla.

The search for a 'scientific frontier' was endless. In the east the British had now taken all Burma, and would perhaps have moved into Siam, too, if it were not for the French in Indo-China. In the west they had wavered between standing firm on the line of the Indus, well within India proper, or pursuing a 'forward policy' and posting their troops as close to the Russians as possible. Sometimes they had thought the actual possession of Afghanistan necessary. Sometimes they had settled for a policy that would merely keep the Russians out of Kabul, too. They alternately occupied and withdrew from several remote outposts in the Hindu Kush: and the legend of British arms in India, fostered so brilliantly by Kipling, was born out of the rocks and wadis of the north-west, where the savage tribesmen lay in ambush behind the next rock, the Afghans brooded behind the tribes, and behind all stood the Russians.

Since 1893 the Indo-Afghan frontier had been demarcated, and the British were building up Afghanistan as a buffer State, with gifts of arms and money. At the same time they were trying for the first time to subdue the tribes who lived in semi-independence on the Indian side of the line. Roads were built, boundary posts set up, forts established throughout the territories of the Afridis, the Mahsuds, the Waziris, the people of Swat, Gilgit and Chitral. Once content with controlling the plains at the foot of the mountains, the British now intended to hold the heads of all the passes, and since 1895 Chritral, far to the north in the Hindu Kush, had been permanently garrisoned.

All this offered many excitements to the British—Anglo-Indians were often accused of fostering Russophobia at home, in order to keep the Great Game alive. The tribespeople, though, deeply resented the new interference. A holy man known to the British as the Mad Fakir, and described by Winston Churchill as 'a priest of great age and of peculiar holiness', travelled around inciting them to rebellion. He was helped by the news just reaching those distant provinces of Muslim triumphs elsewhere in the world: the Sultan of Turkey had

proclaimed himself Caliph, the Turks had defeated the Christian Greeks in war, the British themselves were having a difficult time against the Mahdi. There were wild stories of imperial reverses—the Suez Canal was said to have been seized by the Turks and leased to Russia—and the Mullah claimed that the Faithful could never be hurt by British bullets, and used to display a mild bruise on his own leg which he said was the only result of a direct hit from a 12 pound shell. Serious trouble was brewing on the frontier. British reinforcements were already on their way, punitive expeditions were common, dark rumours of Russian conspiracy or intervention flowed freely down to Simla.

There was a man living in the town called A. N. Jacob, a curiosity dealer, a mesmerist and a conjurer. He had been rich in his time, but had been ruined by an action he brought against the Nizam of Hyderabad, who had refused to pay for a diamond brooch Jacob had sold him. As a result he was boycotted in all the Indian States, the source of his wealth, and was reduced to a modest business with the Anglo-Indians, living in a house partly furnished with pieces from the Brighton Pavilion (the Nizam had bought them from the British Government).[1] Jacob was a mysterious man, immortalized by Kipling as Lurgan Sahib in *Kim*, with his eyes whose pupils eerily closed and dilated, his genius for disguise, his strangely foreign English, his unexplained contacts with princely house and underworld, his curio shop cluttered with devil-masks, Buddhas, prayer-wheels, samovars, Persian water-jugs and spears. The simpler Indians naturally assumed this queer figure to be a magician, but the British, no less baffled, placed him in a category just as self-evident: Russian spy.[2]

9

It was a bad year in India, and the Jubilee celebrations in Simla were sadly muted. In Calcutta, the Viceroy's other home, there had been

[1] Some of them may now be seen in the Victoria Memorial Museum at Calcutta.

[2] The wide experience of the Indian security services in dealing with the dangers of Russian subversion was for long reflected in the counter-espionage organization at home, whose agencies employed many former Indian police officers at least until the Second World War.

a terrible earthquake, causing many deaths, and so weakening the structures of the city that they dared not fire a Jubilee salute, nor even thunder out a hymn on the Cathedral organ. In Bombay there was plague. In Orissa there was famine. The frontier was aflame with tribal violence. India had just abandoned the silver standard, and was in economic difficulty. In Bengal and in Bombay there was political trouble, remote enough from the Abode of the Little Tin Gods, but serious enough to disturb the more far-sighted of the seers. There was not much air of festivity in Simla that June. Only a few parades, church services and processions of notables marked the occasion of Jubilee, and perhaps a few of the memsahibs quoted to each other, with indulgent giggles, Targo Mindien's Diamond Jubilee Rhyme:

> *Arise! fair Venus, my dream in Beauty; refulgence! forth*
> *from Father Time's liquid silver sea,*
> *In all thy dazzling splendour, with thy magic wand from*
> *Love, it is the Empress-Queen Victoria's Diamond Jubilee.*

Lord Elgin, the Viceroy, was frankly bored. He had never much wanted to be Viceroy, and in this he was not alone, for oddly enough eager Viceroys were hard to find. The significance of the office was almost beyond ambition. The Viceroy of India had few peers in Asia. The Tsar of Russia, the Emperor of China were scarcely his superiors, the Shah of Persia and the King of Siam trod carefully in his presence, the Amir of Afghanistan and the King of Nepal were frankly at his mercy, the Dalai Lama would be well advised to respect his wishes and the King of Burma was actually his prisoner.[1] He occupied the throne of Akhbar and Aurangzebe, he stood in the conquering line of Alexander, and he was officially said to *reign*, like a king in his own right. Yet it was a kind of exile for an Englishman. The most able men generally preferred to pursue greatness at home, living in gentler palaces in greener fields, and few Viceroys had been of the very first rank, as statesmen or even as administrators.

For all that pomp, all that subservient respect, the State balls

[1] He had been since 1885, when King Thebaw, his two queens and his mother-in-law were taken prisoner at the end of the third Anglo-Burmese war, and sent to live at Ratnagiri, an old Portuguese fort on the west coast of India. The more forceful of his wives, a bloodthirsty woman called the Supayalat, was known to the British soldiery as Soup-Plate.

and the bodyguards and the obsequies of princes—it was all a kind of charade. The Viceroy was only a temporary Civil Servant, on a five-year term, and would presently go home again. The rules of British India were inescapable, and exact. When a Viceroy sailed out to assume his dignities he was entitled to a grant of £3,500, to cover his travel expenses and equipment. When he returned to England at the end of his service he was allowed a ship of the Indian Marine as far as Suez, the limit of his power: but once there, he and his Vicereine were all on their own, could claim no more divine appurtenances, and must seek the help of Thomas Cook's for their onward travel, paying their own fares.

CHAPTER FIFTEEN

Consolations

Oh, I've seen a lot of girls, my boys, and drunk a lot of beer,
And I've met with some of both, my boys, as left me mighty queer,
But for beer to knock you sideways and girls to make you sigh,
You must camp at Lazy Harry's on the road to Gundagai.

We camped at Lazy Harry's on the road to Gundagai,
The road to Gundagai! Five miles from Gundagai!
Yes, we camped at Lazy Harry's on the road to Gundagai.

Australian Bush Song

15

THE New Imperialism was born out of a medley of moods and circumstances, not all of them happy, some of them distasteful. It emerged a boisterous credo, full of swank, colour and sweep. On the face of it the British seemed to be having a marvellous time, bathing in the glory of it all, swathed in bunting and lit up with fireworks. The late Victorians were not half so strait-laced as their reputation was presently to imply. Their young men were full of dash and energy; they revelled in the stimulations of the outdoor life; the pleasures of Empire lay not only in national pride, duty performed and dividends paid, but also in the particular consolations a people could devise for itself, when placed in a position of absolute command in an alien land and climate.

2

Sport was the first. The British took their games with them wherever they went. Sport was their chief spiritual export, and was to prove among their more resilient memorials. They took cricket to Samoa and the Ionian Islands, and both the Samoans and the Ionians took it up with enthusiasm. They went climbing in the Canadian Rockies, and by 1897 the Canadians had their own Alpine Club. They introduced football to the aborigines of Australia, and wherever in the world the ground was flat enough they seem to have built a tennis court. The highest golf course in the world was made by the British at Gulmarg, in the Himalaya, 8,700 feet high: the highest cricket pitch was near by, at Chail. In Salisbury, Rhodesia, the pioneers were already playing cricket matches between the Public Schools Boys and the rest, and a chief qualification for a job on the administration was said to be a good batting average. The first American golf course was laid at New York in 1888, but the

British had been playing the game at Calcutta since 1829. Boxing was compulsory in the British Army. 'Open order, march!' the order ran. 'Front rank, about turn! *Box*!'

Above all the British took with them everywhere their taste for equestrian sports, inherited as it was among their friends the Indian princes from the warlike tendencies of their forebears. In those days the horse and the gentry still went together, racing and hunting were the passions of the English upper classes, and horsiness was more than a social phenomenon; it was an historical legacy, too. The thoroughbred horse went with them always, and there was scarcely a town in the Empire which did not have its race-course—a scrubby little ring of beaten-out turf on the veldt, or splendid arenas like Calcutta's or the Curragh in Ireland, with their glittering grandstands, brilliant white rails, club-houses and sprinkled lawns. They used to have race dances at Calcutta, with public breakfasts, and curious alternations of sweepstake and country dance, and at Madras the sportsmen of the East India Company had built themselves a delightful set of assembly rooms beside the track, a tall big-windowed building with fine wide terraces and flagstaffs, and emanations of punch and nosegay. As early as 1891 Lord Randolph Churchill was complaining that his horse had been nobbled at a race meeting at Salisbury, Rhodesia, a charge that rings all too true: and when Queen Victoria sent four envoys from the Royal Horse Guards to visit Lobengula in his kraal, almost the first thing they did was to arrange a race meeting, including the Zambesi Handicap and the Bulawayo Plate.

The race-course at Simla was on the high plateau of Annandale, surrounded by tall pines and deodars, and deliciously secluded. The race-course at Colombo was in the middle of the city, like a bullring in Spain.[1] The race-course at Hong Kong was in Happy Valley, separated from the Chinese cemetery only by a fence of bamboos. The Poona race-course was inside the General Parade Ground. The Badulla race-course ran all the way round a little lake. An artillery range straddled the Lucknow race-course. The Darjeeling race-course was said to be the smallest in the world, and the Calcutta race-course was claimed to be the largest. In many parts of the

[1] It is now an open air lecture-hall of the University of Ceylon.

Empire the climax of the social season was a big race meeting. From every part of Australia the graziers made their way to Melbourne in October, to ensconce themselves and their families in the comfortable old-school hostelries of the city, and show themselves off at the Melbourne Cup: often the whole year was remembered by what happened that day, and Australians would refer to the past as 'the year Newhaven won the Cup', or 'the year Wait-a-Bit lost by a head'.[1] The great day of the Calcutta year was the day of the Viceroy's Cup race, for a cup given annually by the reigning Viceroy. 'The grandstand is filled', wrote G. W. Forrest in the nineties, 'with noble dames from England, from America and all parts of the world, who have come with their spouses to visit the British Empire. In the paddock is a noble duke, a few lords, one or two millionaires from America, and some serious politicians, who have visited this land to study the Opium Question, and feel ashamed of being seen at a race-course. The air resounds with the cries of the bookmaker, and an eager crowd surges around the totalizer—for on the Viceroy's Cup day even the most cautious bank manager feels bound to have one bet.' After the church and perhaps the law court, the race-course was the principal landmark of a British imperial city—as prominent as the amphitheatre of Rome, and with much the same meaning.

When they were not racing the British were likely to be hunting, for wherever they went they scratched together a pack of hounds, reinforced it with the odd terrier, and set off in pursuit of fox, jackal, elk, pig, hare, red deer, hyena, or whatever else was available to be chased. (Everybody in the Empire seemed to possess a fox-terrier, a bullterrier or a spaniel: no group photograph is complete without a dog in somebody's arms, and in India many imperial households had their own dog-boy, generally the son of a more senior employee.) There were scores of light-hearted hunts in India, and in Africa, so strong was the ethos of the British, even a few Boers took up the sport, and were to be seen authentically costumed in pinks, shouting Tally-ho in Afrikaans. The Montreal Hunt, founded

[1] The Cup is still the great event of the Australian season, and the Windsor Hotel in Melbourne, one of the graziers' favourites, seems to me on the whole the most comfortable I know.

by British officers in 1826, flourished in the heart of French Canada.[1] The Calpe Hunt started with a pair of foxhounds actually on the Rock of Gibraltar, where foxes lived high in the brush among the apes: by the nineties it was one of the smartest imperial hunts, was regularly entertained by Spanish grandees on their estates across the frontier, and once went over to Tangier, 'where a wolf gave an excellent run of over 40 minutes and a distance of nine miles'.

In India pigsticking, like polo, was pursued with passion, encouraged by immense silver trophies presented by Maharajahs. The Kadir Cup for pigsticking was one of the principal sporting trophies of India (it was won in 1897 by Mr Gillman, Royal Horse Artillery, on Huntsman). This tremendously exciting sport, in which a single man on horseback with a spear was pitted against boars, tigers, buffalo, or even rhinoceri, had been popular among the British since the early days of the East India Company: by the nineties the north-west provinces of India were its headquarters, and on the great day of the Kadir Cup sometimes a hundred spears competed, and the men and their horses settled in gay tented camps upon the Punjab plains, practising their runs with stampeding hoofs and dust-clouds in sunshine, like knights before jousting.

Whatever there was to chase or kill, the British pursued. In those days the reaches of the Empire teemed with multitudes of game, the deer and the zebra roamed Africa in their countless thousands, and conservation was not yet a preoccupation of nature-lovers. Hawkers called 'hare-wallahs' used to frequent the Indian cantonments, selling live hares and wild cats to be chased by the soldiers' whippets, or jackals to be pitted against two or three dogs in a ball-alley. If there was nothing to fish, the imperialists stocked their rivers with trout and salmon from home, so that some of the highland hotels of New Zealand, for example, faithfully reproduced all the tangy pleasures of Scottish fishing inns, with knowledgeable ghillies in attendance, fishing books lovingly kept up, malt whisky before big log fires at the end of the day. No colonial handbook was complete without its

[1] It was only in the 1950s that French-Canadians were welcomed in any numbers to this very exclusive hunt: until then, I was once told in Montreal, the country was only hunted by 'English Montrealers of a certain type'.

chapter on the blood sports, though when Sir George Scott compiled his admirable Burmese guide he was obliged to observe that the Burmese did very little hunting themselves owing to the 'mingled pity and dislike' with which hunters were regarded by Buddhists.

3

Drink came next—food did not interest them half so much. 'Diseases Affecting the Whole Empire', was a heading in Volume VI of the *Oxford Survey of the British Empire*, and the very first ailment to be discussed was Alcoholism. It is easy to see why. All classes of the British abroad, Governors to troopers, seem to have drunk terrifically—sometimes to alleviate a grim climate, sometimes because they were lonely, and often because it was part of the general effervescence of life. In the imperial cities the breweries went up almost as fast as the race-courses, and many brewers in England produced beers especially for colonial markets—'Produced by Brewers', as was claimed for Wrexham Lager Beer, 'thoroughly conversant with the requirements of a Tropical Country'. Millers, the Colombo importers, offered a lager bottled for them in Germany, and a malt whisky especially bottled in the Highlands. The sundowner was an institution throughout the tropical Empire—that first delectable drink of the evening, brought to your veranda with glistening paraphernalia of ice-bucket, napkin, carafe, and soda-siphon, by a servant in a long white gown and a crimson cummerbund, a tarboosh or a turban: the custom began, it was said, because it was thought that the moment of sunset was particularly ill omened for malaria, and that a strong drink taken then, perhaps with a shot of quinine in it, was the best prophylactic.

It was the British from Britain who were the heaviest drinkers. None of the colonials could match them. The Australians already had a reputation as beer-drinkers, and they also produced excellent wines—Trollope thought the white wine of the Upper Yarra vineyards, at 6d a pint, the best *vin ordinaire* he had ever tasted: but their consumption of alcohol per head was hardly more than a third that of the British at home. The Indian breweries were producing rather more than 6 million gallons of beer annually: 3 million gallons of it was

drunk by the British soldiery, who called it 'neck-oil', 'purge', or 'pig's ear', and who often grouped themselves in 'boozing schools', dedicated to the common spending of all available funds on drink. The greatest single problem facing the Calcutta police in the 1890s was the spate of drunken British seamen at week-ends: in the Royal Navy more officers were court-martialled for drunkenness than for any other offence.

. Among the moneyed classes, and the gamblers, champagne was the drink of the day. When West Ridgeway, later Governor of Ceylon, marched under Roberts from Kabul to Kandahar, he was haunted throughout by the thought of iced champagne. So terribly did it pursue him that when Roberts ordered him to ride as fast as he could to the nearest railway station, with an urgent dispatch for the Viceroy, the first thing that occurred to him was that at any Indian railway station iced champagne would be available. He telegraphed ahead to reserve a bottle, he rode breakneck for three days and nights—'and oh! the disappointment: the ice was melted, the champagne was corked, and the next morning I had a head'.

So important was champagne to these men of Empire. One of the many complaints of the Assistant Commissary-General, when Wolseley's army was having difficulties in the Sudan campaign of 1884, was that the champagne, officially taken for medicinal purposes, was 'of very indifferent quality, and calculated to depress rather than to exhilarate the system'. Officers' messes normally carried vast amounts of champagne around with them on campaigns —General Buller, on this same advance up the Nile, used to give seven-course dinners in his tent, washed down with any amount of it—and champagne was ordered as a matter of course for any imperial triumph or venture. 'Champagne' Anderson, a jolly old prospector of the Rhodesian nineties, got his name because after selling a claim for a satisfactory profit he ordered himself a hotel bath of champagne, at 25s a bottle. Lord Avonmore set off for the Klondike with seventy-five cases of champagne: unfortunately it froze, and was auctioned off in the main street of Edmonton—it went for 25 cents a case, successful bidders instantly breaking the necks of the good bottles, and drinking them there and then.

It is not surprising that the temperance workers were active in these hard-drinking years of the imperial heyday. The Army had its own Temperance Association, whose canteens in every overseas station sold only soft drinks, cakes and bread and butter; members were given a medal after each six months of teetotalism, and official positions on the association were much coveted, allegedly because good money could be made on the side, to spend on whiskey. One of the most eminent reformers was Thomas Cook, the travel king, who began life running a temperance hotel, and whose first conducted tours were temperance outings. Cook never demanded total abstinence of his clients, as did his rivals, Frames Tours, but he never hid his distaste for strong liquor, however happily the British officers, feet up on the rail, swigged their whisky on his Nile steamers. He was an active teetotaller all his life, and once recorded with satisfaction that there were 5,908 recorded abstainers in the Indian Army. The dangers of contaminating native peoples with alcohol were always alive in the evangelist mind—and with reason, for the Australian aborigines, the Canadian Indians, the Maoris and the Polynesians had all been half-rotted by liquor, when first introduced to it by the British. Sometimes a native ruler saw the point, and proved in his conversion more abstemious than his converters. Khama, the great king of Bechuanaland, not only compelled his entire tribe to turn Christian, but in the 1880s decreed prohibition throughout his domains. In a country several times the size of England the only place where a drink could be sold to anyone, African or European, was the railway refreshment room—that ultimate haven of Empire. Khama called alcohol 'the enemy of the world', and wished it could all be spilt into the sea: but he was out of his time, for there has probably been no more effective agency for distributing this particular consolation throughout the world, than the thirsty Empire of the British.

4

They liked their creature comforts, and were able to indulge them more luxuriously than they generally could at home, especially in the tropical possessions. With their coveys of servants and their

social privileges, they could live in a class above themselves, elaborated in grandeur as they rose in rank, until at last in their retirement back they went to England, to live in obscurity with a housekeeper and a jobbing gardener, and be known to the neighbours, after ruling a couple of million people for half a lifetime, as having been 'something in the colonies'. In the early days of Empire they had adopted the sybaritic ways of the natives, dressed themselves in silks and reclined languidly on divans with hookahs: as late as 1859 Samuel Shepheard, founder of Shepheard's Hotel in Cairo, was portrayed dressed altogether as an Egyptian, feet up on a wide and squashy sofa, with a shallow tarboosh on his head, a parrot at his elbow, and a splendid brass hubble-bubble conveniently at hand. By the nineties the British usually preferred their own varieties of relaxation, and wherever they went they took with them the chintz, the leather arm-chairs, the glass decanters and the potted plants that were the hall-marks of cultivated leisure at home.

The club was pre-eminently a product of this portable décor, barring only the chintz. Insulated against the world outside, barred almost certainly to natives and very likely to females, with its own hierarchy of president, committee and senior members, the club was a comforting enclave of Englishness, its familiar features unchanged whether it was deposited in equatorial heat or near-Arctic cold. It was social centre, library, hotel, town forum, recreation ground all in one. If ever the British community wished to forgather, it would do so 'up at the Club': and whenever the wandering Briton wished to find company of his own kind he had only to get himself introduced to a member, and soon he would be standing at the bar as if he owned it, asking his neighbour if he happened to know 'Tommy' Oldbourne, who'd been Forest Officer in those parts in the eighties. Some clubs were exceedingly luxurious. The Kimberley Club, in the heyday of Rhodes and his diamond cronies, was as lavish as you might expect: it was a graceful low white building, arcades below, veranda above, with wrought-iron railings, imposing lamp standards, a pair of tall flagpoles and a small projecting balcony, like those on the Doge's Palace, from which overwhelmingly successful financiers might harangue or encourage the toiling speculators below. It reeked of success, lived by diamonds, and was

frequented by all the flashiest millionaires of the day—Rhodes himself, lounging in his wicker chair on the terrace, the indefatigable Alfred Beit, who dined there every evening, returning to his office after dinner to continue making money till midnight, or Barney Barnato, the ex-boxer from London, who drowned himself by jumping from a ship in Cape Town harbour on Jubilee day.

The club at Madras was described, in *Ivey's Club Directory*, as 'one of the most magnificent clubs in the world, amidst the splendours of tropical vegetation and surrounded by luxuries which Nature and Art combine to offer those who can enjoy spacious apartments, cool colonnades, the grateful sea-breezes wafted across green fields laden with the perfume of roses and mendhim, while ice, fruit and flowers —to say nothing of admirably trained servants—contribute to the snatches of Sybarite enjoyment in which even a soldier may at times be allowed to indulge'. It was in the club at the hill station of Ootacamund in southern India—'Snooty Ooty'—that a subaltern called Neville Chamberlain, in 1875, first thought of adding an extra coloured ball to the billiards table, and thus invented the game of snooker: it was named after the term given in the British Army to a first-year officer cadet, and the original rules were hung on a wall in the Ootacamund Club, at the start of their phenomenal journey around the world.

In Australia the clubs very early became strongholds of established wealth and dignity in a disrespectful continent. The grandest of them was the Melbourne Club, which had begun indeed as a rip-roaring affair, whose members went in for false fire-alarms, pushing policemen into mud-holes, stealing door knockers or fighting not very deadly duels—they had a special annexe to creep into, to sleep it off or lie low. It had matured into a very bastion of respectability, with handsome renaissance premises in Collins Street, liveried menials and large lace-curtained windows through which the eminent bankers, politicians, graziers and mining men of Victoria could look out upon the life of their metropolis, and deplore the passing of the old days. The Rideau Club in Ottawa had elegant premises directly opposite the Parliament Buildings of the Canadian Confederacy, with balconies allowing members a canopied grandstand view of every ceremonial. The Kildare Street Club in Dublin

was the stronghold of the Anglo-Irish, a fortress of British ascendancy almost as formidable as Dublin Castle itself, and designed by the architect Benjamin Woodward in his most overpowering Venetian Gothic.

Let us visit, for a taste of imperial club life at its most agreeable, the Hill Club at Nuwara Eliya in Ceylon. This little town lay high among the tea estates of the interior, in country which had known the young Samuel Baker among its first British settlers, and the baby Jack Fisher among its residents. It was the principal hill station of Ceylon, and a perfect period piece of the Victorian Empire. Set on a grassy plateau among the hills, immediately below the highest mountain on the island, it was like a model hill station in an exhibition. The British had laid out a park, with a maze and a botanical garden. They had dammed a little lake. They had marked out gentle walks around the surrounding woods, and named them for great ladies of the colony—Lady Horton's Walk, or Lady McCallum's Drive. Fir trees flourished, and gave the place a Highland look. There was a big half-timbered Grand Hotel, and a gabled cottage for the Governor of Ceylon, with a pond and a croquet lawn of exquisitely mown buffalo grass. There were the inevitable golf and race-courses, and villas strung about the lake like fishing lodges round a loch; and an English church, of course, and a lending library; and poised most benignly above the plateau, the Hill Club.

It was a low, baronial sort of building with gardens all around it. Its windows were mullioned, and inside it the atmosphere of an English or more properly a Scottish country house was diligently re-created. If the private houses of the British Empire tended towards the suburban, the clubs smacked distinctly of landed gentry. *Blackwood's*, *The Field*, the *Illustrated London News* lay on the smoking-room table, and *The Times* and the *Morning Post*, not more than a month old, were carefully smoothed in the breakfast room. Glass-enclosed upon the walls were the champion trout of the local hill streams, descendants of those first brought to Ceylon by the British fifty years before. There were rod racks about, landing-nets, somebody's waders in the back passage, and when a rattle of wheels was heard outside out ran a couple of turbaned servants to help another

sportsman from his tonga, collect his bags and his rod case, his walnut fly box and his boots, and usher him inside for his bath and his sundowner. Service at this club was paternal, or perhaps avuncular. The planting families used it as a second home, and the club servants were like family retainers to them all. The Hill Club had a useful little library, mostly books about Ceylon, but it was chiefly a place for outdoor men. The grave seniors of the Indian Civil Service might not feel at home here: this was the Pax Britannica at its most boyish and breezy, where the bedroom fires flickered in the mountain evenings like nursery memories, and a chap slept like a log.[1]

5

Throughout the length and breadth of the Empire a well-spoken, reasonably well-connected young man, with a few introductions in the right places, and a sufficiently entertaining line in small talk, could travel by himself without feeling the need for an hotel. If he did not stay at clubs, somebody was sure to invite him to stay at a bungalow. Family travellers, though, must depend upon hotels or the official rest-houses which the British erected in most of their Eastern possessions. Then as now the good traveller did not greatly care. Henry Beveridge,[2] a retired Indian Civil Servant on a sentimental revisit to India in the 1890s, happily put up at the Temperance Hotel in Mango Lane, Bombay, where the daily all-in charge was 3s 4d, and the monthly tariff £4. Others were less easily satisfied. G. W. Steevens thought there were only four hotels in India that could 'indulgently be called second-class', while all the rest were 'unredeemably vile'. The only country inns in Rhodesia were thatched huts of clay attached to the trading stores, and Kipling paints a compassionate portrait of a British commercial

[1] Nuwara Eliya (pronounced more or less *Noorellya*) has miraculously defied the years. The little town is almost unchanged, the Governor's cottage is impeccably kept up for the Prime Minister of Ceylon, and in 1965 the Hill Club still had not admitted a single Ceylonese to membership.

[2] Father of Lord Beveridge and so grandfather of the Welfare State. He joined the East India Company in 1836 and died in 1929, the year the British Labour Government declared Dominion status to be its goal for India.

traveller stuck forlornly in an hotel—'dark and bungaloathsome'—
in one of the sleazier corners of Empire. 'Isn't this a sweet place?
There ain't no ticca-gharries, and there ain't nothing to eat, if you
haven't brought your victuals, and they charge you three-eight a for
bottle of whisky. Oh! it's a sweet place!'

It was only along the great trade routes that the Empire spon-
sored its own luxury hotels, whose names had entered the vocabu-
lary of travel. Of them all the most famous was Shepheard's in
Cairo. Its new building had been finished in 1890, and it stood in
Italianate glory, looking across the Ezbekia Gardens to the Opera
House, with Cook's almost next door. Its original fortunes had been
built on the Overland Route to India, before the cutting of the Suez
Canal. Now it prospered largely because of the Cairo winter season,
which brought hundreds of rich Europeans and Americans to Egypt
each year. Shepheard's wide terrace was the most celebrated of
rendezvous, with its carpeted staircase to the street, its vast potted
palms, the impassive gold-braided suffragi at its door and the
medley of snake-charmers, souvenir-sellers, dragomen, donkey-
men, and miscellaneous touts who haunted the pavement outside,
sometimes shouting to the toffs above to suggest a trip to the
Pyramids, the purchase of a camel saddle or some small expression of
baksheesh.

Everybody knew Shepheard's. The hotel's Golden Book was full
of fame and royalty, and that welcoming terrace became a mirage-
like objective for travellers labouring down the Nile out of Africa.
There is a drawing of Stanley arriving there in 1890, after three
years in the interior looking for Emin Pasha: he is dressed still in
his pith helmet and high boots, and as the manager, in a frock-coat,
clasps the explorer's right hand with both of his own, an English-
man on the terrace waves his hat and raises a cheer, a flounced lady
lifts her *lorgnette*, and a porter in a tarboosh looks curiously through
the front door of the hotel—'the fashionables of Cairo,' Stanley
wrote, 'in staring at me every time I came out to take the air, made
me uncommonly shy'. Rudolf von Slatin, escaping from eleven
years' imprisonment by the Mahdi, made for Shepheard's to write
his book *Fire and Sword in the Sudan*: he became one of the hotel's
best-known regulars, and a staff with a taste for honorifics loved

referring to him by his full sonorous title—General Baron Sir Rudolf von Slatin Pasha.[1] It was at Shepheard's, too, that Gordon had stayed, impatiently waiting for Cook's to complete the travel arrangements, before he left Cairo in 1883 for Khartoum and his death. Shepheard's was a legend already, and one of the classic travel experiences of the imperial age was to sit on its terrace on a winter morning, with a Turkish coffee and a sticky cake, watching a parade march by outside—the tarbooshed bandsmen puffing away at their bugles, the British commander ineffably superior on his horse, and in front Shepheard's own water-man laying the dust with squirts from his leather water-bag, backing away before the advancing military, and chivvied by testy superiors on the pavement.

No other hotel was quite so famous, but several more were as familiar to the travellers of Empire as home itself. There was the Casino Palace at Port Said, with its huge glass-roofed terrace, looking across the mole to where the P. and O. lay coaling, or the Crescent at Aden, which opened directly upon the British Army's horrible hot parade ground. At Bombay they were building the monumental Taj Mahal, which was to be the most imposing building in the city, outshining even the great structures of Government, and standing flamboyantly striped, turreted and balconied upon the Apollo Bund, the very first thing to greet the new arrival in India. At Colombo there was the G.O.H.—the Grand Oriental Hotel—a huge lumpish hostelry called by *Murray's Handbook* 'one of the best hotels, if not the best, in the East'. At Calcutta there was the awful Great Eastern, monumental and morose, at Singapore Raffles', a delightfully sun-shaded, courtyarded, loose-limbed sort of hotel, famous for its long cool drinks and its food, notorious in those days for its squalid rooms. At Hong Kong the hotels on the waterfront, run on American lines, sent their own launches, house flags at the prow, to meet the liners steaming into harbour. All across Canada, wherever the Canadian Pacific Railway passed, enormous castle-like

[1] von Slatin, born in Austria in 1857, governed a Sudanese province under Gordon, and was captured by the Mahdi in 1883. He escaped to Egypt in 1895, returned to Khartoum with Kitchener, and became Inspector-General of the Sudan when Anglo-Egyptian rule was restored there.

hotels sprang up, spaciously called the Château This or That, and sometimes so dominating their cities that the hotel in the centre of Quebec has been popularly supposed, ever since, to be the ancient fortress that was the city's *raison d'être*.

All these were very grand hotels indeed.[1] They lived by the Empire, had mostly risen with its fortunes, and were now in their plushy, palmed and Electric-Illuminated prime. Perhaps more suggestive of the best imperial pleasures, though, were the houseboats for which the British had a particular fondness. At Aswan, high up the Nile, one could hire a *dahabia*, one of the long-prowed sailing-boats which still provided passenger service down to the Delta for those who could not afford Cook's steamer fares. This would be exquisitely converted by Cook's, and equipped down to the last table napkin, and it could be towed more or less where you wished, preferably within reach of one of the better hotels, for tea-dances or tennis. Even more delicious were the houseboats of Kashmir, moored on the celestial lake of Srinagar beneath the Karakoram, and served by floating shops that drifted out from town each morning. These quaint craft were devised because a Maharajah of Kashmir, fearing an influx of retired British officials into his arcardian State, forbade Europeans to own land there. The Europeans took to the water instead, and in about 1875 the first of the Kashmir houseboats were launched. They looked like little Thames-side chalets mounted on hulls, with dormer windows and shingle roofs, the whole slightly orientalized by curving prows: and on their decks the exiled British, gazing across the water towards the white ramparts beyond, took their tea and crumpets, did their embroidery, devised new phrases for their journals in uninterrupted content.

[1] Most of them still thrive. Shepheard's was destroyed in the Cairo riots of 1952, but has been rebuilt on an even better site, beside the Nile. The terrace of the Casino Palace at Port Said is sadly dingy now, but the hotel service is still geared to the passage of the India boats through the canal. The Crescent Hotel at Aden is still the best in town, while the Taj Mahal in Bombay remains the most imposing building in the city, and is perhaps the grandest hotel in Asia. The G.O.H. in Colombo has been redecorated in advanced colours and indigenous motifs, removing its last traces of imperial splendour, but Raffles has kept its character, and the Canadian Pacific hotels still boast in the Royal York at Toronto 'the largest hotel in the Commonwealth'—1,600 rooms, and an Imperial Lounge.

6

They had developed to a new pitch of finesse the art of living in tropical countries. The specialist outfitters of London offered all kinds of ingenious devices for defeating the equatorial climates—patent ice machines, spine-pads, thornproof linen, the Shikaree Tropical Hat, in white and brown canvas, from Henry Heath's Well Known Shoppe for Hattes in Oxford Street. The tent of a British Army officer in the tropics was a sight to see, with its portable writing-desk, its canvas camp bath, the gleaming boots laid out on their trees beside the 'Union Jack' Patent Field Boot Container, the taut white 'Up-Country' Mosquito Net and the 'Unique' Anti-Termite Matting on the floor. Private houses, though stuffily packed with the bric-à-brac of the day, were shaded by verandas and cooled by hand-powered fans, worked by invisible servants in the room next door (in the best-ordered households the punkah magically started swaying the moment you showed signs of pausing in a room, to glance at a picture or pin your hair up). Every kind of al fresco activity was popular. The British loved picnics, and camping parties, and boating, and often at Government Houses, if there were too many guests for the bedrooms, great comfortable tents would be erected on the lawn for the overflow.

Even so, the Victorians in their tropical possessions must have been fearfully hot and sticky. Their clothes were so heavy, they were so loaded down with protective devices like puttees (against snakes) and neckpads (against heat-stroke), that a dressy occasion must have been horribly uncomfortable. For the most part to be smart was to be dressed just as you would be at home in England, even though the temperature might be 109 degrees in the shade. Women used to order complete outfits from London, with dress, hat, gloves, bag and shoes to match (or if they could not afford it, at least took great pains to conceal the fact that their dresses had been made by a tailor in the bazaar). When one took a turn on the Maidan at Calcutta one wore a thick frock-coat and a top-hat. Men really did dress for dinner in remote tropical outposts, if only to keep some sense of root and order. The British soldier in the tropics,

though he changed into white uniform, still had his jacket brass-buttoned to the chin—and carefully dandified himself each evening, buttons polished and hair slicked, even if he had nowhere to go but the canteen in the cantonment. As if all this were not enough, a favourite recreation of the British was the fancy dress ball, to which guests often came weighed down with elaborate fineries—when Lord Roberts gave one at Simla in 1887, eighteen officers of the Royal Irish came in a body in long scarlet coats and powdered wigs.

There was an overpowering aura of closeness—one can scarcely speak of sweatiness in such a context—to the whole grandeur of Empire, the epauleted, gold-braided jackets, the heavy silks and long skirts, the dark brown paint of the Government offices. The taste of the late Victorians was ill suited to the administration of a tropical Empire. There is a picture of the Wiltshire Regiment officers' mess at Peshawar in 1886 which depressingly suggests this portentous clutter. The table is thick with regimental silver, trophies and elaborate oil lamps and sauceboats and pepper-pots and goblets, and the walls seem to sag beneath the weight of antlers. Flags are draped here and there, napkins are impeccably folded, and the sixteen chairs for the officers are packed so tightly together in the midst of it all that there looks scarcely room for the servant to manoeuvre a crested soup plate between them. The homes of the senior civilian officials were just as overloaded with consequence. Government House at Poona, where the Governor of Bombay spent his summers, was built in the château style, like a Canadian hotel, and had an eighty-foot tower, a grotto, a lake and innumerable gazebos, arbours and summer-houses. Inside it was burdened all over with dark wood panelling and chandeliers, festooned with pictures of kings and maharajahs, crammed with gigantic and lugubrious pieces of furniture. It must have been difficult indeed for the Governor, when wearing his sword for ceremonial receptions, to pass from one saloon to another: but he was used to it all—his other palace, in Bombay, had two dining-rooms, one for the dry weather, one for the monsoon.

7

They enjoyed themselves with tourism. The British, for all their

aloofness, were indefatigable sightseers. The Victoria Falls very soon became a tourist spectacle, and even India was full of the symptoms of the trade—the blackguardly guides, bowing obsequiously, the picture-postcard man at the Taj Mahal, or the chairs with long poles attached to them, in which the trippers from Bombay were carried by coolies up the long steep steps to the caves on Elephanta Island. A team of four guides was considered convenient for sightseers in Madras—'No 1 to lead, No 2 to see that he does it, No 3 to see that No 2 does his duty, while No 4 supervises the lot'. They habitually called British tourists 'My Lord', in the Empire of those days: Kipling says gharry-men in India used to warn off rival carriages by claiming they were 'rotten, My Lord, having been used by *natives*'.

The British enjoyed themselves with the theatre, too. Calcutta had four professional English-speaking theatres, Melbourne three, and there was even one in Rangoon—though most of them only played music-hall and harmless farce. Sometimes fairly distinguished companies from London undertook a tour of the more urbane imperial centres: Charles Carrington, one of the best *avant-garde* producers of the nineties, spent three years touring India, Australia, New Zealand and Egypt with Ibsen's *A Doll's House*. Well-known musical companies from London toured the garrison theatres of India, and Thespians in the mellow tradition of ham and fly-by-night often turned up on the frontier stations; like the well-known Professor who was a familiar figure of the Rhodesian veldt, plodding with his sad troupe from one stand to the next, Hamlet to pantomime. Amateur theatricals flourished almost everywhere, and seem to have formed an absolutely essential part of the imperial way. When Kipling wanted to invent a conversation to show the sameness of imperial conversation everywhere, this is what he wrote: 'And then, you know, after she had said *that* he was obliged to give the part to the other, and that made *them* furious, and the races were so near that nothing could be done, and Mrs —— said that it was altogether impossible.' The most familiar photograph of social life in the Empire of the nineties, to be found in faded sepia print in picture albums from British Columbia to the Cape, shows Colonel Hampstead, Mrs Rathbone, Miss Susan Walkley-Thomas and the Reverend Arthur Millstead, poised precariously in too much make-

up holding teacups, at a climactic moment of last year's production of *Caste*.[1]

And naturally they enjoyed themselves with sex. The late Victorians were, for all their later legend, as full-blooded as any other generation, and the annals of their imperialism are rich in sexual adventure. Frank Richards recalled, in his book *Old Soldier Sahib*, the irrepressible randiness of the British soldier abroad in those days. Commanding officers often established regimental brothels, to cope with it: in Burma the military authorities imported Japanese prostitutes, and most Indian garrison towns had brothels reserved for the white troops, inspected by military doctors for cleanliness and patrolled by military police, who did not hesitate to beat up any native seen approaching the girls. Itinerant whores— 'sand-rats'—habitually followed any British regiment on the march in India, and the pimp's cry 'jiggy-jig, sahib' haunted the British soldier the moment he set foot outside his barracks.

As for the women of Empire, Kipling badly damaged their reputation for purity with his stories of the goings-on in the Indian hill stations. The historical novelist Maud Diver undertook to restore it in a book called *The Englishwoman in India*, but even she had to allow that the British grass widow in the hills had many temptations to resist. The two most insidious dangers, Miss Diver thought, were military men on leave and amateur theatricals, but many memsahibs fell too for the exotic allure of the East. Dennis Kincaid, an Indian civil servant, reported that they were often much moved by a well-known Pathan marching song called *Wounded Heart*, and sometimes asked to be told the words: but unfortunately the least obscene lines in the song, Kincaid said, were those of the final verse, which ran: 'There is a boy across the river with a — like a peach, but alas I cannot swim'.[2]

[1] A play (by T. W. Robertson) which seems to have obsessed the Empire, dealing as it did with a humble girl's marriage to an aristocratic guardsman, and his unexpected return from the colonial wars to dash the predictions of those who thought that never the twain would cleave.

[2] Kincaid tells this story in his exceedingly entertaining *British Social Life in India*, 1608–1937 (London, 1938). *Old Soldier Sahib* (London, 1936) was the first, and possibly the only, full account of a British private soldier's life under the Raj.

8

One easily detects pathos in these pleasures. These were often people putting a brave face upon it. Some were pretending to be grander than they were. Some were tortured by that cruel and incurable disease, home-sickness. Some were compensating for pleasures that England denied them. Some were just making the best of things, drinking themselves silly, gambling themselves broke. The first-generation emigrant was generally disillusioned, and hung on only for the sake of his children. The expatriate merchant only wanted to make his pile before he hurried home to Guildford or Inverness. Perhaps the only really happy men of Empire were the men of lofty duty: those to whom it was not a spree at all, nor even a passable way of spending a few profitable years, but a vocation. Real happiness emanates from the pages of the missionary journals, with their bright-eyed conviction of Christian opportunity: and they seem to have been genuinely happy men who sat in their tents dispensing justice to the backward peoples, decreeing imprisonment here, waiving a levy there, in the absolute knowledge that the Raj was right.

CHAPTER SIXTEEN

Challenge and Responses

Oh, God will save her, fear you not:
Be you the men you've been,
Get you the sons your fathers got,
And God will save the Queen.

A. E. Housman

16

A WISTFUL satisfaction of Empire, it seems in retrospect, was the fulfilment of challenge and response. Much of the driving force of imperialism, as of Victorian progress in general, was the energy sparked by man's struggle with his own environment, and to many of the imperialists the struggle was an end in itself. The notion of a perpetual striving was essential to the morality of the day. Darwin's strictly biological 'struggle for existence' had been given metaphysical overtones by artists and philosophers from Carlyle to W. E. Henley, and now all the best didactic poets dwelt upon Man's conflict with the inconceivable hostility of Time, or Nature, or Life—'Say not the struggle naught availeth!' 'I am the captain of my fate', 'You'll be a man, my son'—

> *For men must work, and women must weep,*
> *And the sooner it's over, the sooner to sleep;*
> *And good-bye to the bar and its moaning.*

A puritanical pleasure in hardship was often allied with a boyish delight in rip-roar, the two formidably combining to produce a breed of stoic adventurers, for whom the imperial mission was a larger embodiment of a personal challenge. These instincts were, of course, strongly reinforced by the training of the public schools, with their emphasis on spartan endurance, and we may assume that it was officers rather than men who enjoyed the possibility of sudden death in inaccessible ravines of the Karoo, that district commissioners relished the summer heat more often than expatriate engine-drivers, and that most of those who went gold-digging for the fun of it could afford to do without the gold anyway.

2

But one of the most enviable advantages of being born an Englishman

in the later years of the nineteenth century was the range of adventure that was offered you. No need then for National Parks or synthetic wildernesses. Half the empty places of the world were a Briton's for the seeking, and everywhere young Britons were roughing it, fighting it out, taking a chance or living wild, under the respectable aegis of imperialism. This was good for the spirit of the nation. The existence of the Empire opened a man's horizons, offering him, if only through the vicarious medium of explorers' narratives or the *Boy's Own Paper*, a release from the daily humdrum; and for men in the field the imperial amalgam of duty, risk and fresh air could provide complete fulfilment. 'I . . . have had a hard life but a happy one,' wrote Robert Sandeman, an Indian administrator of celebrated dash, 'in the feeling that I have helped men to lead a quiet and peaceful life in this glorious world of ours.'

Quiet and peaceful are not the first adjectives that spring to mind in recalling the imperial adventure, for much of it was straightforward blood-and-thunder, and Sandeman's own career had been full of knife-edge daring—'Robert Sandeman!' his Scottish dominie had said, 'ye did little work at school, but I wish ye well. And I wadna be the Saracen of Baghdad or the Tartar of Samarkand that comes under the blow of your sabre.' There was a folk-lore of violence in the British Empire. At Fort St George in Madras they proudly displayed, as a proper memento of the imperial service, a wooden cage in which an officer called Arbuthnot had been imprisoned by the Chinese during some forgotten adventure. He was a huge hairy man with a red beard, and he kept gold coins in his pocket to present to anyone he came across uglier than himself. This was the sort of hell-for-leather eccentric whose example was most cherished, and the memoirs of the imperialists often recall with dry affection really rich specimens of rascaldom or escapade, whether for or against the Empire. In Egypt, for example, young Thomas Russell soon developed a sort of malevolent understanding with the Bedouin cattle thieves of the desert, who often floated their quarry across the Nile by fixing inflatable goatskins to their bellies. In India the last of the Thugs, the hereditary fraternity of stranglers, were sometimes nostalgically visited (a Pass was Required) at the settlement established for their reform at Jubbulpore—the story of

their suppression was one of the great thrillers of Empire, and a trip to Jubbulpore was like taking the children to the Chamber of Horrors at Madame Tussaud's.

In Ceylon they revered the memory of Major Thomas Rogers of Her Majesty's Ceylon Rifle Regiment, who was supposed to have shot 600 elephants, and who found retribution in the end when he was killed by a stroke of lightning—his tombstone at Nuwara Eliya, too, was three times struck by lightning before it finally disappeared. ('*Lo these are parts of His ways,*' said the memorial tablet in Kandy, '*But the thunder of His power who can understand?*') Innumerable imperial anecdotes deliberately mix up the comic and the very dangerous, a piquancy always relished by the British. We hear often of the Indian stationmaster's telegram down the line: 'TIGER ON PLATFORM STOP STAFF FRIGHTENED STOP PRAY ARRANGE', or its more sophisticated variant from upper Egypt, in which a man on a lonely Nile station was said to have cabled to Cairo: 'POST SURROUNDED BY LIONS AND TIGERS'. Back went the reply from Cairo: 'THERE ARE NO TIGERS IN AFRICA', and back again went the Empire-builder's simple riposte: 'DELETE TIGERS'. Above Jamalpur a favourite tombstone wryly commemorated a Welsh imperialist, Gwilym Roberts, 'who died from the effects of an encounter with a tiger near this place, AD 1864'.

3

For a century living dangerously, or alone, had been a way of life for a minority of the British people, to a degree that no other European nation could match, and this experience was by no means ended. There were still pirates to be intercepted in Chinese waters, slave-traders to capture in the Persian Gulf, Nandi tribesmen with poison arrows in East Africa—there was no antidote to the lethal paste they smeared on their arrow-heads, even injections of strychnine proving ineffective. Man-eating tigers had still to be tracked down, and when they built the Uganda Railway they not only had to cope with murderous lions but sometimes scooped the scorpions and ants in bucket-loads from their camp sites. In hundreds of African trading-posts, high up steamy malarial rivers, or all alone

in the immense hinterland of Swaziland, with a hitching-post outside, a few sheep grazing, and a local chief tippling whisky surreptitiously behind the counter—in any such isolated store the traveller might find a perfectly familiar, down-to-earth Yorkshire shopkeeper running his business with an easy-going acumen, not ambitious for fortune nor particularly nostalgic for home, just treating life as it came. High in the hills at Mardan, on the north-west frontier of India, the men of the Queen's Own Corps of Guides kept perpetual sentry-go on the most turbulent of border areas, their outposts hidden away in the arid hills, their patrols exchanging desultory rifle-fire with the intractable local tribes—a handful of Englishmen with their Sikh, Dogra and Pathan soldiers, perched on the edge of the Empire in permanent emergency.

There were Englishmen commanding sealers that sailed for the ice out of St John's, training elephants in the Burmese teak forests, dragging logs with ox-teams out of the Canadian backwoods, skirmishing with ungrateful primitives anywhere from the plains of Manitoba to the Irrawaddy basin. The world was a stranger place in those days, and the British often embarked upon these adventures marvellously wide-eyed and innocent. When a young adventurer called Matthew Morton, aged 20, decided to go out to Rhodesia in 1894, he asked at the Castle Steamship Company's office in Glasgow how to get to Bulawayo. They told him he could probably take a cab there from Johannesburg, and off he trustfully went: but in the event the journey north from the Rand entailed five weeks in an ox-wagon and nineteen days walking with a pack-donkey. And this is how Charles Rudd, Rhodes's agent in his original dealings with Lobengula, saw the great black king when he first reached his kraal in Bechuanaland: 'He had his dinner brought to him while we were there, he went back into the wagon and they put a blanket over him and he lay down with his head and arms over the front box of the wagon, and a mass of meat, like the pieces they give to the lions at the Zoo, only as if it had been thrown into a big fire, was put before him, and some kind of bread, he told the slave boy who brought the meat to him to turn it over, and then he began to tear off pieces with a kind of stick altogether very much like a wild beast.'

The *naïveté* of the approach certainly added to the excitement—clearly Mr Rudd was venturing into new worlds—but the dangers were none the less real. The Empire was ornamented everywhere with memorials of sudden death. One of the most striking selections was displayed in the nave of St George's Church at Madras, a virile sort of structure itself, in a wide ravaged churchyard like a recently fought-over battlefield. Here lay someone 'cut off by the hand of an unknown assassin at Bellary', and one who 'fell by the hands of a band of fanatics', and one killed in action 'on the fortified heights of Arracon', and one who died 'from the effect of a coup de soleil, while gallantly leading his regiment at the storming of the fortress Chinkeang Foo'. At the battle of Ferozeshah died 'the last of three brothers who fell for their country on the battlefields of Asia'. Several men were 'lost at sea while on a voyage to Rangoon with the headquarters of their regiment on board the transport *Lady Nugent*', one died of jungle fever 'contracted during a few hours passed on the Yailegherry Hills', and one simply suffered, saddest of all, 'a premature and sudden dissolution in a distant clime'.

All this, at the end of the Victorian century, was part of the British experience, and they were proud of it. Joseph Chamberlain approached his duties at the Colonial Office in a mood of pugnacious bravado—the Jubilee celebrations themselves, mounted with such pomp and panache in the face of a bitterly jealous Europe, were a snook cocked at the world. Imperialists abroad often behaved with similar gusto. When the coffee crop failed in Ceylon many of the British planters moved elsewhere, but many more gamely transferred the remains of their capital, their skills and their hopes to a crop that was altogether new to them—tea. When they found gold on the Rand Mr Thomas Sheffield, proprietor of the *Eastern Star* newspaper in Grahamstown, a thousand miles away, decided the profits would be greater up there. One day in 1889 he published issue number 2,042 of his paper, with the announcement that 'with this issue the *Eastern Star* will cease to shine in the firmament in which its first rays were shed, and to move in the orbit which has been its daily round for the last 16 years. But it will rise again in another quarter of this South Africa of ours away to the north, where

'*There is gold to lay by, and gold to spend,*
Gold to give and gold to lend.'

Next day he packed the entire equipment of the newspaper on the
train to Kimberley, and thence conveyed it by laborious stages of
ox-cart across the veldt to the infant Johannesburg. Seven weeks
after his departure from Grahamstown, in his new premises on the
Reef, Mr Sheffield published issue number 2,043.[1]

4

Into the mystique of every British settlement some particular old
adventure had by now been absorbed, and had become familiar to
every schoolchild. They mostly seem to have been heroic defeats,
and this perhaps reflected the classical education of so many im-
perialists, conveying the British in spirit to Thermopylae, or to the
bridgehead with Horatio—or perhaps in the Eternal Struggle brave
failure was somehow more salutary than success. In Australia the
origins of the colonies were, owing to a shortage of anything more
inspiring, most famously commemorated in a dreadful picture of
the discovery by two explorers, Burke and Wills, that a food cache
they expected to find in the middle of the Outback was in fact
empty, condemning them to another eight months of heroic night-
mare. In Canada the picture on the schoolroom wall showed the
death of Wolfe at Quebec, fragile and selfless upon the Plains of
Abraham, with the army of his gallant enemy silent in the back-
ground. In Rhodesia the classic scene was Allan Wilson's last stand
against the Matabele—*There Was No Survivor*. In Natal the eighty
men of Rorke's Drift held out for ever against their 4,000 Zulu
attackers, immortalized in scarlet and gunsmoke by the brush of
Lady Butler. And in England the Spirit of Empire was perhaps most
popularly symbolized by the vision of General Gordon, that Galahad
or Gabriel of the later Victorians, standing guileless, unarmed,
fresh-faced, almost radiant, at the head of the stairs in his palace at
Khartoum, while the ferocious Mahdists in the hall below, brandish-
ing their assegais, prepared to murder him. (There was, as a matter

[1] The paper flourishes still as the Johannesburg *Star*.

of fact, another version of the scene, which had Gordon on the landing blazing away with a revolver at the advancing savages: but it was the image of martyred British innocence that most people preferred.)

5

But there was to this great communal exploit, this epic dispersal of a people and its power, a poignant meaning, too. Not everybody died heroically, leading their men at Chinkeang Foo. The challenge of Empire must have seemed bitter enough to many a poor wife, condemned to unhealthy exile for most of her life, her children far away at school in England, her complexion slowly crumbling in sun and humidity, her one pitiful ambition a cottage with a bit of garden somewhere quiet in the West Country. At a time when Europeans could seldom bring themselves to mix socially with coloured people she must often have been terribly lonely: only five women were present when the White Rajah of Sarawak entertained the entire European community to dinner in 1887. Many a district officer, too, no doubt regretted his vocation as he opened his precious letters from home in the desolation of veldt or jungle. *My mother's writing!* (as one of them wrote)

> ——*my hide is tough,*
> *And the road of life has been somewhat rough.*
> *The fount of my tears, one would think, was dry,*
> *But it always brings a tear to my eye.*

Emigration, spirited and hopeful though it sounded, was often only the last resort of the unutterably dejected, for whom home seemed to offer no chances. 'If crosses and tombs could be erected on the water,' it was said of the transatlantic migrations of the Irish, 'the whole route of the emigrant vessels . . . would long since have assumed the appearance of a crowded cemetery.' Emigrants often ended up in doss-house or institution—there were generally at least a dozen destitute Britons in the Bombay workhouse—and all too often arrived in the colonies utterly ignorant of what to expect. A writer in the *Oxford Survey of the British Empire*, recording the case of a farm labourer who returned to England after a single Canadian

winter because he found it too cold, commented severely: 'Perhaps he had lacked, not through his own fault, that schooling in imperial geography which should be an integral part of imperial education.'

The tropical climate was a terrible hazard, in the days when the mystery of malaria had not yet been solved, and the very science of tropical medicine had only just been born. The inescapable miseries of dysentery had a different wry nickname in each possession— Gippy Tummy, Poonaitis, Karachi trotters. Nervous disorders in India were called by the soldiers 'the Doo-lally tap', after a notorious transit camp at Deolalie, near Bombay, in which generations of Britons awaiting a ship home had found their nerves cracking under the strain of heat and boredom. West Africa had been killing or wrecking Britons for 300 years, and it is said that by 1897 there were $1\frac{1}{2}$ million British graves in India. In 1880 the mortality rate among British troops there had been 24.85 per thousand, and an astonishing number of the most distinguished imperial soldiers died in their early thirties. 'We've got cholera in the camp', runs one of Kipling's Anglo-Indian laments:

> *Oh, strike your camp an' go, the bugle's callin',*
> *The Rains are fallin'—*
> *The dead are bushed an' stoned to keep 'em safe below.*
> *The Band's a-doin' all she knows to cheer us;*
> *The Chaplain's gone and prayed to Gawd to 'ear us—*
> *To 'ear us—*
> *O Lord, for it's a-killin' of us so!*

It was popularly supposed that cholera travelled about in a small invisible cloud of germs, two or three feet above the ground, and soldiers sometimes preferred to sleep on the floor, in the belief that the cloud would harmlessly over-fly them.

'Two monsoons are the life of a man', ran an old Anglo-Indian saying, and even Bryce, who was no alarmist, wrote: 'The English race becomes so enfeebled in the second generation by living without respite in the Indian sun that it would probably die out, at least in the plains, in the third or fourth generation.' The most familiar imperial epitaph was 'Died At Sea On the Way Home', and many a regimental roll contained more deaths from sickness than from

enemy action. The big Indian trains carried coffins as a matter of course, in case any passenger succumbed *en route* from heat stroke or cholera; *Murray's Handbook* is full of cautious advice about hygiene and infection—'the traveller must bring food with him', is the book's dark advice on a visit to Bijapur, 'as well as insect powder'. 'Life at sea-level in Jamaica', we are told, 'is a deadly trial to the unacclimatized European'.

Time and again whole families were destroyed by cholera and typhoid. Three little English children—Alice Daniell, 4; Lindsey Daniell, nearly 3; Georgina Daniell, nearly 2—lay beneath parallel slabs, each a different size, outside the English church at Pusselawa in the highlands of Ceylon. It was a haunting spot. The church was a little grey and whitewashed building, with a corrugated-iron roof, wire-netting windows, and dark-leafed tropical trees beside the gate to simulate the churchyard yews of home. There was a Hindu shrine in the next field, and on the other side of the church was the graveyard of the Christian Tamils, their epitaphs scrawled in indecipherable red paint that had sometimes dripped off the wooden crosses to the makeshift plinths below. Crows squawked in the trees above, cocks crowed from the hovels on the hillside, the gardener's brush swished lazily in the sunshine, sometimes a shrill chatter of women's voices rose suddenly from the village below, to end in laughter or angry squabble. The churchyard smelt of dust and scented foliage, the church of hassocks and candle-grease.

Few visitors, I suspect, bothered to inspect the gravestones of the little Daniells, which were tucked away at the back of the church, and there were no Daniells left in Ceylon to care for them: but those who scratched away the forty years' mould from their slabs would find that all three children died within two days in September 1866, and had been brought up here for burial from their father's tea estate down the hill. It was thought at the time that they had died because there was viper grass in their rhubarb tart, but they all really died of cholera. Their broken-hearted parents abandoned the imperial adventure at once, and went home to England, where Mr Daniell sadly took Holy Orders.

CHAPTER SEVENTEEN

Stones of Empire

I must be gone to the crowd untold
 Of men by the cause which they served unknown,
Who moulder in myriad graves of old;
 Never a story and never a stone
Tells of the martyrs who die like me,
Just for the pride of the old countree.

<div align="right">Alfred Lyall</div>

17

IT was by their buildings that earlier Empires were most arrestingly remembered. Storks upon a Roman viaduct, proud towers in an Andean plaza, the squat menace of the Pyramids, seen small but alarming from the Mokattam hills—any of these could instantly suggest to an unlettered visitor the age and power of a lost dominion. The British in their imperial heyday had evolved no style so absolute as the Roman or the Egyptian, if only because they were members of a wider civilization, sharing a culture with the rest of the Western world.[1] Buildings would not be their chief memorials: but across their Empire, nevertheless, they had left architectural imprints that were recognizably their own, to remind posterity with a gable or a clock-tower that the Raj had passed that way.

In their earlier years of Empire they had scattered through their possessions buildings in the Queen Anne and Georgian styles, reflecting the ordered security of society at home, and now commonly called Colonial. Much of the best was in the lost colonies of the United States, where the Americans had given the style subtleties of their own, and in the old parts of the Empire there were many good examples too, stabled and impeccable in Nova Scotia, or wilted by heat and humidity in the estates and merchant settlements of the tropics. They gave a sense of continuity to the British presence, linking the plantations of the old Empire with the Chartered Companies and railway workshops of the new: but far truer to the spirit of the imperial climax, and much more widely admired by the British, was the heterogeneous collection of idioms loosely called the High Victorian. The characteristic form of the imperial prime was romantically picturesque, loosely derived from Gothic or Byzantine models, and ornamented all over with eclectic variety. It

[1] Though Sir Osbert Sitwell once suggested that a British Empire style might 'lie dormant' in the Brighton Pavilion.

was not how one imagines an imperial style. It was not exactly imperious. But in the elaboration of its hybrid forms, the towering exuberance of its fancy, its readiness to accept a touch of the exotic here and there, its colossal scale and its frequent impression of enthusiasm wildly out of hand—in all these things the style truly reflected this high noon of imperialism. In Canada the British adopted mansard roofs and château turrets, in India they built railway sheds of Saracenic motif, and in British Columbia, looking westward across the Pacific, they built a Parliament with pagodas. But beneath all these alien veneers the authentic British showed, in the red brick and the mullion windows, the wrought iron and the commemorative medallions, or just in a true-blue inscription, recording the cost of it all, commemorating an occasion, or honouring, like the text on the Simla telegraph office, prefectorial values:

MOLEM AEDIFICII MULTI CONSTRUXERUNT:—
RATIONEM EXEGIT I. BEGG[1]

2

Supreme in every imperial city stood the house of God, on a hill if there was one about, and generally Gothic. Sometimes it was a princely pile. On a hundred improbable imperial sites, encouched in buffalo grass or dripped about by frangipani, there stood a genuine Anglican cathedral, with a Bishop's Palace somewhere near and a flutter of surplices in the Sunday trade winds. Even more than the mansions of colonial governors, these stately buildings expressed a sort of hook-nosed and scholarly assurance, and gave the traveller from England an uncanny sense of *déjà vu*. There was one very like Hereford in the Punjabi town of Ambala, on the road from Delhi to Kalka.[2] There was one rather like Lincoln down the road from the Renaissance-style Post Office, the Classical Town Hall, the Byzantine market and the Tudor Government House in Sydney. The cathedral at Calcutta used to look like Salisbury, until the 1897

[1] 'Many men erected the stonework of this building: I. Begg directed the work.'
[2] It was bombed by Pakistani aircraft during the fighting with India in 1965.

earthquake knocked its spire off.[1] The cathedral at St John's, New-foundland, started by George Gilbert Scott in 1844, was burnt out in a fire in 1892, and now stood portentously, a vast humped shell, high above the clapboard streets of the port.[2] The cathedral at Lahore was by Scott, too, and was all layered in the brown dust of the Punjab, with a baked brown close, a few brown stringy trees, and a catechism echoing across the Mall from the brown cathedral school across the way. The cathedral at Fredericton, New Brunswick, was modelled originally on the parish church at Snettisham in Norfolk, and completed according to the advice of the Ecclesiological Society of Cambridge. The cathedral at St Helena was described by one Governor of the island, R. A. Sterndale, as being 'utterly devoid of architectural beauty outside or in'.

If there was not a cathedral, there was certainly a parish church. There it stood in splendid incongruity on heathen strand or far-flung waterfront, and not only Anglicans were moved to find it there, for like those Mounties at the head of the White Pass, it spoke of order and authority, meals at the proper time, clean sheets and punctual trains. Any of a thousand would serve us for examples, but let us choose the church of St John which stood in a fine wide churchyard above the waterfront at Hong Kong. St John's was in the very best part of town. Government House was its neighbour one way, Flagstaff House the other, and within convenient walking distance were the barracks, the parade ground, the cricket ground and the public gardens. Behind rose the steep streets of the Peak, the most fashionable residential area. In front was the waterfront, looking across the marvellous harbour to Kowloon. Easily, benignly, the tower of St John's presided over those varied scenes. The water-front buildings in those days were vaguely Italianate in style, in a kind common to all European settlements in China, and the quay-sides themselves were picturesquely Chinese, all coolie hats and sampans. The slab of the Peak behind was tawny and brown, except where the taipans had planted their lush gardens, and the general colour of the scene was a bleached grey, as though all the paints had slightly faded. The stance of St John's, however, was unaffected by

[1] When they rebuilt it, without the spire, it looked like Canterbury.
[2] It is rebuilt now, but still unfinished.

it all. It stood there precisely as it might have stood in Cheltenham or Tunbridge Wells, assimilated into the scene by sheer force of character. Like the minaret of a mosque, it represented more (or less) than a faith: it was the emblem of a society, expressing temporal as well as spiritual values, and clearly built upon the assumption that if God was a church-goer at all, he was obviously C. of E.

3

Next to the home of God, the home of the Empire-builder. The domestic architecture of the Victorian Empire was everything that it was at home in England, with tropical overtones. There was no class or style of contemporary British housing that you could not find, lifted bodily, somewhere in the overseas possessions. Even the mean terrace houses of industrial England were reproduced in the cities of Australia, where a British proletariat existed to occupy them; the Australians also favoured a peculiarly froward kind of bungalow, with grey-washed walls and lead-coloured iron roofs, which they disguised with an acacia or a couple of Norfolk pines to look like a week-end cottage. The English suburban villa, as we have seen, was broadcast throughout the Indian hills, and the first thing any conventional colonial magnate did, when he had made his pile in Parramatta or Kimberley, was to build himself a really lurid Gothic mansion, just as urned, terraced and carriage-swept as any his contemporaries were erecting in the environs of Manchester. Even the odd folly appeared in the Empire, honouring the traditions of English eccentricity: the Astana, the palace of the White Rajahs of Sarawak, had a Gothic tower and high-pitched roofs of wooden shingles, and was supported on white-washed brick arcades.

Often these replicas of home were absurdly ill suited to their setting—if not in looks, at least in comfort. Even in England those florid piles were scarcely functional, and when one added to their original disadvantages all the hazards of tropical life, from termites beneath the hall floor to troops of servants' babies in the stable-yard, they must sometimes have made the memsahib's heart sink. But there were exceptions, even in the heyday of High Victorian. The English settlers in South Africa were building some very

agreeable homesteads, trim with trees and fences like Kentucky stud-farms, and far more comfortable than the shambled farms of their neighbours the Boers. The tea-planters' houses of Ceylon, with their immensely tall narrow corridors and their outdoor kitchens, were often surrounded by admirable lawns of coarse mountain grass, upon which the planters' ladies enviably sat, buzzed about by harmless insects and salaamed by passing serfs.

The archetypical Anglo-Indian bungalow was an uninspired compromise. In the beginning it was simply a box, for living in, with a veranda all around it to keep it cool. When British families began to go to India a second storey was placed upon the box, and on top of it again a sleeping platform was often built, with a ladder to reach it from the roof on the very hottest nights of the hot weather. Cool creepers were encouraged to grow over and around the veranda, and sometimes it was covered with an aromatic screen, moistened with running water by coolies outside, and smelling sweetly fresh and herbal. Behind was the compound, in which the servant community lived, and all around was sprinkled garden, acting as insulation against the hot dust of street or desert. Upon this basic form every sort of change was rung, and in its grander versions the bungalow had anything up to twenty rooms—a dining-room and a drawing-room downstairs, bedrooms and a family sitting-room above.

Such a house stood for imperial sense. For imperial sensibility we will pay brief calls upon two very different possessions. At Zomba, in Nyasaland, the British Consul accredited to 'the Kings and Chiefs of Central Africa' had built a Residency that was a model of its kind, beautifully set upon the slopes of a forested mountain (the home of Rider Haggard's People of the Mist) and surrounded by delicious half-wild gardens. It had conical towers at each end, to fortify it against savages, and verandas upstairs and down, and was proudly claimed to be the finest building in East Africa north of the Zambesi: with its steep roof and big low rooms, the mountains behind and the wide lush valley in front, it looked genuinely indigenous to Africa, a sensitive synthesis of sun and shade, ruling and ruled.

The houses on the Savannah at Port of Spain, capital of Trinidad, offered sensibility of a more distracted kind. There architectural

clairvoyants could peer behind the composure of Victorianism into its wild reality. The Savannah was a wide green park, perhaps a mile across, preserved more or less in its natural state. There was a bandstand and the usual race-course, and on the grass groups of negro and Indian boys, scattered across the green, played interminable games of cricket, occasionally bursting into impromptu carnival. Trees ran down to the edge of the grass, and the whole was encircled by an electric tramline. Around this wide expanse a staggering gallimaufry of mansions surveyed the scene. Some were domed, some were stained-glassed, some had turrets, some had gables. There was half-timbering, and pictorial tiling, fenestration ranging from the medieval to the Georgian, spikes and pagodas, weathercocks everywhere, casement windows as of faery lore, bobbles and battlements, mullions and ornamental ironwork, silhouettes of Rhenish castle or Loire château—all in esplanade on the edge of the Savannah, in mad embodiment of the imperial variety.[1]

4

Public buildings of the most august elaboration honoured the Queen, the Arts and Sciences or the principle of imperial Government. Town Halls were scarcely less imposing than Parliament buildings, and clock towers were ubiquitous—the one in the middle of Colombo had a lighthouse on top, and the one at Aden was much the most prominent structure in the colony, standing high on a bare hill overlooking Steamer Point. Many of these enormous buildings were designed by soldiers, others by celebrated English architects of the day, but so vastly overwhelming was the spirit they represented that it was very difficult to tell the Captain of Engineers from the new Palladio. It was the spirit of Art for Empire's sake. We read that when a wealthy south Indian philanthropist decided to found a boarding-school in Madras 'his attention was directed not only towards improving the results at the University Examinations but also the construction of an artistic pile of buildings

[1] The Port of Spain houses are still in their full glory, with more cricketers than ever shouting '*Owzat?*' or 'Very pretty, sir', in the best imperial fashion on the Savannah. The Zomba house is now a hostel for Government employees, and its grounds form a public garden.

with a tower in the middle'. The tower-in-the-middle impulse informs many of the great buildings of the Pax Britannica. Their purpose does not seem to matter, and is seldom clear. They may be railway stations, libraries, ladies' colleges, covered markets. All are heavily clothed in symbolic ornament, and come to blur indistinguishably in the mind, a general mass of pomp strewn across the world in the Queen's name.

Probably the most daunting group of official buildings in the Empire was in Bombay. It stood like a massive palisade in parallel with the sea, separated from the beaches only by an expanse of brownish turf, a railway line, and a riding-track called Rotten Row. Here in three great blocks the Establishment of the Bombay Presidency was concentrated, celestially removed from the chaos which, out of sight beyond Esplanade Road and the Victoria Terminus, ran indescribably away to the north. Side by side stood the Secretariat, the University, the Library, the Clock Tower, the Law Courts, the Public Works Department, the Post Office and the Telegraph Office—a group of public buildings worthy of a great capital, and unmatched for scale in any English city outside London. It was a heady parade. Some was Venetian Gothic, some French Decorated, some Early English, and the Post Office, so the guidebook says, was simply 'medieval (architect, Trubshawe)'. Enormous palm-mat awnings shaded the windows, and high on their vast balconies dignitaries of the Raj could sometimes be seen strolling in white suits, discussing sewage costs with underlings or interviewing contractors. Nothing could be more unbendingly official than these buildings. They looked as though never, in all their years of dignity, did a lady drop a scented handkerchief upon their stairs, or a small boy prop his hoop against the porter's lodge. The Secretariat alone, designed by Captain H. St Clair Wilkins, Royal Engineers, had taken seven years to build, and a notice inside recorded with approval that whereas the estimated cost was Rs 1,280,731, the actual cost was only Rs 1,260,844.[1]

In Simla, steel-bolted offices below the Mall; in Wellington, New Zealand, the largest wooden buildings in the world, designed

[1] The buildings remain, daunting as ever, but land reclamation has removed them some distance from the sea, and tempered their majestic effect.

not to hurt if an earthquake demolished them, and containing all
the Ministerial offices and all the Archives of State; in Bulawayo,
Rhodesia, a white-walled and thatched-roof Government House
built on the site of Lobengula's kraal; and in Ottawa a Parliament
building which illustrated, better than any other, the romance of the
imperial ideal at its best, the dream of cloud-capped towers and halls
of brotherly debate which shimmered in many an Empire-builder's
mind. The Parliament of the Canadian Confederacy was seen from
the start as an epitome. Canada was the idealist's end of Empire—a
people united in reconciliation, a colony emancipated, a wilderness
civilized, the principles of parliamentary democracy transferred in
triumphant vindication from an ancient capital to a new. When they
built their Parliament the Canadians were consciously building a
symbol, and they chose a properly sacramental site. The west bank
of the river at Ottawa is flat, and runs away sullenly into the wilder-
ness and the frozen north. The east bank is high and wooded, rising
in grand bluffs above the water, and offering wide desolate prospects
in every direction. Up there, in a site unmistakably of the New
World, the English architects Thomas Fuller and Frederick Stent
erected the most sumptuously imperial of buildings. It was best seen
from Major's Hill, a little way downstream, for there its symbolisms
showed clearest. To the left were the stepped locks of the Rideau
Canal, descending steeply to the river in a virtuoso demonstration
of man's mastery over nature. To the right the river ran away
infinitely cold and uninviting, sometimes clogged with huge rafts,
and chuffed over by steamboats. High in the middle, lapped by
respectful trees and statuary, the turrets, towers and variegated
roofs of Parliament rose in mysterious supremacy—a tall clock-tower
their apex, outlier wings with mansard roofs and gabled windows,
the library of Parliament buttressed and octagonal like an English
chapter-house—with roofs of green and purple, and stonework
splashed everywhere with reds, yellows and whites. Proud Cana-
dians took their sons up Major's Hill, to point out the lessons of
this majestic spectacle: and watercolourists threw an extra glow
around it all, as they might embellish an allegory.[1]

[1] The principal architect of this great group was Fuller (1822–98), who
was born in Bath. The central block was recognizably related to the Univer-

5

One day in 1836 Colonel William Light, Surveyor-General of South Australia, stood on a bluff above Holdfast Bay and chose the site of Adelaide. He was the bastard son of a Royal Navy captain and a Malay half-caste woman, and had gone to Australia at the invitation of Gibbon Wakefield, who had high-flown plans for one of his colonies there. Light's job was to survey the country and apportion land to settlers, and almost the first thing he did was to pick a spot for the capital. The city was started absolutely from scratch, on military principles, in a place deliberately and scientifically selected out of the endless bush. First Colonel Light decreed a circular road, surrounding the entire site. He lined it all around with parkland, as an insulation against the bush, and in its centre he deposited a double city: to the north a residential area, around Wellington Square, to the south a business area, around Victoria Square. Between the two lay another park, with the Torrens River running through it, containing Government House, cricket grounds, a parade ground and an artificial lake. Adelaide was an elegant little city from the start, and though in the course of time Light's plan was partly overlaid by haphazard development, still it remained a standing reproach to the cheek-by-jowl disoriented cities of the Mother Country.[1]

It was a paradox of Empire that the British, the most pragmatic of peoples, should have best expressed themselves architecturally in planned townscapes—in groups rather than individual buildings, skylines rather than façades. This was partly because sites were generally virgin, and partly because soldiers so often laid out settlements, and partly because in their overseas possessions the British allowed themselves to be more formal and methodical than they often were at home. There were no sentimental yearnings for the

sity Museum at Oxford, which Fuller knew, and which had been completed in 1855.

[1] Poor Light, though he is now gratefully remembered in Australia, came to a sad end. He resigned his job after a series of differences with his superiors, and died in 1839, aged 54, penniless and tubercular, in a cottage of mud and reed near his city site, nursed by his English mistress Maria.

crooked way, the rolling way. Right angles were *de rigueur* in the imperial towns, streets were often numerically named: many cities, like Adelaide, were built to a grid. Streets were often immensely wide, to allow ox-trains to turn in them, and the setting of spire against dome, tree against clock tower, was often arranged with methodical finesse. Foreigners were frequently struck by what seemed to them an uncharacteristic logic of design: von Hübner, surveying the straight broad streets of Australia, concluded that the young Englishmen of the colonies 'lean to the American'. Certainly the cities which the British had summoned into existence across the world were notable for a spaciousness, an airiness, that suggested boundless promise—as though the colonial planners foresaw from the very start their couple of shacks and a lean-to shop transformed into a metropolis.

Melbourne, for example, had been founded only sixty years before, when a Mr John Batman signed a land agreement with the aboriginal chiefs of the area—the three brothers Jagajaga, together with Cooloolock, Bungarie, Yanyan, Moowhip and Mommarmalar. No Colonel Light stepped in, to enlighten its origins with green belts and zoning, but it had already become a city of consequence, gilded with the profits of sheep-range and gold-rush. It was built to a grid, regardless of the shape of the ground. Each main street was flanked by a lesser access road, so that Lonsdale Street had its Little Lonsdale Street in parallel, Bourke Street its Little Bourke Street, Flinders Street its Flinders Lane. The business houses had their front doors on a big street, their back doors on a small, and suavely among them proceeded the supreme Australian thoroughfare, Collins Street, already claiming itself to be the finest street in the southern hemisphere (to every other Melbourne Street, Miss Clara Aspinall had written in the 1850s, 'there is an American, go-ahead spirit, very objectionable to the well-regulated minds of our sex'). There were no squares or crescents: the centre of the city was rigidly geometrical, partly because it made land sales easier, and it was in the suburbs that the individualism of Australia found expression. These were very British. Carlton was frankly modelled on Bloomsbury, and when they established their first seaside suburb the Australians naturally called it Brighton. Street after street the

villas extended, each in its garden, across the Yarra River and down
to the sea; rich and showy houses, often delightfully touched up
with decorative cast-iron, with ballrooms and nurseries, fern houses
and coach houses, stucco decorations everywhere and stained glass
on the landing. From these elegant and commodious retreats, as
the panegyrists used to say, furnished in the costliest taste of
four-poster and mahogany, such magnates as had escaped the bank
crash of 1893 drove into town along broad tree-shaded boulevards,
out of *rus* into *urbs*, to their flamboyant offices on Chancery Place,
to lamb chops at the Melbourne Club, or simply to perform the
social ritual known as 'doing the Block'—strolling up and down the
north side of Collins Street, fetching up at last at Gunsler's Vienna
Café, where *everybody* went.

English visitors might scoff at such a city ('isn't it a little far
from Town?'), and Melbourne citizens of cosmopolitan pretensions
habitually disparaged it, too. But these great cities of the white
colonies—Melbourne, Sydney, Toronto, Durban—were already
much finer places than the industrial cities of the English provinces.
They were handsome towns: not subtly handsome, but boldly so.
In the detail they often slavishly copied English patterns, but in the
whole they had a freshness all their own, as though their builders
had torn Birmingham or Manchester breezily apart, and begun all
over again.

> *Give me old Melbourne and give me my girl,*
> *And I will be simply all right,*
> *Does anyone know of a better old place,*
> *Than Bourke Street on Saturday night?*

6

The British, who generally neglected their waterfronts at home, or
blocked them all off with high-walled docks, used them rather better
abroad. They created no Golden Horns, it is true, and wasted a few
such marvellous sites as Wellington or Vancouver, but one did not
easily forget the harbour-front at Hong Kong, the formal splendour
of Empress Place in Singapore, or St John's in Newfoundland,
with its tumble of wooden houses secreted behind the Narrows.

Sometimes the imperialists even set out to give gaiety to their water-
fronts. Almost the first thing they created at Aden was a forlorn
and blistered Esplanade, facing Front Bay. Sydney Harbour was
flanked with little villas, perched Riviera-like high and low along its
banks, and the seafront at Durban, where the Zulu rickshaw boys
waited outside the hotels with bells on their ankles and feathers in
their rickshaw wheels, was already one of the brightest of Victorian
water-places. As for the esplanade at Colombo in Ceylon, that isle
of imperial delights, it was almost Breton in its seaside elegance, and
only seemed to be awaiting Proust's young ladies, to flounce along
the boardwalk with their bikes and parasols. At one end stood the
swanky Galle Face hotel, with its gay sunblinds and majestic hall
porters; at the other the British Army barracks were built in sunny
enfilade, like expensive hotels themselves; facing the sea was the
oval-shaped Colombo Club, white, shuttered and Members Only;
between them all stretched a huge seaside lawn, beautifully main-
tained by the Municipality, with white rails like a race-course all
around it, and Dufy ships sailing brightly by beyond the seawall.

And at Madras, beyond the Coromandel surf, the British erected
the best of all their city skylines, a romantic extravaganza com-
parable to that Whitehall view from the little bridge in St James's
Park. In London the oriental elaboration seemed gloriously alien:
in Madras, the oldest British city of the Raj, exotic flourishes seemed
only proper. The skyline was like a cross between the Kremlin, a
story-book Damascus and St Pancras railway station. Its buildings
were, in fact, quite widely separated, and various in their styles, and
seen close to resolved themselves into huge warrens of courthouses
and Government offices, all arched and vaulted, with sunshine and
rain pouring alternately down open staircases, and immense piles
of documents glimpsed beneath portraits of old Governors and
judges through barred unglazed windows. When seen from a dis-
tance, though, through the haze of the Carnatic noonday as your
ship approached the anchorage, something ethereal happened to
those structures: their walls were lost in the bustle of the city,
and only their bulbous roofs and towers seemed to float above
Madras, insubstantial against the blur, portly for Victoria and
domed for the East.

7

'The Maharajah gave the order and Yakub Sahib made the garden.'
In every city the sahibs softened their architecture with gardens,
and of all expressions of the imperial taste, the gardens were the
most satisfactory. The English predilection for the paradise garden,
nature unobtrusively coaxed into order, was richly encouraged in
the tropics, where the imperial gardeners found plants readier than
anything at home to intertwine and luxuriate in the profusion they
preferred. This was a ruling race with green fingers. The great
gardens of the British Empire were mostly botanical gardens
created for scientific purposes, but they were never mere open-air
laboratories, while around their own houses, and in their public
parks, the British lovingly grafted imperial cuttings to the root of
English landscape art.

The best of the imperial gardens had an air of exuberance, as
though their creators have been given *carte blanche*. The two famous
botanical gardens of Ceylon, for instance, felt like English gardens
magically released from the restraints of English taste and climate.
Peradeniya, outside Kandy, was done to a Blenheim scale: the river
Mahawali-ganga almost surrounded it, giving it a theatrical unity,
and everything about it was lavish—royal palms, vast clumps of
bamboo, greenhouses and wicker arbours veiled in creeper, an
eerie grotto of an orchid house, flower gardens dramatically laid
out, colour by colour in big bright slabs. Its high-altitude subsidiary,
Hakgalla, was its antithesis. It stood secluded in the mountains
beyond Nuriya Eliya, a favourite object of Grand Hotel excursions,
and it was like an English garden in a dream, blurred and suggestive.
Peradeniya was best seen on the evening of a sunny day, when the
shadow gave depth to its grand manner, and threw the silhouettes
of its palms nobly across the green. Hakgalla excelled in a Scotch
mist in early morning, when its maze of little paths, thickets and
hollows opened unexpectedly one after another through the haze.
It was only just short of a wild garden, its foliage exquisitely checked
on the brink of anarchy, and it was dominated by ferns—damp and
lacy ground ferns, tangled rock ferns, and the beautiful tree ferns

peculiar to Ceylon, whose leaves formed a high caparison, and dripped their rain-drops all around the edge.

The British had never stopped creating botanical gardens—those on the island of Dominica, in the West Indies, though already a superlative collection of tropical plants, had been founded only in 1891. The gardens at Sydney, which meandered delectably along the shores of the harbour, predated the city itself, for on the same site had been planted the flowers and vegetables brought out with the First Fleet of convicts in 1788: but the senior imperial gardens of all lay on the banks of the Hooghly at Calcutta, removed from the city's clutter on the other side of the river. Behind them passed the Grand Trunk Road, on the first stage of its march across India, and over their walls the masts and upperworks of ships could be seen, silently moving up and down the river. Into this retreat the British had brought tropical specimens from every part of the world—mahogany and Cuban palms, mangoes, plantains, giant South American creepers, tamarinds and casuarinas: and Bishop Heber wrote of the Calcutta botanical gardens that they would 'perfectly answer to Milton's idea of Paradise, if they were on a hill instead of a dead flat'.

The British had a genius for parks, and in the end perhaps it would be for these noble urban expanses, preserved with such a sense of scale and human values, that their Empire would longest be thanked. There was something very superior to the imperial parks. They seemed to announce a grand disregard of petty side-issues, like land values, or property rights, and at the same time a mastery of nature apparently so complete that their designers could afford to relax their discipline, and let things run a little wild within the stockade of the surrounding city. King's Park at Perth, indeed, was simply a slab of native bush, fenced about above the harbour and preserved for ever as the aborigines had known it: while Phoenix Park in Dublin, though it contained a zoo, a race-course and several official residences, was so vast—1,750 acres—that it was virtually open country, its paths highways and its mansions country houses. The Maidan at Calcutta was just the opposite: in the centre of a tumultuous oriental metropolis (for by the 1890s the City of Palaces was scarcely recognizable) a huge ordered pleasure-garden, scru-

pulously British, with tennis courts, golflinks, bicycle tracks, cricket pitches, riding roads, innumerable statues of generals and administrators, and down at the river's edge an ornamental pagoda, a substantial piece of loot from Burma.

The Maidan was originally no more than a clear field of fire for Fort William, but sometimes the creation of such a park showed astonishing self-denial. Nobody doubted that Vancouver, incorporated as a city in 1886, would one day be among the chief ports of the Americas. It was founded as the western terminus of the C.P.R., and was already booming. Yet in a particularly covetable part of the city area, beside the narrows which formed the harbour entrance, the city fathers established a park. It was to become, so many travellers thought, the most beautiful park in the whole world, half savage, half domestic, with water on three sides of it and the soft Pacific winds ruffling its trees—a damp west coast park, where the moisture steamed out of the tree-bark when the sun came out, and sometimes even the morning birds were to be seen preening their feathers in a haze of vapour. The great port grew all around it, but never encroached, and sentinel for ever at its gate stood the Queen's Governor-General of the day, Lord Stanley, with the inscription upon his plinth: 'To the use and enjoyment of people of all colours, creeds and customs for all time, I name thee Stanley Park.'[1]

8

The garden instinct of the English did not always survive migration.

[1] The successors of Empire have been sensible of all these garden glories. On the great green at Peradeniya, during the Second World War, Lord Mountbatten set up the headquarters of his South-East Asia Command, but the garden remains glorious, and now forms an appendage to the University of Ceylon along the road. The Sydney garden makes a backdrop for the city's bold new Opera House, the Dominica gardens were described by Mr Patrick Leigh-Fermour, in 1950, as 'the most perfect botanical gardens I have ever seen'. Phoenix Park has passed unscathed through permutations of Empire and independence, and its zoo remains pre-eminent for the breeding of lions. The Maidan at Calcutta, though stripped of its plinthed Viceroys and trampled by the feet of a million angry demonstrators, remains at least an open space. When I speak of the travellers who consider Stanley Park the most beautiful of all, emphatically among them I number myself.

The private houses of the simpler Australians and Canadians notably lacked greeneries—not just because of the climate, for public gardens thrived, but perhaps because life was too near the soil already, without bothering about herbaceous borders. The Briton fresh from Britain, though, as soon as he moved into a new bungalow, or set down the family baggage on a new small-holding, almost always got hold of some seeds or cuttings to make himself a garden. The gardens of Government Houses were often the only consolations for restless Governor's ladies, and tea among the orchids on the buffalo-grass lawn was an imperial institution—the wildest dreams of Kew were the facts of Katmandu. Sir George Grey, the man the aborigines so loved, created a remarkable garden on the island of Kawau, in the Hauraki Gulf, north of Auckland. He built a house of concrete there, stocked it with a good library, and surrounded it with exotic foliage. He brought oaks from California, Norfolk Island pines, Chinese willows, pines from Tenerife, fibrous plants from Chile and Peru, silver trees from South Africa, camphor trees from Malaya—and all through the shrubberies, to be glimpsed by the studious statesman from his library windows, ostriches and white-ringed Chinese pheasants stalked, and kangaroos queerly lolloped.

Most expatriate Britons, counting the months to home leave, had garden aspirations of a different kind. Love of their own country was very strong among this people; nostalgia and home-sickness were among their weaknesses. It was roses these transient imperialists pined for, stocks and honeysuckle, lavender hedges and spring daffodils. Up their little gardens sprang, hopeful around each bungalow, and there were rose-petals in bowls in the sitting-room, and nodding wallflowers beside the compound gate. With luck, when the Empire-builder moved elsewhere, or went home for good at last, his successor loved the garden in his turn, so that it proliferated down the generations, and was immortalized in scrapbooks. If not it very soon languished. The weeds of the country started up triumphantly, tangled trees overcame the flower-beds, and presently all that was left in souvenir was a bramble of English roses gone wild in the undergrowth, their scent forgotten and their colours faded.

CHAPTER EIGHTEEN

Tribal Lays and Images

England, none that is born thy son, and lives
by grace of thy glory, free,
Lives and yearns not at heart and burns with
hope to serve as he worships thee;
None may sing thee: the sea-wind's wing beats
down our songs as it hails the sea.

Algernon Swinburne

18

SOLDIERS, sailors, politicians, engineers, merchants and men in the street responded to the call of Empire. Artists were more chary. The most talented young men of the nineties, the exquisites of Art Nouveau, the Yellow Book and the Café Royal, expressed values outrageously opposed to those of the imperialists. When *Figaro* once offered its readers a translation of Hunt's Jingo rhyme—'*Nous ne voulons pas la guerre, mais, par Dieu! si nous combattons*'—the translator was forced to admit that he had been unable to '*arriver à la sauvage énergie de l'original*'. The London intelligentsia was unable to arrive at it either, and though in the universities there were attempts to evolve an intellectual rationale of Empire, creative people were not generally stimulated by the savage energy of the time.

There was a coarseness to the New Imperialism which repelled many Englishmen. In its early days, beneath the magic touch of Disraeli, it had seemed an oriental fabric, tinged with chinoiserie and Hindu fable, scented with the incense that appealed to the generation of the Oxford Movement, and tasselled like a Liberty sofa-cover. Carlyle, Tennyson, Ruskin, Matthew Arnold had all, at one time or another, celebrated the grandeur or the burden of Empire in language of moving nobility, while graceful fancies brought home from the East added spice to English design, like the gay bubble-domes of the Brighton Pavilion or the hospitable stone pineapples on the gateposts of country houses. By the nineties, though, the imperial idea had been vulgarized—adopted by the Penny Press, and loudly painted over. Barbaric Africa was the stadium of Empire now, all was more brutal or more seamy than it used to appear, and aesthetically the movement was running to excess, too noisy, too garish, too grandiose. British imperialism had lost its old air of amateur superiority, and was indeed actually

335

engaged in competition with upstart foreign rivals: it was hard to reconcile the idea of Thermopylae, white-jerkined heroes upon a sun-scoured pass, with all the bands and blarney of the Jubilee, or even with Kitchener's armies labouring with desperate caution and at excessive expense up the Nile. Most of the best artists boggled at the theme, finding it irrelevant to their passions, and of those gifted men who seized upon it only one or two worked its mass of material into lasting art.

2

No English Delacroix arose, to celebrate in swirls of crimson the arrogant pageantry of Governors or Frontier Guides. No Turner painted the Punjab Mail running through Rajputana, or the ships of Empire hull-down at Kantara. No bitter genius looked behind Kitchener's moustache, as Goya had looked into the eyes of Wellington. There were few ferocious cartoonists to rip away the shams of Empire: *Punch* seldom went further than gentle chaff, and Max Beerbohm's mock-Britannia was really rather attractive. What one might call the Imperialist School of painting consisted chiefly of respectful portrait painters, delineators of official ceremonial and water-colourists of pleasant nostalgia.

Only one memorable painter responded absolutely to the heroic theme: Lady Butler, wife of an Anglo-Irish general and sister of Alice Meynell the poet. Elizabeth Butler, *née* Thompson, was said to have acquired her taste for military subjects at a blow, like a revelation, after watching some army manoeuvres in 1872: but her husband must have infected her with an almost complete range of military emotions. A Catholic from Tipperary, he served in India, Burma, the Channel Islands—went to Canada for the Fenian fighting, to West Africa for the Ashanti wars, to South Africa for the Zulu wars, to Egypt for Tel-el-Kebir, to the Sudan with Wolseley— was the author of *Akim-Foo: the History of a Failure*, and thought the Gordon relief expedition 'the very first war during the Victorian era in which the object was entirely worthy and noble'. Out of it all he emerged an intuitive sympathizer with rebel nationalists all over the Empire.

This stormy soldier was Lady Butler's devoted companion for more than thirty years, but while his mind moved ever farther away from the principles of the New Imperialism, her art was trapped in a convention of military pride. She became suddenly famous in 1874 with a picture called *The Roll Call*, which Queen Victoria acquired, and thereafter she was rigidly typed as a painter of war. She was easily the Army's favourite artist, because she always got the uniforms right, and the great public loved her work because it so faithfully expressed the British mystique of splendour in misfortune. Even her titles were perfect: *The Remnants of An Army, The Defence of Rorke's Drift, Steady the Drums and Fifes*. In sitting-rooms up and down the land, in club smoking-rooms from tropic to tundra, engravings of Lady Butler's pictures prominently hung. '*Floreat Etona*', an apotheosis of subaltern courage, was in every other boy's room at Eton, and Ruskin declared *Quatre Bras* to be 'the first fine pre-Raphaelite picture of battle that we have had'. Perhaps the most celebrated of all her works was *The Survivor*, which portrayed the solitary Dr Brydon, the only man to escape from the massacre of the British in Afghanistan in 1838, hacking back to Jellalabad on his emaciated pony. It was, to most British minds, a scene at once tragic and stirring, especially as they knew that 'Bobs' would later revenge it: but one wonders how General Butler felt about this immortalization of a campaign which, of all the colonial wars the British fought, was perhaps the least justified.[1]

3

Few other professional painters made the Empire either their subject or their market, though the amateurs were always prolific, husbands and wives alike setting up their easels and dashing off a landscape at the drop of a topee—the Simla Fine Arts exhibition was one of the great events of the Indian season.

In the self-governing colonies professional art had a difficult time of it, because nothing local was considered worthy of a gentleman's house, and the best drawing-rooms were always decorated with the burns, allegories and battle-scenes of genuine Royal Academicians,

[1] Lady Butler, who had six children, died in Ireland in 1933.

imported at vast cost from England. In the art schools of cities like Melbourne, Cape Town and Toronto the safest orthodoxies of the day were assiduously passed on to young colonials, often by instructors from London. When rebels did arise, like the 'Heidelberg' painters of Australia, who looked at their country in an altogether new way in the late 1880s—when painters did break away from the norm, they generally returned to it soon enough, and ended up as fashionable nonentities painting flattering portraits of magnates' wives.

Sometimes professionals went out to try their luck in India, directly commissioned like Val Prinsep, or on speculative ventures. There was, in fact, a recognizable Anglo-Indian School—landscape and portrait art in which the robust frankness of the English style was subtly washed or attenuated by native influence. The best-known example hung, in the 1890s, in the ballroom of Government House, Madras, and was a favourite conversation piece at balls and soirées. It was Thomas Hickey's portrait of Eyre Coote, one of the most formidable of the early Indian administrators, which awe-struck sepoys, in the absence of its subject, used to salute instead. It was a fairly frightening picture still. Coote had a cadaverously saturnine face, a Kabuki mask-face, and he is pictured with one hand on his sword-hilt, as though he is just resheathing it after decapitating somebody. There is a sepoy on his knees behind him, and another attendant holds various pieces of accoutrement at his side. An air of ritual catastrophe impends, and one would not be surprised to see the picture conveyed on swaying poles in some arcane ceremony, Coote's eye flashing right and left, and innocents all about shading their eyes against the influence (though, in fact, the Governor, when Hickey pictured him, was probably only putting on his fineries for some harmlessly decorative function).

4

Most of the statues in the British Empire were statues of Queen Victoria, but in their day several memorial sculptors had found profitable imperial fields. Those inescapable portrayers of marble grief, John Flaxman, Francis Chantrey and Richard Westmacott,

were represented all over the Empire (their heavier works had often gone out as ballast), and here and there a heroic effigy stood out from its stodgy peers with a touch of life and laughter, or even a sneer. Charles Summers's huge group of the lost explorers Burke and Wills, looming lugubriously over Collins Street in Melbourne, was a grim reminder to Australians of the red emptiness still at their backs.[1] Lord Nelson high on his column in Dublin, placed there by Thomas Kirk in 1808, looked a little lumpish from ground-level, but was easily able to inspire the loathing of the Irish dissidents, and seemed sure to be blown up one day.[2] The statue of Lord Cornwallis in Fort St George in Madras was by Thomas Banks,[3] and showed a cast in the hero's left eye. Asked why he had thought it proper to 'commemorate this obliquity of vision', the sculptor had explained, in a reply Veronese would have relished, that if the cast had been *inwards* it would have suggested a contracted character, and he would have suppressed it: 'but as eyes looking to the right and left at the same moment would impart the idea of an enlarged and comprehensive mind, I have thought it due to the illustrious Governor-General to convey to posterity this natural indication of mental greatness'.

For pious respect was the hall-mark of imperial sculpture, and recreations of triumph and carnage, in the French manner, were regrettably rare. A perfect example of the British genre was the façade of the Crawford Market in Bombay, an ambitious structure in what was described as the Flemish-Moorish style, with flagstones imported from Caithness and iron roof supports shaped like griffins. The stone reliefs above the entrances portrayed such an India as the British dreamed of, represented by groups of chiselled Indian

[1] Summers, who died in 1878, went out to the Australian goldfields in 1852, and finally set up shop very grandly in Rome, where his art reached a climax in a marble group of Queen Victoria, the Prince Consort and the Prince and Princess of Wales, for the public library at Melbourne. His Burke and Wills, since moved a few hundred yards to Spring Street, still cast a chill on Melbourne—for years a picture of this statue appeared in every school primer in the State of Victoria.

[2] It was, in 1966.

[3] The first English sculptor, Joshua Reynolds thought, to produce 'works of classic grace', who also had the good fortune to marry the co-heiress to the site of Mayfair. He died in 1805.

agriculturists: slender, dignified people, with large well-behaved dogs at their feet, standing erect and trimly shaven at the edge of their fields and looking loyally out of their cornice, one supposes, towards an unseen and much-beloved district officer. Wisdom, age, beneficence were more often commemorated than daring or bravura, and for a representation of the sheer awfulness of Authority one could hardly improve upon the splendid bronze of Lord Reay, Governor of Bombay, which was erected there in 1895, and which showed him immensely bearded, unshakeably serene, huge, terribly old and utterly infallible, sitting in wide ceremonial robes opposite the General Post Office.[1]

5

But they were mostly of the Queen. Like unearthly plants that summer the statues of the Queen-Empress sprouted through the foliage of Empire. They were not yet stained with verdigris or bird-droppings, nor had the tropical mosses and grasses filled in the cracks between their granite blocks. Troops of coolies and gardeners brushed their plinths, superintendents of parks periodically inspected them, princely donors took their house guests to admire them, and peasants out of the countryside, lined up beside their drooping spike-chain rails, gazed silently upon that plump metallic matron, chewing their betel-gum or smoking their loose-rolled Jamaican cigars. To many she must have seemed some species of totem or fetish-figure, for in those huge imperial images she appeared to have nothing so ordinary as legs, but was rooted immovably in the soil, bronze to granite to earth itself.

6

Marches and oratorios, fanfares and even ballets sounded the imperial strains; gigantic choirs sang patriotic cantatas; the splendid anthems and Magnificats of Anglican Victorianism seemed to re-

[1] Where he remains. The eleventh baron, he was the head of the Clan Mackay, but his mother was Dutch and he began his career in the Dutch Colonial Office. He died in 1921.

sound through the English cathedrals from distant tympani of Empire. And tormentedly through the genius of Edward Elgar ran melodies of the imperial theme, sometimes brash, sometimes melancholy, echoing those varying moods in which sensitive minds so often contemplated the great adventure. Elgar reached middle age in the heyday of the New Imperialism, in that provincial society which was perhaps most susceptible to its dazzle, and for a time he succumbed to the glory of it all. In Elgar's Worcestershire of the nineties the innocent manifestations of imperial pride must have been inescapable, drumming and swelling all around him: but if at first his response was conventional enough, in the end it was to give the imperial age of England its grandest and saddest memorials.

He was a Catholic, the son of a Worcester music-seller and organist, and he left school at 15 to be a solicitor's apprentice. No inhibitions of background or education restrained his instincts. His was not the clean white line, the graceful irony, the scholarly allusion. He plunged into the popular emotions of the day with a sensual romanticism, expressing himself not only in music, but also in a flowery and sometimes Jingo prose. He was 40 years old in the year of the Diamond Jubilee, and he saw himself then as a musical laureate, summoned by destiny to hymn Britannia's greatness. He wrote three celebratory works. There was a cantata called *The Banner of St George*, with a grand finale glorifying the Union Jack. There was another called *Caractacus*, predicting out of its ancient context the fall of the Roman Empire and the rise of the British. There was an Imperial March, played first by massed bands at the Crystal Palace, and later, by special command of the Queen, at a State Jubilee Concert—the only English work in the programme, for music was one field in which the British claimed no pre-eminence. Elgar already had in his pocket-book the tune of *Land of Hope and Glory*, which was to become, set to words by A. C. Benson, the high anthem of British Imperialism, and he professed himself unblushingly nationalist. 'England for the English is all I say—hands off! There's nothing apologetic about me.' Imperialists took Elgar to their hearts. Military men tapped their feet to his strong tunes and healthy harmonies. Elgar collaborated with Kipling in several songs and a cantata called *The Fringes of the Fleet*, and for all his

Catholicism he seemed to stand for everything properly Anglican and open-air, muscular virtues, honest loyalties—English music should have to it, he thought, 'something broad, noble, chivalrous, healthy and above all an out-of-door sort of spirit'. Elgar married the daughter of a distinguished Anglo-Indian general, and he was much taken with the county style of life. Sometimes he pretended not to be interested in music at all, in his zeal for gentlemanly English attitudes, and it gave him pleasure when he was mistaken for a general in mufti himself.

What an ass it makes him sound! With his military posture, his Woolwich moustache, his taste for racing and honorifics, he would have made a perfect butt for satire, if any satirist had been interested. But Elgar was a genius, and a genius, as he wished it, of a peculiarly English kind. There was a ridiculous aspect to him, and it was this that was expressed in his New Imperialism music: but there was also a profound, contemplative and vulnerable side to his nature, and this was reflected in far greater things. His Jingo period was short and delusory, for very soon there entered into his music, once so bellicose, a sad and visionary note. He was no longer writing for the brass bands and choral societies of Worcestershire, nor even for the Crystal Palace. Greater matters than pomp and circumstance engaged his spirit, those manly tunes deepened into more anguished cadences, and there seemed to sound through his works premonitions of tragedy—as though he sensed that all the pride of Empire, expressed at such a comfortable remove in the country drawing-rooms of the West Country, would one day collapse in bloodshed or pathos. Truth will out. Elgar, who wrote the paean of Empire, lived to compose its elegy.[1]

7

The difficulty about imperialism as a literary motif was its diffuseness. It had so many purposes, often contradictory. Its most coherent

[1] Elgar's great period began in 1899 with the Enigma Variations, and lasted until the death of his wife in 1920. He still wrote patriotic music, Coronation Odes and Marches, the Pomp and Circumstance pieces, and he was made Master of the King's Musick in 1924: but long before his death in 1934 it was clear that *The Dream of Gerontius, Falstaff,* the two symphonies and the two concertos would long outlive the thump of his early nationalism.

prophets never quite succeeded in reducing it to theory, and whenever somebody seemed about to devise a shapely formula, a stutter of Maxims announced that the acquisition of some totally different category of possession had knocked it askew already. To some writers the imperial mission formed an aspect of Romanticism, especially in its Victorian guise of noble duty. Rider Haggard, for example, of *She* and *King Solomon's Mines*, was a practising imperialist himself—it was he who had run up the Union Jack in the square at Pretoria, when the British annexed the Transvaal in 1877—and he was genuinely excited by the imperial attributes of fortitude and loyalty he lavished on his heroes. Writers like Conrad and Robert Louis Stevenson, anything but imperialists themselves, used imperial scenes as backdrops for their fictions: and their evocations of sun and open sea, the whip of the sail and the scented landfall, satisfied that pining for adventure and exoticism that was part of the imperial emotion. Even the aesthetes of the earlier nineties, the Beardsleys, the Wildes and their *Yellow Book* disciples, were responding to the national appetite for extremism, while their antithesis, W. E. Henley, apotheosized the public school ideas of grit and self-denial: crippled by tuberculosis himself, he compiled an anthology of English poems 'commemorative of heroic action or illustrative of heroic sentiment', and summed up a nation's passionate pride of country in the ecstatic stanza:

> *Chosen daughter of the Lord,*
> *Spouse-in-Chief of the ancient Sword,*
> *There's the menace of the Word*
> > *In the Song on your bugles blown.*
> > *England—*
> > *Out of heaven on your bugles blown!*[1]

But the later nineties were thickened years, and as the New Imperialism mounted to its climax it was celebrated mostly in rhetoric or jingle. It seemed to bring out the worst in artists, even

[1] Haggard lived until 1925: his *She* had already been filmed in 1897—it was the first film ever shown in Ceylon. Conrad died in 1924, Henley in 1903. When Stevenson died in 1894 sixty natives cut a way for his coffin to its burial place on the top of Mount Vaea in Samoa.

good artists, and some of the imperial poetry was terrible. *Nigh twenty years have passed away* (wrote Ernest Pertwee, for example, recalling the heroes of the Zulu wars)

> *Since at Rorke's Drift, in iron mood,*
> *'Gainst Zulu fire and assegai*
> *That handful of our soldiers stood;*
> *A hundred men that place to guard!*
> *Their officers Bromhead and Chard.*

Here Francis Doyle points a favourite imperial moral:

> *Vain, mightiest fleets of iron framed;*
> *Vain, those all-shattering guns;*
> *Unless proud England keep, untamed,*
> *The strong heart of her sons.*

Here the Rev. A. Frewen Aylward describes a familiar situation in the field:

> *A foe-girt town and a captain true*
> *Out on the Afric plain;—*
> *High overhead his Queen's flag flew,*
> *But foes were many and friends were few,*
> *Who shall guard that flag from stain?*

And here George Barlow disposes of suggestions that the One Race may be losing its virility:

> *The race is growing old, some say,*
> *And half worn out and past its prime;*
> *But English rifles volley 'Nay',*
> *And English manhood conquers time.*
> *Then fear not, and veer not*
> *From duty's narrow way:*
> *What men have done, can still be done*
> *And shall be done today!*

In the flood of verses that greeted the Jubilee itself the clichés came in relentless spate, Crown and Flag and Fleet and Throne, Duty with Beauty, Malta with Gibraltar, State with Great, Honour

escorting Freedom across the Ocean Deep, and inevitably at the end of it all the virtual impossibility of finding anything new to rhyme with Victoria:

> *Hail our great Queen in her regalia;*
> *One foot in Canada, the other in Australia.*

8

Out of the frenzy three writers emerge, already famous in 1897, who seem utterly indigenous to that moment, as though they could have celebrated no other English epoch, and who were indeed prime movers of the national spirit.

The first was G. A. Henty, born in 1832 but still going strong. Nobody enjoyed the period more, in person or in art, and nobody made better use of it. After an expensive education (Westminster and Cambridge), Henty began a life of adventure as a hospital orderly in the Crimean War, and presently graduated to war journalism. He was with Garibaldi in the Tyrol, with Napier in Ethiopia, in Paris under the Communes, with the Russians at Khiva, with Wolseley in the Ashanti country, with the Carlists in Spain and the Turks in Serbia. All these experiences he distilled into jolly yarns, together with a long series of specifically imperial adventures. They were resoundingly successful from the start. Who had not read *On the Irrawaddy: A Story of the First Burmese War*, or *By Sheer Pluck: A Tale of the Ashanti*, or *For Name or Fame*, or *The Dash for Khartoum*? It was a dim uncle who did not at least consider, as he thumbed through the Army and Navy Christmas catalogue, *Redskin and Cowboy* or *At the Point of a Bayonet*. Henty was once the editor of a magazine called *The Union Jack*, and he was a regular contributor to the *Boy's Own*: probably nobody more profoundly influenced the late Victorian generation of young Britons. He prided himself, we are told, on his 'historical fidelity and manly sentiment': but it is sad to discover, by comparing one of his racy reconstructions with the standard historian's account of the same episode, how simple was his technique of adaptation, so that such a phrase as 'Simpson was determined that his relations with the authorities should not be adversely affected by these events', might come out,

in *Mogul and Merchant: A Tale of John Company*, something like this: 'Simpson laughed. "Whatever happens," he told the boy, "I shall stick by the Maharajah, and hope that he thinks none the worse of me for it." ' Were it not for his manly sentiments, one might almost accuse Mr Henty of *cribbing*.[1]

A second truly imperialist writer was the Poet Laureate, Alfred Austin. Lord Salisbury judged the public mood astutely when, in 1897, he appointed as Lord Tennyson's successor this eager expansionist, an almost paranoically conceited versifier whose elevation was greeted by intellectual London with mingled derision and dismay. The New Imperialism had triumphed, even in poesy. *Punch* described the Austin ingredients as being one British Lion, one England's Darling, three ounces of patriotism, three ounces of loyal sentimentality, one pound of commonplace and classical idioms *ad nauseam*. Austin was appointed Laureate chiefly because Swinburne, the obvious candidate, was disapproved of by the Queen: but it was as though the scholarly Salisbury, noting with distaste the distorted nationalism of the plebs, had thrown them a minstrel to their own crude taste. The very first thing Austin wrote on assuming office was his notorious poem in *The Times* on the Jameson Raid, by which he will probably be longest remembered, and of which one stanza may stand as representative of his whole output:

> *There are girls in the gold-reef city,*
> *There are mothers and children too!*
> *And they cry, 'Hurry up! for pity!'*
> *For what can a brave man do?*
> *If ever we win they'll blame us;*
> *If we fail, they will howl and hiss.*
> *But there's many a man lives famous*
> *For daring a wrong like this.*

There was truth to this unfortunate poem—many a man *did* live famous for daring wrongs more reprehensible than a Jameson Raid. What made it so unhappy was its apparent endorsement by the official bard of the principle that if a wrong succeeds it is a wrong no

[1] He died in his yacht *Egret*, lying in Weymouth Harbour, in 1902.

longer (especially since there were strong suspicions that *The Times*, which paid £25 for the piece, was itself privy to the conspiracy). But though the poem was greeted with ribaldry from intellectuals on both sides of the Atlantic, the general public loved it, and *The Times* had many requests for permission to reproduce it or set it to music. Salisbury evidently knew his man—and his electorate. It was Austin's opinion that no poem could really be called great unless it was an epic or a dramatic romance extolling simultaneously love, patriotism and religion, and this was, of course, a simulacrum of the imperial mission, as it seemed to the New Imperialists. Tennyson, Browning, Arnold, Swinburne were all unfitted to the splendours of the age, Austin thought, because they were either feminine or lyrical—two un-imperial attributes.[1]

Yet the third of our writers, a short-sighted journalist of fey and sentimental inclinations, was himself as potent an imperial force as any battle fleet or India Council. Rudyard Kipling, 32 in 1897, was already at the height of his fame.

> *Far-called, our navies melt away;*
> *On dune and headland sinks the fire:*
> *Lo, all our pomp of yesterday*
> *Is one with Nineveh and Tyre!*
> *Judge of the Nations, spare us yet,*
> *Lest we forget—lest we forget!*

Like a slap in the face from an old roistering companion, Henry V turned princely, one morning that festive summer Kipling's poem *Recessional* appeared in *The Times*. It sounded a sombre, almost a frightened note, a warning against overconfidence, 'frantic boast and foolish word'. Its sacramental solemnity jarred, and seemed to imply that the Jubilee celebrations were all tinsel and conceit: but there were many people in England who recognized its justice, and *The Times* printed columns of grateful letters. Almost nobody else in the kingdom could have expressed such views at such a moment, and commanded such respectful attention: and though the hysteria

[1] Austin was apparently impervious to criticism, and this is lucky, for nobody has had a good word for him since his death in 1913.

of the New Imperialism shrilled on its way unabashed, still the publication of *Recessional* was a watershed in the imperial progress—the moment when the true laureate of Empire saw, apparently for the first time, something ugly beneath the canopy.

As Cervantes was to his declining Spain, Kipling was to this climactic Britain. In the pages of *Don Quixote* every nuance of the age was somewhere illustrated: in Kipling's poems and stories there was almost no facet of imperialism, no British mood or attitude, no character of Empire that did not find its place. It was all there somewhere. Kipling seemed to understand all the disparate motives of Empire—perhaps he even shared them all, at one time or another: the various philosophies he distilled in his writings were a kind of imperial symposium, a mock-up. Of all the imperialist poets, Kipling was alone in his expertise. Tennyson never set eyes on Lucknow, Alfred Austin never rode down to Doornkop, poor Henley's heroisms were enacted on a hospital bed. But Kipling was an Anglo-Indian of the second generation, born in India. The Empire was his nursery. Around his childhood the Civil Servants came and went, the regiments were posted home to depot, the visiting parliamentarians devised their instant answers to famine or land settlement: but Kipling was of the country, and he spent the best part of his young manhood there. Elderly Anglo-Indians predictably derided his pretensions to an understanding of the country, but Kipling was entitled to feel that his roots, like Kim's, were in imperial soil.

The peak of Kipling's popularity coincided with the climax of the New Imperialism. When, a few years later, the cause lost its certainty, Kipling lost some of his readers. For a few years he, more than anyone, gave voice to the national emotions. If he had hymned the Empire fifty years earlier, few would have listened. If he had laboured the theme fifty years later, he would have been shouted down. As it was, his art and his moment perfectly fitted. He alone, with all the world of the imperial adventure revolving around those years, turned it into a body of literature—perhaps no other English artist has been so identified with a moment of history. Kipling was an imperial figure in his own right: his American publisher once described him as 'the world's first citizen'.

Yet imperialism was only a means for Kipling. At his worst, it is true, he thumped a tub as crudely as anyone. Even Elgar thought some of his work 'too awful to have been written', and reports of his first visit to America, very young and precociously celebrated, were enough to make a Jingo squirm: asked by reporters for his reactions to San Francisco, he replied: 'When the *City of Peking* steamed through the Golden Gate I saw with great joy that the blockhouse which guarded the mouth of "the finest harbour in the world, sir" could be silenced by two gunboats from Hong Kong with safety, comfort and dispatch.' But if he often seemed blood-thirsty and xenophobic, no less often did he honour the brotherhood of man, at a time when that conception was out of fashion among the English. In a period of proud isolation he was a passionate Franco-phile, and a percipient—if often maddened—admirer of America. While the British went through their worst phase of colour con-sciousness, Kipling was honouring the strong man of any race:

> ... *there is neither East nor West, Border, nor Breed, nor Birth,*
> *When two strong men stand face to face, though they come from the*
> *ends of the earth!*

Nobody saw more clearly through the petty pretences of imperial life, the expatriate snobberies, the red tape and the bumble. Kipling could never have written as G. W. Steevens wrote of the lascar—'this sort of creature has to be ruled'—for he loved India with a sensual liberty, and captured its colours and sounds, squalors and nobilities with devoted precision. The most truly splendid of his heroes were Asiatics—Kim's Lama, Gunga Din, or Sir Purun Dhas, K.C.I.E., the Prime Minister of Mohiniwala, who became a guru in his old age, and lived in friendship with the wild beasts of the hills. The public only snatched at Kipling's eulogies of Empire, or his romantic evocations of its duties and excitements: but he mocked it, too, berated it sometimes, and like the excellent reporter that he was, relished a good exposé now and then.

His view of Empire, though it seemed to synthesize the public attitudes, was in fact intensely personal. Just as he fitted into no social slot, or artistic coterie, so his political conceptions were less

orthodox than they seemed. He once described in mystical terms his view of the Pax Britannica: 'I visualized it, as I do most ideas, in the shape of a semicircle of buildings and temples projecting into a sea—of dreams.' In less abstracted moments he sometimes saw the Empire as a benevolent despotism ruled by the people of the Five Nations—the five great white settlements, Britain included. This was not because he believed one race to be inherently superior to another, but because he thought the races were good at doing different things. The Indians were good at spiritual exercise. The Japanese made lovely objects. The French knew better than anyone how to make the most of life. The British were best at governing. Kipling tended to scoff at the notion of a developing Empire, its subject peoples gradually ushered towards self-rule—when he did suggest it, as one chore of the White Man's Burden, he was careful to emphasize how very gradual the process ought to be. He was often contemptuous of the half-educated native, and he detested the idea of Westernizing the oriental peoples, or presuming to improve them.

The purposes of imperial rule, he thought, were simpler: to administer justice, to distribute law and order, to build the roads, railways, docks and telegraphs that were the foundations of prosperity. Kipling saw the British Empire as an immense technical consultancy, providing compulsory services: expert legal advice, unrivalled administration, technical skills of every kind. In the astonishingly productive years of his early manhood these are the functions he repeatedly celebrated. His imperial heroes were the doers, the law-givers, the governors, the engineers. He idealized the district officers, brought the common soldiers to life, even celebrated the very machines, ships and locomotives of Empire. It was the professionalism that he most admired, just as he respected craftsmanship in art, and polished his own poems and stories as meticulously, and with just as fine a respect for tolerances and adjustments, as any gnarled workshop foreman of the East India Railway, lovingly passing his grease-rag over a universal joint.

Kipling spoke for his age in its taste for bravado and exotic splash, and in that grand poem *If*— he summed up for a whole generation of Englishmen all that was best in the public school ideal:

If you can talk with crowds and keep your virtue,
 Or walk with Kings—nor lose the common touch,
If neither foes nor loving friends can hurt you,
 If all men count with you, but none too much;
If you can fill the unforgiving minute
 With sixty seconds' worth of distance run,
Yours is the Earth and everything that's in it,
 And—which is more—you'll be a Man, my son!

He was out of sympathy, though, with many imperial intentions. He expressed no interest in the profit of Empire, public or private. Commerce seemed to bore him, and the merchant princes one might expect to meet in his pages only appear in caricature. He was not a practising Christian, and the evangelical side of Empire was not to his taste. He was concerned more than most with the effect of Empire on the character of the imperialists themselves: it was the *duty* of the British to rule these vast territories, austerely, efficiently, grandly. Kipling was not one of your wild expansionists, and he was only intermittently boastful.

He was a muddled man in many ways, naïve in some things, inspired by conflicting emotions, now responding to one imperial call, now to its opposite. He was identified everywhere with the boom of the New Imperialism: but like Elgar, he was carried by his genius far beyond the trumpery excitement of politics, or even history's passing crazes, and would be remembered in the end not as an imperial seer, still less as a propagandist, but as a great and often mystifying artist. To the end of his life he thought *Recessional* the best poem he ever wrote.[1]

9

In literature as in art, the British settlers overseas were inhibited by the prestige of the home-grown product. When they did write

[1] Kipling's later years were not all happy. The intelligentsia turned against him, the public found his later style unattractive, his only son was killed in the First World War, and for the last twenty years of his life he suffered from a painful duodenal ulcer. But honours poured on him from home and abroad, and when he died in 1936 he was buried in Westminster Abbey.

books or poems, they often had their eye on a readership in the
Mother Country, and laid on the local colour thick, with Maori
love-affairs, Zulu atrocities or Red Indians howling across the
prairies of the West. Educated emigrants were frequently possessed
by rosy visions of the culture they had left behind, looked down
upon local idioms and landscapes and were always on about spring
flowers in Hertfordshire or the way things were done at Cambridge.
Even the folk-art was muted. The Canadians sang no rollicking fron-
tier songs, such as their American neighbours allegedly dashed off
around the camp fires, and the British in the Cape and Natal were
perhaps overawed by the powerfully Biblical culture of their neigh-
bours the Boers, so that their presence seems in retrospect oddly
pallid or agnostic; as if they were only tentatively there at all, and
certainly not in the mood to make bawdy rhymes about it. The
Rhodesians had not been over the Limpopo long enough to embody
the experience even in doggerel. What might be considered an Anglo-
Indian folk-literature, mostly produced by senior Civil Servants, was
generally cut to a sixth-form pattern, full of parodies and very obscure
allusions.

It was only in Australia that one could observe the first glimmer-
ings of what the imperialists would like to call a Greater British
culture. The Australians had the advantage of being all on their own,
with no Americans next door and no Boers to cap each jollity with a
quotation from Ezekiel. A leathery, swaggering people still, they
often felt no very powerful affection for the ways of the Mother
Country, and were in Australia either because they were the descen-
dants of convicts or because nowhere could be much farther from
England. Their new landscape was something altogether *sui generis*,
with its own lolloping fauna and ghostly foliage, and the origins of
their settlement, if ignoble, were certainly interesting. Cockney and
Irish strains combined to give their society punch and humour, and
the feeling that all was an open slate gave it an easy-going, republican
feeling.

This new kind of England already had a literature, and a lively
body of folk-song and ballad. Its tradition, sweet and sour, ironic
but generous, had been launched by Adam Lindsay Gordon, an
English emigrant who had killed himself at Melbourne in 1870.

Gordon's *Bush Ballads and Galloping Rhymes* had been popular all over the Empire, and for many people they had summed up the whole ethos of colonial adventure, the fresh start and the new fraternity:

> *Life is mostly froth and bubble,*
> *Two things stand like stone:*
> *Kindness in another's trouble,*
> *Courage in your own.*

The implicit bond of exiles, cobbers or mates of the Outback ran through the Australian folk-art, and gave it an air of comradely devil-may-care which, not always justly, attached itself permanently to the Australian myth. Here, in Charles Thatcher's poem *Look Out Below*, is the young digger off to make his fortune:

> *A young man left his native shores,*
> *For trade was bad at home;*
> *To seek his fortune in this land*
> *He crossed the briny foam;*
> *And when he went to Ballarat,*
> *It put him in a glow,*
> *To hear the sound of the windlass,*
> *And the cry 'Look out below!'*
>
> *Wherever he turned his wandering eyes,*
> *Great wealth did he behold*
> *And peace and plenty hand in hand,*
> *By the magic power of gold;*
> *Quoth he, as I am young and strong,*
> *To the diggings I will go,*
> *For I like the sound of the windlass,*
> *And the cry 'Look out below!'*

And here is a settler's family in trouble, in a favourite bush song:

> *Our sheep were dead a month ago, not rot but blooming fluke,*
> *Our cow was boozed last Christmas Day by my big brother Luke,*
> *My mother has a shearer cove for ever within hail,*
> *The family will have grown a bit since Dad got put in gaol.*

So stir the wallaby stew,
Make soup of the kangaroo tail,
I tell you things is pretty tough
Since Dad got put in gaol.

This was a working-class culture—the vigour of a British prole-
tariat offered the freedom of an empty continent. There was scarcely
a soul in Australia who would not learn the story of Romeo and Juliet
as told by C. J. Dennis's larrikin in *The Sentimental Bloke*—the perfect
comeuppance to those supposed slights of cultural superiority
which colonials so often fancied and resented in Englishmen. The
overseas British as a whole were rudely disrespectful to everything
la-de-da: the Melbourne urchin's approach to Shakespeare vividly
expressed their ambivalent feelings towards the Old World and the
Mother Country. Here are two stanzas of it:

> *Doreen an' me, we bin to see a show—*
> *The swell two dollar touch. Bong ton, yeh know.*
> *A chair apiece wiv velvit on the seat;*
> *A slap-up treat.*
> *The drarmer's writ by Shakespeare, years ago,*
> *About a barmy goat called Romeo.*
>
> *'Lady, be yonder moon I swear' sez 'e.*
> *An' then 'e climbs up on the balkiney;*
> *An' there they smooge a treat, wiv pretty words*
> *Like two love-birds.*
> *I nudge Doreen. She whispers, 'Ain't it grand'*
> *'Er eyes is shinin': and I squeeze 'er 'and.*[1]

Finally Australia gave to the Empire the best of all its marching
songs, perhaps the best any Empire ever had—*Waltzing Matilda*
A balladist called A. B. Paterson ('The Banjo') wrote the words of
this superb piece, and they were set to a tune that probably began

[1] *The Sentimental Bloke* was turned into a stage musical in the 1950s.
When I saw it in Sydney the lady in the next seat succumbed into snuffles
during the Romeo and Juliet monologue: it was part of her childhood, she
told me, and the sound of the dear old words made her cry. I was moved, too.

as a seventeenth-century English soldiers' song, *The Bold Fusilier*.[1]
The theme was scarcely heroic—a swagman caught stealing a sheep
jumps into a waterhole and drowns—but the lyrics were full of
broad euphonious Australianisms, billabong and coolibah, jumbuck
and tucker-bag: and set to that swinging melody they seemed to
sum up all the audacity of the wide horizons, that marvellous sensa-
tion of ever-open doors which many Englishmen knew for the first
time in their lives, when they sailed away from the slums or rural
littleness of England to the new countries of their Empire:

> *Waltzing Matilda, Waltzing Matilda,*
> *You'll come a-waltzing, Matilda, with me;*
> *And his ghost may be heard as you pass by that billabong,*
> *'You'll come a-waltzing, Matilda, with me'.*

[1] Paterson (1864–1941) claimed never to have heard the words of this song,
and to have been attracted purely by its tune, but the original lyric rings
familiar:

> *A gay Fusilier was marching down through Rochester,*
> *Bound for the war in the Low Country,*
> *And he cried as he tramped through the dear streets of Rochester*
> *'Who'll be a sojer for Marlbro' with me?'*
>
> *'Who'll be a sojer, who'll be a sojer, who'll be a sojer*
> *For Marlbro' with me?'*
> *And he cried as he tramped through the dear streets of Rochester*
> *'Who'll be a sojer for Marlbro' with me?'*

Waltzing Matilda was first sung in public at the North Gregory Hotel at
Winton in Queensland: a plaque on the pub says so.

CHAPTER NINETEEN

All by Steam!

Do you wish to make the mountains bare their head
And lay their new-cut forests at your feet?
Do you want to turn a river in its bed,
Or plant a barren wilderness with wheat?
Shall we pipe aloft and bring you water down
From the never-failing cistern of the snows,
To work the mills and tramways in your town,
And irrigate your orchards as it flows?

It is easy! Give us dynamite and drills!
Watch the iron-shouldered rocks lie down and quake,
As the thirsty desert-level floods and fills,
And the valley we have dammed becomes a lake.

Rudyard Kipling

19

AMONG the waters of the Indus Basin, stingily watered by the five rivers of the Punjab—Jhelum, Chenab, Ravi, Beas and Sutlej—the British created a new country. It was an uninviting part of India. For nine months of the year it was no good to man or beast, and its only inhabitants were the *janglis*—disputatious nomads who made a living from cattle-thieving, and did not much welcome strangers. There were virtually no towns or villages, no roads whatever, only a dun gloomy wasteland, with a rainfall so sparse that when it showered, so they said, one horn of a buffalo got wet, but not the other.

Along the edges of this barren place, and across it here and there, the five rivers fitfully ran, and in the last decades of the century the British conceived the idea of so tapping their waters that the whole bowl of the Indus might be irrigated and settled. Men on the spot saw this as a way of solving India's perennial problems of famine and overcrowding. Visionary New Imperialists at home thought the Punjab might become a granary for the whole Empire, as the North African provinces had fed Rome. The latest technology was to be applied to the achievement of orderly progress and human improvement, in the best traditions of philanthropic imperialism. As they planned the great work the British knew they were following mighty and ominous precedents, for waterworks had always been the hall-marks of imperial climax. The aqueducts of the Romans strode across France and Spain masterfully, to crumble when the barbarians took over. The irrigation works of Egypt and Mesopotamia flourished under strong rulers, silted up under weak. So for the British, too, the rebirth of the Indus deserts would commemorate an Empire's prime.

In 1897 the first of the new colonies, on the lower Chenab, was being established. The British approached the task with methodical,

Indian Civil Service care. They divided the land to be reclaimed into squares, $27\frac{1}{2}$ acres apiece, to be distributed under strictly enforced conditions among carefully chosen Indian settlers. The new colonists were mostly picked from districts with traditions of good husbandry, and they were generally settled in ethnic or religious groups—Sikhs with Sikhs, Muslims with Muslims, *janglis* warily with *janglis*, wherever possible with people from their own home district and similar background. They were by no means mollycoddled. They had to sink their own wells for drinking-water, build their own houses by a specified date, plant a decreed number of trees per acre, set up their own boundary-marks, and make their own contribution to the communal amenities. Every few miles, the planners determined, there would be a village—an ideal Indian village, designed specifically for the environment, with sites for mosque, temple or Sikh shrine, a school sometimes, a few shady trees, a village shop or two, a central square with a well in it and a pond for watering the cattle. At further intervals there would be market towns, where the administrative offices would be built, the bigger shops, the processing plants, police stations, hospitals and veterinary dispensaries. A railway was thrown down the centre of the area, and a network of roads was built to link the towns and villages, the stations, the railway junctions and the river crossings: no village was more than twelve miles either from a railway station or from a market centre. Drains were cut, sewage works built, doctors and teachers and veterinary surgeons posted: and up and down the Indus basin, between the rivers, the imperial engineers cut a mesh of canals—major canals along the watershed, a filigree of lesser ones feeding towns, villages and smallholdings. The Chenab, falling out of the Himalaya, was blocked as it entered the plains, and its water was distributed evenly throughout the system.

This adventure, emulated over the years in a series of Punjab colonies, was a prodigious success. Gradually the separate settlements coalesced, the green squares of cultivation lost their awkwardness, the raw little towns matured into an untidy norm, and the irrigated country of the Indus became part of geography. A new spirit of enterprise infused the whole region: new strains of wheat, cotton and sugar-cane, too, and new ways of growing them, until

the once desolate Punjab became, if not the granary of Empire, at least one of the most prosperous of the Indian provinces. The canal provinces even showed handsome returns on the capital invested—not always bragged about, in case people demanded a reduction in the water-rates: and the British looked upon them with justifiable pride, as a diligent Pharaoh might have inspected a rising pyramid.[1]

2

The British Empire was a development agency, distributing technical knowledge around the world, and erecting what economists were later to call the infra-structure of industrial progress—roads, railways, ports, posts and telegraphs. This was not generally a deliberate process. *Laissez faire* was still the watchword in such matters, and it was Joseph Chamberlain, moving into the Colonial Office with his brisk businessman's efficiency, like a new chairman of the board after a successful take-over—it was Chamberlain who first saw the systematic diffusion of modern technique as a duty of Empire. To him the Empire was an undeveloped estate, and as the new chairman might invest in a computer or call in a management consultant, so he turned to science and technology to make the most of the assets. Not until the 1890s did the Colonial Office concern itself with the systematic improvement of agriculture, with veterinary medicine and husbandry, tropical disease and social welfare. In a muzzy sort of way, though, the British had long assumed these matters to be part of the stuff of imperialism—part of the civilizing process. 'To the English people in world history', Carlyle had written, 'there have been, shall I prophesy, two grand tasks assigned: Huge looming the grand industrial task of conquering some half or more of this terraqueous planet for the use of man; then secondly, the grand Constitutional task of sharing in some pacific endurable manner, the fruit of said conquest. . . .'

[1] The Punjab colonies expanded fast—by 1940 the Lower Chenab colony alone supported 1½ million people—and all went well with them until the irrigated land was attacked by salination, a rotting of the soil caused by a rise in the level of the underground water table. It splotches the green fields like mould, in patches of grey decay, and by the 1960s it was said that the Punjabis were losing 150 acres of land every day. The Indus Basin was split between India and Pakistan in the partition of 1947.

It was a century since the chances of history had given Britain pre-eminence in the age of steam, and in fact she no longer led the world in technology. Germany and the United States had both overtaken her, and by the nineties railway engineers were crossing the Atlantic not to advise the Americans how to run their trains, but to pick up ideas from the Baltimore and Ohio. Imperialists in the field, too, were sometimes beginning to find their arts education a disadvantage. It had not mattered fifty years before, when technical development was usually a matter of digging a well or cutting a dirt track through a forest: now the jobs were more complicated, and the imperial Civil Services sometimes wished they had more scientists on the payroll. As it was, a classical education was so universally expected among senior imperial functionaries that when Joseph Thomson,[1] the African explorer, wished to discuss one of the most technical of all subjects, clitoridectomy among the women of the Masai, he printed the relevant appendix to his book in Latin, to make sure it would be read only in the right quarters.

Set against the primitive expanses of the Empire, though, the technical skill of the British seemed positively demonic, and most people probably still vaguely assumed Great Britain to be the workshop of the world, the home of inventors, steelmasters and bridge-builders. 'Whiz! Whiz! all by wheels,' said Kinglake's Turkish pasha in *Eothen*. 'Whiz! Whiz! all by steam! The armies of the English ride upon the vapours of boiling cauldrons, and their horses are flaming coals!' Some such image, less vividly expressed, doubtless still entered the minds of the Empire's simpler subjects, when they tried to conceive the power of their masters.

3

Some of the imperial works really were on the colossal scale. In India the whole British-built irrigation system included some 40,000 miles of canals, irrigating nearly 20 million acres—much the

[1] Thomson (1858–95) was the first man to cross Kenya to the Great Lakes of Africa. He was overshadowed, in his lifetime and after, by his more flamboyant rival Stanley—the Scot outcoloured by the Welshman—and once said that he was neither an empire-builder, nor a missionary, nor truly a scientist, but 'doomed to be a wanderer'.

greatest system of waterworks in history. The dam at Tansa, near Bombay, was claimed to be the largest piece of masonry erected in modern times: two miles long, 118 feet high, with a road along the top. In the west of India an astonishing tunnel under the rocky mountains called the Ghats conveyed water from the Periyar River, on the coastal plain, to the flatlands on the eastern side of the mountains. In the central plain almost the whole flow of the Ganges was, in winter and spring, diverted into a canal, cutting across the grain of the Himalayan drainage so boldly that for miles it leapt over or burrowed under a series of torrents and river beds, in one of the most spectacular displays of Victorian technique.

In Canada the Welland Canal had been cut to circumvent Niagara, in Australia water was piped 350 miles to the Kalgoorlie goldfields, and in Egypt the British had remodelled the entire irrigation system, basing it for the first time on perennial irrigation—storing water in times of plenty, releasing it in times of drought. This was the Empire's one lasting contribution to the welfare of the Egyptians. It was not all disinterested altruism, for the British wanted Egyptian cotton for the mills of Lancashire, but it did much to release the peasant from the old bondage of pasha and moneylender. Sir Benjamin Baker, designer of the Forth Bridge, was already building the Aswan Dam, one of the great engineering works of the world, which was to create a storage reservoir north of Wadi Halfa. Downstream a series of lesser barrages diverted water into the farmlands of middle Egypt, and below Cairo the Delta barrage raised the level of the water to supply three large feeder canals. Much of this work was done by engineers on loan from India. All the way along the lower Nile, from Damietta and Rosetta on the Mediterranean to remote upriver stations only now being established by Kitchener's armies, imperial engineers and agronomists were at work: but the upper Nile was a closed book to them, no information reached them from the troubled Sudan, and they could not forecast the height of a flood, or know when to expect it. It was as though the great river flowed into the floodlights of Empire out of an immeasurable cavern.

It was not an age of great roads, and by the end of the century few of the roads the British were building were on the grand scale: roads into the Ashanti country, to keep the defeated kingdom down,

into northern Burma and Rhodesia, into the mountainous interior of Ceylon to supply the new tea plantations—none too soon, it seems, for not so long before, when a Glasgow financier had visited the island to inspect his £100,000 property there, he had taken one look at the frightful roads, returned to Scotland by the next boat, and sold the estate. Not many of the imperial roads were surfaced, and most were very elementary. In the open frontier country of India they used simply to light a fire at a distant point, and aim their road at the smoke.

Here and there across the Empire, though, strategic highways built before the steam age carried the proper Roman stamp. One was Thomas Telford's celebrated road from Shrewsbury to Holyhead, which swept superbly through the wild Welsh highlands, crossed the Menai Straits by a revolutionary suspension bridge, and arrived at the Irish Sea in a lather of breakwaters and fortifications, looking across to Dublin with an imperious air—ready to keep the Anglo-Irish stocked with almanacs and saddle-leather, or ship another battalion of infantry to keep the peasantry in order. Even grander were the transcontinental roads of India, sometimes laid by the British on older foundations, with lofty names and romantic itineraries: the Hindustan–Tibet Road, which Lord Dalhousie had decreed in 1850 to link the British and the Chinese Empires, running up from the plains to Simla to peter out in the inaccessible Himalaya; or the Grand Trunk Road, which crossed India from one side to the other, Calcutta to Delhi, Delhi to Lahore and the frontiers of Afghanistan—deserted by the British since the railways came, but still redolent with splendid names and memories, and marked every two miles by a stone tower, like an imperial highway of the Caesars.

A broad beaten track across the Egyptian desert preserved the memory of the Overland Route. Lieutenant Thomas Waghorn,[1] Royal Navy, had created this way to India, spending most of his life on it, until in the 1840s the P. and O. company took it over. Passengers and mail were disembarked at Alexandria, and sent up

[1] Waghorn (1800–50) was commemorated by Thackeray in *From Cornhill to Cairo*: 'He left Bombay yesterday morning, was seen in the Red Sea on Tuesday, is engaged to dinner this afternoon in Regent's Park and (as it is about two minutes since I saw him in the courtyard) I make no doubt that he is by this time at Alexandria or at Malta, or perhaps both.'

the Nile by steamer to Cairo: there they were transferred to horse-drawn vans, and off they went across the Overland Route to Suez and the India boats. There were seven relay stations on the desert track, with food, fresh horses and the inevitable champagne, and for thirty years the service was the chief mail route from Britain to India. The railway to Suez killed it, and the cutting of the Suez Canal: but in 1897 its wide track across the desert was still used by camel-trains and solitary travellers, one or two of its rest-houses were still perceptibly in business, and imperialists of a romantic turn could still imagine their forebears, in nets, goggles, topees and mufflers against the sand, bowling across the waste towards their empires in the east.[1]

4

But this was the railway age—its tail-end in Britain, where the astonishing and often scandalous years of railway boom were over, but still its heyday in the overseas Empire. These were the years of the snort, the hiss and the green-gold livery, mahogany booking-offices like gigantic confessionals, railway stations of diocesan gravity. All the ritual of the railways was transferred by the British to the ends of their grateful Empire.

Britain's experience in railway-building was still unrivalled. British engineers, with British financiers behind them, were responsible for foreign railway systems as far apart as China and the United States, and almost the first thing that crossed the British mind, when a new territory was surveyed or a stroke of expansion contemplated, was the best location for a railway line. The great railways of the Empire, Bryce thought, would remain 'to witness to the skill and thoroughness with which a great nation did its work'. More than half the railway mileage of Asia was British, and five-sixths of the African mileage. The romance of the imperial railways was very dear to New Imperialists. When Rhodes first planned his railway across the chasm of the Victoria Falls, where the spray rises from the cataract like a cloud across the plain, he saw the meeting of the steel lines and the eternal waters as a meeting between equals,

[1] The present road from Cairo to Suez follows the line of the Route, and the rest-house half-way is the last of the relay stations.

and decreed that the bridge must stand so close to the falls that the passengers would see the spray upon their windows.[1]

Some sensational things were done by the imperial railway engineers. While that irrigation water went through the Ghats in one place, in another the Great Indian Peninsular Railway was hoisting itself across them in a phenomenal complex of tunnels, bridges and sidings, the trains now labouring up what seemed to be an impossible jungle gradient, now suddenly backing into a reversing siding and starting off afresh in the opposite direction. On the Uganda Railway trains had to be loaded, truck by truck, on to a kind of elevator, and slid gently down a dizzy slope to the depths of the Great Rift. In Ceylon the mountains were so steep that at one time the engineers wondered despairingly if they ought to abandon the idea of locomotives altogether, and haul all their trains up the hills by huge stationary engines. There was almost nowhere in the Empire where they would not lay a railway. There was one in Malta, 8½ miles long, and there were two on the island of Mauritius, and an adorable little train, with easy chairs on canopied open wagons, puffed up a two-foot track around Darjeeling to deposit its passengers at the highest railway station in the world—Ghoom, at 8,000 feet. Lord Napier took a complete railway with him when he sailed from Bombay to Ethiopia in 1868, and Kitchener was laying one as he went southward into the Sudan.[2] In 1897 they were completing one in Newfoundland, starting one into the Yukon, half-way through one in Burma, thinking about one from Suakin to Berber, plotting one from Singapore through Siam to India, grumbling about not having one to Salisbury in Rhodesia, negotiating one from Hong Kong to Canton, surveying one up the Kabul River into Afghanistan, hard at work on one from the Kenya coast to the Great Lakes of Africa.

[1] They can when the wind is right, at some times of the year, but it would have been much easier to cross the Zambesi six miles upstream. The bridge was completed in 1905, one of its designers being Sir Ralph Freeman, who built the Sydney Harbour Bridge.

[2] Kitchener's line was the basis of Sudan Railways, later to become one of the most comfortable systems in the world, but Napier's was a terrible flop— the engines would not work, the rails did not fit, vital spares and tools had been left behind in India, and the railway was only just finished in time for the withdrawal of the expedition.

The purpose of the last was partly to open up Uganda to trade and settlement, and partly to protect the southern flank of Egypt against foreign meddling. The coastal terminus of this line delightfully represented the spirit of the imperial railways. In those days Mombasa was an Arab seaport almost untouched by Western civilization—a town of tall balconied houses and narrow scented lanes, palm trees, hookahs, bearded magnificoes and women smothered head to foot in black. An ancient Portuguese fort commanded the town, and in its deep harbour the dhows lay exhausted in the heat, waiting to load up with spices and ivory for Arabia and the Persian Gulf. In the very centre of this medieval place, almost within sight of the dhow harbour, the British had built a solid, sensible, standard sort of railway station. It was the kind of station one might expect to find on a fairly busy branch line in the West Country, except that it was made of whitewashed mud. Its booking-offices were trim, its luggage counters capacious, its platform benches freshly painted, its sleeper-beds well weeded—all done to a neat and modest pattern, and ready, one might think, to take Mrs Proudie up to London for a conference, or receive the school special at the start of an unusually sunny summer term.

From this homely building there set out into the interior of Africa a railway so set about by savagery that for several months its construction was delayed by man-eating lions,[1] and once a Punjabi labourer was found strung up on a pole full of Nandi arrows, like a warning crow on a fence. Endless misadventures attended the construction of the Uganda Railway, rinderpest, famine, plague, attacks by hostile tribesmen, attempted murder in the construction camps, drought, smallpox and collisions on the track: but it reached Lake Victoria in the end, and there it was met by the steamboat *William Mackinnon*, prefabricated in England and carried up the route of the line by several hundred labourers.[2]

[1] Two of them now stuffed in the entrance hall of the Field Museum in Chicago—they had been made famous by J. H. Patterson's book *The Man-Eaters of Tsavo*.
[2] This line became the Kenya and Uganda Railway, with the reputation of being the best-run railway in the Empire. The original Mombasa station is no longer in use, but will all too easily be recognized by regular travellers on British Railways.

5

There was no grand plan for the railways of the Empire. In general they were built to British standards and methods, as against American or Continental, but there was no attempt to standardize them. Even the Irish railways ran on a different gauge from the railways in England, and the six Australian States, disregarding the advice of the Colonial Office, worked on three different gauges between them. Often, nevertheless, there was grandeur to their conception. Rhodes saw his Cape-to-Cairo railway in epic terms—a British highway up the spine of the continent, with through trains from one end to the other, and feeder lines branching east and west to the Indian and Atlantic Oceans: it was precluded by the agreement, in 1890, which gave Tanganyika to the Germans, and when the idea was later revived, and there was an attempt to lease land in the Congo to skirt Tanganyika, the Germans themselves prevented it.

All around the African coast railways like the Uganda line were for the first time taking Western trade and technology into the tribal areas of the interior. The South African railways, Bryce reported, had made Cape Town, Kimberley, Johannesburg and Pretoria a single social unit, where all the important people knew each other—Johannesburg and Cape Town, he said, were in closer social touch than Liverpool and Manchester, or New York and Philadelphia. The confederation of Canada, fulfilled in 1871, would not have happened if it had not been for the Canadian Pacific Railway —British Columbia refused to join unless a transcontinental line were built. To some Britons this line seemed the key to the unity not only of Canada but of their whole Empire, for it offered a new, secure and all-Red route to the orient; Columbus's vision fulfilled at last, and in as thoroughly British a way as he would doubtless have preferred, if he had lived in the right century. The Canadian Pacific was already romantically dubbed the Queen's Highway, and at its Pacific end the Royal Navy had built its base at Esquimalt. There was even talk of constructing a new port on the west coast of Ireland, through which the posts for Australia could pass for Halifax

and the C.P.R. mail train (a route which would involve six tran-shipments, but would never leave the shelter of the flag). The C.P.R. was the only single-system railway crossing the American conti-nent. Its trains made the journey at an average speed of 28 m.p.h., and the British thought it highly significant that its very first train-load of material was a consignment of stores for the Pacific Squadron of the Royal Navy.

In India especially, in all things the apogee of Empire, the rail-ways stood for historical change. They bound the country into a unity, and they prised open the internal economy of India, each district self-sufficient and oblivious to the next. The railways opened the eyes of many Indians to the size of their country, even to the existence of communities other than their own. Some were built for military purposes, some specifically to move grain about at times of famine, and they were mostly financed by private British capital, with Government subsidies or guarantees (the only one built entirely with Indian capital was that little treasure of a line up to Darjeeling).

Some of the railway companies were, by the standards of nine-teenth-century Asia, marvels of modern organization. The East India Railway Company, for example, though its carriages were notoriously dirty, was the richest company in India and one of the most thorough. Its administrative offices were enormous palaces of paper-work, packed with multitudinous docketed files in red tapes and paper-clips, laboured among beneath the twirling fans by armies of bemused babus. At Jamalpur the Company had built its own headquarters town, with living quarters for its British em-ployees. Its streets had names like King's Road, Victoria Road, or Steam Street, and its houses were built to a standard design, but in varying sizes, nicely laid out in village style, and so arranged that no employee lived far from his work. There was a communal swim-ming pool, a library, a Masonic lodge, a night school for apprentices, an Institute with half a dozen tennis courts, and once a week the East India Railway Volunteers, a militia company, paraded at the drill hall in grey and red uniforms, led by a band—membership of the force was a condition of service with the Company. The E.I.R. was a paternal employer, run by Scotsmen and North Country men.

Many a son followed his father into its service, and to Indians a job on its payroll was only inferior to a job in the Government.

For the British the railway stations of upcountry India were fulcrums of Anglo-Indian security, as those cable stations were oases in the Outback of Australia. Steam, piston grease, the stuffy smell of waiting-rooms, starched white dining-room napkins, smudgily printed time-tables, soldiers at junction platforms drinking tea out of saucers—all these were basic ingredients of Anglo-India, as organic to the Raj as hill-stations or protocol. The Indian railways stimulated the Englishman's imagination, and gave him a Roman pride. In Indian cities the grandest and most ornate of the public buildings were usually the railway stations and offices, hulking mock-oriental caravanserais, Saracenic, Moghul, all domes, clocks, whirligigs, stained-glass windows, immense glass-and-girder roofs, beneath which the railway lines lay like allegories of order in chaos. There the great trains steamed and hissed: the British engine-driver grandly at the cab of the mail-train locomotive; the British conductor with his check-board at the first-class carriage door; the British stationmaster at the end of the platform, dressed splendidly in dark blue, like an admiral at the quay; the British passengers stalking down the platform in a miasma of privilege, pursued by coveys of servants and porters with bags, children, bedding, and possibly a goat to be tethered in the guard's van, and provide fresh milk for the journey.[1] All around was the theatrical confusion of India, which Empire had tamed: a frenzy of Indians, in dhotis, in saris, in swathed torn rags, in noseclips, ankle-bangles, turbans, baggy white shorts, scarlet uniforms, yellow priestly robes, topees, bush-jackets, loin-cloths; hawkers shouting in hollow voices and peering through train windows with blazing eyes; office messengers hurrying importantly by to post their letters in the mail-coach box; entire families sitting, sleeping, clambering about, feeding babies or apparently dead on piles of baggage, tied up with string; and some-

[1] Later the Indian railways came to be run largely by Eurasians. At our moment the crews of the most important trains, and the masters of the biggest stations, were expatriate Britons, often former Army N.C.O.s: Kim's father, ex-Colour-Sergeant O'Hara of the Mavericks, had become a gang foreman on the Sind, Punjab and Delhi Railway.

times a desperate beggar, a man with no face or a legless boy, darting terrifyingly out of nowhere to seize upon a likely straggler.

The British gentry travelled first-class, usually with a servant's compartment next door—on the South India Railway a little window linked them, for milord to give his orders through. The Indian gentry travelled second-class; British other ranks, commercial men and mechanics went intermediate; and pushed, levered, squeezed, squashed into the slatted wooden seats of the fourth-class compartments, travelled the Indian millions. A journey across India took anything up to a week, and the wise sahib took his own padded quilts and pillow, his own tiffin-basket (which should always be kept furnished, *Murray's Handbook* advised, 'with potted meats, biscuits, some good spirit, and soda water'), and a few good books (such as, Murray suggested, Sir W. Hunter's *Indian Empire*, or Sir Alfred Lyall's *Rise and Expansion of the British Dominion in India*). There were refreshment rooms at most junctions, but the experienced traveller telegraphed his requirements ahead, and as the train drew into Chanda or Gadag, out of the shadows would leap a man in white, carrying your luncheon on a tray, covered with a napkin— fiery curry, vivid chutney and onions, chupattis, to be washed down with a draught of Scotch from your tiffin-basket. So immediate was this service that it was as though the man had been awaiting you there all morning, holding his tray: but you had to eat fast, for before you left he would want the plates back, and as the train moved off again, with a creaking of its woodwork and a distant chuffing of its engine, you might see him bowing perfunctorily still, as he retreated to the Vegetarian Food Stall for the washing-up.

The Indian railways provided all sorts of social services, ancillary to their grander functions. Murray is full of their usefulness. The stationmaster at Jungshahi would arrange your camel for you. There was a comfortable Waiting Room ('with *Baths*, etc.') at Neral. Travellers to Verawal might find it convenient to get permission from the stationmaster to retain their first-class railway carriage at the station, and to sleep in it at night. For the Englishman in India the railways were a reassurance, a familiar constant in an often unpredictable world. With Newman's Indian Bradshaw on one's lap, a stalwart engine-driver of the Great Northern Railway up front,

and the certainty of a tonga awaiting one at Kathgodam station, one could lean back in one's seat ('unusually deep', Murray says) in rare security. Someone, somewhere, it seemed, had got the hang of the place. To travellers in the remote Himalaya, one marvellous moment of a descent into the plains was the sight of a distant plumed railway train, streaming across the flatlands with a whisper of starched linen and chilled champagne. To the new arrival at Bombay, awaiting apprehensively the plunge into the Indian hinterland, nothing could be more comforting than the Punjab Mail, glistening and eager in the gloom of Victoria station, as British as the Crown itself, and sure to be on time.

6

In the last three decades of the century much of the Empire was mapped for the first time, generally by soldiers, sometimes by roadbuilders and railwaymen. No such slabs of empty territory had been so thoroughly surveyed before, and London was the world centre of cartography, just as geographers in most countries reckoned their longtitude from Greenwich. Strategy was the chief impulse of the work. The very first British official maps were of Ireland, and were drawn (in 1653) when the British wished to distribute the lands of rebellious Irishmen among their soldiers and settlers. Ever since the British had been mapping those countries they wished to subdue or occupy, and generally the more determined the local resistance the more thorough the maps. This made for a patchy system. Canada, which was mostly empty, was covered by a hodge-podge of boundary maps, railway maps, exploration maps, geological maps for speculators and sketch maps drawn up by adventurers in the Rockies. In Australia, where there had been virtually no local resistance, there were virtually no topographical maps. India, on the other hand, was very thoroughly mapped—all of it on the scale of $\frac{1}{4}''$ to the mile, most of it on an inch to the mile. South Africa was oddly neglected,[1] but Rhodesia had been well mapped from the start, if only to make sure the gold reefs would be properly located.

[1] As the British Army was humiliatingly to discover a year or two later, when it seldom knew where it was during the Boer War.

Elsewhere in Africa most colonies and protectorates had accurately surveyed frontiers, with less accurate surveys around the chief settlements and along the coastlines, while the interior of the continent remained, for the most part, a smudge on the map, delineated only from guesswork or the imprecise observations of explorers. Kitchener, himself a skilful surveyor, had taken a large mapping mission with him into the Sudan, busy even then surveying a million square miles of potential Empire: but Africa was still the dark continent, and part of the excitement of the New Imperialism was the lure of the uncharted—'the other side of the moon', was Salisbury's simile for the Upper Nile Valley, and the systematic reduction of the Empire to grids and projections was, for the men of those days, a task akin to the mapping of space. Napoleon, surveying the Great Pyramid of Giza, is supposed to have cried to his veterans: 'Soldiers, forty centuries look down upon you!' The British, almost as soon as they arrived in Egypt, lugged a theodolite to the pyramid's summit and made it a triangulation point.

7

They were making a start with tropical medicine. The first school in the world exclusively concerned with the subject was being built that year in Liverpool, home port for the West Africa trade. In many parts of the world the British were the first heralds of the message that cleanliness and health went together, and they were just beginning to understand a few of the hitherto intractable tropical diseases. They knew that beri-beri was caused by rice from which the outer grain layers had been stripped. They knew that leprosy and cholera were bacterial, and that the filaria worm was the cause of elephantiasis. Sir Ronald Ross, in India, was pursuing the theory that malaria was caused by the anopheles mosquito, and Patrick Manson, medical adviser to the Colonial Office, had convinced all but the most rigid devotee of spine pad and siesta that the health hazards of the tropics were seldom due simply to heat.[1]

[1] Ross (1857–1932) was born in India, the son of an Indian Army general, and served with the Indian Medical Service. In 1894 he met Manson (1844–1922), who had been a doctor in China, had done much research into tropical

Yet the work that remained to be done was staggering, and perhaps not even the most sanguine New Imperialists really thought they could raise the health standards of the overseas possessions to the level of those at home. The filth and ignorance of so much of the Empire made a mockery of preventive medicine, and it was only in 1897 that the Colonial Office, under Manson's inspiration, seriously bothered about tropical disease—until then its administrators had gone out heedless of causes and uninformed of cures. The new town of Nairobi, starting absolutely from scratch beside the Uganda Railway, blindly reproduced all the insanitary horrors of the ancient East, hundreds of cramped, dark, unventilated houses just made for disease, evil-smelling and damp with sewage. Literally millions of Indians died of the plague in an average decade: almost every great religious assembly led to an outbreak of cholera, and when, during the Bombay plague of 1897, the police and the Army took over, forcibly clearing houses and establishing sanitary zones, the people rioted in protest. In Malta, where they had not yet discovered that the goat was the carrier of Malta fever, an average of 600 British servicemen went to hospital with the disease each year, and within three years of their arrival in India more than 80 per cent of Europeans were attacked by enteric fever. During the five years it took to build the railway from the Indian Ocean to Umtali, in Rhodesia, nearly 500 Indians and 400 Europeans died: they used to run sweepstakes on the temperatures of the sick, the man with the highest fever winning the pool—if he lived.

The average Empire-builder seemed to accept these miseries fatalistically. A young man called T. E. Fell sailed out to the Gold Coast in the summer of 1897, to take up his duties with the Government, and wrote a series of letters home during the voyage. He is much concerned, poor boy, with the coming torments of the climate. He is sure to get the fever, he says, but Mama is not to worry, because everybody gets it. Still, he does wonder what it will be like, and how long it will last—though dear Mama must remember that

diseases, and had first thought that malaria might be caused by the mosquito. To the two of them is jointly due our understanding of malaria, and they both died honoured and famous in England.

they all get it within a week or two, and it will be best to get it over soon. He is surprised to find how well he feels when they go ashore briefly at Freetown, but on arrival at Accra reminds his mother that, though he is sure to succumb before very few weeks have passed, she is on no account to worry about him.

The days pass, though; the weather seems very pleasant; young Mr Fell, though overworked, is quite enjoying himself, and the premonitions of disease grow fewer—he is sure to get it sooner or later, of course, but in the meantime the company is agreeable enough (except for Mrs What's-Her-Name, who is, 'altho' a lady, not my style, large, bouncy, slangy, colonial and drinks cocktails'). By the end of the year he seems to have forgotten about the fever, and writes cheerfully of the small black insects that infest his dinner table: 'The more I squash the more arrive and each one squashed emits the exact odour of Worcester Sauce, so I am thinking of bringing out a patent.'[1]

8

One gets the unfortunate impression, from the records of the time, that the British were more interested in the physical welfare of their own people than of their native subjects. It is true that they proudly claimed to have eliminated famine in India, by irrigation and by better transport. 'If we had a complete record of the fortunes of an Indian village during the last three hundred years', wrote Sir T. W. Holdernesse of the Indian Civil Service, 'we should probably find that its population had ever and anon been blotted out by some terrible drought. A famine in this sense is no longer possible in India.' But we seem to read more about the health of the British Army overseas, or the British settlers of the temperate zones, than we do of the poor natives, who were generally supposed, perhaps, to be used to it all, or beyond hygienic redemption. Kipling classed the improvement of health among the categories of the White Man's Burden—

[1] Fell survived until the 1920s, dying at sea while returning to Fiji after leave. He served in the West Indies too, but is said to have been lonely throughout his colonial service, so that there is a retrospective poignancy to his early letters home.

All by Steam!

Fill full the mouth of Famine
And bid the sickness cease

—but generally it was the Christian missionaries who seemed to care most about the bodily well-being of the tropical peoples. There were no women in the colonial services of the Empire. Compassion was not its strong point.

It was a man's Raj, and it did much of its work simply by virile example—by putting on display the glitter, punch and profit of the scientific civilization. In everything they did the British demonstrated to their simpler subjects the power that was given man by the mastery of technique, whether it be expressed in the range of a Lee-Enfield or the tripling of crops by proper irrigation. Technical formulae, laboratory precision had been introduced for the first time into many aspects of tropical life. The standard Indian opium cake, made at the Government factory near Benares, was defined as 'Pure opium 70 consistence, poppy petal pancakes, *lewa* of 52.50 consistence, and a powdering of poppy trash'—a prescription soon to be smoked away, by heathen Chinamen in fetid alcoves, into clouds of methodless delight.

The mere sight of the technical civilization was enough to stir a stagnant culture—the very fact of ice-boxes, telephones, telegraph offices, Empire No. 1 'Incomparable' Folding Baths. One of the symbolic scenes of Empire was that of the wondering native, confronted for the first time in his life by one of these modern marvels, and thus jolted into the realization that, though his tribal capital might indeed be the centre of the universe, and his native king the Lord of the East, West and Sunrise Peoples, still there might be something to be learnt from the white man after all. We see the aborigines of New South Wales, for instance, stopped in their tracks, as well they might be, by their first glimpse of Sydney's double-decker steam trams—towering steel vehicles with scalloped awnings, wreathed in smoke from their traction engines. We see the Indians of the Six Nations dazed among the conifers as the coaches of the Canadian Pacific sweep by with a wail of the steam-whistle towards the Pacific. The white-robed Egyptians flutter down to Boulak, the ancient river port of Cairo, to see Mr Cook's new

steamer, *Rameses the Great,* bolted together from its component parts and launched into the Nile. The baffled Bechuanas, face down on their kopjes, peer to the plains below as the steam engine of the Matabele Expedition starts to chug in the middle of its laager, and the electric bulbs mysteriously flicker and light up in the officers' mess-tent.

Often such marvels seemed to arrive miraculously packaged direct from the Great White Queen, for the British were specialists in prefabricated structures. The south-east bank of the Mersey at Liverpool was known as the Cast-Iron Shore, because so many prefabricated iron buildings were made there for markets abroad, and the catalogue of Hemming's, the Bristol ironworks, offered a completely prefabricated hotel, with a veranda, and a substantial Gothic-style church, with tower—a popular item in Australia—at £1,000. In Salisbury, Rhodesia, the Senior Judge lived in a prefabricated house of papiermâché boards on wooden beams, imported from England and called the Paper House. It had gables and pleasant verandas, stood on brick piles, and looked comfortable enough, if a little wobbly.

9

The natives saw this millennium, and it worked. As a random example take the statistics of Ceylon. It had been unified under British rule in 1815, and in the eighty-odd years since then the British had impregnated it with the material signs and values of the West. They had built 2,300 miles of road and 2,900 miles of railway. They had raised the cultivated area from 400,000 acres to 3,200,000, the livestock from 230,000 head to 1.5 million, the post offices from four to 250, the telegraph lines from nil to 1,600 miles, the schools from 170 to 2,900, the school pupils from 2,000 to 170,000, the hospitals from none to 65, the annual tonnage of shipping cleared from 75,000 tons to 7 million. They had opened 12 banks, started 35 periodicals, launched a Government savings scheme with 18,000 depositors and a Post Office Savings Bank with 38,000 depositors.

In the deepest mountain jungles of Ceylon there lived the Rock Veddahs, bow-and-arrow aborigines with straggled hair and

bushy beards, who had never mastered the simplest arts of cultivation, and conducted their frugal barter incognito, leaving their honeycombs on a stone in a clearing, and only returning for their scraps of cotton cloth when there was nobody else in the forest.

CHAPTER TWENTY

Freedmen

Tides of Fundy—Tides of Fundy
What is this you bring to me?
News from nowhere—vague and haunting,
As the white fog from the sea.
Night and day I hear fresh rumours,
From an unknown fabled shore,
Of new orders soon to reach me,
And a summons at my door.

<div align="right">Bliss Carman</div>

20

IN 1897 the most-frequented route into the goldfields of the Klondike, in the north-west corner of Canada, ran from the coast of Alaska, in United States territory, over the White Pass to Lake Bennett and the tributaries of the Yukon River. To thousands of adventurers of every nationality this terrible journey was a memorable introduction to the Pax Britannica.

Skagway, the Alaskan port at the foot of the trail, was perhaps the most lawless town on earth. It was one enormous confidence trick, a municipal swindle, totally beyond the control of Washington and run by a villain of superlative skill called Jefferson Randall Smith—'Soapy' Smith to history. Almost everything in town was geared to the fleecing of innocent new-comers, as they spilled hopefully off the ships from the south. Teams of rogues met them on Smith's behalf—'The Reverend' Charles Bowers, 'Slim Jim' Foster or 'Old Man' Tripp—posing as philanthropists of one kind or another, and exquisitely skilled in techniques of robbery, fraud or extortion. Skagway was infested with Smith's spies, stooges, tame lawyers and sham charities. The Merchants' Exchange, the Cut Rate Ticket Office, the Civic Information Bureau, the firm called Reliable Packers—all were front organizations for Soapy Smith. So was the Telegraph Office, across whose counter many a new-comer passed his safe arrival message and his fee, for there was in fact no telegraph line to Skagway. The fates seemed mysteriously to conspire against the gullible new arrival: and when at last he found himself, bruised, dazed, cheated of all he had, homeless and destitute in the streets of Skagway, sometimes Soapy Smith himself, breathing shocked and charitable concern, would offer him just enough cash to get him back to Seattle again, grateful at the last and well out of the way.

From this dream-like Gomorrah, where nothing was what it

seemed, the more resolute or sceptical prospectors set out neverthe-less for the Klondike, shouldering what was left of their gear, and labouring up the long steep mountain trail, deep in snow, that was to remain for ever in the world's memory.[1] Up they stumbled, boot to boot, shrouded in dark greatcoats, loaded with bales and packs and crates, dragging their tortured pack-horses up the ice like figures out of Dante. Thousands of pack-animals died on the way, to be pushed over the brink or trampled underfoot: but so long as the pass was open the rush continued, the rabble behind forcing on those in front, so that the line of stampeders seldom stopped or broke, but moved inexorably, day after day, towards the bleak and windswept summit of the pass.

On that summit flew the Union Jack. There the Queen's terri-tories began. In a wooden hut half-buried in the snow waited the officers of the North West Mounted Police, very British, staunch and gentlemanly, with their Queen's Regulations, their files and their always gleaming brass buttons. They had a Maxim gun to keep villains out, and in that cruel semi-Arctic setting they dili-gently imposed the imperial standards. Nobody could enter Canada over the White Pass unless he had a year's supply of food and all the necessary equipment to survive. Horses with sores or injuries were shot at once, to prevent unnecessary suffering. The injured were given first-aid, the perplexed were advised, Smith's men were sent packing back to the coast, all were checked and counted. Massive in their fur hats and immense beaver coats, the Mounties were like images of order up there, sure and incorruptible. After the fantasies of Skagway they must have seemed wonderfully substantial.

The Mounties had moved into these regions only three years before, when the first prospectors reached the Yukon. It was debat-able whether they really had a right to control the White Pass, for the frontier between Canada and the United States was not de-

[1] Though the best-known pictures of all are of the Chilkoot Pass, the next gap to the north, through which 22,000 people were to travel in the following year. Over the White Pass itself there now move the shiny stainless steel container cars of the White Pass Railway, taking supplies to the town of Whitehorse, and bringing down to the container ships at Skagway the mineral products of the booming interior.

marcated: but their presence in the Yukon, and the tradition of British authority which they represented, made the Klondike gold rush like no other. Violence was almost unknown, even in the gaudiest days of the stampede. In Dawson City, the most extravagant of the boom towns, with its clapboard saloons along the Klondike River, its gambling joints and its brothels, its flamboyant millionaires and its fabulous consumption of liquor—even in Dawson City the proprieties were scrupulously balanced. A girl might set up as a prostitute indeed, in her crib on Paradise Alley, but she certainly might not flaunt herself in a belly-dance, or show her knickers on the music-hall stage. A man could get roaring drunk six nights a week, but he must not talk obscenely, brawl, or speak disrespectfully of the Queen. Children might not be employed in saloons, spirits might not be sold to minors, 'using vile language' was one of the most frequent charges in the police courts—a well-known badman from Kansas was once ejected from a Dawson saloon simply for talking too loud.

As for Sundays in that rip-roaring little metropolis, they were as absolutely sacred as Victoria herself could demand. The bars, theatres and dance halls closed at a minute before midnight every Saturday night, and not a whisky was sold again, not a hip was wriggled, not a bet was placed, until two in the morning on Monday. The Sunday sounds of Dawson City were psalms and snores. No kind of work was allowed. Men were arrested for fishing on a Sunday, or for sawing wood. The only hope of living it up, between Saturday night and Monday morning, was to take a boat downriver and slip across the line into the States—out of reach of the Pax Britannica and its stern schoolmarm values.

2

Canada was still a colony of the British Empire. The greatest and oldest of the self-governing overseas territories, far bigger than the whole of Europe, it still possessed no absolute sovereignty of its own. Its laws, signed in the name of the Queen, could theoretically be overridden by the Imperial Parliament at Westminster. Its foreign policies were decreed by London, and it was represented abroad by

British Ambassadors—the only Canadian overseas agent lived in London and was accredited to the Colonial Office. When Canada concluded a trade agreement with a foreign Power the British Government appended its signature, too, like a trustee with a juvenile ward. The Governor-General in Ottawa, Lord Aberdeen, behaved partly as the president of an autonomous confederation, Canada, but partly as the representative of the imperial Power, reporting back to the Colonial Office in London—a kind of super-Ambassador, empowered to intervene even in the internal affairs of Canada. Canada's very title recognized this ambiguous status. When the Confederation was formed in 1867 its chief architect, John Macdonald, proposed to call it the Canadian Kingdom, but the British Government of the day had insisted on a less absolute definition: the Dominion of Canada.

To Canada, as everywhere, the British had transferred such of their institutions as seemed suitable. No two countries could be much more different than England and Canada, but it was an English Constitution that governed the Confederation. Its Governor-General played the part of the monarch, advised by a Prime Minister and his Cabinet. Its Senate was non-elective, like the House of Lords, and real power lay, as it did at Westminster, in the House of Commons. There was no hereditary aristocracy, but Canadian statesmen still received honours from London, and knights abounded in these forest glades. The imperial forces maintained their bases at Halifax and Esquimalt, ships of the Royal Navy regularly sailed up the St Lawrence as far as Montreal, and from end to end of Canada memorials stood in witness to the imperial tradition: the enormous cenotaph in Halifax commemorating the two Nova Scotian officers killed in the Crimean War; or the memorial at Ottawa to Wm. B. Osgood and John Rodgers, of the Guards Company of Sharpshooters, killed in action at Cutknife Hill in 1885; or the monument at Fort Walsh, far in the west, which honoured those men of the Mounted Police who, 'by defeating hunting bands of Blackfoot, Crees, Assiniboines, Salteaux and Sioux, imposed the Queen's law upon a fretful realm'.

The Queen's law! This is how a police proclamation read, in the Canada of the 1890s:

CANADA

VICTORIA, by the Grace of God, of the United Kingdom of Great Britain and Ireland, *Queen*, Defender of the Faith, etc etc.

TO ALL WHOM these presents shall come, or whom the same may in any wise concern,—GREETING.

A PROCLAMATION

WHEREAS, on the 29th day of October, one thousand, eight hundred and ninety-five, Colin Campbell Colebrook, a Sergeant of the North West Mounted Police, was murdered about eight miles west of Kinistino by an Indian known as 'Jean-Baptiste', or 'Almighty-Voice', who escaped from the police guard room at Duck Lake; AND WHEREAS it is highly important for the peace and safety of Our subjects that such a crime should not remain unpunished;

NOW KNOW YE that a reward of FIVE HUNDRED DOLLARS will be paid to any person or persons who will give such information as will lead to the apprehension and conviction of the said party.

WITNESS, Our Right Trusty and Right Well-beloved Cousin and Councillor the Right Honourable Sir John Campbell Hamilton-Gordon, Earl of Aberdeen; Viscount Formartine, Baron Haddo, Methlic, Tarnes and Kellie, in the Peerage of Scotland; Viscount Gordon of Aberdeen, County of Aberdeen, in the Peerage of the United Kingdom; Baronet of Nova Scotia, Knight Grand Cross of Our Most Distinguished Order of St Michael and St George, Etc, Governor General of Canada, At Our Government House, in Our City of Ottawa, this Twentieth Day of April, in the year of Our Lord one thousand eight hundred and ninety-six and in the Fifty-Ninth year of Our Reign.

Threatened with such solemnity, Soapy Smith himself might momentarily have blenched, before relieving Our Right Trusty Cousin of his Grand Cross.

3

The imperial hegemony was tactfully exerted. Nobody in London wanted to bully the Canadians, still less goad them into republicanism. In practice the Governor-General seldom intervened, obligingly assenting sometimes to legislation frankly directed against

British trade, and the imperial Government politely consulted the Canadians, before signing foreign treaties that might affect them. Canada had been Britain's first experiment in colonial emancipation —the forerunner, it was hoped, of noble things to come, as the other white colonies of the Empire advanced to proper nationhood. It was the famous report brought home from Canada by Lord Durham, in 1839, that had led in the end to the establishment of cabinet Government, on the Westminster pattern, in the white colonies of the Empire. Since then, so the British liked to think, Canada had stood as proof that looser imperial ties would dissuade the colonies from seceding like the Americans—that they would not gallivant away with independence, but would actually cling closer to the Mother Country, like ever-grateful daughters about a never-ageing Mama.

The real relationship between London and Ottawa could not easily be defined. One could not look it up in a reference book. It was a *modus vivendi*, based upon ambivalences, sympathies and the realities of power, and very difficult for foreigners to master. The imperial links were maintained in twilight, sometimes relaxed, sometimes stiffened, so subtle that few people really knew just how independent Canada was, and while Englishmen generally supposed it to be virtually a sovereign State, Americans and continentals generally regarded it simply as a colonial outpost, behaving as Britain told it to.[1]

4

Canada had become a nation, of a sort, just thirty years before, when the Confederation was formed. It was geographically united, in a way, when the Hudson's Bay Company gave up its rights of sovereignty, in 1870, and handed over the half-explored regions of the west and north. The Dominion now comprised six Provinces, each with its elected Assembly, plus the inconceivable wildernesses of conifer, tundra and ice which faded away into the unknown Arctic. In the north-west Alaska was American. In the north-east

[1] Old-fashioned Americans still sometimes talk of Canada as a British colony, and it is true that in theory the Canadians cannot alter their own constitution without the consent of Westminster.

Newfoundland and its dependency Labrador staunchly maintained their own autonomy:

> *Hurrah for our own native Isle, Newfoundland,*
> *Not a stranger shall hold one inch of its strand.*
> *Her face turns to Britain, her back to the Gulf—*
> *Come near at your peril, Canadian wolf!*

For the rest, Canada looked a logical sort of slab on the map: self-contained, huge, very solid.

In reality it was a flabby State, tenuously strung together, and racked by inner tensions. Canada was only inhabited in patches along the American frontier: thick clusters in the east and west, scattered clusters in the middle, almost nobody at all in the north. Between one settlement and the next there extended a wasteland, sometimes of forest, sometimes of empty prairie—mile upon mile of dark green and brown, totally uninhabited, deep in snow for half the year, and relieved only by gloomy fly-infested lakes. No Canadian town was far from the wilderness, and up every Canadian road, just beyond every horizon, lay the frozen immensities of the north. In the interior the winters were terrible and the summers stifling: Everywhere the gigantic emptiness of the place made its presence felt—so big that forty Mother Countries could be squeezed into its mass, and the most grandiloquently imperial mind could hardly imagine the One Race peopling all its corners.

Queen Victoria had herself chosen the site of the Dominion capital, so tradition said, by closing her eyes and stabbing a map with a hatpin. She hit Ottawa, then an obscure lumber-town called Bytown, and there all the paraphernalia of federal Government had been erected, on a glorious site above the Ottawa River—a parliamentary pile that anyone would be proud of, and a castle of a railway station almost next door. The one would be perfectly useless without the other, for some of the federal parliamentarians had to travel 2,000 miles to attend a debate, and so devastating were the problems of distance in this sprawling State that there were times when Canada actually seemed to exist for its railways. Railway politics repeatedly dominated national affairs, swirling around interminable disputes of finance, landownership, strategy and competition.

Whole towns, whole Provinces even, depended upon the railways for their survival, and the entire flavour of Canadian life was tempered by the railway ethos—from the hick towns of the prairies, setting their clocks by the swoosh of the morning train through the depot, to the greatest cities of the settled east, whose biggest buildings were generally railway hotels. The railways played a vital part in every Canadian life, and everyone knew the different railway companies by reputation or at least by nickname—the Dust and Rust (Dominion Atlantic Railway), the Get There Perhaps (Grand Trunk Pacific) or the Never Starts On Time (Niagara, St Catharines and Toronto).

The greatest force of all was the Canadian Pacific, which had literally summoned the Dominion into being. It was built chiefly by private enterprise, much of the capital coming from London, but with Government subsidies and a land grant of 50 million acres of good land. The last spike was driven at 1885, at Eagle Pass in the Rocky Mountains, connecting for the first time the Atlantic and the Pacific shores of Canada, and at once the C.P.R. became an imperial Power itself. It saw itself, as the British saw it, as a link in an all-British route to the orient, and presently it launched its own steamships on both oceans, to convey goods and passengers under one house flag all the way from London, via Vancouver, to Hong Kong or Sydney. At home it was even more powerful. It enjoyed a monopoly of the transcontinental traffic, it was a vast landowner, its tycoons were among the great men of Canada. All along the line its works stood as a reminder of its influence: the great company offices and hotels, like inner keeps of the cities; the stations, built to a standard pattern from coast to coast, except when they burst into the monumental flourish of termini; above all, the trains themselves, hauled by their majestic wood-burners—immensely long trains by the standards of the day, snaking and plodding their way across those merciless landscapes, sometimes negotiating loops so sudden that engine and caboose passed each other in opposite directions, with coaches heated direct from the engine, so the brochures boasted, and electric light in every compartment—the most confident things in Canada, and almost the only earnest that this was really a nation at all.

5

The first Europeans in Canada were the French, but the British considered themselves justifiably masters of the country. They had won it by right of conquest, when Wolfe had defeated Montcalm on the Plains of Abraham above Quebec, nearly 140 years before. By 1897 the British outnumbered the French by nearly two to one, and of the seven Provinces only Quebec, the original Nouvelle France, was French in language and custom. The strength of the British in Canada was above all their Britishness. At this moment of their history patriotism and imperialism were synonymous, and like true-born Britons everywhere, British Canadians were caught up in the enthusiasms of the day—proud to belong to so great a brotherhood of nations, at such a climax of its career. Canada sometimes had differences with England, and sometimes resented those last colonial leading-strings, but in the summer of 1897 grievances were momentarily forgotten. Who would not wish to be British, at such a time? The Canadian flag was still the Union Jack, the national anthem was *God Save the Queen*, and the presence of a large French minority only made the British more British still: even the Irish of Canada were mostly Protestant Scots-Irish, as staunch and loyal as anyone. It was the proud boast of the grandest Anglo-Canadian mansions that not a stick of furniture in the house, not a knife, not a single painting of Highland cattle in a gloomy brownish glen, was home-produced—all came, as they liked to say, from the Old Country.

In many a Canadian settlement British ways had been maintained uncannily down the years, sometimes heightened rather than weakened by pride and remoteness. The city of Victoria, in Vancouver Island on the Pacific, was so unremittingly English that it was already something of a joke, and was generally supposed to be inhabited exclusively by retired Anglo-Indians, eating tea-time crumpets or playing creaky cricket in the thriving British Columbia League.[1] At Regina (ingeniously named by Queen Victoria's daughter

[1] It has been getting steadily more British ever since, as the tourist advantages have grown more apparent, and now even has its own replica of

Louise, in a country already chock-a-block with matronymics) the North West Mounted Police had established its depot with a fanfare of British military tradition—red coats, plumed white helmets, swagger sticks and braided jackets, as rigidly paternal as any ancient regiment of the line, and as stoutly devoted to the code of the officer and gentleman. The Mounties' crested mess china was made for them by T. G. and F. Booth in England, and everywhere in the West they stamped an imperial hall-mark of their own—there they go in every old photograph, among the feathered and blanketed Indians and the high-wheeled buggies of the pioneers, always a couple of spanking troopers, in pill-box caps and pipe-clayed accoutrements, as though they have arrived direct from Aldershot.[1] Scotsmen thronged Canada. The Governor-General numbered among his A.D.C.s two members of the Royal Scottish Company of Archers, and in 1895 a book called *Men of Canada, Or, Success by Example*, numbered among its worthies Messrs MacCabe, MacCarthy, MacCraken, MacDonald, Macfarlane, MacKeen, Mackendrick, Mackenzie, Mackey, Maclean, Macleod, Mac-Millan, Macpherson, MacTavish, and even the Reverend D. H. Macvicar. In the lakeshore country of Ontario the people who called themselves The Scotch lived in an intensely concentrated enclave of Highland values—honest, austere and bony people, Nonconformist almost to a family, who lived in villages like Campbellton, Iona and Fingal, and went in for Caledonian Games.[2]

Anne Hathaway's Cottage. 'Havin' a rippin' time, old bean', says the slogan on a souvenir card they sell there, and there is a picture of a man with walrus moustaches and a topee, holding a cricket bat.

[1] Now renamed the Royal Canadian Mounted Police, the Mounties are still intensely British in style, and the Regina depot is like a British regimental headquarters of the swankiest and most civilized kind—the phrase 'Members Only' on its doors refers simply to members of the force, troopers or commissioners. The men still wear red jackets, originally adopted because all over the world red had become the symbol of British imperial authority, and was recognized as such by Indian tribes who trusted the Queen's soldiers more than the President's. The Mounties' horses are now used only on ceremonial occasions, but in the slang of the Canadian underworld a cop is still called a horseman.

[2] The Scotch and their villages have not greatly changed, and were astringently described in 1953 by John Galbraith the American economist,

There was no exact dividing line between a Canadian Briton and a British Briton. Their accents were diverging, it is true, but they carried the same passports and usually honoured the same ideals. Tory especially called to Tory. Papers like the Toronto *Mail and Empire* were as jingo as the *Daily Mail* itself, private schools all over Canada assiduously inculcated the English public school code, the University of Toronto subjected its undergraduates to intellectual and moral systems that came direct from Oxford and Cambridge (like many of its dons). In every Canadian town the Anglican Church, often presided over by imported Anglican clergymen, represented the established English order so dear to many colonials, its beauty of form and its certainty of merit. There was a good deal of ornery individualism among English-speaking Canadians, especially in the Maritime Provinces, where the pretensions of Tory colonials were not widely admired, and a Yankee republicanism was not uncommon: but hundreds of thousands of British Canadians regarded the imperial saga as part of their own national heritage. The excitement of the New Imperialism was almost as intense in Toronto as it was in London. Acquisitions at the Public Library that June included *The Navy and The Nation, Glimpses of Life in Bermuda and the Tropics, The Sikhs and the Sikh Wars*: news from India was fully reported in the newspapers, and the properly British Canadian would have been affronted indeed, if somebody had suggested that the Royal Navy was not his.

6

The British Canadians were loyal to the Crown as a matter of course. The German, Ukrainian and Scandinavian immigrants were loyal as a matter of convenience. The $1\frac{1}{2}$ million French Canadians were often loyal by default. The British were the conquerors, they were still the conquered—they still spoke of the Conquest, meaning the British subjection of Nouvelle France. The peace settlement in 1759

who was one of them, in his book *The Scotch*. A man I met at Iona Station in 1966, wearing blue denims and a railwayman's hat, and leaning against a pillar outside the village store, told me that the book was not generally popular in the community. 'Not true?' I surmised. 'Too true', was the reply.

had been, the British thought, generous. The French had been allowed to retain their religion, their language and their laws. When the Confederation was born French was recognized as one of its two official languages, and in the House of Commons Quebec was represented by sixty-five members. In 1897 the Prime Minister himself was a French Canadian, and the happy settlement of old differences was often quoted by sanguine imperialists as evidence of the blessings a benevolent Empire could bestow.

But the French Canadians were a people apart. A few educated families mingled with the British on equal terms, a few social aspirants had been assimilated into the English *élite*, and Laurier himself, as Prime Minister, was a persuasive exponent of imperial ideas, dizzily fêted in London that summer (he did not know, he said afterwards, whether the Empire needed a new constitution, but he was sure the visiting Premiers did). Most French Canadians, though, accepted the fact of their British citizenship with an apathy that merged into surliness. They were a dispossessed nation. Their loyalties to France had long been watered down—the French Revolution had passed Canada by, and these *habitants* were Frenchmen cast in a discarded mould, talking an archaic dialect and governed by pre-Napoleonic laws. They did, for the most part, what their priests told them: they accepted legal authority, whatever its source, and withdrew into the cave of their own ancient culture, where nobody would bother them. Lord Durham had called them a people without a history, meaning that they had no intellectual tradition. They were mostly simple, superstitious peasant people, imprisoned in their own ways, with no education except what the Church allowed them, and little share in the national life. So timidly had they ventured into business and commerce that even in the French Canadian villages of Quebec the store was frequently kept by a Scot.

All through the St Lawrence country those little villages ran, with strips of narrow cultivation down to the river's edge—the French had not accepted the principle of primogeniture, and the holdings were likely to grow smaller in each successive generation. A steepled church stood on an eminence, with the priest's house near by, and sometimes there was a manor house in the grand

Norman manner, a relic of the French seigniory that had once governed Nouvelle France, but had mostly returned to Old France long before. Life in such a village was in no way British. Scarcely a sign of the imperial authority was to be seen. The architecture was French, the sounds were French, the smells were French and so was the cooking. There were miracle-shrines of Catholic sanctity, hung about with discarded crutches, and fusty French inns with hanging hams, and formidable elderly ladies in shiny bombazine, disapprovingly on stools at parlour windows. It was a hushed, anachronistic country, Arcadian in some ways, stagnant in others, looking always down to the highway of the St Lawrence River— along whose broad waters the Queen's ships, flying the Red Ensign, passed in an endless stream to Quebec and Montreal.

7

An English Canadian, W. H. Drummond, looked upon these people that summer, and drawing upon reserves of patriotic optimism, wrote the following Jubilee tribute on behalf of an imaginary *habitant*:

> *I read on de paper mos' ev'ry day all about Jubilee*
> *An' grande procession movin' along, an' passin' across de sea,*
> *Dat's chil'ren of Queen Victoria comin' from far away*
> *For told Madame w'at dey tink of her, an' wishin' her bonne santé.*
>
> *Onder der flag of Angleterre, so long as dat flag was fly—*
> *Wit' deir English broder, les Canayens is satisfy leev' an 'die.*
> *Dat's de message our fader giev' us w'en dey're falling on Chateaugay,*
> *An' de flag was kipin' dem safe den, dat's de wan we will kip alway!*

Mr Drummond was dreaming. The French Canadians did not much resent the festivities of Empire, but they hardly celebrated them, either. If the mass of *habitants* were numb to politics, an active minority was developing a French Candian nationalism of its own. This was one of the very few countries in the British Empire where there was, that Jubilee summer, resentment of the imperial domination. Much of the French Canadian emotion had

attached itself to the martyred figure of Louis Riel, a French-Indian half-caste who had rebelled against imperial rule in the West, and had been hanged at Regina in 1885. Riel was scarcely a French nationalist himself. His supporters were half-breeds and Indians, semi-wild men from the settlements along the Red River, fighting for the right to own the land they cultivated, and live in their own prairie style. But the French Canadians adopted Riel as their symbolic champion, the champion of minority rights, and when the Confederate Government hanged him they recognized the gesture for what it was—a declaration of English-speaking supremacy, and a warning that the imperial culture, while it might tolerate dissent, would brook no opposition.

It really was an imperial culture, and the English presence in Quebec was almost a colonial presence. In Montreal, boldly at the head of the Place Jacques Cartier, Lord Nelson stood upon an obelisk: and if the south side of the Place d'Armes was still French and Catholic around the church of Notre Dame, the east side was dominated by the imperial classicism of the big British banks. Quebec City was still recognizably a capital occupied in war. Physically it was the supreme expression of Frenchness in North America —the Kyoto or Toledo of Nouvelle France. It stood heroically on a bluff above the St Lawrence, girded in grey walls, cramped, higgledy-piggledy, picturesque, with narrow cobbled streets and squares, and nuns down every alley. Carved episcopal mitres guarded great gateways, across the dark courtyards of hostelries floated fragrances of onion soup and *coq au vin*.

But upon this ancient tumble an imperial damper had been laid. Of the 68,000 people of Quebec City only about 10,000 were English, but they triumphantly dictated its tone. The grand old citadel on the hill above the river was hung about with British trophies: along the road, beside his battlefield, Canada's conqueror lay beneath a kingly epitaph—*Here Lies Wolfe Victorious*. The Lieutenant-Governor's mansion, Spencerwood, was a lovely old house in the best colonial manner, all creeper and colonnade, and deliberately dominating the Place d'Armes was the Anglican Cathedral, built by the Royal Engineers to the pattern of St-Martin-in-the-Fields, with a royal pew in it, and the graves of a Fellow of All Souls, a Duke of

Richmond and a Private Secretary to a Viceroy of India. The vast Château Frontenac Hotel, at the apex of the city, looked like a medieval French fortress, but was really a railway hotel, where nobody deigned to speak French outside the kitchens. The more expensive shopping streets were full of terribly British shops, posh saddlers, deferential family apothecaries, London-trained tailors and dressmakers By Appointment to Her Grace. The social life of the upper crust was exquisitely English: some distinguished families disclaimed knowledge of even the most elementary French. The Garrison Club was almost exclusively Anglo-Canadian, only a few French gentlemen of ancient lineage and cosmopolitan tastes escaping the black-ball. Beside the quays the big waterside houses of the British lumber merchants exuded a glow of private comfort, and the famous boardwalk along the bluff, on the site of the palace of the French Governors, looked with its bright parasols and its ornamental kiosks astonishingly like something out of Anglo-India. The imperial presence was inescapable. The British Canadians talked of the French simply as 'Canadians'; as one might say natives.[1]

The French generally suffered it all in silence. London felt exceedingly remote to them. They recognized that British imperial policy had not been ungenerous, and they doubtless realized that if ever Canada were absorbed by the United States their racial identity would be much less secure—one could not imagine an antique form of provincial French as a recognized medium of debate in Washington. But they certainly cherished no love for England: not even the exuberant Laurier, Knight Commander of the Order of St Michael and St George, would care to claim so much. They often respected British justice. They sometimes copied British ways. But at heart they felt themselves to be on opposite sides of an indestructible fence. Sometimes they dreamt that, with their far higher birth-rate, they might one day re-establish France in Canada. More often they

[1] Sixty years later Britishness has almost disappeared from Quebec City. The Garrison Club is overwhelmingly French, Spencerwood has been renamed Château des Bois, lift-boys at the Château Frontenac are reluctant to talk English, the old-school English shops have almost all vanished and only a few elderly British ladies remain to tell the tale. Wolfe's memorial was destroyed once by vandals, and when they rebuilt it they removed from its epitaph the word 'Victorious'.

simply cherished their antipathy privately, or sublimated it in Mass and folk-song.

8

They did not, for example, throw squibs at the Jubilee processions on June 22. The Archbishops and Bishops of Quebec, indeed, sent loyal messages to the Queen, and the most respected French Canadian poet, Louis Frechette, accepted a C.M.G.—he was already a member of the Académie Française. Laurier had gone off to London with the good wishes of the nation: the British thought he was putting up a thundering good show, though a Canadian, and the French thought he must know what he was doing, because he was French.

In Ottawa the enthusiasm was unlimited. Mr G. H. Mcgloughlin, at the corner of Sparks and Bank, announced that he would be straining every effort 'in not only commemorating THE EVENT OF EVENTS but in making you feel that this is the most economic dry goods store in Ottawa', while Kern's piano warehouse bore the motto 'Victoria Is Queen But Kern Is King'. At twelve minutes past six on Jubilee morning—twelve after noon in London—Canada's reply to the Queen's message was put on the electric telegraph, and soon afterwards the capital was awoken by a cacophony of church bells, factory hooters and locomotive whistles. During the morning some 10,000 children assembled outside Parliament holding Union Jacks and waiting for the Mayor of Ottawa, who failed to show up. Lord Aberdeen was there, though, and made a nice little speech to the children ('we need not be high and mighty in order to have a good influence, and be faithful in our work'), and told them to give three more cheers when the first ones did not go too well. In the afternoon there was a singsong on Parliament Hill—*Land of the Maple, Hearts of Oak, The British Sailor's Toast*—and in the evening a comic bicycle parade, with cyclists dressed as goblins and Turkish soldiers, and Mr Jardine Russell a popular success in the character 'Sweet Enough to Kiss'. 'God Save the Queen' and 'Dieu Sauve La Reine' went up in fairy lights, and to judge from the local papers the only disconcerting feature of the day, if you forgave the Mayor, was the arrival in Ottawa, by C.P.R. from the west, of a

gang of pickpockets—led, so the papers said, 'by the Gold Tooth Kid from Kentucky, whose mouth is one mass of gold, and who is one of the sharpest pick-pockets in America'.

Probably the jolliest Jubilee procession anywhere in the Empire took place in Montreal, where the celebrations were dominated by Buffalo Bill and his entire outfit, including Indians, Bedouin, Cossacks and Annie Oakley—The Peerless Lady Wing Shot. On the other hand no Jubilee photograph could be much more poignant than a snapshot of the procession at Utterson, Muskoka, a lumber settlement in the lake country east of Georgia Bay. This appears to have been a lugubrious fête. Utterson was evidently not one of Canada's proudest municipalities, for its main street seems to be ankle-deep in mud and is lined only with dilapidated huts, either not quite finished or not altogether collapsed. The day looks brownish-grey, though that may be something to do with the emulsion, and the pavements are utterly deserted. Not a single soul is there to wave as the procession passes. Only the celebrants themselves give a macabre animation to the scene, a single file of dispirited-looking men, not a woman among them, trailing morosely down the centre of the street. They are wearing hats and fustian Sunday clothes, and have a determined set to their faces, as though it is only British grit that will see them through the funeral.

9

It was not a contented country. Canada was the most thoroughly emancipated of the British colonies, but it was riddled with ambiguities. It had just recovered with remarkable resilience from an economic recession, and now its trade was increasing faster than anyone else's: but it was a half-way country, a hybrid or compromise, neither this nor that. It was not a colony in the ordinary sense, nor a nation in the word's full meaning. It was British in one way, but not in another. It was vast, but it was empty: rich but excessively uncomfortable. The British Canadians were proud to share the glory of the British super-nation, but not anxious to share its responsibilities—'Why should we waste men and money in this wretched business?' demanded Macdonald, when invited to send

Canadian soldiers to the Sudan. 'Our men and money would be . . . sacrificed to get Gladstone and Co out of the hole they have plunged themselves into by their own imbecilities.' The French Canadians hardly felt themselves to be part of the Empire at all. 'With courage, with perseverance, with union, with effort, and above all with a constant devotion to our religion and our language,' wrote Faucher de Saint Maurice in 1890, 'the future must be ours. One day we shall be Catholic France in America.'

Most disturbingly of all, the Canadians, British or French, were not exactly Americans. The gold sovereign was legal tender in Canada, but so was the gold American ten dollar coin. The gigantic fact of the United States next door overshadowed Canada always, and made the Dominion feel, in this as in so much else, not quite the real thing. British Canada had come into being in reaction against the existence of the United States, and in 1897 it still lived by reflex—its attitudes, its purposes, its prosperity, even the way it talked and lived, decreed by the presence of the Americans so near and so very large. 'Repricocity'—free trade with the United States—was a dominant issue at every Canadian election, and it was only thirty years since the Irish rebels known as the Fenians had unsuccessfully invaded Canadian territory from across the American frontier, some thought with Washington's connivance. American money, skill and intellectual influence crossed the border more insistently each year, and in response the Anglo-Canadians became more stuffily Anglo, the French Canadians more darkly French. Canada was distracted by the United States—sometimes repelled, sometimes magnetically attracted, now up in arms at a frontier dispute, now talking fulsomely about blood-brethren and family resemblances. Lord Salisbury once compared Canada to a coquette, flirting sometimes with the Americans, sometimes with the British, and certainly neither Power could be altogether sure of Canadian reactions. This was an uncertain nation, often tart and nervous. 'We are part, and a great part, of . . . Greater Britain', the *New York Times* had announced, in a generous access of Jubilee emotion, but the *Ottawa Free Press* replied waspishly: 'Quite correct. Come right back into the fold. You will be welcome, though some of the bad elements you are afflicted with will not be very palatable.'

The nineteenth century was America's century, Laurier once said, the twentieth would be Canada's. The Canadians were proud of their achievements so far—the C.P.R., the settlement of the West, the great Welland Canal, the creation of a confederation at all in such unpromising circumstances: but behind their pride was a kind of loneliness. The oldest British settlements in Canada were those in Nova Scotia, along the bays and little gulfs of the lovely Atlantic shore. There the Empire Loyalists, trekking northwards from New England at the Revolution, had enriched the original settlements with loftier architecture and more spacious husbandry. There were few more attractive villages in the British Empire than Mahone Bay, say, down the coast from Halifax. It lay delectably around a creek, with three small churches, side by side, reflected in the harbour as on a souvenir tea-tray. Its houses were white clapboard, its green swards ran down to the water's edge, its colours, in the golden fall or the green spring, were water-colours, clean and pure off the sea.

Yet even to Mahone Bay and its peers of Nova Scotia there was a strain of melancholy. This was Maine without the Yankees, or perhaps Kent without the squires. There was an isolation to these Canadian shores, on the rim of a half-inhabited continent, that was only partly physical. Self-doubt contributed to it also, and nostalgia, and every sweep of the Atlantic tide, rolling up the Bay of Fundy, lapping the old wharfs of Digby or Bridgewater, only seemed to make the solitude more nagging, and the purpose of the Dominion cloudier:

> *News from nowhere—vague and haunting,*
> *As the white fog from the sea.*

In the emancipation of Queen Victoria's Canada we may detect some prophetic glimpses of the anxieties that occur, when great Empires disintegrate at last, and leave their distant children to evolve identities of their own.

CHAPTER TWENTY-ONE

On Guard

At this door
England stands sentry. God! to hear the shrill
Sweet treble of her fifes upon the breeze,
And at the summons of the rock gun's roar
To see her red coats marching from the hill!

W. S. Blunt

21

THE Pax Britannica was not a boastful fraud. Thanks largely to British power, since the Napoleonic Wars the Western world had enjoyed one of its more tranquil periods. There had been the Crimean War, the American Civil War, the Franco-Prussian War, but there had been no general international conflict, such as had inflamed the nations on and off for 300 years before. With half the key fortresses of the world in British hands, with the communications of the world at Britain's mercy, with a British naval tonnage greater than that of any likely combination of enemies, Queen Victoria really was the first arbiter of the world, and had imposed a British peace upon it.

It could scarcely be described, however, as a peaceful century for the British themselves. 'If we are to *maintain* our position as a *first-rate* Power,' wrote the Queen herself, with sundry underlinings and sudden capitals, 'we must, with our Indian Empire and large Colonies, be *Prepared* for *attacks* and *wars, somewhere* or *other*, CONTINU-ALLY.' She was right. The cost of Empire was an almost ceaseless running battle against reluctant subject peoples, so that a professional soldier in the 1890s could have spent almost all his working life on active service. There was no discharge from the wars. As A. E. Housman wrote, in the saddest of Jubilee poems:

> It dawns in Asia, tombstones show
> And Shropshire names are read;
> And the Nile spills his overflow
> Beside the Severn's dead.

The New Imperialists were not ashamed of this record. 'It is of course', observed the Jubilee issue of the *Daily Mail*, 'the prerogative of the sovereign to wage war . . . the Victorian era is destined to go down to history as emphatically the period of small wars.' The

paper listed as the Chief Campaigns of Victoria's reign China 1837, Afghanistan 1838, the Crimea 1854, China 1856, Persia 1856, the Indian Mutiny 1857, Abyssinia 1867, the Ashanti Wars 1874, the Zulu Wars 1878, the Boer War 1879, Afghanistan again in 1879, Egypt 1882, the Sudan 1896. There were in fact many more. There were the Maori Wars in New Zealand, protracted and bitterly fought. There were two rebellions in Canada. There were wars in Burma and Rhodesia, and many obscure skirmishes in the Niger Basin, and interminable snipings, ambushes and punitive expeditions along the North-West Frontier of India. The Empire had not all been acquired by force, but it took constant force to hold it.

In support of it all a new militarism was popular in Britain. Kipling had touched up the Army's shoddy image, and military similes and models were much in vogue. *Onward Christian Soldiers* was the hymn of the day. The Salvationists called their new movement an Army, and when they set up a mission in a new country were said to have 'occupied' the place. The boys were organized in Brigades, the Anglican Church was more than ever militant. Marches were all the rage, books about battle and bloodshed poured profitably off the presses, great full-throated anthems like soldiers' choruses were sung by armies of singers at mass concerts in the Albert Hall—'where 200 singers might suffice for art', commented the *Illustrated London News* of a Handel festival, 'twenty times 200 alone seems to reach the limits of our desires, when it comes to a question of homage from the great British nation'. The British were brassy with success. They seemed to win all their wars in the end, and they were acquiring an ear for trumpets. As Hilaire Belloc observed:

> *Whatever happens we have got*
> *The Maxim gun and they have not.*

2

The land forces of the Empire were drawn, in effect, half from Britain, half from India. The white colonies had their own small militias, commanded by officers from Britain, and there were two coloured colonial regiments—the West India Regiment, with a

battalion normally in West Africa, and the Hong Kong Regiment. There was, though, no Imperial Army, and as the self-governing colonies had no say in the formulation of policy, so they had no formal obligations of imperial defence. It fell upon the British themselves and their Indian vassals to guarantee the land frontiers of the Empire, and it was said that the British Army was the hardest worked in the world. The battalions at home, when they had supplied the needs of the overseas Empire, were, so Sir George Campbell wrote, 'like spent fish, emaciated and exhausted: or at best their ranks were filled with immature and untaught boy recruits'. They were all volunteers, and by the standards of the Continental Powers the British Army was comically small: but it was scattered across the world, in every sort of country, and the range of its experience was unequalled. It had not fought a European enemy since the Crimean War, unless you counted the Boers: but for every British soldier at home one was always abroad, and the Army's list of battle honours grew longer, more exotic and more obscure each year, until only the most dedicated old soldier could tell you where his regiment had achieved its lesser glories, or why.

About a third of the British Army was normally in India, where policy decreed that there should be one British soldier for every two sepoys. In 1897 there were some 212,000 men in the Regular Army, with 26,000 horses and 718 field guns. About 72,000 men were in India, 32,000 on colonial stations, the rest at home. Of the line infantry, fifty-two battalions were in India, twenty-three in Ireland, seven in Malta, six in South Africa, three at Gibraltar, three in Egypt, two at Mauritius, one each in Canada, the West Indies, Singapore, Bermuda, Ceylon and Hong Kong. There were Regular cavalry regiments in India, Ireland, South Africa and Egypt. There were military prisons in Barbados, Malta, Bermuda, Egypt, Gibraltar, Nova Scotia, Ceylon, South Africa and Ireland. There were Royal Engineers all over the Empire, building everything from slaughter-houses to cathedrals—in British Columbia they had laid out a mining town, New Westminster, complete with Victoria Gardens, Albert Crescent, and little squares named for royal princesses. As for individual officers of the British Army,

they might be almost anywhere, and the extra-regimental lists made curious reading. There were officers training local militia in Honduras. There were 108 officers with Kitchener in the Egyptian Army. One officer was physician to the Crown Prince of Siam, one was director of Persian Telegraphs, and one ran the Egyptian Slavery Department.

Everywhere the Army's garrison buildings were descended from a common Indian pattern—even in Britain, where several particularly draughty barracks and military hospitals were reputedly designed for tropical stations, and erected in error at home. With their red-brick walls, their verandas, their big square windows, their long low silhouettes and their officers' villas tucked fastidiously away among the trees, they were an inescapable part of the imperial landscape. Halifax, Nova Scotia, was a good example of a garrison town—still manned by British forces in those days, and very much a military society. Army headquarters was in the Citadel, a splendid fortress on a hill, surveying the sweep of the harbour below, and supplied with an elegant clock tower by Queen Victoria's father. Up there the noon gun was fired with a puff of white smoke above the ramparts, and the Last Post sounded with exquisite melancholy every night. The garrison church of St Paul's, a graceful frame building of pine and oak, was rich in regimental ensigns and military memorials, and on the Grand Parade outside its doors the garrison marched swankily about on ceremonial occasions, its drums and trumpets echoing among the old grey houses of the port. The Army had its cemetery and its military hospital, its favourite taverns and its familiar social courses, charted by generations of young officers through the drawing-rooms of the town. When a battalion went home, half Halifax went down to the quayside to see it off on the troopship, the soldiers filing up one gangway, their families up the other, while the bands played dear old sentimental tunes upon the quayside, *Will Ye No Come Back Again*, or *The Girl I Left Behind Me*. The soldiers flirted in the public gardens. The officers played polo, sailed their yachts in the harbour, and sometimes went to cockfights, abetted by local Irishmen with fingers along the sides of their noses.

This was the British military life as it might be lived, with

regional variations, in Singapore or Malta, Bengal or the Cape of
Good Hope: and the Garrison Library at Halifax, housed in a cosy
red-brick building in the Artillery Lines, had inherited the books
from the Garrison Library at Corfu, one of the very few military
stations the British had ever voluntarily abandoned.[1]

3

The Army List of 1897 records only nine British military attachés in
foreign countries. As an imperial police force it was efficient enough,
but neither by temperament nor by training was it fitted for *la
grande guerre*. Twenty years had passed since Edward Cardwell
had undertaken the last thorough reform of the Army, and by now
it was not only complacent, after so long a run of easy victories, but
also sadly out of date. In the age of the machine-gun it had just
emerged from the era of red coats and purchased commissions. It
had only recently abolished the numerical Regiments of Foot, such
as Wellington had commanded—the War Office was still holding
1s 4d, the estate of James Wells of the 57th Foot—and the social
structure of the Army had hardly changed at all. Its different
branches were highly stylized, like so many clubs, or theatre com-
panies. Officers of the Royal Engineers, it was said, were all 'mad,
married or Methodist'. Officers of the Guards regiments were excru-
ciatingly fashionable. The smarter cavalry and infantry regiments
were still almost family concerns, so instinctively did son follow
father, and their lists of mess members often read like extracts from
some parody of a social register. The King's Royal Rifle Corps
had on its books in 1897 officers by the name of Buchanan-Rid-
dell, Montagu-Stuart-Wortley, Milborne-Swinnerton-Pilkington,
Blundell-Hollinshead-Blundell, Douglas-Pennant, Soltau-Symons,
Pearce-Serocold, Sackville-West, Herbert-Stepney, Culme-Seymour,

[1] The British Army left Halifax in 1906, after 157 years, but its shades
remain. The Citadel, now a museum, retains traces of the old spit and polish,
many of the barracks buildings survive, and in the Cambridge Library may
still be seen the books from the Ionian Islands, with the Corfu garrison stamp
on them. Mr Thomas Randall, whose book on Halifax led me to them,
suggests that they may have been used by the young Lafcadio Hearne, whose
father was a surgeon with the British Army in Corfu.

Duckett-Steuart, Cooke-Collis, Brasier-Creagh, Thistlethwayte, Prendergast and Featherstonhaugh.

The exquisite sensibilities of the officer class had long been a joke among the ruder kind of imperialist. The cavalry regiment which went to Rhodesia to fight the Matabele was very welcome at the Administrator's balls, but raised some horse-laughs in Pioneer Street, and Kipling records a soldier's disrespectful nicknames for his own company commander—Collar and Cuffs, Squeaky Jim, Ho de Kolone. When the cavalry regiments raised a Heavy Camel Regiment to go up the Nile with Wolseley in 1884 they wore red serge jerseys, ochre cord breeches and blue puttees, and groomed their camels like horses: among the officers to be seen ineptly tangled in their bridlery were Captain Lord St Vincent, Captain Lord Cochrane, Lieutenant Lord Rodney, Lieutenant Lord Binning and Lieutenant Count Gleichen (who wrote a book about it, and grew rather fond of his camel Potiphar). A private income was essential for officers such as these, and nobody would have dreamt of joining the Guards without one. 'Good God,' one subaltern is supposed to have said, when told the War Office had deposited £100 in his bank account, 'I didn't know we were *paid*!'

And if the best regiments were officered entirely by the upper classes, the other ranks of the British Army were still all too often the scum. In many a respectable English home, bowered country cottage or scrubbed tenement of Nonconformists, to admit a son in the Army was like confessing a misdemeanour. The Army was where the bad lots and the Irish went, and soldiering as a trade, however glorious it was as a national principle, remained disreputable. It was an old barracks refrain that the hero of wartime became the outcast of the peace, and on an old stone sentry box at Prince Edward's Gate, Gibraltar, some embittered sentry had long before inscribed the lines:

> God and the Soldier all men adore,
> In time of trouble and no more,
> For when war is over
> And all things righted,
> God is neglected,
> And the Old Soldier slighted.

4

This was not a promising formula for modern war: an officer corps recruited from the moneyed gentry, a rank and file recruited from those who could get no other jobs. There was no General Staff, and the strategic ideas of British generals were generally based either upon the campaigns of the Crimea—themselves fought to Wellingtonian texts—or upon the experience of colonial wars against impotent enemies. 'Field Officers entering captive balloons', said a Queen's Regulation of the day, 'are not required to wear spurs.' There was an active prejudice against cleverness in Army officers, against theorists, even against new ideas. Until 1895 the Duke of Cambridge had been Commander-in-Chief, and it was he who once remarked to an eminent British general: 'Brains! I don't believe in brains. *You* haven't any, I know, sir!'

The British Army was the only large volunteer force in Europe, and among Continental observers it was generally dismissed as negligible, for all its social glitter and immense regimental spirit. In 1882, for the Egyptian campaign, it had taken the British a month to mobilize a single Army Corps, and then only by summoning horses from cavalry and artillery units elsewhere: in 1870 the Germans had put fifteen Army Corps into action in two weeks, with three times as many horses as they needed. The British had been forced to draw upon reserves for Kitchener's campaign in the Sudan, and it was said that in a general mobilization the British Army could put a force into the field rather smaller than Switzerland's. Britain had no allies, and if it ever came to a sudden land war against a European enemy would appear to be doomed. 'It appears', wrote General J. F. Maurice, sadly, after fighting against Zulus, Ashantis and Arabi's Egyptians, 'that despite the historic past of the British Army on the Continent, the general impression among foreign officers [is] that literally we have no army at all.' All the splendour of the Army's tradition, the ancient uniforms of lancer and dragoon, the breastplated Horse Guards, the kilts and sporrans of the Highlanders, the tabs, or special buttons, or marching pace, or mascot, cherished by each regiment as a token of its special worth—all this meant little, set against the military machines of Russia or Germany. The British

Army, though unquestionably splendid, was small, scattered and cumbersome.

5

But also at the Queen's command stood another Army, of different reputation. The Indian Army was not often accused of amateurism. Like most things the British organized in India, it was nothing if not well ordered, and distance heightened the enchantment of it all. Ballad, legend and travelogue had made it seem a paragon of armies, at once spare and romantic, an ideal army of fraternal interracial loyalties, where every man knew his place, and would willingly die for the honour of the regiment. India was certainly a very military country; 40 generals were stationed there. Bryce thought the whole place had 'an atmosphere of gunpowder'—it was a military society, he said, and the English were in India primarily as soldiers. 'India has been won by the sword,' the Governor-General Lord Ellenborough had said in the days of the Company, 'and must be kept by the sword.' In every Indian town the military presence showed, in the smart new cantonments of the north-west, all whitewashed pebbles and orderly-room fire buckets, or old forts of the seacoast like Fort William in Calcutta, its grey peeling gateways and redoubts peering through the banyan trees, with moats and towers and flagstaffs everywhere, and goats cropping the grass-covered outerworks.

In many ways the Indian Army was the antithesis of the British. Its officers, all British, were mostly men of the upper middle classes, without private means, to whom soldiering was a job. When Churchill was sniffing at the bourgeois provincialism of the Anglo-Indians, the Indian Army officers at Bangalore were probably sneering at the fancy pretensions of his own regiment, the 4th Hussars. There were very few patricians in the Indian Army: socially much the grandest soldiers in India were the princely officers of the Imperial Service Corps. The other ranks, on the other hand, nearly all Indian, formed an *élite* of their own. They were all volunteers, but they mostly came from martial peoples to whom soldiering was the most honourable of callings—Muslims and Sikhs, Rajputs, Dogras, Mahrattas, and ferocious Gurkhas from the vassal-kingdom of Nepal. These splendid men were easily indoctrinated

into the British system of regimental soldiering, with its fierce small loyalties and its paternal unity. The Indian Army had begun life as the private army of the East India Company, and it really formed three separate armies, each self-contained—last relics of the forces run in the old days by the Presidencies of Bengal, Madras and Bombay. It was essentially a territorial force, recruited tribe by tribe or race by race, and in the Indian Army list its units were listed ethnologically. The 6th Bombay Cavalry, for instance, whose officers wore dark green with primrose facings, gold lace, dark blue and white puggrees, red kullahs and primrose throat plumes—the 5th Bombay Cavalry (Jacob's Horse), stationed then at Fort Sandeman in the Punjab, had a squadron of Jat Sikhs, a squadron of Pathans, and two squadrons of mixed Derajat Muslims and Baluchis. Such regiments had begun as volunteer companies of yeomen, whose Indian troopers provided their services, with horse and equipment, in return for a small wage and the prospect of loot. By 1897 a trooper's monthly pay was still only about £2, and out of it he still paid for his own horse and gear, rifle and ammunition apart. Much of the regimental business was still conducted in durbar—a general assembly of all ranks, presided over by the colonel: the regiment thought of itself as a family concern, in the horse trade.

The Indian Army was absolutely at the disposal of the British Government—more absolutely, in a way, than the British Army itself. It was free, in that India paid for it, so that its size and equipment was not subject to the vagaries of a vote at Westminster. It had enormous reserves: there were at least 350,000 men in the armies of the Native States alone, all of which could at a pinch be summoned to the imperial service, and the northern provinces of India offered almost inexhaustible recruiting grounds. You could do things with Indian troops that you could not do with British: Indian soldiers were not subject to the Mutiny Act, and there was no Indian Parliament to raise awkward questions about welfare, rates of pay or family accommodation. The Indian Army was like a Praetorian Guard of Empire, set apart from the public control, and available always for the protection of the inner State.

It was probably not quite so formidable as it seemed. Its quality was patchy. Not all the regiments of the south, with their mixed

companies of Muslims, Tamils and Telingas, would have struck much chill into the Cossack heart. The legendary Indian cavalry regiments, in all their shimmer of plume and puggree, were often better at show and pigsticking than at slogging away on manoeuvres. Moreover the Indian Army was Indian. Devoted though its soldiers nearly always became to its traditions, and loyal though they had proved themselves since the Mutiny, still the British could not quite afford to trust it. They had not forgotten Lucknow and Cawnpore. Roberts, when he was Commander-in-Chief of the Indian Army, used to reckon that if ever he led it to war against a foreign Power only half its troops could be considered absolutely reliable. The British allowed the Indian Army no artillery, no arsenal, and no Indian commissioned officers. Every Indian brigade contained its British Army battalion, to stiffen the whole and keep an eye on the sepoys. Indian soldiers were not eligible for the Victoria Cross—they had their own equivalent, the Indian Order of Merit—and never far from any Indian Army barracks was a British Army garrison. British units in India always carried rifles and ammunition on church parade, in case another mutiny broke out during Matins.

Britain's enemies naturally had high hopes of sepoy disaffection, but to the British public at home, nurtured on self-congratulatory soldiers' memoirs, or panoramas of martial grandeur in the pages of the *Graphic*, the Indian Army must have presented a blazing image of force and exotic experience. It was always in the news. In the very week of Jubilee four regiments of Sikhs and Punjabis were marching into the Tochi valley, wherever that was, to avenge the death of Mr Gee, Political Officer, murdered on his way to collect a fine imposed upon some dissident tribesmen. If there was one kind of adventure that appealed to the late Victorian British, it was the adventure of the North-West Frontier. The terrain was fierce. The immediate enemy was hospitable, soldierly and cruel. The names of the fields of skirmish rang splendidly: Swat and Malakaland, Citral and Tirah, through whose passes the Orakzais, the Wazirs, the Afridis and the Mohmands flitted like menacing shadows, and upon whose crests men like Yeatman-Biggs, Lockhart, Blood and Maclean stood watchful in their topees, shading their

eyes against the setting sun. It had all the elements of folk-myth, and the British loved it: loved it in the idea, idealistically portrayed in Drawings by Our Special Artist; loved it in the reality, for there was excellent sport to be had out there, by a young man of spirit and no ties.

It was there, too, best of all, that the British Empire could be seen on guard. Fifty miles behind the Khyber flowed the Indus River, one of the grand facts of the Empire, and at the place where the Grand Trunk Road crossed it there stood the garrison town of Attock. Here Alexander had crossed the Indus, on his way to conquer India, and here the Emperor Akhbar had built a great fort of polished pink stone. At Attock the British had thrown a double-decker iron bridge across the Indus, a lumpish powerful structure, railway above, road below, with iron gates at each end to be closed at night with chains and huge bolts, and watchful sentries with fixed bayonets. Across it their armies moved, year after year, on their way to the forts, cantonments and entrenchments of the tribal country and the Afghan frontier. On the lower deck the infantry swung by, the commissariat carts, the cavalry with their lances and fluttering pennants: on the upper deck the troop trains clanked their way towards Peshawar, barehead soldiers lolling at their windows, or singing bawdy songs inside. There were block towers, gun emplacements, watchtowers along the ridge, and often the roads over the escarpment were cloudy with the dust of marching platoons. Trumpets blew at Attock, officers trotted up the hill to the artillery mess in the fort, the flag flew above the ramparts, and all the way along the Peshawar road were carved regimental crests, the dates of old campaigns, or simply the initials of British soldiers, scratched on a stone as the battalion rested on the march.

High above it all, blocking the northern horizon, were the white crests of the Hindu Kush, the last frontier of the Empire, separating this familiar world of pageantry and requisition order from whatever barbaric mysteries lay beyond.

6

It was in India that the martial heroism of Empire had found its

most sacred apotheosis. The battles of the Indian Mutiny were fought almost entirely in Hindustan and the Central Provinces, so that people in the south of India, for example, scarcely knew the war was happening: but it had profoundly impressed the imaginations of the British. We have seen how it affected their racial attitudes. More extraordinary was the epic allure which still lingered about its legend, forty years later. 'We are indebted to India', wrote Sir Charles Crosthwaite,[1] 'for the great Mutiny, which has well been called the Epic of the Race.' It was also called 'our Iliad', and seen in awed retrospect the British heroes of the Mutiny did seem champions in a classical kind, clean-limbed and generous. In India their graves were lovingly tended, and their sometimes self-composed epitaphs were still freely quoted to impressionable adolescents— 'Here Lies Henry Lawrence, Who Tried to Do His Duty', 'Here Lies All That Could Die of William Stephen Raikes Hodson', or the great manly inscription beneath which John Lawrence, General, aged 35, lay in the dusty cemetery beyond the walls of Delhi. Memorials to the British dead of the Mutiny, and their loyal Indian subjects, stood all over central India, some grandiose, like the tall Gothic spire on the ridge above Delhi, some movingly unobtrusive, flaked obelisks beside the highway, or faithfully polished brasses in the aisles of garrison churches. Of the ten pages *Murray's Handbook* gave to the city of Delhi, for nearly a thousand years one of the great capitals of Asia, five were devoted to the events of the Mutiny ('. . . the enemy poured upon them a shower of shot and shell . . . the siege guns, drawn by elephants, with an immense number of ammunition waggons, appeared on the Ridge . . . his lofty stature rendered him conspicuous, and in a moment he was shot through the body, and in spite of his remonstrances was carried to the rear to die. . . .').[2]

[1] Who was among the first to enter the I.C.S. after the Mutiny, going on to be Lieutenant-Governor of the North-West Frontier Province before his death in 1915. How vivid the scenes of the Mutiny must have seemed to him, when he arrived in India, aged 22, in August 1857, and how astonishing that they seem to have inspired in him feelings of *gratitude*!

[2] The proportion was successively reduced, as the book was revised, until by the eighteenth edition (1959) the Mutiny got less than half a page, its events being of interest, as a footnote says, 'mainly to those of British birth'.

The great shrine of the epic, and perhaps the supreme temple of British imperialism, was the ruined Residency at Lucknow, in which a small garrison, with its women and children, had held out in appalling conditions against an overwhelming force of mutinous sepoys. The story of the siege and relief of Lucknow was familiar to every Victorian schoolboy, and had been immortalized by Tennyson in a stirring balad:

> *Banner of England, not for a season, O banner of Britain, hast thou*
> *Floated in conquering battle or flapt to the battle-cry!*
> *Never with mightier glory than when we had rear'd thee on high*
> *Flying at top of the roofs in the ghastly siege of Lucknow—*
> *Shot thro' the staff or the halyard, but ever we raised thee anew,*
> *And ever upon the topmost roof our banner of England blew.*

Everybody knew those lines, and the scene of the great siege became a place of pilgrimage. From Hill's Imperial Hotel, the Civil and Military Hotel, the Royal or the Prince of Wales's, the visitors in their hundreds were taken down the road by tonga to the old Residency compound: and there they found the battlefield preserved just as it was when Henry Havelock's Highlanders fought their way in at last to relieve the garrison—

> *Saved by the valour of Havelock, saved by the blessing of Heaven!*
> *'Hold it for fifteen days!' We have held it for eighty-seven!*

There were sweet English flowers everywhere (phlox, sweet peas, antirrhinums), but the buildings had been left in their shattered ruins, and the visiting parties, holding their long skirts above the dust, and shaded by pink parasols, could walk from one scene of heroism to the next—imagine the murderous line of fire from beyond the Baillie Gate, see just where Captain Fulton set up his eighteen-pounders at the Redan, thrill to the memory of Lieutenant Macabe, sallying out beyond Sago's garrison to spike two enemy guns, or shudder in the cellar where the women and children had huddled through nearly three months of bombardment—

> *Heat like the mouth of a hell, or a deluge of cataract skies,*
> *Stench of old offal decaying, and infinite torment of flies,*
> *Thoughts of the breezes of May blowing over an English field,*
> *Cholera, scurvy, and fever, the wound that would not be heal'd . . .*

On the highest point of the compound stood the Residency itself, half-destroyed but still imposing, with the remains of a tower and an air of proud authority—fine and fearless in the sunshine, rubble all around. A few guns still stood sentinel over the lawn: and night and day down the years, as it had throughout the siege, from the broken battlements of the Queen's House the banner of England flew.[1]

7

No other imperial war had left memories so hallowed, and sometimes the British public scarcely noticed that some hard-fought campaign was being fought at all—so remote were the battlefields, so uncertain was the average Englishman's command of imperial geography, and so common an occurrence was what the Army called a 'subaltern's war'. Dimly out of the past, though, they might see the victors of Empire parading: Roberts riding through Afghanistan, in an astrakhan hat on Vonolel; Wolseley and his soldiers paddling canoes up the Red River to put down Riel's rebellion in the Canadian West; Napier with his scholars and elephants labouring along the mountain tracks of Ethiopia; 12,000 British soldiers dashing up the Irrawaddy in flotillas of river boats; the White Rajah at the head of his private army, helter-skelter in pursuit of Dyaks; the eighty undefeated stalwarts of Rorke's Drift, who earned ten Victoria Crosses in a single night.

Possibly they also remembered Gordon's forlorn bugle-signals to his outposts across the river—'Come to us, Come to us'; or Dr Jameson and his policemen, humiliated on the veldt at Krugersdorp; or the Boer War of 1881, the only British war against white men since the Crimea, when General Colley's troops were driven panic-stricken from Majuba Hill; or Colonel William Hicks and his 10,000 Egyptian soldiers, obliterated by the Mahdi in 1883; or the terrible first war against the Afghans, in 1838, when the solitary Dr Brydon, the only man to escape the slaughter of the British in Kabul, rode exhausted into Jellalabad upon his pony.

[1] It flew until August 15, 1947, when British rule came to an end in India: but the Residency ruins are still preserved as a museum, and its Indian curators have left everything as it was, down to the phlox and the sweet peas.

But for most people, one supposes, all these triumphs and reverses were confused in the historical memory, stirred up with flags and patriotic colours, and blended into a general impression of glory.[1]

8

Between them the two armies of the British Empire could muster, in peacetime, perhaps 400,000 men (the Roman Empire at the time of Trajan was said to have had armies of 300,000 men). It was a small force for its duties, and fortunately it had never been tested in open war. This was not because the British disregarded war as an instrument of policy. They had cool nerves, and in fact they repeatedly gambled with the possibility of a great war, and juggled dexterously with *casus belli* in the pursuit of their imperial ends. Salisbury was generally conciliatory towards the Germans, wary of the Russians, smoothly diplomatic to the French, but there were times when war against any of them seemed quite likely. It was only against the Americans that the British were, at root, unwilling to contemplate war at all, fiercely though the two nations sometimes confronted one another. Whenever it came to the point, in a conflict with Washington, the British gracefully withdrew, for it was already becoming apparent to them that one day the survival of the Empire might depend upon a special relationship with the United States: besides, one potent strain of the New Imperialism was the idea of Anglo-Saxon supremacy—a joint destiny, as Rhodes hazily conceived it, towards the mastery of the earth.

Generally the British peacefully won their case, and that string of imperial campaigns bore little resemblance to the kind of wars Great Powers conceived for diplomatic purposes. Colonial wars

[1] One stumbles across some unexpected monuments of these forgotten conflicts. A touching British military cemetery survives in Kabul, with graves from three Afghan wars—also a solitary British gun, high and toppled on a ridge above the city. There used to be a memorial to the men of the Jameson Raid, at the place where they briefly fought and surrendered; but I could find no sign of it in 1966—only the bare and bitter veldt, its horizons punctuated by monuments no less relevant: the pyramidical dumps of the gold-mines, and the endless little white houses, mile after mile in the distance, of the black locations.

demanded special techniques—the War Office published a book called *Small Wars: Their Principles and Practice*—and the swift transfer of troops and supplies from continent to continent became a speciality of British military men. They may not have frightened the Germans and Russians much, but they were adept at semi-irregular warfare in difficult country, and at confronting adverse primitive odds with disciplined calm—holding their fire, keeping their nerve, against the frenzies of painted *impis* or subtle Afridi sniping. Many British troopers with experience of war in India and in South Africa joined the United States Army for service in the Indian wars. The Americans indeed assiduously studied British methods of colonial war, and at one time considered forming irregular regiments of friendly Sioux, as the British enlisted the warrior peoples of India. For the British armies fought their little wars with a calculated ferocity inconceivable to most patriots at home. During the Afghan frontier campaigns of 1897 no holds were barred: all prisoners were killed (on both sides), many villages were burnt to the ground, nobody who resisted the Raj could expect mercy. 'There is no doubt that we are a very cruel people', Churchill wrote home from the frontier.

The Roman Empire was never at peace, from the beginning of its history to the rule of Augustus, and as Victoria foresaw, war became part of the everyday British experience, too; war of a small and distant kind, it is true, but none the less real for that—none the less noble for those who saw it as an instrument of greater ends, none the less exhilarating for those who loved the smell of the gunsmoke, nor the less tragic for those, friend or foe, who had not yet learnt to ask the reason why.

> *Here dead lie we because we did not choose*
> *To live and shame the land from which we sprung.*
> *Life, to be sure, is nothing much to lose.*
> *But young men think it is, and we were young.*

CHAPTER TWENTY-TWO

At Sea

Drake he's in his hammock till the great Armadas come,
 (Capten, art tha sleepin' there below?)
Slung atween the round shot, listenin' for the drum,
 An' dreamin' arl the time o' Plymouth Hoe.
Call him on the deep sea, call him up the Sound,
 Call him when ye sail to meet the foe;
Where the old trade's plyin' an' the old flag vlyin'
 They shall find him ware an' wakin', as they found him long ago!

Henry Newbolt

22

TO every right-thinking Englishman the Army was only a
second shield. The Pax was primarily a peace of the sea, and
the little land wars of the Empire were only picturesque asides. As
Lord St Vincent had observed, long before his descendant had taken
to riding camels up the Nile, 'I only say they cannot come by sea.'
The Royal Navy was the very heart and pride of the Empire. Upon
it, as everybody knew, the security of the realm rested, and around
it there flew, like a cloud of reassuring signals, an accretion of
legends and victorious memories, mellowed by age, gunsmoke,
rum and saltspray. In the nineties the Nelson touch was more
than just a romatic tradition: it was, at least in theory, a profes-
sional outlook.

The Navy had never seemed more magnificent than it did in
1897. Its 92,000 sailors manned a fleet of 330 ships, with 53 modern
ironclads, 80 cruisers, 96 destroyers and torpedo boats, splendidly
dubbed with the names that Kipling loved—*Cyclops* and *Hecate*,
Badger, *Bouncer* and *Bustard*, *Pickle* and *Snap*, *Rattlesnake*, *Ajax*,
Colossus, *Basilisk* and *Cockatrice*, *Jupiter*, *Hannibal* and *Mars*, *Thunderer*
and *Devastation*, the torpedo gunboats *Boomerang* and *Gossamer*, the
destroyers *Dasher*, *Lynx*, *Wizard* and *Boxer*. This was beyond cavil
the supreme Navy of the world. *Jane's* that year reported that the
French Navy was numerically its nearest rival, with 95 ships, fol-
lowed by Russia (86), Germany (68), the United States (56) and
Italy (53). The fleets of lesser Powers candidly copied the uniforms,
the style, and the equipment of the Royal Navy—thirteen foreign
navies used British guns. At home its name was almost as sacred as
the Crown itself, and just as popular. Sailor costume was the fashion-
able dress for boys and girls alike, with the name of the latest British
battleship proudly on the cap-ribbon, and it was with something
approaching reverence that the *Daily Mail*'s reporter watched the

naval contingent swinging up Ludgate Hill on Jubilee day—they marched, he said, with 'the steadfast calm of men who have been left alone with God's wonders at sea'. Naval questions could be guaranteed to spark heated debates at Westminster, and the progress of the Navy, its construction plans, its relative size, was followed with a kind of sporting interest by the public—every year the Government published a White Paper listing the naval strengths of all the Powers, like a form book. Everybody knew about the Two-Power Standard, the practice of maintaining the fleet on a scale 'at least equal to the naval strength of any other two countries', which had been official policy since 1889. 'There are two factors in the celebrations', *The Times* wrote of the Jubilee, 'which transcend all others in their significance as symbols of the Imperial unity. One is the revered personality of the *Queen*, the other the superb condition of *Her Majesty's Fleet*.' The true bond of Empire, the paper said, was naval supremacy: without a dominant Navy the Empire would be 'merely a loose aggregate of States which derive some commercial advantage from each other'.

So the Jubilee review of the fleet at Spithead was really the most significant function of the whole celebration. It was arranged as a spectacular propaganda display, demonstrating to the Powers the Navy's ability to assemble vast numbers of modern ships at any one place at any one time. It was claimed to be the largest assembly of warships ever gathered at one anchorage—173 ships, including more than fifty battleships, in lines seven miles long—and most of them had been designed, laid down and completed within the past eight years: yet no ships, it was repeatedly emphasized, had been withdrawn from foreign stations for the review. The Admiralty presented this lesson with style, and down the long lines of anchored warships the visiting grandees sailed in an elegant little convoy of inspecting vessels. The Prince of Wales led the way, in the royal yacht *Victoria and Albert*—a paddle-steamer, with two gracefully slanting funnels and a gold-enscrolled prow. The yacht *Enchantress* followed, carrying the Lords of Admiralty, the *Wildfire* with the colonial Premiers, the *Eldorado* full of foreign Ambassadors, the *Danube* loaded deep with the House of Lords, and finally the mighty *Campania*, largest and fastest of Cunarders, carrying both the House

of Commons and the gentlemen of the Press—provision having been made on board, so *The Times* correspondent elaborately reported, 'for those comforts which the enervating influences of civilization and the internal economy of the human frame have taught us to desire'.

The fleet itself, supplemented by a respectful line of foreign warships, was dressed overall, and looked superb. It was that ornate period of naval architecture in which the influence of sail was still apparent in the design of warships, and the battleships of the Royal Navy were not yet painted in grey, but flaunted a rich combination of black and yellow. Rank upon rank they lay there, with funnels side by side or huge yellow airvents, catwalks at the stern, canopied look-outs on spindly masts, their hulls complicated with the booms of torpedo nets, their boats swung out on high davits—decks scrubbed to the raw grain of the wood, brasswork polished thin, the wheelhouse glass miraculously crystal, the sailors impeccably paraded at the rail and at the stern, high on a perpendicular staff, the huge White Ensign gracefully fluttering. There was nothing like a British battleship, for a show of pride, pomp and seamanlike skill. Multiplied by fifty on a single afternoon, the effect must have been dazzling: and as the royal yacht led its companions down the line, suddenly there shot out of nowhere, in a mad dash of Nelsonic impertinence, the fastest vessel in the world, Charles Parsons's *Turbinia*, 2,000 horsepower driving nine screws, demonstrating with dramatic and altogether unofficial effrontery the superiority of British marine engineers. 'Her speed was', reported *The Times* man, a little unsteadily by now, 'simply astonishing, but its manifestation was accompanied by a mighty rushing sound and by a stream of flame from her funnel at least as long as the funnel itself.'[1]

[1] Parsons (1854–1931) was the son of the Earl of Rosse, whose telescope at Birr Castle in Ireland was the largest in the world. The *Turbinia*, with a speed of 34 knots, was his first ship, and the effect of this unscheduled publicity display was immediate. The Navy ordered two turbine-driven destroyers, and by 1905 Cunard used turbines to power the 30,000-ton *Carmania*. Parsons became the owner of Grubb, Parsons, the optical firm, makers in 1967 of the 98-inch Isaac Newton telescope for the Royal Observatory. He took out 300 patents in all, and only failed, it is said, in trying to make artificial diamonds.

2

The Royal Navy did not lack self-esteem. It loved to show off its brilliance and its seamanship. There was nothing on the seas to equal the panache of a British warship, when she sailed into a foreign port all flags and fresh paint, the Marine band playing on the forecastle and the captain indescribably grand upon his bridge. This was a genial sort of conceit. The officers of the Navy did not think much about war and its horrors. 'We looked on the Navy more as a World Police Force than as a warlike institution', wrote one officer in retrospect. 'We considered that our job was to safeguard law and order throughout the world—safeguard civilization, put out fires onshore, and act as guide, philosopher and friend to the merchant ships of all nations.' The Navy's discipline was strict, but there was to its spirit much of the breezy *bonhomie* of sail. Its sailors were recognizably the Jolly Jack Tars of the wooden walls, trained in all-round seamanship like sailing-ship men; padding around the decks in bare feet, moving generally at the run, often bearded and bronzed through service on tropical stations. Its executive officers were frequently men of private means—these were still the days of 'half-pay', on which an officer might be placed without notice at the end of a ship's commission—and prided themselves on their self-reliance. Nothing in Nelson's life appealed more to the British than his loyal disregard of orders, and in the 1890s the Royal Navy was rich in highly individual commanders. Algernon Charles Fiesché Heneage, 'Pompo' to the Navy, habitually carried a stock of twenty dozen *piqué* shirts in his ship, was alleged to break two eggs every morning to dress his hair, and took off his uniform coat when he said his prayers, because for a uniformed British officer to fall on his knees would be unthinkable. 'Prothero the Bad', Reginald Charles Prothero, was one of the most alarming persons ever to command a warship, with a black beard down to his waist, flaming eyes, huge shoulders, an enormous hook nose and a habit of addressing everyone as 'boy', even sometimes his eminent superiors. Arthur Wilson, 'Old 'Ard 'Art', when he commanded the Channel Squadron, used to ride out of Portsmouth Dockyard on a rattly old

bicycle, gravely saluted by the sentries, and on June 6, 1884, laconically entered in his diary: 'Docked ship. Received the V.C.' Gerard Noel, greeted with a cheery good morning on the bridge of his ship in the small hours, turned with a snarl and replied: 'This is no time for frivolous compliments.' Robert Arbuthnot was so absolute a martinet that when, soon after he had handed over a ship to his successor, a seagull defecated with a plop upon the quarter-deck, the Chief Bosun's Mate remarked without a smile: 'That could never 'ave 'appened in Sir Robert's day.' 'Tell these ugly bastards,' William Packenham instructed his Turkish interpreter, when sent ashore to quell a rising in Asia Minor, and surrounded on all sides by angry brigands, 'tell these ugly bastards that I am not going to tolerate any more of their bestial habits': when an elderly lady at a civic luncheon asked him if he was married, he replied courteously: 'No, madam, no. I keep a loose woman in Edinburgh.'[1]

3

These were the extravagances of a lost age, and the Navy still lived half in its glorious past. Earlier in the century it had probably been the most complex and advanced organization in Britain, but technology had overtaken it. It had no war plans, because for fifty years there had been no serious challenge to its supremacy. Its officers had little tactical or strategic training, but relied largely on seamanship and the Nelson touch, or on a rigid acceptance of inherited methods. Bold they might be in their private lives, but their professional drive was blunted by protocol and tradition. For all their fun and charm they were often fearfully ignorant of the world, and interested only in their beloved Navy: in those days naval officers began their careers at 12 or 13, when they joined the training ship *Britannia*, and spent their whole life insulated within the service. The ships of the Royal Navy were scattered across the world in

[1] All these remarkable officers had successful careers. 'Pompo' (1834–1915) became an Admiral, and a well-known opponent of Fisher's reforms; Noel (1845–1918) an Admiral of the Fleet; Wilson (1842–1921) Admiral of the Fleet and First Sea Lord; Packenham (1861–1933) an Admiral and Bath King of Arms. Arbuthnot (1864–1916) became a Rear-Admiral, but died in command of a cruiser squadron at the Battle of Jutland.

ones and twos, a battleship here, an armoured cruiser there, with squadrons in the East Indies, the West Indies, the Pacific, the south Atlantic, with cruisers in Australian waters and battleships off China—a habit of dispersion inherited from the days of sail, when it took at least three months to sail to India. Sometimes ships went off on goodwill cruises for months at a time, with no prearranged course or instructions—'Well, boys,' the captain would say to his wardroom in the morning, 'where shall we go today?'

In *materiel*, too, the Royal Navy was deficient in some important respects—notably guns. An Admiral's annual report on his squadron made no mention of gunnery, and this was almost the last Navy in the world to be equipped with muzzle-loading guns.[1] Until the apparition of the *Turbinia* at Spithead, the Admiralty had persistently ignored Charles Parsons's revolutionary inventions, and many of the Navy's ships on distant stations were obsolete, 'too weak to fight, too slow to run away'. It was true that numerically the Navy was overwhelming, but each ship's company, or at least each squadron, tended to think of itself as a self-contained unit, trained to perfection in its own chosen specialities, but with no conception of how to combine in a fleet action, and only the haziest idea of what to do if war broke out. The Admiralty thought more in terms of land than of sea—of particular stations, rather than the grand whole of the oceans, with the result that the Navy had forfeited its mobility, and was tied to fuelling bases, repair yards or traditional trouble-spots. Appearances counted most of all. The success of a commander was judged chiefly by the appearance of his ship, how white its paintwork, how burnished its brass, how smart its time-honoured drills. Swords were worn at sea, and officers sometimes spent their own money on extra brasswork or paint for their ships. On the battleship *Duke of Edinburgh* in the late eighties the nuts of all the bolts on the aft deck were gilded, the magazine keys were electro-plated, and statues of Mercury embellished the revolver racks. The guns were fired as seldom as possible, because the blast blistered the paintwork (ammunition was occasionally thrown overboard, to save shooting it off).

[1] By 1900 the Italian Navy was the only other: it then had four muzzle-loaders on its ships, but the Royal Navy still had 300.

4

The social structure of the Navy, though not so archaic as the Army's, was still based upon privilege. The executive branch of the service was very smart, and in 1897 its officers included two princes, two dukes, a viscount, a count, an earl, four lords by courtesy, eight baronets and thirty-five honourables. There were twelve titled captains (though they also included Captain John Locke Marx), and they lived very much like gentlemen. To get good stewards they often chipped in out of their own pocket, sometimes doubling a man's official pay, if they thought he could add suavity to the hospitality. A senior officer's servants became in effect his personal retainers: a captain's coxswain would move with him from ship to ship, familiar with all his foibles, until in the end, very often, he retired ashore with him, to serve him as a salty kind of butler in his old age. An admiral, whose standard pay was £5 a day, was entitled to a personal establishment of a secretary, a flag lieutenant, a coxswain and ten domestic servants, and wherever he went on the Navy's service he found awaiting him an exceedingly comfortable Admiralty House: tropically terraced on the bay at Trincomalee, demurely Georgian at English Harbour in Antigua, ecclesiastically Victorian, like a rectory, at Esquimalt in British Columbia, or tucked away up a solitary creek at Simon's Bay in South Africa, where the Admiral Commanding used to anchor his flagship directly outside Admiralty House, and there were always live turtles tied to the end of his jetty, waiting to be turned into soup.

The executive branch looked haughtily down at the engineering branch—'mechanics', 'greasers', 'whose mammas', as the radical Fisher once said, 'were not asked to take tea with other mammas'. In the 1890s the engines of a ship were generally as distasteful to the executive officer as the tank was later to become to the disinherited cavalry, and there was still a nostalgic yearning for the great days of sail. ('Great satisfaction was manifested at Portsmouth', we read, when the brig *Sealark*, which had been delayed by gales, beat up from the eastward for the Jubilee review under a full head of sail.) Hardly a single officer of gentle birth was prepared to

learn the messy mechanical trade, and the engineering branch was full of names like Samuel Rock, Elijah Tricker and Daniel Griffin, contrasting hornily with the Frederick W. Talbot Ponsonbys or the Honourable Henry A. Scudamore Stanhopes up on the bridge. As for the ratings, their pay could be as low as 7d a day, their quarters at sea were revoltingly cramped, and they had to eat their miserable victuals with their fingers, knives and forks being considered prejudicial to naval discipline and manliness. The Navy had no shore barracks—between commissions the seamen lived in old line-of-battle hulks. They were given no physical training,[1] and half of them could not swim.

The Royal Navy was an intensely conservative body, wrinkled with quaint anomalies. The Board of Admiralty was a gilded relic of earlier centuries, meeting in its beautiful eighteenth-century chambers in Whitehall, and acting as patron to several church livings, including that of Alston with Garrigill and Humshaugh. The Navy List included eight ancient functionaries called Vice-Admirals of the Coast of Great Britain, and four Vice-Admirals of Ireland. All in all, there was a marvellously humorous fascination to this force. For its officers life was often one long working holiday, full of high spirits and good company: and the ratings, too, for all their harsh conditions, were generally loyal to the service for life, and unshakeably proud of it—group photographs of ships' companies emanate a delightful sense of cocky cheerfulness, very different from the moustachio'd melancholy that seemed to hang around the crews of French or Russian ironclads.

It was very much an imperial Navy. It was excellent at showing the flag, charming important guests, overawing recalcitrant natives, rescuing shipwrecked mariners, relieving the victims of natural disasters, looking splendid and behaving stylishly. Maltese boatmen were carried on flagships of the Mediterranean Fleet, together with their high-prowed gondola-like *dghaisas*: and nothing was more colourfully imperial than the sight of one of these bright-painted craft, lowered from the deck of a British man-o'-war, gliding ashore

[1] Until 1900, when the Admiralty noticed that the men, deprived of the exercise of going aloft on sailing-ships, were getting flabby, and introduced the Physical Training Branch with a Swede as its first instructor.

with its swarthy Latin oarsman at the stern and a party of laughing English officers in its cushioned seats. Sometimes there were Navy scares in Britain, and alarmists made the flesh creep with talk of immense building programmes abroad, new kinds of Russian turret-ship, or much improved torpedoes in France. They always subsided after a month or two. The British had absolute confidence in their Navy. It was supreme. It had always won. It glittered, and was much loved.

5

British naval strategy, such as it was, had been distorted by the allure of Empire. The days of gunboat diplomacy were over, and the Fleet was dispersed to meet enemies that were never likely to arise, or to cope with situations that were not really relevant. What the country really needed was not far-flung magnificence, but modern strategic planning, concentrated force, and Admirals whose vision went farther than the good of the service, and glimpsed the world beyond the Sultan's reception or the Ambassador's ball for the Fleet. In the past, before imperialism glazed the British vision, the dangers of dispersal had often been more clearly seen. Sydney Smith once observed that the British maintained garrisons 'on every rock in the ocean where a cormorant could perch', and Sir William Molesworth told the Commons in the 1840s that 'activated by an insane desire of worthless Empire, into every corner of our colonial empire we thrust an officer with a few soldiers; in every hole and corner we erect a fortification, build a barracks, or cram a storehouse full of perishable stores'.[1]

The New Imperialists saw things differently. For them the Empire was itself the chief concern of British policy, and the Blue-Water Policy, the thesis that Britain was best defended by the

[1] Smith (1771–1845), the celebrated Canon of St Paul's, had two brothers in the East India Company, but once wrote so scathing an indictment of British rule in Ireland that it was, on Macaulay's advice, suppressed. Molesworth (1810–55), an extreme and hot-blooded radical, was Colonial Secretary for a few months in 1855, but his chief claim to national gratitude was that as Commissioner of the Board of Works he first opened Kew Gardens to the public on Sundays.

widely dispersed force of the Navy, was paramount. Seapower alone, Monypenny thought, had made Britain the supreme regulating power of the earth: it was the ubiquity of the British presence, in all five continents, that was the strength of the island kingdom. Other theorists believed that the cruces of British power were no longer in the United Kingdom at all. Some saw the Mediterranean as the centre of imperial gravity, others Canada, with its coasts on two oceans, its limitless resources and its new transcontinental railway line—the defence of Canada, wrote L. S. Amery,[1] was the very touchstone of imperialism, to which every other consideration must give way.

So the initiate of Empire, as he sailed proprietorially along the sea routes, looked out with complacent pride at the scattered sea-bastions of the Flag. They were like policemen on duty, ensuring all was well. As spectacles they could certainly be superb. Gibraltar from the deck of a passing ship was splendid and terrible enough to move even that lifelong opponent of imperialism, W. S. Blunt—*'God! to hear the sweet shrill treble of her fifes upon the breeze!'* With the semaphores on its ramparts, the battleships at its feet, the distant sound of bugles from its barracks beneath the Rock, Gibraltar was like a declaration of intent to the passing voyager: what we have, it seemed to say, we hold. Malta was terrific, too, with the warships steaming in and out of Grand Harbour beneath the fortifications of the Knights—'I would rather see the British on the heights of Montmartre,' Napoleon had said, 'than in possession of Malta.' Hong Kong, bustling on the rim of China, was like a great British dynamo pulsing away in the East, and at Trincomalee— 'Trinco' to the Navy—the Royal Navy had built its base on one of the grandest of all harbours, big enough to shelter the entire Eastern Fleet: the dockyard lay in the lee of a palm-covered ridge, and a gigantic banyan tree, all knotted and gnarled, gave shade to the Admiral's garden.

Most hauntingly of all, the traveller might find his way to Bantry Bay, on the west coast of Ireland, at a time when the Channel

1 Who was the son of a member of the Indian Forestry Department, and became, in 1924, Secretary of State for the Colonies, and later Secretary of State for India. He died in 1955.

Fleet was lying there on exercise. Not a glimpse or a hint of its presence would he discover, as he travelled through the bare Caha Mountains: but as he crossed the last ridge above Bantry, there in the long desolate fjord below him, hidden away among the hills, suddenly he would see the fleet, brilliantly alive. There the great ships lie, black, white and yellow, bow to stern in their anchorage, some with sails furled above their high funnels, some with barbette guns like forts upon their decks. Steam pinnaces chug officiously across the bay, with gigantic ensigns preposterously out of scale at their sterns, and bearded sailors swanky with their boat-hooks. There are jolly-boats rowing smartly down from Bere Haven, and flags flying everywhere, and a tremendous sense of disciplined agitation, painting, polishing, saluting, men swarming up steel ladders, officers alert on white scrubbed bridges and over all a drift of black smoke from fifty yellow smoke-stacks.

Perhaps there is the thump of a band at practice, from the Admiral's flagship down the bay, echoing over the water behind the hammering and the shouting of orders, the beat of machinery and the laughter. Or perhaps, as the traveller stands there marvelling, there is a sharp panting and scuffling out of sight, and over the ridge appears a landing-party of half a dozen sweating bluejackets, slung around with webbing equipment, wearing khaki gaiters and carrying rifles: stocky thicknecked fellows who talk to each other breathlessly and obscenely in West Country accents, and are led at a stumbling half-trot by a midshipman so pink, so white, so maddeningly sure of himself, so dapper in his white stiff collar and cording, that he might have stepped straight from a serial in the *Boy's Own Paper*, 'There she lies, men,' he pipes as they pause for a moment on the grassy ridge, and look back to the ships below.

'There she bloody lies,' murmur the seamen *sotto voce* in reply; 'there she lies, you lucky buggers.'

CHAPTER TWENTY-THREE

Imperial Effects

In our Museum galleries
Today I lingered o'er the prize
Dead Greece vouchsafes to living eyes—
Her Art forever in fresh wise
* From hour to hour rejoicing me.*
Sighing I turned at last to win
Once more the London dirt and din;
And as I made the swing-door spin
And issued, they were hoisting in
* A winged beast from Nineveh.*

And as I turned, my sense half shut
Still saw the crowds of curb and rut
Go past as marshalled to the strut
Of ranks in gypsum quaintly cut.
* It seemed in one same pageantry*
They followed forms which had been erst:
To pass, till on my sight should burst
That future of the best or worst
When some may question which was first,
* Of London or of Nineveh.*

<div align="right">Dante Gabriel Rossetti</div>

23

'*PASSPORTS*' (said Baedeker, 1887): 'These documents are not necessary in England, though sometimes useful in procuring delivery of registered and *poste restante* letters. A *visa* is quite needless.'

With such an indulgent ease did England admit her visitors in those days, and the foreigner from more shuttered and suspicious States must have felt he was entering an imperially spacious kingdom. Once inside, however, he would find surprisingly little physical evidence that this was an imperial kingdom at all. The only two imperial events mentioned in Herr Baedeker's *Outline of English History* are 'Foundation of the East India Company' and 'Canada Taken from the French'. His bibliography includes no book about the Empire, and even his separate volume on London lists the great imperial offices only *en passant*, and does not bother to mention, for instance, that the laws passed by the House of Commons might govern the affairs of a couple of hundred million people who had never set foot on English soil.

The imperial venture had not much marked the British. They were still far more an island than an imperial race. If the visitor found his way to one of Frith's immense genre pictures—*Derby Day, The Railway Station*, or *Ramsgate Sands*—which were consciously intended to be epitomes of the time, he would find that nothing imperial showed at all (unless you count ostrich feathers—up to nine guineas a fan in 1897): not a bronzed face, not a blackamoor page, not even a Maharajah instructing his jockey.[1] In its most penetrating degree

[1] W. P. Frith (1819–1909) had long endured the sneers of the *avant-garde*, but the public loved his work, and it was lavishly reproduced. I have a strong fellow-feeling for a craftsman who said of his most successful work, *Derby Day*, that 'the acrobats, the nigger minstrels, gypsy fortune tellers, to say nothing of carriages filled with pretty women, together with the sporting element, seemed to offer abundant material for the line of art to which I felt obliged—in the absence of higher gifts—to devote myself'.

British imperialism had been active for hardly more than a decade: in a kingdom moulded by a thousand years of historical continuity, it was only paint on the façade.

2

Let us ourselves, guide in hand, wander around London, this heart of the world, and see how much imperial gilding shines on its ancient structure. Then as now it was the city of all cities, giving to its visitors a Shakespearean sense of the universal—as if all the foibles, glories, riches and miseries of the human condition were concentrated there. Greater in area and population than any other capital, it lay there vast and blackened along the Thames, the smoke of ships and factories swirling perpetually among its towers. More often than not its skies were obscured with grey cloud, and the river flowed through it sluggishly, thick with filth. Far around the capital the Victorian suburbs extended, from slum to respectable terrace to detached villa, mile after mile into the blighted countryside: in the centre, lapped by the most rollicking night life in Europe, the offices of State rose grave and grey, Gothically pinnacled, and attended by that arcane shrine of the English, Westminster Abbey.

We are in the heart of the British Empire. The obvious place to start our inspection is Thomas Cook's in Ludgate Circus: but it is disappointing to find that its doorman, who has until recently worn a kind of white topee, intended to evoke the liveliest East-of-Suez images, has already reverted to a plain blue cap, after 'prolonged and embarrassed protests' from the staff. The great monuments of London are hardly less reticent about their imperial connections. In the Tower they show us a few old guns from Aden. In St Paul's and Westminster Abbey a handful of imperial heroes, Gordon, Henry Lawrence, Livingstone, Havelock, are altogether swamped by the mass of kings and queens, legislators, scientists, philanthropists, artists, or soldiers and sailors made celebrated by long centuries of war in Europe. Perhaps as we wander down Whitehall we may see one or two authentic men of Empire, sunburnt young men looking a little awkward in their stiff white collars, or shuffling with portentous wheeze up the steps of the India Office: but the imperial offices

are embedded indistinguishably in the warren of Whitehall, and nobody seems to know which is which. No Dyaks or Zaptiehs mount guard outside St James's Palace; no pagoda roofs or African caryatids stand in imperial symbol; among all the bright frescoes of the Houses of Parliament we shall find only one with an imperial motif—and that concerned with seventeenth-century India.

A few deliberately imperial institutions may be pointed out to us. The Imperial Institute in South Kensington is a showcase of Empire, partly an exhibition of raw materials and manufactures, partly a club for people interested in imperial affairs, partly a commercial bureau—*rich in symbol and ornament*, Tennyson had written of it, *which may speak to the centuries*: but it is too big, or too solemn, for the available enthusiasm, and if we venture through its elaborate halls, towered and vaulted like an Indian railway station, we shall find it depressingly echoing and deserted. At the Victoria and Albert Museum we shall see the collection of Indian art first assembled by the East India Company, but its rooms, too, are unlikely to be overcrowded, and if any members of the public are showing a marked interest in anything, they are sure to be looking at Tipu Sultan's famous Tiger-Man-Organ, an ingenious toy which represents an Indian tiger eating an Englishman, the tiger growling and the sahib feebly gurgling from an interior mechanism. If we are male, and well introduced, we may look in at the Oriental Club, originally for 'noblemen and gentlemen associated with the administration of our Eastern Empire'. We may be invited to the East India Club, where the talk is all of pigsticking and well-remembered subhadars, or even attend a session of the Omar Khayyam Club, dedicated to the pleasures of oriental literature, whose membership is limited to fifty-nine because the FitzGerald translation was published in 1859.[1]

Observe, as we walk down Victoria Street, the new offices of the several Colonial Agents, New South Wales, Victoria, the Dominion of Canada, all advertising their opportunities in window-posters,

[1] Imperial preoccupations, and the taste for exotica that accompanied the New Imperialism, certainly contributed to the running success of the English *Rubaiyat*, but Edward FitzGerald himself (1809–83) had nothing imperialist to his make-up, and lived almost his entire life as a kind of recluse in Suffolk.

and pointing big cardboard fingers towards their Immigration Offices. Here are the Albany Rooms, much frequented by people from the Cape and Rhodesia (the Count de la Panouse, '*sang bleu* and a great gentleman', had met his wife Billy there—she was one of the housemaids). Here is the Royal Academy, that unchallengeable arbiter of colonial taste, among whose admired exhibits, in the summer show of 1897, is *A Wee Rhodesian*, by Ralph Peacock, in which a very small, very white baby lies in the arms of a very black smiling houseboy, against a background of tropical blossom. The bookshops of the capital are well stocked with imperialist matter, recent reprints of Dilke, Seeley and Marcus Clarke, Henty and Kipling everywhere, Baden-Powell defying the Salisbury reviewers, Slatin Pasha's popular *Fire and Sword*, just off the presses and dedicated to the Queen-Empress. The British Museum shows surprisingly little in the way of imperial loot, but its library, we are assured, has a right to a copy of every book published anywhere in the Empire.

Here and there among the billboards, the brass plates, the advertisements plastered across the face of London, in the backs of guide-books thumbed through after luncheon, in prospectuses left lying around the club smoking-room, are hints of the existence of those immense possessions in the sunshine. *The Homeward Mail* is on sale at a few bookstalls—it comes out weekly to coincide with the arrival of the Indian mail—and so is *The British Australasian* (incorporating the *Anglo-New-Zealander*). Thresher and Glenny are advertising a new Jungra cloth shooting-suit ('impervious to thorn and spear grass'—*vide The Field*). Bessom and Co., with their depots in Poona and Calcutta, assure us that their Reeds for Military Bands are the *only* ones for use in tropical climates, and L. Blankenstein and Co. announce themselves, with a honky-tonk panache, as Colonial Pianoforte Manufacturers. Rose's Lime Juice get their juices from the Finest Lime Plantations in the World, at Roseau, Dominica; Ship and Turtle Ltd, of Leadenhall Street, make their soups from West Indian Live Turtle Only. In premises at 22 Oxford Street are Messrs Ardeshir and Byramji, whose head office is in Hummum Street, Bombay, and down the road Henry Heath boasts that his Shikaree Tropical Hat is now patronized by nine royal families. Newman

Newman the paint people offer a special selection of slow-drying water-colours for hot climates. It is satisfactory for imperialists to know that 'thousands who tried SALADA Ceylon tea as an experiment now use it altogether, and could not be induced to go back to the commonplace adulterated Teas of China and Japan'.

Up alleys off the Strand, among the bank signs of the City, around the corner from the India Office, are the Colonial Merchants, the Colonial Bankers, the Colonial Exchanges. Henry S. King, the East India Agents in Pall Mall, will book you servants in India. Grindlays in Parliament Square will advise you on Colonial Bonds. The Chartered Bank will issue you a draft on their branches in Rangoon or Hong Kong. The National Bank of India in Threadneedle Street will assume full responsibility for the collection of Indian pensions. William Watson's at Waterloo Place will ship wine at wholesale prices to Mauritius. The Union Line is only too anxious to convey you to the Gold and Diamond Fields of South Africa, but a huge placard above 21 Cockspur Street brags that THE RICHEST GOLD AND SILVER MINES ARE TO BE FOUND IN BRITISH COLUMBIA AND THE CANADIAN KOOTENAIS—APPLY WITHIN.

3

And if, like every other visitor, we finally strolled down the Mall, to end up with our noses poking through the railings of Buckingham Palace, as the guardsmen stamped through their sentry-go with little clouds of white clay billowing from their belts—then we might feel that we really were in an imperial presence at last. The trappings of the British Crown did suggest something bigger than an offshore island, and in the years since Victoria's promotion to Queen-Empress the pageantry of her throne had been injected with imperial symbols. She herself, though she thought of England as a European country, had a taste that way. She loved signing herself V.R. & I.—Victoria Regina et Imperatrix—and much enjoyed entertaining exotic imperial visitors at Windsor or Buckingham Palace ('One does not really notice it,' she once observed, contemplating the fact that a visiting group of Red Indians, war-painted

and encrusted with beads, were in fact naked to the waist). On her favourite walking-stick, said to be made from a branch of Charles II's oak, was fixed a little Indian idol, part of the loot of Seringa-patam when that Mysore fortress was taken by Lord Cornwallis in 1792. She it was who popularized the pink and yellow glassware, ornamented with lily patterns of vaguely oriental outline, which became known as Queen's Burmese: and she gave her title, too, to Her Majesty's Blend, a mixture of Indian and Ceylon teas prepared for her by Ridgeway's in the days when the imperial teas were challenging China tea for popularity. Kashmir shawls, all the rage in 1897, were chiefly famous because each year the Queen-Empress graciously accepted one from the Maharajah of Kashmir.

Victoria liked to greet her Indian guests in halting Hindustani, and her attachment to her Indian clerk, the Munshi, who succeeded the ghillie John Brown in her affections, edged towards the scandal-ous—she once asked her Viceroy in India to obtain a grant of land for him at Agra, and sometimes she even allowed him to answer letters for her. At the big dinner in Buckingham Palace on the eve of her Jubilee she wore a dress embroidered in gold that had been specially worked in India ('dreadfully hot'). Her Ministers knew that the old lady's sharp experienced eyes were focused on any imperial episode—Salisbury himself once had to apologize for calling Indians black men. A shimmer of imperial consequence hung around Victoria's throne, and thus by osmosis around the purlieus of her palace: from the large white donkey which Lord Wolseley had sent her from Egypt (white donkeys were royal there) to the Koh-i-Noor diamond, a legendary wonder of the East since the fourteenth century, which was taken by the British from Ranjit Singh the Sikh, and was now the splendour of the Queen's crown. Whoever possessed the Koh-i-Noor, ran the legend, possessed India: just the kind of legend Queen Victoria liked.

4

The New Imperialism was too new, and too sudden, to have changed the look of London. The public had only recently acquired its passionate interest in Empire, and Waterloo and Trafalgar still

meant far more than any number of far frontier skirmishes. The Imperial Jubilee was mostly froth, whipped up for the occasion by Press and politicians.

Yet in quieter colours, not to be observed by the casual visitor, the imperial experience did form a strand in the national tapestry. Among the middle classes especially thousands of families cherished imperial souvenirs, or aspired to imperial décors: Benares brass and trinkets from the Gold Coast, lengths of Indian silk waiting to be made up, a line of ebony elephants on the mantelpiece, a group of suntanned officers posed in careful asymmetry outside a sun-bleached bungalow, coloured shells from the orient cemented to a summer-house.[1] In many a sewing desk were kept young Harry's letters, sent home faithfully month by month, telling dear Mama and the girls all about last week's soirée at Government House, and the trouble he was having choosing curtain materials for the bungalow, and what a ripping time he had upcountry, and affectionate regards to dear Papa from their Ever-Loving Son.

Here we may eavesdrop, through the study door, upon Uncle James explaining to his brother the rector just how much money young Bob will need, if he really wishes to enter the Indian Army—he can live on his pay in a Mountain Battery, perhaps, but he must realize that the Cavalry would be *quite* beyond his means. Here dear little Miss Cartwright, who has always seemed so unlikely a spinster, confides in us at last, while we await the gentlemen after dinner, that were it not for a certain person she had been, well *particularly* fond of—in the Mutiny—he was buried, she believed, somewhere near Meerut—but there, all that was long ago, and we must tell her all *our* news. . . .

This house seems to be African all over, prints of kraals and jungle caravans, masks and shields and monkey-skins; this seems to smell faintly of spices or perhaps incenses, and a tinkle of temple bells comes from its garden, near the bird-table, and those gourds on the butler's tray have a Polynesian, or Malayan, look to them—

[1] At least one great fortune was based upon this finicky enthusiasm. Marcus Samuel (1853–1927) began as an importer of oriental shells, extended his trade to rice and curios, became interested in petroleum and called his oil company, founded in 1897, after his original commodity: Shell.

Burma Forestry, do you think, or could he have been British Guiana? And sometimes, in the list of recent wills in *The Times*, there appears a name dimly and not always enthusiastically remembered from the past—'Great God, that's Hawkins the rubber man, a perfect pest, treated his natives like dirt and never stopped complaining about port dues—eighty thousand he left, bless my soul—a perfect blackguard.'

5

Half without knowing it, the British had picked up thousands of words from their subject peoples, and enriched their own language with them. A few were South African Dutch (*laager, veldt, trek*) and at least one was Red Indian—*toboggan*: but most of them came to England out of the East. Perhaps the most delightful imperial book of all was *Hobson-Jobson*, a dictionary of Anglo-Indian words and phrases compiled by Sir Henry Yule in the 1880s.[1] There were at least sixteen other Anglo-Indian glossaries, but this instantly became the most famous, and there was no Englishman with Indian connections who would not know what you meant, if you said half a minute, I'll look it up in *Hobson-Jobson*.

'Considering the long intercourse with India,' wrote Arthur Burnell, who expanded the book after Yule's death, 'it is noteworthy that the additions which have thus accrued to the English language are, from the intellectual standpoint, of no intrinsic value. Nearly all the borrowed words refer to material facts . . . and do not represent new ideas.' This was perhaps because so few Englishmen, under the influence of Macaulay and his school, had taken the native civilizations seriously: the word *Hobson-Jobson* itself, a flippant Anglo-Indianism for any sort of native festivity, was taken from the terrible wailing cry of the Shia Muslims—*Ta Hussein, Ta Hassan!*—when they grieve for the death of Ali's sons at Karbala.

[1] Nobody could be much more Anglo-Indian than Yule (1820–89). The son of an East India Company soldier, he served in the Bengal Engineers and married first the daughter of a Bengal civilian and second the daughter of an Anglo-Indian general. He transferred to the Indian political service, and when he came home to England in 1875 was appointed to the Council of India. One of his brothers became British Resident at Hyderabad, the other was killed while commanding the 9th Lancers in the Indian Mutiny.

Many Anglo-Indian words—caste, cuspidor, mosquito—had been inherited by the British from their Portuguese predecessors in the East. When the planter bawled '*Boy!*' sending an indignant shiver down the spine of the visiting liberal, who was generally not quite outraged enough, all the same, to forgo his chota-peg for his principles—when that hunting-cry of sahibs went up in the club, the thirsty imperialist was really only shouting, as the Portuguese had before him, '*Bhoi!*'—the name of a Hindu caste of palanquin- and umbrella-bearers. *Char*, the British soldier's name for tea, reached the army via the East India Company, but really originated in Japan, where the early British merchant venturers transcribed the Japanese word for tea as *tcha*. Rickshaw came via India from Japan, too, and was originally *jin-ri-ki-sha*—'man-force-car', the name the Japanese gave to a conveyance invented for them by an ingenious missionary, W. Goble, about 1870. The word gymkhana appears to have been coined by the British in Bombay, and was based upon the Hindustani *gend-khana* or ball-house—what the Indians called an English squash court. The word catamaran was simply the Tamil for 'tied trees', and the original Juggernaut was Krishna, the eighth avatar of Vishnu, who was dragged in hideous image through the streets of Puri in Orissa, its devotees throwing themselves beneath its wheels to be crushed. British soldiers in India had their own cheerful use of Hindustani. A thief was a loose-wallah, a nail-wallah was a manicurist, the Good Conduct Medal ('for 20 years of undetected crime') was called the Rooty Gong, meaning the Bread-and-Butter Medal. Old India hands pride themselves on their ability to 'sling the crab-bat'—swear in the vernacular.

An astonishing number of Indian words had slipped into the language without anybody much noticing, as the following self-conscious sentence shows: 'Returning to the *bungalow* through the *jungle*, she threw her *calico* bonnet on to the *teak* table, put on her *gingham* apron and slipped into a pair of *sandals*. There was the tea-*caddy* to fill, the *chutney* to prepare for the *curry*, *pepper* and *cheroots* to order from the *bazaar*—she would give the boy a *chit*. The children were out in the *dinghy*, and their *khaki dungarees* were sure to be wet. She needed a *shampoo*, she still had to mend Tom's *pyjamas*, and she

never had finished those *chintz* hangings for the *veranda*. Ah well! she didn't really give a *dam*, and putting a *shawl* around her shoulders, she poured herself a *punch*.'[1]

A little slang had come bouncing back to Britain from the Antipodes—'up a gum tree', for instance—and perhaps the oddest adaptation of all was *cooee*! which was originally the signal-cry of Australian aborigines, imitative perhaps of the dingo, perhaps of the wonga pigeon, but was by the nineties the habitual call of the Kensington Garden nannies, when they wished to recall recalcitrant charges from the Round Pond—'keep within *cooee*, dear', they used to say, as they settled for a gossip on the bench. Charles Thatcher, the Australian poet, once wrote a poem about a digger who had made his fortune in Australia and brought his wife to London, leaving her at 'Hodge and Lowman's splendid shop' while he strolled down the street:

> *She laid out fourteen pounds or more*
> *And the shopman saw her to the door.*
> *Down Regent Street she cast her eye,*
> *But his old blue shirt she couldn't spy.*
>
> *Says the shopman he's gone, I do declare,*
> *Will you step inside and take a chair?*
> *Oh no! I'll find him soon, says she,*
> *And she puts up her hand and cries Cooee!*
>
> *At this extraordinary cry*
> *He ran up in the twinkling of an eye*
> *And to the wondering crowd did say,*
> *That slews you, and then they toddled away.*

6

In 1882 there appeared in the lists of English cat breeds an elegant and patrician new-comer called the Abyssinian. Its genesis was mysterious. Cynics were of the opinion that it was not Abyssinian

[1] She sounds a disagreeable woman, but she was not really cursing, nor am I bowdlerizing her soliloquy: a *dam* was a small Indian coin, as Wellington knew when he popularized the phrase 'a twopenny dam'.

at all, but only a rarified British tabby, and some people preferred to call the breed the British Tick or the Bunny Cat. The truth seems to be, though, that this beautiful creature was first brought to Britain by soldiers returning from Lord Napier's expedition to Ethiopia in 1867. The troops had passed near the ancient Ethiopian capital of Axum, where numbers of sacred cats were kept as acolytes to the cathedral of St Mary, and it is likely that some enterprising fancier whisked one into his kit-bag and shipped it, Amharically mewing, home.[1]

Exotic animals had traditionally figured in the trains of conquerors, and in the second half of the nineteenth century the zoos and private collections of Britain had been wonderfully enlivened by spoils of Empire. Within the confines of the Pax Britannica almost all zoological regions were represented. Every living kangaroo was born a British subject. So was every kiwi, every koala, every duck-billed platypus—and every Dodo, if any sad survivor still lurked in the forests of Mauritius. There were British tapirs and British okapis, and even the giant panda was almost within a British sphere of influence.[2]

The London Zoo was accordingly much the best in the world, and possessed a grander collection of weird living trophies than ever pranced in a triumph of the Romans. Lions, tigers, monkeys, snakes, elephants, rare bats and unimaginable birds were sent home to London by every expedition, spluttering and spitting in their crates, and whenever a royal personage visited some tropical possession he came home with a little menagerie of his own. When the Prince of Wales returned from a visit to India in 1876 the cruiser *Raleigh* accompanied the royal yacht with a cargo of two tigers (Moody and Sankey), a leopard (Jummoo), and large numbers of smaller animals and birds: as the royal squadron steamed up the Solent, to the cheers of crowds lining the shore, this collection of animals howled in response to the signal guns, and on each paddle-

[1] There are still sacred cats at Axum, and their character is recognizably akin to that of the English Abyssinian—which is now popularly supposed in the cat fancy to be descended from the mummified cats of ancient Egypt.

[2] Nothing symbolized the end of Empire more poignantly than the announcement, with the withdrawal from Uganda in 1962, that there were no more British gorillas.

box of the royal yacht itself there was to be seen standing an Indian elephant.

7

A shifting population of colonials moved through London. The white colonials were unobtrusive. The dialects of England were so varied then, and the impress of colonial origin was generally so recent, that an Australian, a Canadian or a South African could often merge into English life unremarked. Numbers of Australians and New Zealanders still came to England to be educated: many Englishmen who had spent half a lifetime in the colonies came home in the end to die. It was difficult still to know just where a colonial began and an Englishman ended. All carried the same passport, and while many British people thought of the self-governing colonies as extensions of the Mother Land, many colonials thought of themselves simply as Britons overseas.

People from the coloured empire were rarer and mostly grander. The coloured servant, once so common in England, was now almost unknown, and most of the coloured people to be seen about were rich or powerful, courted by Authority for political reasons or sent to be moulded in the manners of the ruling race. For years there had been a small Indian community in London, with an active and often dissident intelligentsia: from 1892 to 1895 there had even been an Indian member of Parliament—Dadabhai Naoroji, the Parsee member for Central Finsbury, formerly Prime Minister of Baroda. Ranjitsinjhi Vibhaji, claimant to the throne of Nawanagar, was one of the most popular and successful cricketers in England, playing for Sussex, and for thousands of Englishmen his quick and stylish batting offered a first comprehensible image of the dream that was India. The Hindu ban on sea travel still limited the numbers of young Indians coming to English schools and universities, but since 1890 fourteen undergraduates with Indian or African names had been admitted to Oxford—two were princes, one was a sheikh, and six were at Balliol, adding substance to the legend that all black men preferred that college. When Queen Victoria drove home through Windsor after her Jubilee junketings, waiting in attendance

446

at a ceremonial arch were four Etonians—the sons of the Maharajah of Kutch Bihar, the Prince of Gondal and the Minister of Hyderabad, all resplendent in Indian dress.[1]

8

If the physical imprint of Empire was slight, in 1897 its gusto was inescapable. A vigorous kind of brain-washing was in full swing, conducted by the popular Press, the Government and several active pressure groups. Imperial monuments might be hard to find, but imperial sentiments were deafening. All the energies of the nation seemed at that moment to be directed towards imperial ends; almost no subject of public interest was discussed outside an imperial context; the Empire was an infatuation.

It must have been almost impossible for the untravelled Englishman to resist this ceaseless publicity, and it is easy to see why men like Elgar, in the tractable society of the English provinces, uncritically absorbed it. The vast new readership of the *Daily Mail* was intoxicated by stuff like this piece from Steevens (himself then 28 years old): 'We send a boy out here and a boy there, and the boy takes hold of the savages of the part he comes to, and teaches them to march and shoot as he tells them, to obey him and believe him and die for him and the Queen . . . and each one of us—you and I, and that man in his shirt-sleeves at the corner—is a working part of this world-shaping force.' Over and over again the bulk and wealth of the Empire was emphasized, from soap-box and from pulpit, day after day in the newspapers and edition after edition in the popular imperialist books. The weekly full-page feature of the *Illustrated London News* was repeatedly devoted to imperial topics: The

1 How different it all looks now! Australians and New Zealanders may still assimilate themselves easily enough, but most Canadians and South Africans are unmistakably alien in England. The Rhodes scholarships still bring hundreds of young 'colonials' to Oxford, but there were no Indians at Eton in 1967, and only one African. An occasional Indian and West Indian cricketer still brings grace or gaiety to the county cricket championships, and there is scarcely a city in England that does not have its community of Indians, Pakistanis or West Indians—giving the country a far more imperial look today than it ever had in the age of Empire, and posing problems the Empire-builders never thought of.

Punitive Expedition to Benin, The Massacre in the Niger Protectorate, The Indian Famine, The Plague in Bombay, Lord Roberts on his Arab Charger, Prospecting for Gold in British Columbia, Dervish Fugitives Fleeing Down the Nile, On the Way to the Klondike, Fighting in a Nullah on the Tseri-Kandao Pass.

Since 1868 the Royal Colonial Institute[1] had been assiduously grinding imperial axes. So were the Royal Geographical Society, the Imperial Federation League, the United Empire Trade League. In the schools the glory of Empire shone through every curriculum, interspersed with All Things Bright and Beautiful: it was the duty of every father and school manager, Sir Howard Vincent[2] once said with a genuinely imperial turn of phrase, to 'inculcate the study of Empire on all within their spheres of influence'. In the very month of the Jubilee a schoolboy ran away from Haileybury, the former college of the East India Company, and committed suicide, apparently because the other boys were persecuting him for his opinions about Crete. He disapproved of British intervention in the affairs of the island, where imperial troops were committed to keep the Turks out, and the newspapers dwelt at length upon a tragedy caused by such quixotic views. 'That anyone with our present knowledge of Turks and Cretans should be enthusiastic about them', commented the *Illustrated London News*, 'is amazing. . . It is probable that his mind was unhinged.'

9

The New Imperialism was potent politics. The Conservative-Unionist Government certainly owed its confidence to its staunch imperial views, even Salisbury paying lip-service to the cause, and the ringmaster of the Jubilee was Joe Chamberlain, 'Minister for Empire'.

[1] A society nothing if not resilient: originally the Colonial Society, in 1928 it turned itself into the Royal Empire Society, and it is now the Royal Commonwealth Society, its premises occupying the same London site throughout.

[2] Successively soldier, journalist, policeman and politician, Vincent (1849–1908) was the first director of criminal investigation at Scotland Yard, but was as widely known for the Howard Vincent Map of the British Empire, which ran into nineteen editions.

Fifteen years before Seeley had observed with satisfaction that the political influence on Britain of India was nil. In those days the Empire was not an electoral issue, and the wise politician did not bother his head with it. Seeley was delighted that this was so. He had in mind the situation which might have arisen if Warren Hastings had not been impeached for alleged corruption in India in 1788[1] —an unhealthy domination of Parliament by wealthy vested interests of the Empire. In 1782 Pitt had said, during a debate on Parliamentary reform, 'We now see foreign princes not giving votes but purchasing seats in this House, and sending their agents to sit with us as representatives of the nation. No man can doubt what I allude to. We have sitting among us the members of the Rajah of Tangore and the Nawab of Arcot, the representatives of petty Eastern despots.'

The worst, though, had never happened, and by 1883, when Seeley wrote, it was unthinkable. On very few occasions in the nineteenth century had imperial affairs vitally affected domestic politics. The Afghan War of 1878 contributed to Disraeli's fall, the failure to relieve Gordon, coupled with the Irish issue, in the end defeated Gladstone. Ireland was a running sore, Egypt was once described by Milner as 'the football of English politics'—during the three years after Tel-el-Kebir there were ninety-eight Blue books about the country. But it was only now, in the late nineties, that imperial affairs much mattered at the hustings. Now even Liberals found it necessary to beat the drum, and poor Gladstone, who once told a confused audience that the Liberal Party was opposed to imperialism but devoted to Empire, watched sadly from his last retirement in Hawarden as member after member of his shattered party fell into the moral error he himself had dubbed Jingoism.

Now, in hindsight, imperialists began to claim that Britain owed all her success to the existence of her Empire. 'Our great Empire,' Lord Rosebery once declared with satisfaction, 'has pulled us out of the European system. Our foreign policy has become a colonial

[1] Hastings (1732–1818), Governor-General of Bengal under the Company, was accused of a variety of offences—breaking treaties, selling whole Indian districts, hiring out British troops to a local despot. He was acquitted of all the charges but ruined anyway, *pour encourager les autres*.

policy.' The spirit of the nation, it was said, depended upon the responsibilities of Empire: Britain's triumphant position in the world was a response to the imperial challenge. Having our heroes in India, reasoned Sir Charles Crosthwaite, elevated every Briton, and indeed without the Anglo-Indian champions of the Victorian era there would not have been many. The grandest military funeral since Wellington's had been given to Lord Napier, who never fought a European enemy, and the other exemplars Crosthwaite offered were Henry and John Lawrence, John Nicholson, John Jacob, Herbert Edwardes, Donald Stewart and 'Bobs'—few of them likely to remain for long in the upper ranks of the British pantheon.

With Chamberlain at the Colonial Office, and this temper of thought politically fashionable, the official attitude to Empire was distinctly braced. A series of new institutions was planned or founded, intended to apply the latest British technology and scholarship to the colonial possessions—the Liverpool School of Tropical Medicine, the London School of Oriental Languages, the Imperial College of Science. Oriental scholarship in England, long overshadowed by German work, began to revive. Imperial development was considered systematically, as a whole. New life was breathed into the old idea, and all its buds, shy or gaudy, were bursting into flower.

10

But cause and effect were often muddled: some of the buds were unseasonable, and some went instantly to seed. Nobody had yet made any thorough study of the advantages of Empire, and the general hullabaloo of 1897 was in some ways deceptive. In particular the assumption that the Empire made Britain rich, that the more imperially she behaved the wealthier she would be, was a misconception. It was partly an honest delusion, based upon insufficient evidence, and partly a kind of fraud, devised by men who stood to gain from aggressive national policies.

The colonial trade, which looked so heart-warming portrayed in thick black arrows on diagrammatical maps, was not so important as it seemed. It was arguable that the original flow of imports from

India, under the East India Company, had contributed some of the capital for the Industrial Revolution a century before. It was obviously true that individual firms and families, like Hawkins the rubber man, had been enriched by imperial enterprise. But the staggering wealth which was being celebrated in 1897 had been accumulated above all by Free Trade—that economic philosophy, amounting almost to a dogma, for which the British had abandoned their old system of tariffs and trade restrictions half a century before.

For the Empire had once been virtually a British mercantile monopoly. Preferential tariffs protected the colonial trade, foreign ships were banned from colonial ports, colonies might only export their products to Britain, and in British bottoms. This system had been progressively destroyed during the first half of the century, as Free Trade ideas gathered strength. The repeal of the Corn Laws had preceded by three years the repeal of the Navigation Acts—the one repeal admitting foreign corn into Britain without duty, the other ending the British monopoly of direct shipping routes within the Empire. Free Trade had triumphed, and the old economic meaning of Empire was lost.

To the really dedicated free trader any restriction on commerce with any nation was almost irreligious. Imperial favouritism was incompatible with the creed at its most fervent, and the narrower cause of imperialism seemed almost petty beside the transcendent virtue of the Open Door. Besides, it worked. The British adopted the doctrine more whole-heartedly than anyone, and stuck to it longer, and it could be demonstrated by statistics that Free Trade rather than imperial expansion had made them rich. The Empire was in no way an economic unity, and it was far from self-sufficient. In 1896 Britain had imported 64 million hundredweight of wheat —30.7 million from the United States, 17.2 million from Russia, and only 3.6 million from Canada. Only in potatoes, cheese, apples and fresh mutton was the Empire Britain's chief food supplier: other foodstuffs came overwhelmingly from foreign countries, the Empire generally providing less than 10 per cent. The Empire's total foreign trade in 1896 was worth £745 million: the total inter-imperial trade was worth £183 million. What was more, even in that

high summer of imperialism, while trade with foreign countries was increasing still, trade with the Empire was almost static. The explosion of the British Empire in the preceding twenty years had little effect on Britain's prosperity. Trade scarcely flourished in the enormous new African territories: in 1897 the whole of tropical Africa took only 1.2 per cent of British exports. Each year the colonies bought a larger proportion of goods in foreign countries, and a smaller from Britain. The horse-drawn trams of Bombay were made in New York, and ships of all nations profited from the imperial trade, as Kipling recognized in his ballad of a Calcutta boarding-house:

> *And there was Salem Hardieker,*
> *A lean Bostonian he—*
> *Russ, German, English, Halfbreed, Finn,*
> *Yank, Dane and Portugee,*
> *At Fultah Fisher's boarding-house*
> *They rested from the sea.*

What increases there had been in imperial trade had mostly been with the self-governing colonies, whose economic policies were almost as independent as France's or Germany's, and were certainly not designed to benefit the Old Country. Some people thought, indeed, that the possession of the dependent Empire actually blunted British commercial initiative, offering the feebler salesmen a comfortable feather-bed, tempting the less aggressive firms to rely on British power for their profits. Salesmen were said to study foreign tastes with reluctance, and Steevens reported from one of his journeys 'the usual weary story—foreigners content with smaller profits, excessive rates of interest charged by English agents, inelastic terms of credit, incompetent travellers'.

Even the immense overseas investments of the British were no longer primarily imperial investments. Far more British capital was sunk in the United States than in India, and the disparity was rising. Loans within the Empire might be less liable to default, but loans to foreigners were much better gambles. Indian Government loans returned an average of 3.87 per cent: foreign loans were averaging 5.39 per cent. Nor were colonial loans necessarily better for the

nation as a whole than foreign loans: much of the money that went to India was used to build factories, cotton mills and jute mills which eventually displaced British exports.

Of course the Empire was not just so much needless extravagance. There were obvious advantages, as we have already seen, in controlling the sources and prices of one's raw materials, and in governing one's own markets. India cost the imperial treasury nothing, the Indians paying not only for their own administration and army, but even for part of the cost of the British troops stationed in their country. Some £16 million in Indian gold went to England annually from India, in payment for services and capital—the nearest thing the Crown received to tribute in the Roman tradition. As for the self-governing colonies, their only drain upon the resources of the Mother Country was the cost of imperial defence, while their outpouring of gold, silver, diamonds, wheat, wool and nickel gave strength to the London money market, the centre of it all.

The adventures of the New Imperialism were quite another matter. Trade was *not* following the flag into Uganda, Upper Nigeria, Bechuanaland and the Ashanti country. Burma had to be subsidized. Even Rhodesia had so far drawn a blank. Yet a phenomenal amount of money had been spent, during the past twenty or thirty years, in acquiring these unpromising domains. Wars were fought all over the place, roads and railways were expensively constructed, vast commitments of defence and administration had been added to the imperial burden. British ambitions in South Africa had already snared the Empire into the farcical humiliation of the Jameson Raid, and were now leading it inexorably towards war with the most formidable tribe in Africa, the Boers. Africa, the land of the New Imperialism, was like a quagmire, leading the British ever more deeply into trouble, bringing closer every year a clash between the rival imperialists—if not with the French, whose exploratory parties were then advancing across the continent towards the Nile, then with the Germans, only precariously kept in check by Salisbury's elegant diplomacy. Out of those steamy hinterlands little of value came, and into the kraals of those incomprehensible cultures few British manufactures found their way. In most of the jumble of protectorates and spheres of influence there was

very little government, even under the One Flag, and few British investors were tempted to send their capital down so crooked a drain.

There were critics even then to point out these unpalatable truths. J. A. Hobson based his case upon these very statistics. Dilke, one of the high prophets of the New Imperialism, thought that by deceiving themselves on the economic aims of the Empire the British would be diverted from more practical purposes of 'common nationality and racial patriotism'. Salisbury and his advisers well knew that the drive behind the new British Empire in Africa was mostly defensive—keeping others out, securing older possessions, acquiring bargaining stakes. Lesser breeds without the law of Free Trade were setting the pace now, and the activists of the African scramble were the Germans and the French: the British, who really had quite enough Empire already, grabbed by reaction.

This is not how it seemed to the public at large, nor how the newspapers presented the case. In ten years Britain had acquired new territories fifty times as large as the United Kingdom—what else could that be but profitable enterprise, to make the richest of countries richer yet? It would have been almost inconceivable for the enthusiastic reader of the *Daily Mail* that summer, scanning the list of imperial acquisitions since, say, that year they all went down to Brighton with Aunt Flora, to suppose that all those exotic new names, those Kadunas and Lusakas, those Bulawayos and Bugandas, did not mean hard cash in the imperial till. The idea that it might all be losing money would have shocked him. The suggestion that money might be better spent on schools, hospitals, pensions, would probably have seemed unpatriotic. The thought that it might all be a colossal error of judgement, and that the British might be better off without any Empire at all, would probably have struck him as quite lunatic.

11

So the foreigner's first impression was right in a way. London was not, like Rome, paved with the spoils and trophies of Empire, because this was only incidentally an imperial capital. The New

Imperialism was too new to have planted its own monuments—and too insubstantial, for it was a gusty sort of movement, a sudden gale of emotion, swooping suddenly out of that leaden London sky. It was like a fad: as everybody sang Dan Leno's songs, or copied Marie Lloyd's hair, or went bicycling on summer evenings, so they talked excitedly of Greater Britain and the White Man's Burden, thrilled to Sullivan's settings of Newbolt's *Songs of the Sea*, and dreamt with the Poet Laureate of British victories, land and sea alternately, like schoolboys in bed imagining endless triumphs at the wicket. Beneath this fizz the affairs of England tremendously proceeded, the statesmen practised their delicate art and the Empire-builders did their best.

CHAPTER TWENTY-FOUR

Overlords

God save Ireland, said the heroes,
God save Ireland, said they all.
Whether on the scaffold high,
Or on the battlefield we die,
O, what matter when for Ireland dear we fall.

T. D. Sullivan

24

BY Telford's road or Stephenson's railway line the British travelled to Holyhead in Anglesey: and sailing out to sea through a mesh of forts and stoneworks, in four hours the packet-boat took them to Kingstown. It had once been called Dunleary, but was renamed in honour of a visit by King George IV in 1821.[1] For hundreds of thousands of British soldiers, for generations of British administrators, for a whole class of Anglo-Irish gentry, this was the gateway to the nearest and most fateful of all the British possessions: Ireland.

It was 750 years since Henry II had sent his first English armies to the sister isle, but the British had never quite succeeded in subduing it. It lay there through the centuries festering, a drain on English wealth, a prod often to English consciences. To most Englishmen it was an integral part of the kingdom, like Scotland. The Irishman was only an ornery and inconsequential kind of Briton, talking a comical dialect and pursuing a misguided form of Christianity: if he rebelled against English sovereignty he was guilty of plain treason, like any other subject of the Crown. To the Irish patriot, on the other hand, Ireland was a nation and the Irish were a race: possessing their own language, honouring the most ancient Christian church in the West, with arts and mores and aspirations all their own—an oppressed people whose nationality was being deliberately stifled, so that by the 1890s Gaelic was alive only in a few remote corners of the island, and the land lay ruined and empty. And to plague the issue further still, there were many people on both shores who suffered from a dichotomy of these views, who were not at all sure where the right lay, or what Ireland really was, or what it should mean to be Irish.

Before 1800 Ireland had a parliament of its own, of a kind. It met in handsome classical premises in the centre of Dublin, with its own

[1] And is now Dun Laoghaire.

Houses of Lords and Commons, but since 1692 no Catholics had been eligible to sit in it, so that the native Irish were virtually unrepresented. The Act of Union of 1800 abolished it anyway, and united the English and Irish Parliaments at Westminster; Irish constituencies now sent their members to the Imperial House of Commons, and representative Irish peers sat in the House of Lords in London. Under Gladstone two Home Rule bills had been introduced, intended to revive the Irish Parliament, and give it autonomy in internal affairs. The first had been rejected by the Commons, and led to Chamberlain's defection from the Liberal Party; the second was thrown out by the Lords and led to Gladstone's fall, the return to power of the Conservative-Unionists, and the triumph of the New Imperialism.

The Protestant north-east of Ireland, Ulster, flourished moderately. Its separate character had been moulded early in the seventeenth century, when its aristocracy had fought an unsuccessful campaign against the English, and their lands had been distributed among immigrant settlers, mostly Lowland Scots. Few of its people wanted Home Rule, and in Belfast there were prosperous shipbuilding and textile industries. The Catholic south was a different world. Half-emptied by the fearful potato famine of the 1840s, drained still further by mass migrations abroad, deprived of industry, bled of cash, impoverished by bad agriculture and generations of absentee landlordism, the green landscape lay there stagnant and forlorn. The population of Ireland had been 8 million in 1841: it was 5 million in 1897. Its literacy rate was little higher than Burma's. Its death-rate was actually rising, and Dublin's was higher than any other European city's. Its peasantry was weakened by malnutrition and dulled by a fatalistic form of Catholicism that was peculiarly its own. Its countryside, one of the most fertile in Europe, was neglected and dilapidated—more than 60 per cent of it given up to grass, a proportion unparalleled in the world, and only about 11 per cent ploughed. The chief ambition of young Irishmen was simply to leave: to the cities first, out of the morose countryside, to Liverpool or London next, to America or Australia best of all. Marriages were fewer, and happened later, than in any other country: of women between 15 and 45, only one in three was married. This was

a sick, old country, peopled by absent friends. A standard decoration of the Irish cottage was the daguerrotype of a daughter far away, with her rings and ornaments painted in gold upon the photograph. The country hummed with suggestions of subversion, but peace was maintained in a sullen equilibrium. This was a moment of pause. A series of Land Acts had at least relieved the peasants of their worst social burdens: they had security of tenure now; Ireland no longer often saw the horrible old scenes of peasant eviction, helmeted constables shamefacedly at the gate while the tenants, prodded by an impatient bailiff, stumbled out with their pathetic bits and pieces. The Conservative-Unionists hoped to conciliate the Irish by material concessions—'killing Home Rule by kindness'—and were generous with grants for agricultural improvement, and loans to help the peasantry buy its own land.

Home Rule seemed a dead letter. Charles Stewart Parnell, that fascinating genius of Irish liberty, had died in 1891, and though the spell of his character lived on, still some of the fire had left the movement.[1] Gladstone was at death's door. The British were cock-a-hoop with Empire. The Irish Home Rulers at Westminster could do little but protest or boycott.[2] In the imperial context, set beside the marvels of African expansion, or the Great Game, Ireland's anxieties seemed nagging and parochial. The island brooded impotently.

2

Implanted in this melancholy setting were the Anglo-Irish, successors to settlers whose Englishness had been enforced as a matter of royal policy; under the fourteenth-century Statutes of Kilkenny they had been forbidden to intermarry with the Irish, to speak

[1] Parnell, who was born in 1846, was an Anglo-Irish Protestant himself, like several of the most inspired Irish nationalists, and was the leader of the Home Rule movement at Westminster. Surviving false imputations that he was secretly involved in Irish violence, he was ruined in 1890 when he was named co-respondent in a divorce suit, and died soon afterwards.

[2] Captain Charles Boycott, whose ostracization by angry Irish tenants gave this word to the English language, had understandably left Ireland, and had died at Bungay, in Suffolk, just a week before the Jubilee.

Gaelic or even to behave in Irish ways. This was the Protestant Ascendancy, an imperial ruling caste. Its members could be English-born, English-descended, or simply Anglicized Irish. Though often poor they were usually gentlemanly, and they owned most of the large Irish estates—sometimes complete communities of their own, the smithy, the sawmill, the carpenter's shop, the laundry, the piggery, the dairy, the kennels, all clustered around the big ungainly house with its lawns and rhododendrons. From their ranks chiefly sprang the hunting and shooting men, healthy and imperturbable, whose dash was legendary throughout the Empire, and who represented for many the true Irish character: for the Anglo-Irish were the Middle Nation, English to the Irish, Irish to the English. They shared many of the common settlers' attitudes. They loved the Mother Country in the principle, but not always in the practice. They were separated from the native peasantry by barriers of caste and religion, but sometimes they went native themselves, and embraced the Irish cause ferociously. The Pale, the circuit of delectable residential country around Dublin, had been traditionally their preserve since Henry II's Anglo-Norman barons settled and fortified it: and one of the saddest imperial allusions in the language was the contemptuous epithet 'beyond the pale'—not quite a white man, not a pukka sahib, Irish in fact.

At Duckett's Grove in County Carlow one Anglo-Irish landlord, William Duckett, Esquire, Deputy Lieutenant, celebrated the Diamond Jubilee with a fête. The Union Jack flew from a turret of the great bleak mansion, and the gardens were gay with bunting, white cloths on trestle tables, the scrubbed white frocks of the tenantry and the ribbons of the presiding gentry. There was a nourishing al fresco dinner for the estate employees and their families—150 souls in all, many of them in the Duckett service all their lives, and all of them given a holiday that day with full wages. The health was drunk of Mr and Mrs Duckett and Miss Olive Thompson (locally known, we are told, as 'The Children's Friend'). Plaques were distributed among the young people, engraved with portraits of Queen Victoria, and there were games all afternoon on the lawn, while the old ladies sat chatting in the shade, remembering the Jubilee of '87, the celebrations at the end of the Crimean

War, the Queen's Coronation sixty years before, or best of all the astonishing festivities, it seemed only yesterday, when the 70-year-old Mr Duckett, game as ever, had brought home his new bride and her daughter Miss Olive Thompson, and the tenants had taken the horse from the carriage shafts and pulled the ladies up the drive themselves, cheering and laughing, through the castellated gatehouse and up the long drive with its sculpted images of 'queens and animals and I don't know what'.[1]

In the evening all the local people came to Duckett's Grove for the fireworks: from Ballyhade and Uglin, Killerig and even Ballyhacket Cross they came on foot and in donkey-cart, dressed in their respectful best, and grateful in advance to Mr and Mrs Duckett and Miss Olive Thompson. A great tar barrel blazed as the sun went down, and presently the rockets soared over County Carlow, while Mrs Duckett gave a magic lantern lecture in the coachhouse. They danced till midnight, and then home to their lodges, their gatehouses, their whitewashed cottages went the Irish, and Mr Duckett, Mrs Duckett and the Children's Friend, making sure the flag had been correctly lowered, parted along the long polished corridors of the mansion, and went to bed.

3

Many Anglo-Irish were understandably distressed, when accused of being oppressors. The absentee landlord of evil memory had rarely survived the land reform laws, and the resident landowners were often admirable employers of the paternal kind. If they did not exactly love Ireland, they were often passionately attached to their particular slice of it: they treated their tenants like wayward children, and thought that nobody else understood them. Gladstone and his supporters aroused their bitter mockery. You had to live among the Irish to know them. One had nothing *against* the people, but one had only to look around to realize that they needed strong leadership.

1 I quote Mr James Gaynor, who still lived on the Duckett's Grove estate in 1965, occupying the lodge he was born in eighty-eight years before. He remembered this occasion well, and vividly described it. Duckett's Grove is now a deserted ruin, and the queens and animals have vanished.

The Irish were priest-ridden, credulous and stubborn, but nobody could deny their charm, and surely nobody would dispute that the fête at Duckett's Grove, for example, showed how happy the relationship was, between the *right* kind of landlord and his tenantry.

These were familiar imperial sentiments. The British in Ireland did not think of themselves as Empire-builders, but in a way they were. The land hunger which drove many Englishmen to the distant colonies took many more over the Irish Sea, and there was still a steady flow of retired Army people who lacked the capital to buy estates in England, but could, like Kitchener's father, live a gentleman's life on the other side.[1] They forfeited nothing by emigrating to Ireland. They could still vote in the English elections, and all the appurtenances of privileged English society were available on the spot: an English church in the village, excellent hunting, Trinity College, Dublin, for the boy to go to, if he had a taste for the Church or the Law, fine Irish regiments of the British Army waiting to welcome a soldier's son. The Anglo-Irish were the Establishment of Ireland. Their newspaper was the *Irish Times*, their church the Church of Ireland, disestablished by Gladstone in 1869, but still ornately representative of Authority. Their social life was full and agreeable, and they formed a racy and good-looking *élite*—'tall, strong, handsome chaps', Friedrich Engels thought them in 1856, with 'enormous moustaches under colossal Roman noses'.

Anglo-Irish generals sometimes seemed to enjoy a monopoly of British command, perhaps because Ireland gave more chance of authority to the upper middle classes: the indigenous Irish aristocracy had mostly left long before for France or Spain. The flow of Irish recruits was almost essential to the survival of the volunteer British Army, and the part played by the Anglo-Irish in the wars of the Empire was out of all proportion to their numbers. The shrine of the Ascendancy was St Patrick's Cathedral in Dublin, where

[1] To a degree the Anglo-Irish gentry is self-perpetuating still. Many Englishmen settled in Ireland after the Second World War, to escape the austerities of home, and the Germans and Americans who buy estates there now are presently moulded not into the pattern of Gaelic Ireland, but into the authentic postures and tastes of the old Protestant Ascendancy.

Swift had been Dean. It was decked with Anglo-Irish monuments. Irish wolfhounds lay sleepy at the foot of the Royal Irish Regiment's memorial, scrolls and battle honours all around, with a frieze illustrating the storming of the Shive Dagon pagoda in 1852. Cobwebby flags of Connaught Rangers and Royal Irish Fusiliers hung from the high ceiling, and here was the tomb of the hero Thomas Rice Henn, Royal Engineers, whose troop of eleven soldiers had, in Afghanistan in 1880, covered the retreat of an entire British brigade—'I envy the manner of his death', his compatriot Garnet Wolseley[1] had written of him, '—if I had ten sons, I should indeed be proud if all ten fell as he fell'. Near by a Viceroy of India was remembered: the Earl of Mayo, who was assassinated while inspecting a penal settlement on the Andaman Islands in 1872: an Anglo-Irishman *par excellence*, descended from ten generations of settlers, son of an evangelical father, an excellent shot and rider to hounds, educated at Trinity College and Unionist in all things.

In the choir hung the helmets, swords and banners of the Order of St Patrick, a knightly order which represented the flower of the Anglo-Irish chivalry. In the nave a large royal crest marked the pew of the Viceroy of Ireland, Lord Cadogan,[2] and his wife, a niece of the Anglo-Irish Duke of Wellington. Opposite sat Lady Plunket, whose husband, the fourth Baron Plunket, had been until his recent death Archbishop of Dublin—a Trinity man again, and the grandson of a Lord Chief Justice of Ireland. Next to hers was a pew dedicated to the memory of Sir Benjamin Guinness, the richest man in Ireland, who had restored the cathedral entirely at his own expense, and who was, as it happens, Lady Plunket's father. It was a close-knit society, the Protestant Ascendancy, and seldom abashed.

4

The Cadogans stood, *ex officio*, at the summit of social life in Ireland. As Lord Lieutenant and Governor-General of Ireland the Viceroy had great statutory powers: he was also, like his peer in India, the

[1] Himself buried in St Patrick's.
[2] Cadogan, Eton and Christ Church, was the fifth earl, had been one of Queen Victoria's favourite courtiers, and owned half Chelsea. He died in 1915.

representative of the Queen and thus the fulcrum of pomp and snobbery. Around his citadel, Dublin Castle, revolved not only the hierarchy of the Anglo-Irish proper, but also the class of favoured Irish gentry, the Parsees of Dublin, known scornfully to nationalists as the Castle Catholics. The Cadogans lived spendidly up at the Castle, or in the superb Viceregal Lodge in Phoenix Park that was the official residence. They no longer expected the minstrels, foot-guards, heralds, masters of the revels and gentlemen in waiting who had gone with the job earlier in the century: but there was still a sumptuous protocol and ceremonial to their lives, enacted against a background of great State apartments and historical bric-à-brac. The Viceroys were usually great noblemen, and society aped or adulated them. The Viceregal route to England, from Kingstown to Holyhead, was considered much smarter than the Liverpool route: if a hostess needed extra help for a dinner party, she would cheerfully pay extra for a man advertising himself as a 'Castle waiter'. Young girls listened, hearts a'thump, for the clattering hoofs of the mounted orderly who, trotting from door to door in the Georgian squares of Dublin, distributed the Viceregal invitations to ball or drawing-room.

Sometimes Viceroys had been boycotted, by one party or the other—the Dublin Corporation had declined to meet Lord Cadogan when he made his State entry into Dublin in 1895. In times when the Home Rule movement was in the ascendancy in London, Viceroys were often ignored by passionate Irish Unionists, and the Anglo-Irish disappeared from balls and levees: in times like Lord Cadogan's, with Unionists on top, Irish nationalists were more careful than ever not to be seen dead at the Castle. On the whole, though, the Viceroys were spared the worst of Irish acrimony. They looked decorative, they opened functions with aplomb, and most people loved a lord. At the gates of the Castle, whenever the gentry assembled there for a function, a little crowd of the Irish poor was to be seen, tattered in their thin clothes in the dusk, and sometimes waiting there for hours: not to throw bombs or cat-calls, but only to watch the lords and ladies ride by, in a shimmer of silks and decorations, towards the imperial luxury inside.

The Viceroy was sometimes a member of the British Cabinet,

though he was not often in London. The Chief Secretary of Ireland was always a member of Parliament, often a Cabinet Minister too, and generally spent most of the Parliamentary session at Westminster, dealing with Irish matters in the Commons, and returning to Dublin for the recess. He was the most powerful figure in the Government of Ireland, occupying one of the most demanding posts in the British Empire.[1] He lived in another lovely Phoenix Park mansion, within sight of Viceregal Lodge,[2] and it was he who bound together all the disparate and sometimes anomalous departments of the Irish administration—some branches of the United Kingdom Government, some specific to Ireland. In the Commons he answered questions on behalf of all these departments: as though one Parliamentary Secretary were to deal with the affairs of all the separate Ministries of the United Kingdom. What was more, he was directly responsible for security in Ireland, much the most dangerous of the Queen's dominions, and it was to his office in the Castle that officials of every kind brought their problems and submitted their budgets.

He supervised a peculiar form of government. Some of its anomalies, like the office of Lord Lieutenant itself, were survivals of the eighteenth century, when the island governed itself under the Crown. Others were symptoms of the country's schizophrenic status, half-way between a colony and a Government department. The senior Civil Servants in Dublin were mostly Anglo-Irish, rather than plain English, and many were Catholic: but their loyalties were to London, and they had often come to Dublin after experience elsewhere in the Empire. They ran the place generally on a basis of informal collusion. In so small a city as Dublin, where clubs, Government offices, hotels and restaurants were all within walking distance, they met each other frequently, and were inclined to govern Ireland over whiskeys before lunch. They were cultivated, often talented men, and many of them wrote books, often on obscure or scholarly subjects. Bram Stoker, who was on the staff of the

[1] Throughout almost the whole period of Lord Salisbury's Premierships it was held by one or another of his nephews.
[2] The Viceregal Lodge is now Árus an Uachtarain, the home of the President of Ireland: the Chief Secretary's Lodge is the American Embassy.

Registrar of Petty Sessions, wrote several. One was a textbook on the duties of petty sessions clerks. Another was *Dracula*.

5

This queer régime remained undeterred by all the centuries of Irish opposition. Many of the Anglo-Irish were convinced that they would always be needed in Ireland, or that the Irish peasantry was being deceived by unscrupulous nationalists. The Irish in return, with their gift for social lubricance, generally gave the answer they thought would give most pleasure, doffed their caps with courteous respect, and were perfectly sweet with the children.

The British laboured on with their task of persuading the Irish that they were British, too (though 'West-Briton' had long been a term of derision for the Anglo-Irish). At Galway, in the west, a very odd building gave expression to this intent. This was Queen's College, one of three university colleges set up in the 1840s to educate Irish Catholics in the proper English way, and it was a kind of parody of Christ Church, Oxford, that unshakeably royalist instrument of education: a mock-up, that is, like a plaster mould of a building, with the proportions all wrong and the detail disregarded, but a stumpy Tom Tower unmistakable in the middle, and a general vague impression of Oxford quadrangles. The Irish patriots showed a predictable contempt for such institutions, but many Irish Catholics emerged from them, all the same, to serve the Queen and the Empire. Some entered the Indian Civil Service, and took to India qualities particular to their kind. Michael O'Dwyer, for instance, a famous administrator of the Punjab, was one of the fourteen children of an Irish Catholic farmer and did his best work in intimate contact with the Punjabi peasants—often rogues to an Irish pattern themselves, living lives as close to the soil, and as shot through with brutality, as poor men lived in O'Dwyer's native Tipperary. And Antony MacDonnell, in 1897 Lieutenant-Governor of the North-Western Provinces and Oudh, first distinguished himself in Bengal famine relief, an all too proper task for a passionate son of County Mayo.

There were even attempts to convert the whole island to Pro-

testantism, as a first step to civilization. Before Catholic Emancipation, in 1829, the Irish Catholics had virtually no rights at all—as was said in an Irish court case in 1759, the law 'does not presume a Papist to exist in the kingdom, nor can they as much as breathe here without the consent of the Government'. Later, in the days of the famine, missionaries had sometimes persuaded starving peasants to 'turn' by giving them a bowl of soup. All this was cynically and bitterly remembered by the Irish, but resolute men of Protestantism still tried. The Society for Irish Church Missions to the Roman Catholics still worked 'to promote the glory of God and the salvation of the souls of our Roman Catholic fellow subjects': and on Achill Island, off the Galway coast, a shabby church, a pair of schools, an old printing office, a hostel and a vicarage stood testimony to the efforts of the Reverend E. Nangle, who had established a mission colony there in the 1830s, as a pilot project for the conversion of all Ireland.

He had been enthusiastically supported in England, where it was then widely believed that the True Light would solve all Ireland's miseries, and he was able to buy a large part of the island. He published his own newspaper, the *Achill Herald*, violently assaulting the Catholic priests and their morals, and since he not only controlled all the media of information but was also the chief landowner of the island, it seemed a foregone conclusion that Achill would soon submit, establishing a precedent for all the Irish. Somehow it did not work. A number of islanders were temporarily saved from the burning, but they soon slipped back into the old faith, and the mission lost heart. Mr Nangle found no worthy successors in his office, and by the 1890s the project was abandoned. It was the most determined attempt to proselytize the Irish, except for the French Canadians the largest Catholic community in the Empire: but the Cardinal Archbishop of Dublin, three Catholic Archbishops, twenty-three Catholic Bishops and 7,000 Catholic priests had proved too strong for Mr Nangle, and remained the shepherds of the Irish soul.

6

Much more permanent were the barracks, all over Ireland, by which

the British kept the country quiet. They seemed to be everywhere. Whole towns had arisen around them over the years, and hundreds of thousands of Irish people ironically depended upon them for their livelihood. A good example was Fermoy, in County Cork. This was a town actually created for the British Army. A Scottish merchant who had bought land there in 1789 offered it to the British Government as a barracks site, and himself built the town to serve the garrison. Grey slabs of barrack blocks dominated the little place, high on bluffs above the Blackwater River; ranges and training-grounds surrounded it; the garrison church commanded the town bridge; the garrison commander lived in a pleasant house in a park; Fermoy itself was laid out in regimental fashion, four-square and apple-pie, so that one might almost expect to find its municipal crest set out in whitewashed pebbles in the square, and a British battalion coming here from Poona or St Lucia, Halifax or the Cape, would feel itself instantly at home.[1]

Fermoy seemed organic to Ireland, for all its alien bearing, so long had it been embedded in the lush greenery of Cork: the great military base called the Curragh, in the centre of Ireland, looked more like a transit camp of conquerors, or perhaps the setting for some Anglo-Irish durbar. It lay well away from the town of Kildare, in the middle of a magnificent bare plain—the Salisbury Plain of Ireland, 5,000 acres of unenclosed grassland reserved for the occupying army. Off the Dublin road on one side was the barracks, first established in 1646, a little town of its own, built in the drab railway brick so dear to the British Army, and equipped with the Indian verandas so familiar to us by now from so many parts of the Empire. On the other side of the road was the Curragh race-course, the best in Ireland, where they ran the Irish Derby at the end of June. The Curragh was a sacred place to Irish patriots. There St Brigid, after St Patrick the most revered saint in Ireland, had traditionally grazed her sheep in the Celtic noonday long before. There, in 1798, 350 Irish revolutionaries had supposedly been massacred after laying down their arms. The Irish had been racing horses on the Curragh,

[1] Some of the Fermoy barracks were destroyed during 'The Troubles' of the 1920s, others stand empty and crumbling above the town, and one block forms part of a German-owned pencil factory.

it was said, for 2,000 years, and it was in Donnelly's Hollow on the Curragh that Dan Donnelly the Irishman beat the great English prizefighter, George Cooper, in a never-forgotten bout in 1815.

All these race memories were overwhelmed by the presence of the British, their Irish mercenaries and their Anglo-Irish allies. The soldiers in khaki lines of open order laboured on afternoon exercises across the windy downs. The crackle of rifle fire echoed from the ranges. There were jolly English shouts from the playing-fields, and watery English smells from the cookhouses. Officers jangled merrily, in brake on or horseback, to and from the race-course and the stables, and often the local gentry were to be seen about, clattering home from luncheon with the General, or picking up a party from the mess for a jaunt into Kildare. Nearly every British regiment knew the Curragh. The Prince of Wales had been stationed there in the 1860s, with the Grenadier Guards: his mother came over for a review of the troops, and thought that her dear Bertie, as he marched past with his company, 'did not look at all so very small'.

7

Of all the cities the British had created across the waters, Dublin was the most beautiful. Its sense of space and flow was pure English, and its broad streets, decreed by the Dublin Wide Streets Commission in 1757, allowed the fresh air and sunlight off the sea to flood the city with an invigoration the most ascetic public school prefect would have applauded. Everybody felt the sparkle of the place, its tingle in the air, its mingled suggestions of wit and threat, like a bubbly drink laced with something lethal.

Nelson presided over the capital, high on his column in Sackville Street, and the Georgian public buildings of the city were monuments of patrician authority—hardly touched, since Ireland was not a place where the British wanted to invest money, by the showier display of the Victorians. The Castle itself was grand but forbidding —Victoria thought it *gloomy*—its great cobbled yard surrounded by the long ranges of the Viceregal offices, and surveyed by the white cupola of the Office of Arms. Justice stood above its ceremonial gateway, balancing her scales on an unmistakably Anglo-

Irish hand. Up and down its pavements the sentries laconically tramped, guarding not only the Viceroy but also any prisoners of State there happened to be in the Bermingham Tower, and keeping an eye on the Chapel Royal at the end of the yard, whose Viceregal heraldics seemed to invite vandalism.[1] The splendid classical buildings of the old Irish Parliament had been sold to the Bank of Ireland, with the stipulation they should be so rebuilt that the people would no longer associate them with lost privileges: but the reconstruction had been tactful, and the buildings still stood with properly restrained authority down Dame Street from the Castle. There was nothing remotely Irish to the splendid domed building of the Four Courts, on the banks of the Liffey, or the dark Dickensian close of St Patrick, or the collegiate facade of Trinity. The famous residential squares, terrace after terrace across Dublin, might have been lifted there bodily from London, and even Guinness's great brewery beside the river had a stalwart London look—it had only been permitted to survive, the nationalists said, because the Guinnesses were such staunch Protestant Unionists. Dublin was an English city, one of the loveliest. The most Irish thing about it was the shifting drab flow of the poor people which ebbed through the streets with handcarts and thin horses—innocents from the country in search of jobs, or talkative town sparrows who formed, even then, perhaps the most entertaining proletariat in Europe.

The edge between Anglo and Irish was difficult to define, and became in practice a distinction of religion. Protestants, by and large, lived south of the Liffey, Catholics north, and Anglo-Irish society was as reluctant to cross Sackville Bridge into the Catholic quarters of the north as was the London upper crust to venture south of the Thames into Southwark or darkest Battersea. But Irishness, as the world thought of it, was common to both sides. The Irish literature of the day was mostly Anglo-Irish, and there was little that was Gaelic to the genius of men like Bernard Shaw or Oscar Wilde—Yeats liked to sit and meditate among the imperial monuments of St Patrick's. Dublin was an English city with regional eccentricities, still an alien enclave, a Pale, clustered around its

[1] The last available space for a Viceroy's coat of arms was filled, in 1922, by the coat of arms of the last Viceroy, Lord FitzAlan.

protective castle: for it really was a castle, with ancient military origins, and it stood on a slight elevation above the rest of the city, as though to keep an eye on things.[1]

8

Ireland was the only one of the Queen's dominions whose love for Her Majesty appeared to the British less than absolute. In fact the Irish probably bore no more grudge against Victoria than did the French Canadians, but whereas in Quebec the discontent of nationalists was bottled up in introspection, in Ireland it had repeatedly burst into violence. The British in Dublin were all the more determined to show the flag and beat the drum for Jubilee. They were, however, handicapped. Military grandeur was hard to come by, when the forces in Ireland were virtually an army of occupation, constantly on guard, and unable to leave their camps across the island. Lord Roberts, the Commander-in-Chief, had gone to London to lead the imperial troops in the Jubilee procession, and the commander in Dublin, Major-General Lord Frankfort de Montmorency, had gone to England too (by the Holyhead route, of course).[2] The cruiser *Melampus* and the gunboat *Gossamer* had both sailed away from Kingstown for the Spithead review, taking the Admiral with them, and leaving nothing to fire a signal salute in Dublin Bay. All they could scrape up for the Jubilee parade in Phoenix Park were three squadrons of the 3rd Hussars and four battalions of miscellaneous infantry. 'As a military display', the

[1] Though the purposes of many buildings altered, and the condition deteriorated, the centre of Dublin remained visually much the same until the 1960s, when the first of the high rise buildings marred its skyline, and Nelson was blown up. Many of the street names have been changed, and many of the most elegant squares have gone sadly down in the world, but it is still true to say that almost everything of beauty in Dublin was placed there by the British.

[2] How imperial a soldier's life was in those days is illustrated by this general's career. After the Crimea he served in India, in the Windward Islands, in Canada, in Abyssinia, in the Sudan, in India again and in Ireland. His eldest son won the V.C. at Omdurman in 1898 and was killed at the head of Montmorency's Scouts, in the Boer War. The general himself died in 1902, of apoplexy.

Irish Times had to admit, 'the review cannot be considered a success
—the paucity of troops . . . threw more or less a damper on the
proceedings.'

But they did their best. The obligatory free dinners, flag-hoistings
and illuminations were announced, and the *Irish Times* published
the inescapable Jubilee Ode:

> *Thou rulest supreme, as no other,*
> *Queen, Empress and Woman, in one—*
> *Our Sovr'n, our Lady, our Mother,*
> *Like whom there is none!*

An Irish Honours List was published, too, among those honoured
being Mr Reginald Guinness and Lord Roberts; there was a big
thanksgiving service in St Patrick's, attended by all the nabobs of
the Ascendancy; 'than the bicycle races', one observer wrote,
'nothing finer could have been witnessed. Many of the performances
established records for pluck and endurance.'

9

'Everything was orderly and peaceable', reported the *Irish Times*
ruefully next day, 'till about half-past nine o'clock, and then a slight
break was made in the smoothness of the proceedings.' An aggressive
crowd of Irishmen marched down Dame Street, shouting, brandish-
ing sticks, beating tin cans, singing nationalist slogans and carrying
a black flag, which was hoisted at half mast above the City Hall.
They smashed windows, wrenched lamp standards out of their
sockets, fought with the police and climbed all over the statue of
William III—one young man was seen sitting on the royal shoulders,
pummelling the curly-wigged head. From the roof of the National
Club, a stronghold of Irish dissent, a shower of stones hailed down
on the police below. All the best shop windows were broken in
Henry and Mary Streets, fights broke out all over the city, and
some 200 casualties were brought into the Jervis Street hospital
alone. All over Dublin orators sprang to their soap-boxes. In Phoenix
Park the beautiful Miss Maude Gonne, at a meeting demanding the

amnesty of ten political prisoners held in England, cried in her lovely and very English voice (for she was the daughter of an English colonel) that they would never obtain anything from England until they were able to wrench it from her 'in some hour of danger or defeat, which, pray God, may come soon'. The police got boos and brickbats everywhere, and at 10.30 a second procession appeared in the streets. It carried a draped coffin with skull and crossbone flags, and marched towards the Castle to the beat of a muffled drum. One of its banners carried the words 'The Record Reign', the next said 'Starved to Death'.

The crowd groaned in sympathy as it passed, somebody struck up *The Boys of Wexford*, and all the electric illuminations went out.

10

The *Irish Times* blushed. Ireland had made itself 'the scorn of the British Empire'. When numbers of Dubliners were charged next day with disorderly conduct the magistrate said the city seemed to have been 'in a state of siege': in the coroner's court the inquest on a woman killed during the disturbances degenerated into a nationalist demonstration, with coroner, police, jury and public exchanging hot-tempered insults. The news from the provinces, too, hardly made reassuring reading up at the Castle. There had been disloyal scenes at Cork and Waterford, and at Limerick, where an Australian gift of 900 sheep carcasses and 340 quarters of beef had been distributed to the poor, a crowd of women hooted and booed anyone who applied for it, sometimes seizing the meat from the unfortunate indigents and throwing it into the Shannon. The Jubilee had not been exactly a fiasco, but nobody could pretend that the Irish had celebrated it in any mood of loyal conciliation.

Where there was not actual opposition there was sometimes mischievous parody, for one of the most potent Irish weapons was mockery. Every sort of Irish celebrity turned out to be having a jubilee that year. It was the fiftieth anniversary of the death of Daniel O'Connell, first prophet of Irish independence, and this was celebrated with innumerable High Masses. It was the thirteenth centennial of the death of St Columba, and this was commemorated,

in the very month of Victoria's Jubilee, with immense and fervent ceremony on a mountain slope in Donegal. Monsignors and parish priests in many parts of Ireland celebrated their own jubilees or anniversaries, with parish feasts and episcopal messages. There was more rejoicing that summer over the Golden Jubilee of Canon O'Hanlon of Sandymount, author of a well-loved book about the Irish saints, than there was over the Diamond Jubilee of Alexandrina Victoria, Queen of the United Kingdom of Great Britain and Ireland.

For though this was, by Irish standards, a moment of political hiatus, still the anger of the people was slowly gathering its strength, and combining in movements peaceable and militant. The Irish had almost had enough. Catholic emancipation and agrarian reform had done little to blunt their passions. Their detestation of English rule was constantly underestimated by the British, whose worst prejudices were aroused by Irish hostility, and whose contempt for Irish abilities was profound. 'The moment the name of Ireland is mentioned', Sydney Smith had written, 'the English seem to bid adieu to common feeling, common prudence, and common sense, and to act with the barbarity of tyrants, and the fatuity of idiots.' They could not grasp the force of the separatist movement in Ireland—not just an adolescent craze or a pastime for cranks, but an expression of centuries of emotion, almost ready to flower into revolution. They were also abysmally ignorant about Ireland. Even Gladstone only went there once, and Lord Salisbury never went at all, declaring himself unable to face the miseries of the sea crossing.

The Irish Republican Brotherhood—the Fenians—had long been preparing for violence. Its great strength was among the Irish of the United States—'America,' as a speaker said at Miss Gonne's meeting in Phoenix Park, 'the greater Ireland beyond the seas, where there are millions of Irishmen, disciplined, armed, ready to fight for Ireland.' The Fenians had already mounted one unsuccessful revolution, in 1866, had abortively invaded Canada, and had committed various sorts of outrage in England, including raiding the arsenal of Chester Castle. But a host of less provocative bodies also stoked the patriotic fires. The Gaelic League worked for a revival of the

Celtic ways and language. The Gaelic Athletic Association wished all young Irishmen to play ancient Irish games like hurling and Gaelic football—games chiefly remarkable, as one apprehensive policeman wrote, for their savagery. The embryo Irish trade union movement was strongly nationalist. The Phoenix Literary and Debating Group, in Cork, was really an armed revolutionary movement, and in the mountains of the south fervent young Irishmen practised drill formations at night, or greased their rifles in isolated farmhouses. Ireland murmured, as Kipling wrote, with 'the secret half a country keeps, the whisper in the lanes'.

It was not a mass movement. Most Irishmen were politically numb, and few demanded more than Home Rule within the Empire. But already the portents were ominous. In Belfast the Ulstermen, encouraged by the Conservative-Unionists in London, bound themselves ever more stubbornly to union with Britain—Home Rule would be Rome Rule, Ulster Will Fight and Ulster Will Be Right. 'We declare to the people of Great Britain', a mammoth Ulster convention had resolved in 1892, 'that the attempt to set up . . . an all-Irish Parliament will result in disorder, violence and bloodshed.' In the south, too, the threats were becoming more explicit. 'Let us work together,' cried the young poet Patrick Pearse, the son of an English father, 'and exact a good measure from the English. But if we are deceived there are those in Ireland, and I am one of those, who will counsel the Gael to have no further dealings with the English, but to answer them with the sword's edge.' '*Live Ireland—Perish the Empire!*' was an old Irish slogan now revived: and far away in Lourenço Marques the British Consul, Roger Casement, was already cherishing an Irish patriotism which the British would consider treasonable, and which was never better expressed than he would one day tragically express it himself: 'Ireland has outlived the failure of her hopes, and yet she still has hopes. Ireland has seen her sons, aye, and her daughters too, suffer from generation to generation always from the same cause, meeting always the same fate, and always at the hand of the same power; and always a fresh generation has passed on to withstand the same oppression. . . . The cause that begets this indomitable persistence, the faculty of preserving through centuries of misery the memory of her lost

liberty, this surely is the noblest cause that men ever strove for, ever lived for, ever died for.'[1]

11

The noblest cause? Treason or patriotism? Splendid defiance or squalid disobedience? It was around the name of Ireland that the moral problems of imperialism first assembled: whether one race ever had the right to rule another, and whether the end could justify the means. The miseries of Ireland had infected England, too, and the Irish question was the most crippling of all the imperial burdens. The Irish garrisons, and the Royal Irish Constabulary, were terribly expensive. The Irish M.P.s were a plague to Parliament. The Home Rule movement had split the Liberal Party and toppled the most revered statesman in Europe from his Premiership. Ireland was always on the English mind, like a nearer Egypt. It was a backward people, properly part of the White Man's Burden. It was a proud and ancient people, only kept backward by oppression. It was a nation incapable of self-government. It was incapable of self-government only because it had never been allowed to try. It was really British anyway, and had no right to separate loyalties. It was a Celtic entity, different in race, custom and religion. It would prosper only as part of a greater whole. It would prosper only when it stood on its own feet. It was a nuisance. It was heroic. It was blind. It was prophetic. It did not know its own luck. It had lived in tragedy for eight centuries. Free Ireland and you would dismember the Empire. Hold Ireland and the Empire would never be serene.

Oh Ireland, Ireland, green and bitter island! 'That cloud in the west,' Gladstone had called it. 'That coming storm! The minister of God's retribution upon cruel injustice!'

[1] Casement, who was 33 in 1897, had enjoyed a distinguished career in the Consular Service, but was to be hanged in London in 1916 as an Irish traitor, having conspired with the Germans during the First World War. I have taken an anachronistic liberty in quoting this passage, for it comes from his last statement before the court that sentenced him to death.

CHAPTER TWENTY-FIVE

Omens

Persia and Egypt, Greece and Rome,
And vaster dynasties before,
Now faded in Time's monochrome,
In what do we surpass their lore?

Some things they knew that we know not;
Some things we know by them unknown;
But the axles of their wheels were hot
With the same frenzies as our own.

Francis Burdett Money-Coutts

If precautions were anything to go by, the self-governing plate colonies would be the first to break away from the Empire—possibly not by armed rebellion, like the Americans, but perhaps by the exertion of independent temper. A symbolically demonstrating proclamation was once made by the Australians at a place called

25

'*THAT cloud in the west!*' Here and there across the radiant horizons of the British Empire several such clouds were loosely forming, and gave to a few imaginative watchers a sensation of storms to come. It was as though that blaze of pride were too brilliant to last, like a preternaturally glittering summer day. Kipling caught this mood of presentiment in *Recessional*. Elgar would presently orchestrate it. Fisher felt it, as he watched the Germans building their battle fleets, and realized that all the glory of Empire could be shattered in one exchange of gunfire in the North Sea. Even the public showed a morbid interest in fantasies of foreign invasions and British defeats, calculated to chill the most Jingo spine: one horridly popular French publication, *Plus d'Angleterre*, suggested that when their nemesis came at last the British would have to pay an indemnity of £560 million, and hand over Dover, the entire Royal Navy, most of the Empire and the Elgin Marbles to the French. For one Power to rule so much of the world seemed a challenge to fate—and every educated Englishman was aware of the fate of empires. The most frenetically imperialist of writers seldom failed to mention the fall of Rome, Ozymandias or the decline of Spain, if only to speculate what marvellous things the archaeologists would discover, when they dug through the debris of the Pax Britannica.

2

If precedents were anything to go by, the self-governing white colonies would be the first to break away from the Empire—probably not by armed rebellion, like the Americans, but perhaps by the exertion of independent tempers. A symbolically disconcerting proclamation was once made by the Australians at a place called

Thursday Island, in the remote tropical north of Queensland. This was the very top of Australia, separated only by the narrow Torres Strait from New Guinea, the East India archipelago and Asia proper, and it was one of the hardest places in the world for a big ship to get to: when the British India boats sailed there through the islands their captains often stayed on the bridge for four days and nights, worrying their vessels through the shallows. On Thursday Island, off the tip of Cape York, there was a little town and a naval station—1,500 souls in all, with some fifty whites and a shifting community of Malays, Polynesians, Chinese, a few Japanese pearl divers and a few aborigines. The flag of the Queensland Government flew above the Resident Magistrate's house, and there was a little wooden prison, a post office, a storehouse for the Royal Navy's Australian squadron, a couple of pubs, two or three shops and a courthouse. Immediately behind this clutch of buildings was the bush, and the Sound all about was littered with low sandy islands, baked in heat.

It was a dismal place, away beyond the never-never, but if the Australians ever stamped out of the Empire, Thursday Island might be remembered as their Concord, for it was here that they first showed the world their independence. For years the Queenslanders had been urging the Imperial Government to occupy the island of New Guinea across the water, to forestall the Germans or the French. The British, who had more than enough islands on their books, repeatedly declined: so on March 30, 1883, the day after the English mail-boat had left for London, leaving northern Queensland conveniently incommunicado, the Resident Magistrate at Thursday Island posted a proclamation in his official notice-board. It announced the annexation of all New Guinea, not by the Imperial Government at all, but by the Government of Queensland. A day or two later the Magistrate sailed across the Torres Strait, and ceremonially planted the Union Jack upon the soil of Papua. The British first annulled the annexation in a huff, then agreed to declare a protectorate over the south-eastern part of the island: and when, in 1884, the Germans took the north-eastern coast for themselves, the Queenslanders were understandably piqued.

White colonial defiance did not often go so far, but the Thursday Island proclamation was a warning, and less dramatic disagreements

smouldered on. Colonials intermittently complained that they were not permanently represented on the Judicial Committee of the Privy Council, their own supreme court of appeal, and it irritated them when the British, who controlled their foreign relations, high-handedly ignored their views. In Canada the historian Goldwin Smith[1] campaigned against everything imperialist, to the fury of loyal Anglo-Canadians. In Australia the *Bulletin* stridently derided the 'colonial cringe' and what it liked to call 'The Hempire'. The British, for their part, often found the self-governing colonies an embarrassment. Their racial prejudices were awkward in a multi-racial Empire: Australian laws keeping out Chinese immigrants, blessed with the Queen's assent, were distinctly at variance with the Imperial Government's Chinese treaties, securing British subjects in China every kind of privilege. The way colonials treated their African and aboriginal subjects was often distressing to the British. Both the Australians and the Canadians were in bad odour with the Japanese, a people to whom the British were increasingly drawn. The belligerence of the Australians and New Zealanders in the Pacific chafed against Salisbury's sophisticated diplomacy, and Canada's frontier fears repeatedly caused friction between London and Washington. Britain and France were habitually at logger-heads over Newfoundlanders' fishing rights: when a fishing dispute between the Newfoundlanders and the Americans was adjudicated in favour of Washington, the Newfoundland Legislature refused to pay the damages, and the British Government voted with embarrassment to pay them itself—late one night towards the end of a Session, when nobody would much notice. All in all, if ever the British family of nations broke up, it was debatable whether the daughters would flounce out first, or the mother.[2]

[1] Eton and Christ Church, and formerly Regius Professor of Modern History at Oxford, this angry scholar established his anti-Empire reputation with his book *The Empire* in 1863, and kept it up until his death in 1910. The *Dictionary of National Biography* defines him as a 'controversialist'.

[2] Except in the case of the New Zealanders, who depended entirely upon British markets, and never much wanted to be further emancipated. When, in 1926, the Statute of Westminster gave the white Dominions virtually complete sovereignty, the New Zealanders only signed to preserve the unanimity of the Empire, being perfectly happy as they were.

3

Would the barbarians one day take over? Not, it seemed to the experts again, by force of arms. There were very few British possessions where armed revolution seemed seriously possible, and there was virtually no communication between one subject people and another. The British agencies of security and intelligence were thorough and experienced, and since the Indian Mutiny they had taken no chances: the secret agents of *Kim*, with their cloak-and-dagger habits and elaborate networks of information, were active all over British Asia. Von Hübner made the point that wherever the British lived there was sure to be a faithful servant, a trusty or Man Friday, to warn them of conspiracy: Lascar disaffection on British merchant ships was nearly always given away in advance.

In the black African colonies the last spirit of the Zulus and the Ashantis had been broken, and lesser tribes like the Matabele could not fight for long: even Adowa had not much shaken the military prestige of European armies and their Maxim guns. Kitchener was dealing with the Mahdi—or as Sir Walter Besant[1] put it in an article that summer, 'inspiring with a wholesome dread of the British name the death-despising hordes of the Sudan'. The Egyptians were docile. The French Canadians were dormant. The great Sikh fighting confederacy, the last of Britain's enemies within India, now provided some of the most trusted and admired soldiers of the Indian Army. The Burmese had been pacified, the Maoris were being anglicized, the Australian aborigines were far less trouble than the rabbits.

The two imperial communities which might conceivably rise in arms against the Crown were both white: the Boers of South Africa, the Irish of the Other Island. The formidable Boers, in their endless efforts to get away from the British, the Aborigines Protection Society and the smoke from the next man's chimney, had seldom

[1] Whose sister-in-law, Mrs Annie Besant, gave the British name a different sort of lustre by becoming, as an ardent anti-imperialist, President of the Indian National Congress in 1917. Sir Walter (1836–1901) was a benevolent littérateur who founded the Society of Authors.

failed to humiliate the imperial forces whenever they had clashed: their principles had such punch, their culture was so fanatic, their physiques were so stringy and spare, like the biltong that hung from their saddles, that they made their imperial opponents seem flabby by comparison. As for Ireland, there across St George's Channel was the only real revolutionary situation of the British Empire. Nobody knew how many arms had reached the Irish nationalists, nor how prepared the Fenians were to try another rising: but it was a country, as everyone knew, that was only held by coercion, and twenty-three infantry battalions, with two regiments of cavalry and an army of police, stood on guard in case.

But it was the sea that counted. The sea insulated one possession from another, and gave the British, in effect, internal lines of communication. The British Army might not be very terrible to enemies in Europe, but it was expert in swift movement over vast distances, from one side of the Empire to another. If rebels within the Empire were to succeed, it would only be by scattered guerrilla tactics, tantalizing the heavy imperial forces and making them look foolish, without much hope of driving them out altogether. Since the Kaiser's friendly telegram to Kruger at the time of the Jameson Raid the Boers had convinced themselves that if even it came to a showdown against Britain the Germans would send troops or at least arms to South Africa. The Irish, too, imagined armies arriving, singing Gaelic marching songs, in Fenian troopships from New York. These were pipe-dreams. The British controlled the seaways, knew all about colonial wars, and would always win them in the end.

No, if they were to lose their Empire by force, it would only be in conflict with some immense equal, engaging their armies in a kind of war they did not understand, and defeating them at the centre. They had no real friends or allies, their strength was half bluff, and the best Navy in the world could not save them against a determined team of European enemies. Then Miss Gonne might find her opportunity, and out of the wreckage some of the colonial peoples might snatch back their sovereignties, restoring their kingdoms, principalities, chieftaincies and sultanates to their former fissiparous consequence.

4

On Jubilee evening the Governor of Bombay gave a banquet in his palace at Poona, where the summer heat hung heavy over lake and grotto, and great ladies of the cantonment conversed stickily with Sassoons. Late that night two British officials, Mr Rand and Lieutenant Ayerst, were saluted into their carriage by the crimson-jacketed footmen at the door, and were driven away into the dark: they had hardly left the gate of the Government House compound when a volley of shots rang out from the shrubbery beside the road, and both men were killed.

A terrible plague was raging in the province of Bombay, and Rand and Ayerst were the plague officers trying to staunch it in Poona. Their methods had necessarily been forceful. They had called in troops to help, segregated people from infected areas into camps, pulled down contaminated properties. They had become dreaded figures among a populace that did not understand their purposes, and any dispossessed householder, half-crazed by anxiety, might have murdered them: but to the British in India their deaths meant far more. Fearful troubles beset India that summer, and the plagues and the famines were accompanied, for the first time since the Mutiny, by stirrings of nationalist feeling. For several days before the Jubilee leaflets had been circulating in Poona and Bombay, reviling the Queen and calling on Indians to boycott the festivities. Three hundred million Indians, they said, were living in slavery, diseased and half-starved. 'Not even a demon would venture to celebrate his conquests in a time of famine, plague and earthquake.' The British newspapers did not give much prominence to the deaths of Ayerst and Rand, but the Anglo-Indians interpreted the tragedy as evidence of seditious conspiracy, and when a few weeks later the murderer was caught and hanged they felt that justice had only superficially been done.

In India an absolute despotism was supported by absolute freedom of speech, and a people with virtually no hope of governing itself was deliberately educated in the highest principles of English liberalism. At a time when only a handful of Indians had penetrated

the senior Civil Service, and the idea of an Indian Governor, let alone a Viceroy, was perfectly unthinkable, thousands of educated Indians were conversant with the views of Burke and Bagehot, and followed debates at Westminster with informed and often partisan interest. This was terribly frustrating. Militant religious revivals fanned the resultant discontent, and a multitude of half-Western-ized graduates, denied the jobs they thought they merited, formed a perfect audience for demagoguery. There were, to use the noun classically applied to nationalists all over the Empire, agitators at large. 'In every province of India with which I am acquainted', Sir Charles Crosthwaite wrote, 'there is scattered about a considerable element of this kind—the vultures waiting for the death of their prey.'

It was, though, more than mere lust for carrion. One response to the challenge of imperialism was inevitably the rise of patriotism in the subject peoples. Even in India, historically a welter of separate entities held together by alien force, a new sense of nation was emerg-ing. Its leaders foresaw that the way to independence was not by any hope of another Mutiny, but by constant argument, agitation, Parliamentary pressure and appeals to the British conscience. 'It may be,' said the nationalist Gopal Krishna Gokhale, 'that the history of the world does not furnish an instance where a subject race has risen by agitation. If so, we shall supply that example for the first time. The history of the world has not come to an end. There are more chapters to be added.'

The British were most harassed by Indian nationalism in Bengal, a province of traditionally argumentative intellectuals, quick of thought, fluent of speech and supplied with all the latest liberal arguments by the University of Calcutta. The political prophet of Bengal in the 80s and 90s was an Englishman, Allan Octavian Hume, the son of a radical politician and a former member of the Indian Civil Service. Hume had been in most ways a model servant of the Raj. He had many of the qualities the service most admired in itself. He had distinguished himself in the Mutiny, first as an admini-strator, then as a courageous soldier. His chief fault was a popular one, disrespect for higher authority and an outspoken readiness to express opinions. He was a celebrated ornithologist in a service of

sportsmen—*Hume and Marshall* was the standard manual of Indian game birds. Hume retired in 1882 and went to live in Simla, where he cherished his theory that before long the new Indian nationalism would become a revolutionary movement, so that its energies ought to be channelled into constructive ends from the start. In 1883 he sent a circular letter to the graduates of Calcutta University, asking for fifty volunteers to 'scorn personal ease and make a resolute struggle to secure greater freedom for themselves and their country, a more impartial administration, a larger share in the management of their own affairs'. The Indian Government approved of these innocuous aims, and when Hume formed the Indian National Congress he and his associates were at first exceedingly polite to the Raj, even inviting the Governor of Bombay to preside over their opening session.[1]

Times changed. Congress became a rallying-point of far fiercer spirit. Its propaganda grew more virulent with the years, its intentions more fundamental. 'It is impossible,' remarked Crosthwaite, 'to take such a Congress seriously . . . their doings serve mainly to show the political immaturity of the present generation of educated Indians.' He was wrong. Congress was another of those small clouds. Behind it generations of incoherent resentment were waiting to burst into the open. In Bombay the Hindu zealot Bal Gangadar Tilak, whom many Britons believed to be at the bottom of the Ayerst affair, was glorifying the splendours of an older India, where violence had been justifiable in a good end, and life had been governed by a Hindu morality far more powerful than the demolitions of Plague Commissioners. In both Bombay and Calcutta the Indian-owned Press was scurrilously critical of the Raj. Most educated Indian 'agitators' only wanted self-government within the Empire, like most patriotic Irishmen: but the longer they were denied it, the more moderate bodies like Congress were forced into extremism, and spell-binders like Tilak came into their own. British rule in India was about as efficient, about as fair, as any Government of the day could offer—'not only the purest in inten-

[1] Hume, who was born in 1829, lived long enough to see the Morley-Minto reforms of 1907, the first positive step taken by the Imperial Government towards the emancipation of India. He died in 1912.

tion,' J. S. Mill had thought, 'but one of the most beneficent in act ever known among mankind'. But it was not, by the nature of things, popular. Its very impartiality meant that it had few particular friends. To many Muslims it had a pro-Hindu bias, and vice versa, and its big, aloof, thick-skinned representatives, respected though they were, were not always easy to love. 'It would be an error to suppose', as Sir John Strachey wrote in the 1880s, 'that the British Government is administered in a manner that altogether commends itself to the majority of the Indian population. This we cannot help.'

5

In Egypt almost nobody wanted the British to stay; when the pashas of the Cabinet cautiously suggested marking the Diamond Jubilee by a public holiday, the Khedive himself quashed the idea. In Burma the people somehow managed to stay apart from the Raj—'an indisposition to serve us', was how one official described the attitude, and the British had not succeeded in raising a Burmese soldiery. In Malta, which had joined the Empire of its own volition, and had always been run by its own officials, there were nationalist grievances of diverse kinds—about self-rule, about the economy, about the national language, about religion. In Jamaica, ruined by the collapse of its sugar market, there was a movement demanding accession to the United States. In the Cape the most clannish of the Boers, rankling at so many decades of British interference in their tribal ways, fantastically hoped that one day the whole of South Africa would be united under their own republican rule. In Canada the French Canadians hugged their humiliation to themselves, in Ceylon successive Buddhist revivals were tinged with sedition. Educated Africans of Sierra Leone and the Gold Coast resented the anglicization of the senior Civil Service, once run almost entirely by Africans. In the Parliamentary stand by Westminster Bridge a large gap in the seats showed how many of the Irish M.P.s refused to welcome the Queen's Jubilee procession: the British profoundly agreed with Bismarck's alleged suggestion that the Irish and the Dutch should change places—the Dutch would soon make Ireland

thrive, and the Irish would let the dikes rot and drown themselves. As Edmund Garrett[1] once wrote, surveying the Irish and the Boer problems in parallel, 'Providence in its infinite indulgence has spared us the task of reconciling any race which combines both the Dutch and the Irish gifts of recalcitrance.'

6

Everything was under control, though, and for the moment the British were less embarrassed by subversion in their Empire than by the complications that arose elsewhere in the world from their possession of an Empire at all. The idea of imperialism was by no means discredited abroad—it was reaching a climax everywhere—but the very size of the British Empire, and its application to so many races in so many parts of the world, was bound to make it enemies. Some of its foreign critics were merely jealous. Some thought the Empire evil. The Irish in particular had their champions everywhere, and especially in America, where hundreds of thousands of Irish emigrants and their descendants were to embitter Anglo-American relations for a generation to come. When Americans attacked the concept of Empire they were thinking partly of that German Empire from which so many of them had escaped in 1848, but chiefly of the British in Ireland. Wherever two or three Kennedys or McCormicks gathered together the name of England was sure to be execrated, and Irish-American comment on the Jubilee was bitter. The English were honouring not the Queen, but themselves, said the New York *Sun*, the chief organ of the Irish-Americans: they only kept the sovereign as a 'theatrical accessory of traditional fetish'—the implication being that such a kingdom was necessarily hostile not merely to Irish rebels but to the Great Republic. In Australia, too, the Irish were a dangerous bore to the British (in 1868 a Fenian in Sydney had tried to murder Prince Alfred, the Queen's second son, shooting him in the ribs when he was about to present a cheque to a charitable cause). As the Queen

[1] At 32 editor of the *Cape Times* and one of the most powerful men in South Africa. A friend both of Rhodes and of Kruger, he had first gone to the Cape for his health, and he died in 1907, aged 42.

said, 'So different from the Scotch, who are so loyal', and as the *Mashona Herald* said in a headline reporting the Irish M.P.s' boycott of the Jubilee procession, 'Just Like Them'. To some imperialists the whole future of Britain as a Power depended upon her Irish policies— the real Home Rule issue, the *Edinburgh Review* once wrote, was whether Imperial Britain was to continue a dominant nation in the world.

The occupation of Egypt involved Britain in countless European disputes, and the expansion of Empire elsewhere in Africa had, for all Salisbury's *savoir-faire*, at one time or another antagonized the French, the Germans, the Italians and the Portuguese. The French were suspicious of British intentions in Burma and Malaya, too, while a squabble with Venezuela about the British Guiana frontier embroiled Britain yet again with the Americans, it being implicit under the Monroe Doctrine that Guiana ought not to be British anyway. The possession of Gibraltar did not endear the British to the Spaniards, themselves then enduring the last melancholy pangs of lost supremacy. The possession of the Falkland Islands was already irritating the Argentinians and the Chileans, both good clients of the British, who nevertheless felt they had prior claims to the islands.

The biggest price of all was paid for India, for all its glory a diplomatic millstone round the British neck. The Tsar Nicholas II once observed that all he had to do to paralyse British policy was to send a telegram mobilizing his forces in Russian Turkestan. India was to Britain like a larger twin, whose hurts were felt in London as they were in Simla, and Britain's foreign policies were twisted by Indian preoccupations. As the rival Powers of Europe built up their fleets and expanded their foundries, half the British energies were expended on securing the routes to India, safeguarding the frontiers of India, placating or overawing India's neighbours. The Trans-Siberian Railway might not seem very relevant to British prosperity, but it was a possible threat to India, and so to Britain. So was the German plan for a railway to Baghdad, and the Hejaz Railway, which the Turks were building through Arabia, and the proposed Russian railway to the Persian Gulf—and every inexplicable border dispute in the marches of Afghanistan, every French misdemeanour

on the Indo-China frontier, the squabbles of sheikhs in south Arabia, the weakening of Chinese power in Tibet—all, because of India, the concern of the islanders off the north-west coast of Europe.

7

Was it all worth it? The most real threat to the future of the British Empire was not the danger of armed rebellion, nor the nuisance of political agitation, nor even just yet the prospect of a world war, but the possibility that the British themselves might lose the will to rule. Thirty years before Matthew Arnold had foreseen the terrible weight of Empire:

> . . . she,
> The weary Titan, with deaf
> Ears, and labour-dimm'd eyes,
> Regarding neither to right
> Nor left, goes passively by,
> Staggering on to her goal;
> Bearing on shoulders immense,
> Atlantean, the load,
> Well-nigh not to be borne,
> Of the too vast orb of her fate.

Arnold's was a voice from another age, and his image of England was scarcely to be recognized in the glaring electric light of the nineties: but one day, nevertheless, the weary Titan might shrug that load off. It must have been so tempting to try the other way, and lead the quiet life in Little England. There were a few, a very few, precedents. Besides the United States, Tangier, the Ionian Islands, Sicily, Corsica and Java had all once flown the Union Jack. Only seven years before Heligoland, for seventy years a British outpost commanding the mouth of the Elbe, had been handed over to Germany in return for African concessions. Queen Victoria thought this a very bad precedent. 'The next thing will be to propose to give up Gibraltar: and soon nothing will be secure, and all our Colonies will wish to be free.' She accepted Salisbury's reassurances dubiously. 'I think you may find great difficulties in the future. Giving up what one has is always a bad thing.'

There were people in England, all the same, who felt it might be done more often. The most persuasive critics of Empire were to be found in Britain itself, and they had four main lines of argument. People like Fisher, though they certainly did not demand the dissolution of the Empire, felt that its emphasis was wrong, and that in their obsession with imperial adventure the British were neglecting far more pressing matters nearer home. People like Hobson believed that the glory was all an illusion, and that the Empire cost far more than it was worth. People like Wilfrid Blunt maintained that imperialism was immoral: it was a cheap aspiration for a great nation, and riddled with hypocrisy. And a few acute observers among the working classes, not quite bowled over by the *Daily Mail*, suspected the Empire to be fine for capitalists, but useless to employees—the first suggestion of a rift, between the rich and the poor, on the value of foreign investments.

All these sentiments, given voice by a handful of political stalwarts like Henry Labouchere[1] and the surviving Gladstonian Liberals, sustained a sizeable anti-imperialist minority in Britain. There was never a moment when the British were unanimous about their Empire, and even after the collapse of the Liberal Party there were many in the land who despised, with Gladstone, those 'false phantoms of glory', and wondered as he did why the British public was shocked at the oppression of the Armenians, but indifferent to the bullying of the Irish.

8

But in that celebratory summer any weakening of the imperial will was imperceptible. Hobson could see no hope that imperialism would collapse at all, and most of those who detected Britain's dimly discernible problems thought they could best be solved by strengthening the Empire, rather than giving it up. The fashionable New Imperialist theory was that the British Empire would only survive a Great Power, able to match up to the new European and American giants, if it bound itself together into some more formal unity.

[1] A Radical socialite, founder of the magazine *Truth*, and for twenty-six years one of the wittiest members of the House of Commons. He died in 1912.

The most popular proposal was an Imperial Federation. This was Chamberlain's dream. The Empire would be turned into a single economic unit protected by imperial tariffs—a sort of closed Free Trade area—and there would be a common defence organization, a common foreign policy and eventually an Imperial Parliament with members from all corners of the Empire. 'Our chance is now,' cried Sir Howard Vincent. 'The fruit is ready to our hand. We grasp it, and leave for tomorrow an Empire in the homogeneous strength of which that of today shall pale and which, self-sustaining, self-supporting, shall eclipse all the world to be Mistress of the land as well as, as now, Mistress of the Sea.' Chamberlain said of the white colonies at a dinner for their Premiers in London that June: 'If they desire at any time to share with us the glories and the privileges of Empire—if they are willing to take on their shoulders their portion of the burden we have borne so long—they may rest assured that their decision will be joyfully received, their overtures will be cordially welcomed by the Motherland.' Imperial Federation, said W. E. Forster, who had founded the Imperial Federation League, must be 'such a union of the Mother Country and her Colonies as will keep the realm one State in relation to other States'. John Buchan speculated about the day when there would be 'a continued coming-and-going between English and colonial society, till the rich man has his country house or shooting box as naturally in the Selkirks or on the East African plateau as in Scotland'.

The details were generally left vague, but it was apparently postulated that the federation would be all white, with India and the rest held in common ward. The only self-governing colony to offer much positive response was Canada. In 1879 the Canadians, in one of their early acts as a Confederation, had imposed a customs duty on British imports, shattering the idea of a Free Trade Empire. Now, in the flush of the New Imperialism, these duties were cut by a quarter. The British for their part abrogated treaties, indirectly affecting imperial trade, which they had earlier concluded with Germany and Belgium. Colonial Preference became one of the watchwords of the New Imperialism, and the Canadian gesture was celebrated in a poem written by Rudyard Kipling and set to music by Walford Davies:

A Nation spoke to a Nation,
A Throne sent word to a Throne:
'Daughter am I in my mother's house,
But mistress in my own.
The gates are mine to open,
As the gates are mine to close,
And I abide in my Mother's House,'
Said our Lady of the Snows.

9

It was not to be. Every year the rationalized Empire of the federalists became less convincing, as yet more African territories were added to the roster, and the shape of the thing became more unwieldy yet. The centrifugal forces of the Empire were too strong for unity. If the white colonies were prepared to think about commercial federation and imperial preferences, they were far less interested in common defence. They were very satisfied with the existing arrangements, under which they paid, between them all, rather less than 1 per cent of the annual cost of the Royal Navy. John Morley the radical said that any Imperial Federal Union would always fail on two issues—tariffs and natives: there was no such thing as an imperial native policy, and some of the Colonial Governments might certainly make awkward partners, if it came to a properly federal Empire, with the White Man's Burden shared among all the white men. Lord Blachford, a former Permanent Under-Secretary at the Colonial Office, once remarked that to suppose that the Anglo-Saxons, 'the great exterminators of aborigines in the temperate zones', would when confederated set a new example of justice and humanity towards the coloured peoples seemed to him 'a somewhat transcendental expectation'. Far from being ready for imperial federation, the colonies could scarcely unite their own territories. Newfoundland had refused to join the Canadian confederation. The Australian colonies were still unable to agree on terms for their own federation. New Zealand, though quite favourable in principle to the idea of imperial union, had in practice refused to join even an Australasian Customs Union. As for the British themselves, bravely

though Chamberlain and his friends might talk of imperial pre-ferences, as a nation they were still staunch Free Traders: man and boy they had profited by it, and what was good enough for their fathers was good enough for them.

So the Federal Empire was still-born. Unity was bravely in the air throughout the Jubilee summer, and the problems of joint de-fence and policy were what the premiers mostly discussed at their conferences: but there were only two real and lasting bonds to keep the Pax Britannica in being. One was force, by which the British kept their dependent territories in hand. The other was sentiment: an indefinable, immeasurable bond which kept the British overseas, for all their grumbles, loyal at heart to Crown and Mother Country. The idea of the British Empire could move men to greater things than swagger and pageant music. The name of England, the presence of the Queen on her inviolate throne, could still send a chill down the colonial spine, and a favourite prayer of Jubilee year was Milton's prayer for the Kingdom: 'O Thou, who of Thy free grace didst build up this Britannick Empire to a glorious and enviable height, with all her daughter islands about her, stay us in this felicitie.'

CHAPTER TWENTY-SIX

'The Song on Your Bugles Blown'

The brave old land of deed and song,
We ne'er shall do her memories wrong!
For freedom here we'll firmly stand,
As stood our sires for Fatherland!

Henry Parkes

26

WHAT this Empire stood for, whether it had a message for the world, how to define its principles—these were matters that the New Imperialists loved discussing, but never very neatly answered. The hazy nature of the structure emanated from its heart. The Liberal Party was humiliated, and the old Victorian faith in the omnipotence of freedom had faded rather, but the English remained an essentially libertarian people. Compulsion was not really to their taste. Their public policies swung from side to side with the swing of the political pendulum, and their private views, even in a period of deafening indoctrination, were varied and vehemently expressed: the Little Englanders argued on, every imperial gesture found its critics, and the Irish Nationalist M.P.s were in effect representatives at Westminster of imperial dissent. Twenty years of determined Government was all Lord Salisbury thought he needed to solve the Irish problem, but in a democracy like the English twenty years of consistent policy was hard to achieve. Nothing had time to settle. Even India had only been part of the Queen's dominions for forty years, and the British, so inclined to compare their Empire with the Roman, often forgot that the Pax Britannica could scarcely be said to have existed for much more than a century.

All this did not make for clear meanings. Enthusiasts hoped that when all the different intentions of Empire were synthesized—when the high-minded was diluted with the ignoble, the altruistic with the avaricious, the Crown purified by total immersion and Exeter Hall stiffened by Admiralty, out of it all would emerge some grand significance—an ideology of Empire, such as Napoleon might have devised. It was not so. There was a dialectic of Empire, but no manifesto. No particular dogma, aspiration, economic theory or social truth was expressed by the Pax Britannica. The British had never been good at formulating abstractions, and their attempts to

elevate the Empire into ordered symbolism remained unconvincing.

2

Was it a Christian Empire? Most late Victorians would have been scandalized, if told that the British Empire was really an agnostic political structure. The missionary motive had been so elemental to its growth, pious talk of spreading the Word so infused its literature, it cropped up so often in prayers, sermons and commemorative services, that the average citizen assumed it to be as orthodox in faith as the Church of England itself, and bound to the Establishment by as many rubrics. Everywhere in the Empire the Anglican Church was identified with Authority—even in the self-governing colonies, where it had no official status at all. The British Army went to war with compulsory church parades, the Royal Navy mustered for divisions beneath its guns, 'muscular Christianity' summed up the ethos of the I.C.S. as well as anything could. Anglican dioceses sprang up wherever the Flag flew: when Bishop Hamlyn, the first Bishop of Accra, arrived at his mission on the Niger in 1896 he prefaced his diary with a glorious water-colour of his own arrival— flat on his back beneath a straw awning in the Church Missionary Society canoe, with eight stalwart converts paddling him, a bosun in a blue hat at the rudder, and at the masthead the flag of the C.M.S., a dove above an open bible. The most authentic imperial heroes—Livingstone, Gordon, Raffles—entered their adventures holding the Good Book as defiantly as ever a conquistador brandished his reliquary among the Aztecs.

'Heaven's Light Our Guide' was the motto of the Indian Empire— the Prince Consort himself had devised it—and few doubted that it was the light of a Christian heaven. The idea of Christianity as *primus inter pares* had not yet commended itself to the British. They might not be actively devout themselves, but they had been brought up in a society that firmly believed the Christian way to be the only truth. Many would probably have found it hard to believe that Queen Victoria had herself added, in her own hand, the following clause to the draft proclamation establishing Crown rule in India: 'Firmly relying ourselves on the truth of Christianity, and acknow-

ledging with gratitude the solace of religion, we disclaim alike the right and the desire to impose our convictions upon any of our subjects.'

But then 'an Empire without religion', Victoria had also written, 'is like a house built upon sand'. There was certainly no shortage of religion as such. Upon the passive mass of Hindus, Muslims, animists, fetishists, sun-worshippers and pagans, corps of Christians were at work. Some 360 different missionary bodies maintained nearly 12,000 Christian missionaries in the field—rather more than the imperial garrison of Malta. They claimed to have converted more than 10 million people to Christianity, and the Bishop of Stepney once declared that the Imperial spirit in the State called for an Imperial spirit in the Church. Everywhere in the Queen's dominions the dynamism of Christianity had left its mark. Pugin's spire at Queenstown sent the emigrants westward into the Atlantic, the towers of the Basilica of St John the Baptist, high above St John's harbour, welcomed them to the New World. The church of St James, within the Kashmir Gate at Delhi, was erected at the sole expense of Colonel James Skinner, of Skinner's Horse, 'in fulfilment of a vow made while lying wounded on the field of battle . . . in testimony of his sincere faith in the truth of the Christian religion'[1]. Sometimes the Archbishops of Canterbury and York swept into the Privy Council chambers to act as assessors in some ecclesiastical appeal from the distant Empire, and any Sunday morning, in any princely State of India, the locals might see the English of the neighbourhood, in their Sunday calico and polished tongas, trotting into town for morning service in the Residency drawing-room—a compulsive routine, it must have seemed, which gave cohesion to their exiled lives, and bound them together in godly purpose. Elsewhere in the Empire congregations were often assembled in order of seniority—highest officials in the front pews, a couple of rows of natives at the very back. There was an opulent Anglican Bishop's Palace in Calcutta, opposite the Cathedral, which must have suggested to the Bengalis immense spiritual resources far away: in Bulawayo the Bishop was taking services among the pioneers with makeshift

[1] He was pleased with the building, legend says, but kindly pointed out to the interior designer that his initials were J.H.S., not I.H.S.

fittings in the Empire Theatre, and was once seen to be announcing the next hymn, *The Church's One Foundation*, standing on a Black and White whiskey crate.

Buried away among it all was a conviction, common among imperialists of diverse kinds, that a spiritual destiny had called the British to their pre-eminence—that they were a chosen people, divinely different, endowed with special gifts, but entrusted with special duties, too. Admiral Fisher thought, only half in jest, that they were the Lost Tribes. Henley thought their country was the 'chosen daughter of the Lord'—

> *There's the menace of the Word*
> *In the Song on your bugles blown.*

Kipling thought God had hidden the frontier territories of the Empire 'till He judged His people ready'. Providence, Destiny, Judgement—all these were basic to the vocabulary of the New Imperialism: when the Queen went to her Jubilee service at St Paul's the *Daily Mail* announced in a sacramental cross-head that the mother of the Empire had gone to do homage to the One Being

MORE MAJESTIC THAN SHE

—as if to imply that she was merely reporting the state of the imperial garrison to her superior officer. War, empire and religion were inextricably related in the public mind. It was a fighting God, an Old Testament, fire-eating God, who seemed to be presiding over the imperial progress—'Lord of our far-flung battle-line'.

If it sometimes looked brash or arrogant, sometimes this Christian certainty was beautiful to encounter. The most magical building in the British Empire stood at a bush settlement called Blantyre, in what was later to be Nyasaland. There, in 1888, a missionary called David Clement Ruffelle Scott decided to build a church. There was at that time no European town of Blantyre at all. Scott was the leader of a Scottish Church mission which had settled there, beside the slave route to the lakes of the interior, as disciples of Livingstone, spreading the Word and educating the natives. He and his colleagues had hacked out a clearing, all among the dripping

foliage, at the foot of the wooded valley which ran up to Zomba and the inner mysteries of Nyasa: and it was there that he decided to build his great church. He knew very little about architecture or construction, but he was genuinely inspired. He built in ecstasy. He made the bricks out of the clay of ant-hills, and he laid the foundations before he had drawn a plan. The building grew as he went along, its shape decreed by two unusual principles. First, it was to have no front, back or sides—each face was to be of equal importance. Secondly, it was to avoid symmetry wherever possible —'Symmetry,' Scott thought, 'means poverty of ideas.' While he worked at his building Scott was also compiling a monumental *Encyclopaedic Dictionary of the Mang'anja Language*, and the two great projects proceeded side by side, year by year, in that steamy and barbaric setting. By 1897 both were finished. The dictionary took its place among the standard works of African reference, and the church became one of the most moving in Christendom.

It was the strangest building. It was vaguely Byzantine, with African ornamentation—Zimbabwe Byzantine. It had a dome, and two towers, and flying buttresses, and innumerable odd projections, turrets, filletings and chisellings. Its bricks had never lost their sandy termite colour, and the church stood in a flat brown expanse of stringy grass, unmistakably a forest clearing still, and surrounded at a distance, like a king's hut in its kraal, by the workshops and classrooms of the mission. On the Communion table stood a book-rest made from the tree under which Livingstone's heart had been buried, upcountry in the Ilala territory. On a buttress of the south-west tower a brass plate commemorated the 365 lunar observations by which, in 1885, Lieutenant H. E. O'Neill of the Royal Engineers had determined the longitude of Blantyre: 2 hours, 20 minutes, 13.56 seconds east of Greenwich.

3

Yet there was no rule to it. In heathen India there was an Established Anglican Church, supported by Indian revenue: in Christian New Zealand there was no official church at all. The Anglican Metropolitan of India came eighth in the Indian order of precedence, after the

Chief Justice of Bengal, but the Archbishop of Sydney had no official place, and in some of the Queen's colonies the Roman Catholic Church was given State aid. No religion was proscribed in the British Empire, and none demanded. At a time—until 1871—when it was theoretically impossible to enter Oxford University without subscribing to the Thirty-nine Articles of the Anglican faith, no religious affiliations were required of the men who ruled the Empire.

To the peoples at the receiving end, the faith of the Empire must have been exceedingly confusing. It was true, of course, that the kind sahib or bwana in the dog-collar was to be found everywhere, drinking gin with the officers in the big mess-tent or prostrate beneath the awning on the C.M.S. canoe: but he might represent any of a dozen different varieties of Christianity, he might be daggers drawn, theologically if not personally, with his brother-in-cloth down the river, he might honour his creed with gorgeous rituals of incense and cloth-of-gold, or self-abasing monologues. In Uganda there were actually religious wars, between tribes converted by Anglicans and tribes converted by Catholics. Perhaps a fifth of the Empire was Roman Catholic—there were 166 Catholic bishops, against 90 Anglican—and sometimes the Catholic cathedral in an imperial colony looked almost as official as the Anglican: in 1897 they had just completed the enormous new basilica of St Thomas at Mylapore outside Madras, the supposed burial-place of the martyred saint, and the site of a Catholic diocese since 1521. Jews and Masons were everywhere, too. The only synagogue in the world where the Sephardic and the Ashkenazic rites were jointly celebrated was in Kingston, Jamaica—in 1882 a great fire had destroyed the temples of both communities, so they polled funds to build one together. Even as they completed St Thomas's basilica at Mylapore, they put the finishing touches to the Masonic Hall in Johannesburg opened that summer, too, and used by the Lodges of the Silver Thistle and Star of the Rand. (There was a synagogue in Johannesburg already, allegedly opened by President Kruger 'in the name of Jesus Christ', but the very first Jo'burg pastor was a Wesleyan, F. J. Briscoe, who took up residence in a wagon in Market Square in 1887.)

In the early days of British rule thousands of Ceylonese adopted the British faith because they thought it was a Government religion, compulsory for British subjects. They soon knew better. It took all sorts to make a British world, and what Raffles once called 'the purest beams of reformed religion' were not all-penetrating. Only the inspiration of individual Christians, and the evident material success of the faith, could really qualify Christianity as an ideology of the Pax Britannica. The gentlest of the imperialists hoped that the Christian example, if it did not actually convert the heathen, would at least stimulate their own religions towards a higher spirituality. Younghusband, for instance, thought that Hinduism had been cleansed by the Christian comparison, and said of the Queen's Indian subjects: 'We sought them merely for trade. We found them immersed in strife. If ever we leave them, may it be in that attitude most natural to them, with their arms stretched out to the Divine.' Certainly some of the manners and motions of Christianity had their effect on other devotions. Semi-Christian sects of a thousand otiose varieties sprang up among the negroes of West Africa and the West Indies, fetish curiously mingled with catechism, Obeah with apostolic succession. On a temple bell at Moulmein in Burma a bell-founder who was surely of Evangelical education had scratched his own fundamentalist warning upon a Buddhist temple bell:

> He who destroyed this Bell
> They must be in the great Hel
> And unable to coming out.

4

A less involved imperial principle was the mystique of the Crown. To this genial madness there was much method. The Crown was not only a focus of loyalty to all the white colonies. To millions of coloured subjects it was the one token of British supremacy that seemed familiar—the one link with their own lost cultures of totem, mystery and chieftaincy. The Crown was still surrounded by trappings of divine right, trumpets and orbs, rubies and sapphires. It

expressed itself in gorgeous symbols, vast palaces, flags and armies: the throne of Tipu Sultan stood in the Viceroy's palace at Calcutta precisely as though it had been taken in a fight between champions, Queen and Sultan cap-à-pie. Towering patricians in Government Houses professed themselves to be no more than the Crown's servants, and above every bench of authority its symbol stood, powerful as a withered monkey's claw in the hut of a magic-man. Upon the head especially of an aged and formidable female sovereign, the Crown was a potent item of joss.

The British skilfully exploited it. Whoever coined the phrase the Great White Queen knew what he was about. The most passionate subversives of Empire, the Irish themselves, retained a sneaking affection for the Queen, imperfectly expressed by Patrick Doyle, a sailor, who was found insensible on the Dublin quays on Jubilee eve, and explained that he had been singing *God Save the Queen* when a Russian sailor assaulted him. To people like the Indians the existence of an Empress, however far away and alien, satisfied inherited tastes for strong personal rulers, like the Moguls and Mahrattas of old. Most middle-class Ceylon households had their big lithographs of Victoria, enbosomed with medals and surrounded by crowns and mottoes in Oxford frames: in Bombay many people thought the plague of that summer had occurred because the civic statue of the Great White Queen had recently been defaced.

Victoria was able to play upon sensitive chords of pride when she dealt with lesser rulers as one prince to another. The King of Tonga was so delighted by signs of imperial condescension that he adopted the name George, after George III, and named his wife Salote, a Polynesian attempt at Charlotte.[1] In 1890 four envoys from the Queen arrived at the kraal of King Lobengula, to tell him that Her Britannic Majesty had granted a charter to the British South Africa Company, entitling it in effect to disinherit him (and in the event to kill him, too). Her envoys were wisely chosen. They were four

[1] It was George's granddaughter Salote who, succeeding George II to the throne of Tonga in 1918, proved the most popular figure at the Coronation of the last Great White Queen, Elizabeth II, in 1953. When Salote died in 1965 the magic of the imperial monarchy had faded, and the present King of Tonga calls himself simply Taufa'ahau Tupou IV, K.B.E.

officers of the Royal Horse Guards, and they clanked into the royal compound dressed in full dress uniform, steel breastplates, high gleaming boots and helmet-plumes drooping low over their eyes. Lobengula was delighted with them, and his warriors queued to see their own faces reflected in the officers' breastplates.[1] The peoples of the Indian States made their salaams to the Queen-Empress by way of their own Maharajahs, lesser inhabitants of the same mysterious plane: when Victoria was proclaimed Queen-Empress at a colossal Delhi durbar, in 1858, thousands of princely feudatories had swarmed to the ancient capital to share the royal unction.

The British missed no opportunity to demonstrate the wealth and grandeur of the Imperial Crown. Royal princes went on splendid tours, royal dukes commanded armies on distant stations. The Queen's satraps carried themselves with airs of consequence far more impressive than any mere ambassador's. They lived and moved like royalty themselves, distributing royal honours from time to time, and behaving very loftily indeed. A rich and self-respecting American woman, at a Viceregal soirée during a visit to Calcutta, was approached by an aide-de-camp with the news that His Excellency would now be graciously pleased to meet her, if she would kindly come to the ante-room. 'In my country,' she retorted, 'gentlemen generally have the good manners to come to the ladies' —and leaving the palace in a huff at once feminist and republican, she boarded her yacht and sailed away. In the colonnade of the church of St John at Calcutta there stood the tomb of Lady Canning, widow of the first Viceroy, who had died of jungle fever in 1861. It was a huge stone sarcophagus covered in crests, big enough to contain a lady of gigantic stature, and it looked like the tomb of the first of a dynasty—as though the British, remembering the thrilling royal chapels of imperial Spain, intended to honour the Viceroys and their ladies in the grand manner of Isabel and Ferdinand.

The ceremonial of monarchy, skilfully translated to the distant

[1] Another Victorian gesture to Lobengula was not so well received: she sent him a wheel-chair for the relief of his gout, but it was unhappily painted in the most unlucky of Matabele colours, black, and had to be hastily repainted scarlet—'I hope it's dry,' was Lobengula's only comment, as he lowered himself gingerly into its seat.

provinces, reinforced the imperial hold. Three knightly Orders sustained the Raj in India—the Most Exalted Order of the Star of India, the Most Eminent Order of the Indian Empire, and for ladies the Imperial Order of the Crown of India. The Colonial Office had its own Order, of St Michael and St George, whose Chancellor's office was along the corridor from the Colonial Secretary's, whose motto was *Auspicium Melioris Aevi*—A Pledge of Better Times—and whose Prelate was the Archbishop of Rupert's Land. All were attended with much glitter: the emblem of the Grand Cross of the Star of India was a cameo of Victoria surrounded by diamonds, with a star of diamonds above and the motto 'Heaven's Light Our Guide'. Loyal bigwigs were made more loyal still by the shrewd distribution of such honours (though the King of Siam turned up his nose at the Star of India, which was, he thought, only suitable for feudatories— 'Better give him nothing at all, then', was Salisbury's unperturbed response). Native dignitaries from Hong Kong to the Gold Coast became knights of English orders, queerly uniting in their persons the legacies of gonfalon and seneschal with heritages of tribal stool or ancestral carapace. In Ceylon a headman called Solomon Bandaranaike, presented with a ceremonial sword by the young Prince Albert in 1882, was officially allowed to adopt the name Bandaranaike Rajakumara-Kadukeralu—'the Bandaranaike who was invested with a Sword by a Royal Prince'.[1] The imperialists themselves measured their careers from honours list to honours list, gradually ascending the scale of royal commendation, and taking it all very seriously. One of Queen Victoria's Jubilee messages came from the Prince of Wales, who told his mother: 'I cannot describe how touched I am by your great kindness in appointing me on the occasion of your Jubilee Grand Master of your great and distinguished Order of the Bath.'

The mystique of royalty was easily stretched into a mystique of imperialism. (A shrewd Basuto once asked Lord Bryce if Queen Victoria actually existed, or if she was purely a figment of British imagination.) On great occasions a rapt elevation seemed to hold the

[1] His son, Solomon West Ridgeway Bandaranaike, godson to the Governor Sir West Ridgeway, became Prime Minister of Ceylon in 1956, and was succeeded in that office by his widow.

whole organization in thrall, hushing even the agitators, and endowing the Empire, for its simpler subjects, with a supernatural immunity. It was the existence of a Supreme Person that did this, giving the Raj a character at once human and all-knowing—an Indian expression for it was *mabap sirkar*, 'mother and father Government'. Queen and Empire became ecstatically fused. *The Empress Victoria's Golden Jubilee Anthem*, a stirring Burmese march, long outlasted the Jubilee itself, and was played (on clarions, bamboo clappers, drums and silk-string harps) whenever the Chief Commissioner visited a town. When One Arrow, a colleague of Louis Riel, was charged with 'levying war against Her Majesty's Crown and dignity', it was translated for his benefit as 'kicking off Victoria's bonnet and calling her bad names'. In India Bryce heard the story of a tiger which had escaped from the Lahore Zoo for several days, defying all efforts to recapture it. At last its keeper, approaching as close as he dare, abjured the beast to return to its cage 'in the name of the British Government'—and it did.

5

Plain Englishness, in those days, was a principle. The British Empire was most decidedly British. This was not mere patriotism, saluting the flag at sundown, sticking up for the Mother Country, or humming *Rule Britannia*, as Lord Rosebery habitually did when his spirits flagged. It too was a kind of religion—which, like Islam, pervaded every human activity, and helped to regulate every function. Quite apart from the laws, the traditions and the facts of authority, there were specifically British ways of doing things. There were emotions no proper Englishman would display. There were tastes and taboos so pungently British that the whole world knew them, and expected them to be honoured. *The Times*, the club, leaving the gentlemen to their cigars, the stiff upper lip, hunting halloos at midnight by tight young subalterns on guest nights, bacon and eggs, walking around the deck a hundred times each morning, cricket, *Abide With Me*—all these were imperial emblems, symptoms of Britishness, parodied and envied everywhere.

Such mannerisms were only just beginning to look funny. A

black tie in the jungle was still more admirable than absurd. The familiar tale of the two Englishmen silently raising their hats to each other as they pass in the middle of a totally uninhabited desert was told only half in mockery. The British liked this tart image of themselves, recognized its force and astutely lived up to it. It was an upper-class image, fostered by the public schools and encouraged by artists as different as Kinglake and Henty: it was an image so totally different from any other, so pronounced of character, so difficult to match or imitate, so rooted in many centuries of national integrity, that in itself it was an instrument of government. It bolstered the unassailable aloofness of the British. It made them seem a people apart, destined to command.

Few imperialists were prepared to modify their Britishness to their environment. Their manners were much the same in Mandalay as in Vancouver Island, and everywhere they applied their own values to the setting. Sometimes their confidence must have seemed insufferable—or at least incorrigible, for there was often a saving humour to it. One could never be quite sure whether they were joking or not. Surely they smiled, when they heard the Bombay clock tower peal out its imperial melodies—*Home Sweet Home* on weekdays, hymn tunes on the Sabbath? Surely they were amused themselves at the incongruity of the English names they imposed so blandly upon the maps of the world? In southern Ontario there were towns called Waterloo, Wellington, Delhi, and into Woolloomoloo Bay in Sydney complacently protruded Mrs MacQuarie's Point. The bays, coves and outports of Newfoundland had names like Bumble Bee Bight, Blow-me-down, Heart's Delight and Mutton Bay. The plan of Nuriya Eliya, in Ceylon, recorded the presence of Scrubs Bungalow, St Agatha's, Unique View, Agnesia Cottage, Scandal Corner and Westward Ho! At Kodaikanal, in the Nilgiri Hills above Madras, a favourite excursion took the picnickers up Coaker's Walk to Fairy Falls. There was a Charing Cross in Lahore; the counties of Jamaica were Surrey, Devon, Somerset and Middlesex; India was strewn with places named for British soldiers, administrators and engineers, like Jacobabad in the Punjab, or Clutterbuckganj in Bengal. Many an imperial place had an imperial nickname. Alexandria was 'Alex' to the British, Rawalpindi was

'Pindi', Johannesburg was Jo'burg from the start, Barbados was 'Bimshire', Kuala Lumpur was 'K.L.', and the sacred Swami Rock in Ceylon, 'The Rock of the Saint' to Hindus, was known to the British Army as Sammy Rock.

So strong an ambience was naturally infectious. Many subject peoples aped the British, encouraged to do so by the British policy of fostering Anglophile *élites*. In the Cape thousands of Africans wore European clothes, even to spats and tie-pins, and in Ceylon, the most thoroughly anglicized of the Asian possessions, even the women were dressing in the European mode. Smart Madrasis liked to let drop the fact that they had an account at Spencer's, the Harrods of the Raj. Young Parsees in Bombay talked of 'going home to England'. In French Canada English visitors were sometimes touched to hear hymns sung to the old air *Nelson est mort au sein de la victoire*, and in Burma they were sometimes disconcerted to hear Indian residents talking to the Burmese in their own brand of pigeon English—'*Hi, boy, get master more ice.*' Even the Boers of the Cape had taken to the well-known English habit of *le week-end*.

In these years African chiefs of savage splendour began to deck themselves in the fineries of imperial Britain—top-hats, tail-coats, epaulettes and topees—and the Indian princes reached an apogee of Indo-Englishness. In North Calcutta many of the local Hindu aristocrats maintained their town houses, and one of the best-known of them was the Marble Palace, the home of the Raja Rajendra Bahadur. It lay in a district uncompromisingly and heart-rendingly Indian. Poverty lapped its gates. Naked sadhus leant against walls, fruit-sellers shouted, rickshaws wavered to and fro, gamblers crouched around their pavement boards, children and cats proliferated and cows loitered in alleyways. The air smelt of curry, joss-stick, dirt and animal droppings. At the gate of the Marble Palace, however, a janissary stood guard with his clouting-stick, and behind it the Raja lived in a style astonishingly imperial. His garden was discreetly ornamented with urns, lions and statues, as though only a ha-ha separated it from the green meadows of the Shires. His house was decorated in the grandest English manner. A couple of Reynolds and three Rubens hung upon its walls. Exquisite clocks and classical statuary stood all about, with a figure

of Queen Victoria, dressed in full ceremonial robes, larger than life
in the hall. In the dining room of the Marble Palace Englishmen were
favoured guests, and we need not doubt that for half an hour after
dinner the ladies, retiring to one of the several silken drawing-
rooms, left the Raja and their menfolk to themselves, their port and
their jolly English anecdotes.

How powerful an abstraction it all was! This is Our Way, it
seemed to say. It is the best. English rule was least popular in places,
like Egypt or Ireland, where this conviction faltered, and English-
ness masked uncertainties and weaknesses. Elsewhere the whole-hog
archetypical Briton, reading his *Times* after his morning ride, may
not have been much loved, but stood as a kind of signpost. Every-
body knew him. He was not easily scared. His word was, rather
more often than most, reliable in small things, if sometimes dubious
in large. He seemed to stand fair and square, freshly shaven. The
pound sterling in his pocket, the Royal Navy at his back, the rules
the old school taught him: that was *his* ideology.

6

To many Britons this was not enough. They wished their Empire
to offer some seminal example of social or political progress, to set
a standard for the nations and be its own memorial. 'We view the
establishment of the English colonies on principles of liberty,' Burke
had said, 'as that which is to render the kingdom venerable to
future ages.' 'Wherever in the world a high aspiration was enter-
tained or a noble blow was struck,' said Gladstone, recalling the
Liberal past, 'it was to England that the eyes of the oppressed were
always turned.' 'England has achieved,' Disraeli claimed, 'the union
of those two qualities for which a Roman Emperor was deified:
"Imperium et Libertas".' The one imperial achievement that gave
satisfaction to everybody was the ending of the slave trade—a
decision enforced impartially on all nations, and sustained by the
Royal Navy ever since. This was right beyond all agitation: the
more sensitive of the imperialists hoped it was for such enlightened
actions that their Empire would be remembered in the end.

In the colonies many sorts of social and political experiments

had been tried, in advance of anything attempted in Europe. The very first true modern democracy was the Isle of Man, which gave the franchise to every man and woman in 1866: but New Zealand came a close second, even enfranchising Maori women by 1893. New Zealand was also one of the first countries with proper factory regulations, industrial arbitration, old age pensions, secular education and State life insurance, and it was the first to elect a Socialist Government—some of its members, according to Lord Onslow,[1] the Governor of the day, 'labourers in actual receipt of daily wages'. Radicalism thrived in Australia, where the trade unions were already powerful. The only really exciting episode in Australian history, exploration apart, was the revolt at the Eureka Stockade in 1854— an armed rising of gold-miners at Ballarat, in Victoria, who felt that their rights were being suppressed by an unfeeling Government, and who had long since become martyrs of reform in the Australian public mind.[2] Sydney in the nineties was full of street orators, workers' processions and venomous public attacks on the landed classes, launched with fiery Irish rhetoric, as often as not, beside the statue of the Prince of Wales in the public gardens. When von Hübner was in the city he was invited to dine with the Governor of New South Wales: but just as the guests were going in to dinner all the menservants went on strike, and ratings from a man-of-war in Sydney Harbour were hastily summoned as substitutes.

In many parts of the Empire State Socialism already existed, and almost nowhere was private enterprise regarded as sacrosanct. The imperial economy had its private and its public sectors, sometimes overlapping. The new Gibraltar dockyard, for instance, the home of the Atlantic Fleet, was being built by Topham, Jones and Railton,

[1] A good old-school country gentleman, who gave his younger son the Maori name of Huia. He died in 1911.

[2] In a longer perspective it seems a sad little episode. The Eureka was a pub, and in a stockade around it some 800 miners, excited by demagogues to fury, fortified themselves against a force of soldiers sent to subdue them. Their grievances were real, but their tactics violently squalid, and when the troops attacked most of them soon surrendered. The miners, who were overtaxed, unrepresented and cruelly chivvied by Authority, aroused much public sympathy, and when the Boer War came the Australians readily went to the help of the Uitlanders of Johannesburg, whom they saw as distant diggers besieged at another Eureka.

but the tobacco business in Cyprus was a Government monopoly. Cook's ran the official pilgrims' office in Bombay, but the imperial railways were mostly built with a combination of State and private capital. England, still the supreme example of the uncontrolled economy, had deposited across the world communities whose economic methods were just the opposite. Free Trade found few adherents among the colonists, who raised their own protective tariffs the moment they were free to do so, and in a way the greatest Socialist State of all was British India, where the Government ran the schools and universities, supervised the medical services, managed most of the railways, all the salt and opium factories and a huge forest property, and in theory owned most of the land.

The self-governing colonies were the most genuinely egalitarian societies in the world. The United States had its own layers of social restriction, but the Australians, New Zealanders, Canadians and English South Africans really were emancipated. Of course they still loved a duke, and respected the Oxford accent, but their equality of opportunity was almost absolute. Origin did not count. One of the most satisfying figures of the British Empire was the English working-man set free at last from the restraints of caste: released from village cage or urban prison, taken from smoky rain to sunshine, from cramped red brick to limitless space of prairie or outback, where no gentleman was going to patronize him, bailiff bully him, vicar exhort him to remember his place; where his sallow skin would bronze down the years, his stooped frame fill out and straighten, his hair bleach a little, his voice lose its deference; where his children would grow up a different kind of animal, bigger and stronger than ever he was, snubbed by no toffee-nosed prissy up at the Grammar, and ready to take on any of your ermined lordlings, any day, yes sirree.

(And his wife? Why, give her a generation or two, and she will rediscover her distant relationship with Lord Cape, for whom of course Cape Town was originally named; will realize that even in a modern democracy some people are, well, not quite the kind we older Australians care to meet; and presently resurrect out there in the sunshine all the social shibboleths she was so glad to leave behind in England.)

7

But if in some corners of the Empire the British were abolishing privilege, in others they were vastly enjoying it. One could not really claim it to be an egalitarian Empire, or a radical one, when the rulers of the African and Asian colonies themselves formed an *élite* privileged beyond the dreams of Etonians, and vast expanses of territory were actually ruled, under the Union Jack, by commercial companies. The theorists of Empire were tortured by the contradictions of it all, and their principal difficulty was the dual standard of the Empire: one standard for Britons, one for the rest. The glory of England lay in her free institutions, now extended so successfully to her white colonies: but the whole coloured Empire was governed as a benevolent despotism. This was an unsolved ambiguity. As Cromer, the most level-headed of Empire-builders, once wrote: 'The Englishman as imperialist is always striving to attain two ideals which are apt to be mutually destructive—the ideal of good government, which connotes the continuance of his supremacy, and the ideal of self-government, which connotes the whole or partial abdication of his supreme position.'

The steady progress of the white colonies towards complete independence, though it made for tedious history, was a proper cause for pride. Whether or not they remained members of the Empire, they were complete nations created in the British image, honouring British standards. Elsewhere the British could flatter themselves that they were guiding a score of less-advanced nations towards democratic independence: here a nominated assembly, there half-elected, municipal constitutions in one country, regional legislatures in another. Surveying the Empire in the nineties, the imperial philanthropist might persuade himself that it was all an immense educational process, raising the subject peoples to equality one by one, and spreading the parliamentary doctrine across the world.

Realists knew that this was a meretricious picture. If that was the intention of Empire, its consummation was so far distant as to be meaningless. Not one Asian or black African colony was

anywhere on the way to self-government. Some were going backwards: blacks and whites had once enjoyed equal rights in Natal, but now there were 7,596 white voters, and only ten black (in a country of 400,000 Africans and 35,000 Europeans). Several possessions had given up their representative institutions, reverting to Crown Colony status, and after three centuries of British rule India was still utterly powerless. Indians might argue points of the law till daybreak, but they had no means whatever of altering it—they could say almost anything they liked in speech or in print, but they were ruled by a Parliament in London in which they were totally unrepresented. The British ruled against the wishes of the populace in Egypt and Ireland, and they ruled without consulting the bulk of the populace almost everywhere else. Their government was in nearly every case more just and more efficient than any conceivable substitute: but it was undeniably government by force —a situation repugnant to the deepest historical traditions of England, which no self-respecting Briton would ever tolerate for himself. To become thrall to a foreign nation, Elizabeth I had said, was 'the greatest misery that can happen to a people'. The British bravely agreed: yet they held, that summer, 320 million foreign people in thrall to themselves.

8

This was the saving flaw of British imperialism, for this Empire did have an ideology after all: the High Victorian concept of fair play, which animated the petitioning sympathizers of the Eureka Stockade as it did the pukka sahibs of the Punjab, and appealed to agnostics as directly as to bishops. The British would not for long support an institution that was patently unfair, or betrayed the muffled decency of their national code. At our particular moment of history they were inflamed by the splendours of the imperial idea. They had been persuaded that it was noble and benevolent. They were excited by heady notions of racial superiority. They were flattered—who would not be?—by all that red on the map, all theirs, all pulsing with their energy, alive with their trade, courage and philanthropy. They believed they were awakening the torpid peoples

of the earth to the ennobling ideas of the West. 'What enterprise that an enlightened community may attempt', Winston Churchill asked himself when he joined Kitchener in the Sudan, 'is more noble and more profitable than the reclamation from barbarism of fertile regions and large populations? To give peace to warring tribes, to administer justice where all was violence, to strike the chains off the slave, to draw the richness from the soil, to plant the earliest seeds of commerce and learning, to increase in whole peoples their capacities for pleasure and diminish their chances of pain—what more beautiful ideal or more valuable reward can inspire human effort?'

But such a mood would last only so long as it seemed *fair*: if ruthlessness were needed to keep this structure standing, the British would presently opt out. 'Yet', as Churchill added, 'as the mind turns from the wonderful cloudland of aspiration to the ugly scaffolding of attempt and achievement, a succession of opposite ideas arise. . . . The inevitable gap between conquest and dominion becomes filled with the figures of the greedy trader, the inopportune missionary, the ambitious soldier, and the lying speculator, who disquiet the minds of the conquered and excite the sordid appetites of the conquerors. And as the eye of thought rests on these sinister features, it hardly seems possible for us to believe that any fair prospect is approached by so foul a path.' Lording it for lording's sake was not the deeper British style. Nor was bullying, arrogance, drilling and flag-wagging. At the heart of the Diamond Jubilee there lay a doubt, or an irony: as though that great nation were play-acting through the summer dog-days, bluffing its wondering audience perhaps, but never quite convincing itself.

CHAPTER TWENTY-SEVEN

Finale

Nobly, nobly Cape Saint Vincent to the North-west died away;
Sunset ran, one glorious blood-red, reeking into Cadiz Bay;
Bluish 'mid the burning water, full in face Trafalgar lay;
In the dimmest North-east distance dawn'd Gibraltar grand and grey;
'Here and here did England help me: how can I help England?'—say,
Whoso turns as I, this evening, turn to God to praise and pray,
While Jove's planet rises yonder, silent over Africa.

Robert Browning

27

QUEEN VICTORIA went home happy on her Jubilee day. History had humoured her, as she deserved. The sun had shone all day—'Queen's weather', the English called it—and there was nothing ironic to the affection her people had shown her. She had rolled through London intermittently weeping for pleasure, and studded her diary that evening with joyous adjectives: indescribable, deafening, truly marvellous, deeply touching.

To Victoria the fabric of her great Empire must have seemed almost indestructible. It had been created in her lifetime, and now in the last years of her reign it had reached its noonday. She would leave it as the most stupendous of heritages for her dear Albert and his innumerable successors. Today imperialism has long lost its power to move men's hearts, and the idea of alien rule, however benevolent, is unacceptable to most civilized peoples. In those days it was different. Self-determination was not yet a creed, nor even often an aspiration, and colonial rule was not in itself degrading. Stripped of its emotional overtones, the British Empire did possess several tremendous merits. It was an association of like-minded States of British origin, whose friendship and kinship would prove a blessing to the world at large. It was an instrument of universal order: its scattered bases had enabled the Royal Navy to keep the world at peace for the best part of a century, and its strong arm had established the rule of law in many once-turbulent places. It was an agency of material progress: everywhere its technicians laid down the foundations of industry, and paved the way for change. It was a mighty stimulant: it injected new ideas into comatose societies, it shook up stagnant cultures, it prodded peoples withdrawn from the world into indignant protest, it pulled half Asia out of the Middle Ages, half Africa momentarily out of barbarism. And like it or not,

it kept Britain herself among the Great Powers for another half-century. It was the existence of the Empire that enabled the British, those champions of liberty, to play a part in the affairs of the nations far greater than their own meagre resources would allow, or their precarious prosperity justify.

2

So their pride was understandable, as they contemplated their possessions that summer. It was a world of their own that they commanded, stamped to their pattern and set in motion by their will. Their flag was, if not loved, at least respected everywhere. Their ships lay in every port, and majestically moved down every waterway. Their trains puffed to intricate time-tables across the plains of Asia. Their armies stood to their guns in gulleys of Chitral or barrack squares of Canada, their administrators ordered the affairs of strangers from Lagos to Hong Kong. Manors in Barbados, Grecian churches in Singapore, conservatories in Melbourne and towers of Madras owed their existence to the British: at their word dams arose in India and cables were thrown across oceans, roads arched towards Tibet or the Pacific, rupees chinked in the godowns of the east, the starter's flag dropped on a thousand race tracks and troops of petty princelings obsequiously salaamed. In every continent the Queen's judges decreed lives or deaths, the Queen's warships swanked into harbour and the sounds of Empire echoed: hymn tunes, reveilles, halloos, sirens, rifle-chatter, 'Play the game' from the schoolmasters and 'Boy!' from the lounging planters. It was a stupendous surge of their own energy that the British were witnessing, and it stood beyond logic or even self-control: as when a man suddenly realizes his own strength, and expects life itself to obey him.

3

The New Imperialism quickly subsided. Two years later the Boer War broke out, and the confidence of Empire faltered. Four years later Victoria died, and an age ended. Twenty years later Fisher's

dreadnoughts found their real enemy at last, not in any spiced tropical waters, where the white gunboats lay, but on a misty afternoon off the coast of Denmark: and Lord Kitchener of Khartoum, no longer monopolizing the Maxim gun, sent his English armies into far greater miseries and heroisms than they ever knew at Lucknow, Rorke's Drift or the Khyber.

Seventy years later the grand illusion had collapsed, and England was a European island once more. The script was discredited, the props had disintegrated, and the British, looking back at that colossal performance, wondering at the scale, the effrontery, the vulgarity and the nobility of it all, could scarcely recognize themselves in the actors up there, or identify their smaller lives with that drama long ago.

ACKNOWLEDGEMENTS

THE faults of this book are patently my own. It has been saved from many more by a number of colleagues, friends and generous acquaintances who applied their specialist knowledge to early drafts of the manuscript. Particular chapters and passages were read by Sir Thomas Armstrong, Miss Pamela Hinkson, Dr Brian Inglis, Father A. Jesse, Major-General James Lunt, Professor Arthur Marder, Lord Morris of Borth-y-Gest, Sir James Penny, Mr J. I. M. Stewart and Mr Clough Williams-Ellis. Finally Mr D. K. Fieldhouse, Beit Lecturer in the History of the Commonwealth at Oxford, most kindly read the whole manuscript. I owe my warm thanks to all these people, hope they will like the finished product, and apologize for mistakes and misjudgements I have slipped in when their backs were turned.

2

A formal bibliography to such a book would be pretentious—I have benefited from works as variously useful as Beresford Harrop's *New Guide to Simla* (Thacker, Spink, Simla, 1925) and M. J. F. McCarthy's *Five Years in Ireland* (Hodges, Figgis, Dublin, 1901). Much of my material has been picked up in the course of travel, in conversation, from newspapers and from books which were only incidentally concerned with the imperial theme. I must acknowledge, though, my debt to a number of books which I have used repeatedly, or which were indispensable in the writing of particular chapters.

First, two nineteenth-century classics of imperialism, Charles Dilke's *Greater Britain* (London, 1868) and J. R. Seeley's *The Expansion of England* (London, 1883). Next, two of the innumerable imperial surveys which were compiled in the period before the First World War: *The Oxford Survey of the British Empire*, edited by

A. J. Herbertson and O. J. R. Howarth (Oxford, 1914) and—for a New Imperialist summary—*The Empire and The Century*, edited by Charles Goldman (London, 1906).

Among more modern general works I have made most use of the *Cambridge History of the British Empire*, volume III, edited by E. A. Benians, James Butler and C. E. Carrington (Cambridge, 1959); D. K. Fieldhouse's *The Colonial Empires* (London, 1966); *Imperialism*, by Richard Koebner and Helmut Dan Schmidt (Cambridge, 1964); *The Imperial Idea and its Enemies*, by A. P. Thornton (London, 1959); and *Africa and the Victorians*, by Ronald Robinson and John Gallagher, with Alice Denny (London, 1965).

For the economics of Empire, I have tried to make intelligent use of J. A. Hobson's *Imperialism* (London, 1902); *An Introduction to the Economic History of the British Empire*, by C. M. MacInnes (London, 1935); *Economic Elements in the Pax Britannica*, by Albert H. Imlah (Cambridge, Mass., 1958); and John Strachey's *The End of Empire* (London, 1959).

I have learnt much from the books of three travellers who happened to be wandering through the Empire at about my period: *Through the British Empire* by Baron von Hübner (London, 1886); G. W. Steevens's two books, *Egypt in 1898* (Edinburgh, 1898) and *In India* (Edinburgh, 1899); and two by James Bryce—*Impressions of South Africa* (London, 1897) and *Memories of Travel* (London, 1923). My section on the imperial law also owes something to Bryce's essay *The Diffusion of Roman and English Law Throughout the World* (Oxford, 1914).

The chapter on Salisbury contains much information from *A Scantling of Time*, by G. H. Tanser (Salisbury, Rhodesia, 1965); the chapter on St Lucia much from *The St Lucia Handbook* (Barbados, 1900), and the chapter on Canada owes particular debts to André Siegfried's *The Race Question in Canada* (London, 1907) and *Building Canada: An Architectural History of Canadian Life*, by Alan Gowans (Toronto, 1966). In the Irish chapter I have made most use of *The Irish Administration 1801–1914*, by R. B. McDowell (London, 1964); *The Victorians*, by Charles Petrie (London, 1960); and *The Irish Question, 1840–1921*, by Nicholas Mansergh (London, 1965). Among my most useful published sources on India have been John Strachey's

India (London, 1903); *Peoples and Problems of India*, by T. W. Holdernesse (London, 1911); *High Noon of Empire*, by Michael Edwardes (London, 1965); and *The Men Who Ruled India*, by Philip Woodruff (London, 1953–4).

My naval chapter, like most naval chapters nowadays, owes much to Arthur Marder's two works, *Fear God and Dread Nought* and *From the Dreadnought to Scapa Flow*, published in London between 1952 and 1966: also I have taken some colourful characters from Geoffrey Lewis's *Fabulous Admirals* (London, 1957). Much of the military material comes from *The British Army*, by J. M. Grierson (London, 1899). Most of the statistics are taken from the *Colonial Office List* or *Whitaker's Almanac*. Fellow addicts of the *Dictionary of National Biography* will recognize my debt to its intoxicating pages, and throughout the work I have consulted the collected edition of Rudyard Kipling's works, printed or reprinted in London in almost any year you care to mention.

For those who care to explore the imperial subject more deeply, I recommend two recent bibliographical books: *Books on the British Empire and Commonwealth*, by John E. Flint (London, 1968), a list of works mostly published since 1940; and *The Historiography of the British Empire-Commonwealth*, edited by Robin W. Winks (Durham, North Carolina, 1966), a collection of bibliographical essays by academic specialists.

3

The Kipling quotations in the book are used by permission of Mrs George Bambridge, Methuen and Co Ltd, Macmillan and Co Ltd, the Macmillan Company of Canada Ltd and Doubleday and Co, Inc., New York. The quotations from C. J. Dennis and Henry Lawson are used by permission of Messrs Angus and Robertson. Mr Hugh Noyes has allowed me to use an extract from a poem by his father, Alfred Noyes. The quotation from Sir Arnold Wilson comes from his book *South West Persia*, by permission of the Oxford University Press. The quotation from Winston Churchill's *The River War* is used by courtesy of Eyre and Spottiswoode (Publishers) Ltd and The Hamlyn Publishing Group Ltd. The two quotations

from A. E. Housman are used in England by permission of the Society of Authors as the literary representatives of Housman's estate, and Messrs Jonathan Cape, London publishers of Housman's *Collected Poems*. In the United States they are reprinted by permission of Holt, Rinehart and Winston, Inc.: the first quotation comes from *1887*, in *A Shropshire Lad*—Authorized Edition—from *The Collected Poems of A. E. Housman*, copyright 1939, 1940, © 1959 by Holt, Rinehart and Winston, Inc., copyright © 1967, 1968 by Robert E. Symons: the second quotation is from *The Collected Poems of A. E. Housman*, copyright 1936 by Barclays Bank Ltd, copyright © 1964 by Robert E. Symons.

I apologize to any copyright holders whose rights I have unwittingly ignored.

4

I could not have written the book without the Bodleian Library and its subsidiaries in Oxford, and the London Library. I am also indebted to the Colonial Records Project in Oxford, which introduced me to several passages of reminiscence, to the National Archives in Ottawa and Salisbury, Rhodesia, to the Colonial Office and India Office Libraries in London, the National Library in Dublin, the Connemara Library in Madras, the Simla Library and the St Lucia Historical Society. Much of the necessary travel was made possible by the skill of my New York agent, Julian Bach.

Pax Britannica is intended to be the centrepiece of three books, the first describing the rise of the Victorian Empire to the climax it describes, the third tracing the imperial decline to that condition of uncertain emancipation in which the British nation now finds itself.

Index

Index